⋆ JOSEPH CORNELL ⋆

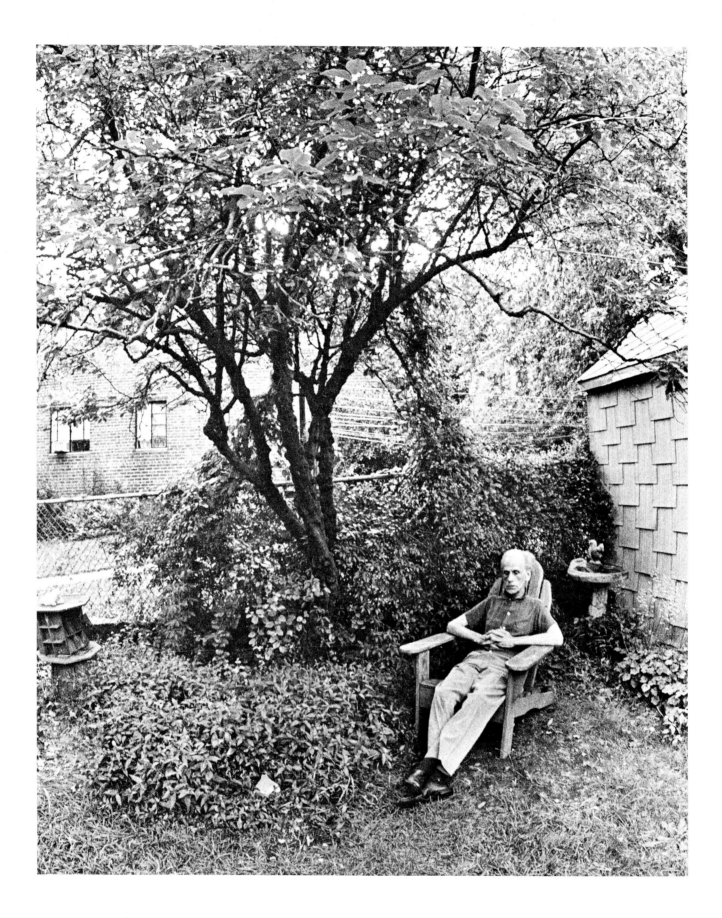

★ JOSEPH CORNELL ★

EDITED BY KYNASTON MCSHINE

ESSAYS BY
DAWN ADES
CARTER RATCLIFF
P. ADAMS SITNEY
LYNDA ROSCOE HARTIGAN

THE MUSEUM OF MODERN ART, NEW YORK

PRESTEL

JOSEPH CORNELL was first published in 1980 to accompany a retrospective exhibition held at The Museum of Modern Art in New York. Although subsequent publications and exhibitions have helped to introduce a larger public to this American artist's extraordinary body of work, I am pleased that this volume has remained a valuable document and that it is once again available a decade after it first appeared. This new printing is published with no changes to the illustrations or texts of the original volume.

Kynaston McShine, January 1990

Reprint 1990 by Prestel Verlag, Munich, in cooperation with
The Museum of Modern Art, New York.

Originally published on the occasion of the exhibition *Joseph Cornell*,
November 17, 1980 – January 20, 1981, The Museum of Modern Art, New York.
Certain plates are covered by claims to copyright noted in the
Photographic Credits.

The poem "Joseph Cornell" © 1967 Maureen Granville-Smith.
Reprinted from *The Collected Poems of Frank O'Hara*, by permission of
Alfred A. Knopf, Inc.

Frontispiece: Joseph Cornell in His Garden, 3708 Utopia Parkway, Flushing,
New York, 1969. Photograph by Hans Namuth.

Distributed in continental Europe and Japan by Prestel-Verlag,
Verlegerdienst München GmbH & Co KG, Gutenbergstrasse 1,
D-8031 Gilching, Federal Republic of Germany
Distributed in the USA and Canada by te Neues Publishing Company,
15 East 76th Street, New York, NY 10021, USA
Distributed in the United Kingdom, Ireland and all other countries
by Thames & Hudson Limited, 30-34 Bloomsbury Street,
London WC1B 3 QP, England

Designed by Patrick Cunningham and Keith Davis
Lithography by Gebr. Czech & Partner, Munich
Printed and bound by Appl, Wemding

Printed in the Federal Republic of Germany

Paperbound ISBN 87070-272-6 (not available to the trade)
Clothbound ISBN 3-7913-1063-1

ACKNOWLEDGMENTS

This volume has been published on the occasion of a retrospective exhibition of the work of a quintessential American artist, Joseph Cornell. His association with The Museum of Modern Art began with his inclusion in Alfred Barr's "Fantastic Art, Dada, Surrealism" in 1936-37 and continued throughout his life. He was a frequent visitor to the Dance Archives and Library of the Museum, as well as to its galleries. The exhibitions "The Art of Assemblage," directed by William Seitz in 1961-62, and "Dada, Surrealism, and Their Heritage," directed by William Rubin in 1968, were two of several occasions on which The Museum of Modern Art acknowledged its special affinity with this artist.

On behalf of the Trustees of the Museum of Modern Art, I wish to acknowledge a great debt of gratitude to all those who have so willingly and enthusiastically contributed to the preparation of this book and to the exhibition it accompanies. To all the lenders to the exhibition, who graciously consented to share their works with a wide audience on this occasion, particular thanks are due.

My colleagues at The Museum of Modern Art have given generously of their information, advice, and time. Foremost is my enthusiastic collaborator on this exhibition, Monique Beudert, of the Museum's Department of Painting and Sculpture. For her discerning eye, astute judgments, and untiring attention to every phase of both exhibition and book, I am profoundly grateful. My special thanks go also to Judith Cousins of the Department of Painting and Sculpture. The contributors to this book have all benefited from her painstaking and imaginative research. In the Museum's Department of Publications, Jane Fluegel brought her customary perception and thoroughness to the editing of this book; Keith Davis and Pat Cunningham provided an appropriately enriching design; and Timothy McDonough oversaw the printing and binding with patience and care. Martin Rapp, Director of the Department, was particularly helpful.

This project has benefited from the full cooperation of the family of Joseph Cornell. Special thanks are owed his sisters Betty Benton and Helen Jagger and his niece Helen J. Batcheller. Through Mrs. Benton's gift of Cornell's papers and documentary material to the Smithsonian Institution, Washington, D.C.— specifically to the Archives of American Art and to the Joseph Cornell Study Center at the National Collection of Fine Arts—information has become available that has given all connected with this project new insights into Joseph Cornell's working methods and biography.

As generous lenders, and as sources of essential advice and aid, the executors of the estate of Joseph Cornell, Richard Ader and Wayne Andrews, have been fully supportive. Their representatives, Leo Castelli, Richard Feigen, and James Corcoran, have graciously provided valuable information and have, in numerous ways, been extraordinarily helpful in the realization of this project. A special debt is owed their associate, Betsy Richebourg, who helped us with countless details. Throughout the preparation of this exhibition and book, we have benefited from her enthusiastic cooperation.

With every Joseph Cornell project, the participation of Mr. and Mrs. Edwin A. Bergman is crucial. They have been more than generous lenders. Their thoughtful support and considered advice are profoundly appreciated. A special tribute goes to several collectors who wish to remain anonymous, but whose inestimable contributions have enhanced this undertaking.

I would like to thank Lynda Roscoe Hartigan of the Joseph Cornell Study Center for providing essential documentation. Diane Waldman of The Solomon R. Guggenheim Museum kindly shared with us her considerable knowledge of Cornell's work. Moreover, her monograph on Cornell has been invaluable. Research on the works illustrated was further assisted by other previously published material; I am especially grateful for the contributions of Dore Ashton, Walter Hopps, and Sandra Leonard Starr. Howard Hussey generously shared with us his extraordinary knowledge of Cornell; he has assisted us in innumerable ways.

Among those who provided helpful information and gave particular assistance in facilitating loans were Irving Blum, William Copley, Donald Droll, Mrs. Marcel Duchamp, Allan Frumkin, Inez Garson, Barbara Guest, Pontus Hulten, Edwin Janss, Ellen H. Johnson, Larry Jordan, Baudoin Lebon, Abram Lerner, Mr. and Mrs. Julien Levy, Carl D. Lobell, John Bernard Myers, Betty Parsons, Mrs. Orin Raphael, Mr. and Mrs. Joseph Shapiro, Brydon Smith, Allan Stone, Joshua Strychalski, Dorothea Tanning, Karen Tsujimoto, Daniel Varenne, Monroe Wheeler, Donald Windham, and Shigeru Yokota.

I am also grateful to James W. Alsdorf, Rudolph Burckhardt, Sandy Campbell, James Demetrion, Emil Forman, Phyllis Freeman, Herbert Gittner, Ludwig Glaeser, Anne d'Harnoncourt, Ethel Hirsch, Ian Hoblyn, David Hockney, Robert Kaufman, Platt Ketcham, Louise Lippincott, William McNaught, Robert Rainwater, David Reynolds, Anne Rorimer, Richard Saunders, A. James Speyer, Joshua Taylor, Mary Jane Victor, Mary Warlick, James N. Wood, and William Woolfenden.

Special thanks are due Waldo Rasmussen and Elizabeth Streibert of The Museum of Modern Art's International Program. Their commitment to Cornell's work has enabled the artist to have, for the first time, a Grand Tour of Europe. A version of this exhibition will be shown in England, Germany, Italy, and France. After the European tour, it will be shown at the Art Institute of Chicago.

I wish to thank the International Council of The Museum of Modern Art under whose auspices the exhibition will travel, and particularly Mrs. Alfred R. Stern, its President. Several members have willingly assisted, among them Emilio Ambasz, Lily Auchincloss, Princess Laetitia Boncompagni, John Brady, Mrs. Konrad Henkel, and Mrs. Charles P. Noyes.

My colleagues Bernadette Contensou of the Musée d'Art Moderne de la Ville de Paris, Jurgen Harten of the Kuntshalle, Dusseldorf, and Nicholas Serota of the Whitechapel Gallery, London, have enthusiastically cooperated in plans for the European showing.

I especially want to thank Richard E. Oldenburg, Director of The Museum of Modern Art, and William Rubin, Director of the Department of Painting and Sculpture. Their encouragement and enthusiasm for this complex undertaking has been greatly appreciated. Particular thanks are owed to Richard L. Palmer, Coordinator of Exhibitions, Cherie Summers, Associate Registrar, and Patricia Houlihan and Antoinette King, Senior Conservators. I am also grateful to Jerome Neuner for his untiring attention to detail in the installation of the exhibition. The Department of Film has provided valuable information on and facilitated the showing of Cornell's films, for which I thank Larry Kardish, Adrienne Mancia, and Jon Gartenberg. Daniel A. Starr of the Museum's Library has prepared the extensive bibliography, for which I thank him.

Many other members of the Museum's staff have assisted in various ways; I would like to thank Mikki Carpenter, Daniel Clarke, Fred Coxen, Diane Farynyk, Steve Hamilton, Betsy Jablow, Frances Keech, Kate Keller, Luisa Kreisberg, Doris Ng, Emilio Poppo, Ruth Priever, Belinda Rathbone, Gilbert Robinson, Richard Tooke, and Sharon Zane.

Finally, on behalf of The Museum of Modern Art, I wish to express my gratitude to the contributors to this book. They have expanded our knowledge and understanding of the full accomplishment of Joseph Cornell.

Any "exploration" of Joseph Cornell inevitably is a combined effort requiring many collaborators. To all who have so liberally given of their knowledge, time, and skill to this project, as well as to the many friends and colleagues who willingly assisted me during the many months "Joseph Cornell" has been in preparation, I wish to express my deepest appreciation.

Kynaston McShine

CONTENTS

Fig. 1 Joseph Cornell: *Castle.* Summer 1944.
Construction, 10⅞ x 20⅞ x 5¾ in.
Private collection

INTRODUCING MR. CORNELL

Kynaston McShine

The art of Joseph Cornell contains intense, distilled images that create a remarkable confrontation between past and present. Founded in the magic and mystery of the poetic experience, his collages, films, and constructions are affirmations of serenity, recollection, enchantment, beauty, the extraordinary. He is the compleat artist, incorporating in his work allusions to art history, music, literature, ballet, theater, film, and natural science.

Cornell, born December 24, 1903, lived on Utopia Parkway in Flushing, Long Island, for most of his adult years. His daily life was simple, but his inner life was complex, rich, deeply romantic. His appetite for culture was vast, ranging from French literature of the eighteenth and nineteenth centuries to studies of the stars in both Hollywood and the heavens. A bibliophile, Cornell read widely, noting in his journals the books he was reading and the associations they brought to mind. He compiled extensive "dossiers" on many different personalities and topics and conducted a far-ranging correspondence—some of it actual, some of it imaginary (not all the letters were sent)—with artists and writers both in New York and abroad. All these concerns were pursued obsessively—and occasionally merged with the realm of fantasy and dream.

Although an almost legendary aura of secrecy and seclusion surrounds Cornell and his work, he was not the total recluse he was generally thought to be.

He had extensive contacts with men and women in the literary, art, and ballet worlds of New York from the 1930s onward. The circumstances of his life demanded that he spend considerable time at home. He lived with his mother and his invalid brother Robert until their deaths in the mid-1960s, only a few years before his own death in 1972. For Cornell, the isolation was that of the scholar in his study, the author and diarist at his desk, the scientist in his laboratory. It is in this context that Cornell's solitary sensibility must be honored and appreciated, for from this quietude emerges some of his most vivid and haunting images.

Speculation surrounds Cornell's beginnings in art, what specifically impelled him to make his first collages and constructions in the early 1930s. The picture is vague; it is known that he produced toylike objects for the entertainment of his brother Robert. His encounter with the collages of Max Ernst most certainly had its effect. However, Cornell's abiding respect and adulation for "the star" suggest another motive—the American dream of fame and stardom. This dream, initially explored within a childlike and enchanted universe of his own creation, was fed by occasional excursions to that other realm of enchantment, Manhattan.

Cornell never traveled, but for him, New York was the substitute for the European Grand Tour, and Forty-second Street a metaphor for all that attracted him to the city. Its fourteen blocks

encompass an immense store of knowledge, both sacred and profane, from the constellations of Grand Central Station's vast ceiling, to the Picture Collections of the New York Public Library, to the shooting galleries, penny arcades, theaters, movie houses, record stores, and souvenir shops of Times Square. It was at any of these three locations—Grand Central, the New York Public Library, or Times Square—that he might emerge from the subway after the journey from his home in Queens.

Although Cornell found materials for his boxes and collages in various quarters of New York, the souvenir shops and back-number newspaper and magazine stores on this street— particularly near Times Square—were a rich source for old advertising cards and movie magazines, plundered for their images particularly in the 1940s. The theater district near Times Square attracted Cornell, too, for its Automats, cafeterias, soda fountains, and sweet shops, where he could observe young waitresses and starlets imbued with dreams of theatrical glory—so much can be seen through the plate-glass window.

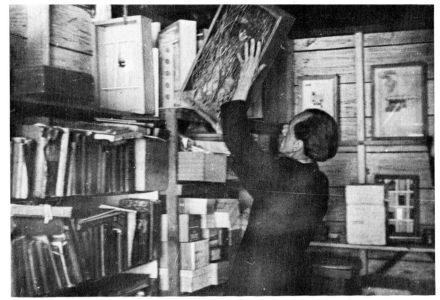

Fig. 2 Cornell in his workshop lifting Untitled (Bébé Marie) (pl. VIII), 1960s

★

Cornell's singular feeling for childhood's games and toys, his sanctification of the small object—a marble or a block, which he treated as if it were a treasure—merged with his nostalgia for the paraphernalia of Victorian parlors —stuffed birds and shell-encrusted compositions under bell jars. Fascinated with the flotsam and jetsam of our lives—from driftwood and dried twigs to postage stamps, sequins, and clay pipes—he preserved these precious items as carefully as any curator protects his collection. This was the raw material for his work. In his basement workshop, he was like an Elector of Saxony in his *Wunderkammer,* a collector in his *cabinet de curiosités* (figs. 2, 3).

Cornell's sensibility as a collector is an important element in his art. He treated the ephemeral object as if it were the rarest heirloom of a legendary prince or princess; one must respect the intensity of his vision and the magic

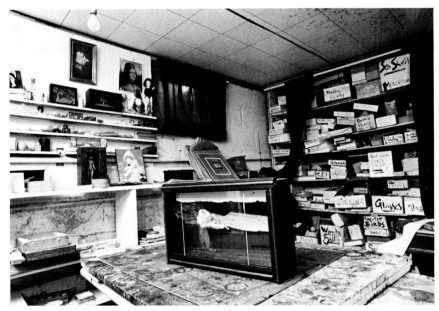

Fig. 3 Cornell's workshop, 1969. Photographed by Hans Namuth

Fig. 4 Joseph Cornell: Verso of Untitled (Discarded Descartes), pl. 180

Fig. 5 Verso(detail) of *Castle*, fig. 1

with which he invested the ordinary with an eloquent and arresting presence. For Cornell, a necklace from Woolworth's had as much value as one from Fabergé, and it became the souvenir of a Romantic ballerina who danced for a highwayman on the snow while crossing the Steppes of Russia (*Taglioni's Jewel Casket,* 1940, pl. 87).

Cornell's association with the Surrealists in the 1930s and '40s enabled him to adopt a free attitude toward the object; it allowed him to assemble a Soap Bubble Set (pl. I) from cork balls, cordial glasses, odd bits of driftwood, and old maps. Perhaps it was his acquaintance with Duchamp and his Readymades that opened the way for Cornell to create his Jewel Cases, Museums, Pharmacies, and Habitats.

Cornell celebrated collage and assemblage as true poetic forms. He was freed by these twentieth-century innovations to juxtapose unlike images, as in the romantic union of a Renaissance painting with a contemporary game from the penny arcade (Medici Slot Machine, pl. 117). Fragmentation is a condition of modern life—it is made manifest in the writing of James Joyce and Gertrude Stein, the music of Erik Satie, and the art of Pablo Picasso and Kurt Schwitters. Cornell's constructions are reliquaries for the fragment, the souvenir, the talisman, the exotic bird, the ballerina, the princess; they evoke hotel chambers, the Grand Tour of Europe, palaces, constellations, and sea journeys.

★

In a journal entry for January 8, 1966, Cornell asserted that he lived one day ahead of conventional time: "This one day is an eterniday in the world I have come to be enveloped in." Cornell attempted to achieve timelessness in the actual facture of his constructions. He varnished and polished the wood so that it would look antique; he collaged pages from old books on the backs of boxes to create the appearance of age (fig. 4). He left constructions out in the elements so that they could achieve a weathered look; on occasion he even placed a box in the oven so that the inner paint would peel and crack, adding to the sug-

gestion of times past. Through these processes, he also achieved subtle coloring.

His attitude toward time is revealed to a degree in his dating of his works. He believed that the process of distillation and refinement required to produce his art could not be precisely dated, so that although he sometimes supplied dates, often there were none. In certain cases, he disconcertingly preceded the inscribed date by a qualifying "circa." He often signed works in mirror writing, reminiscent of Leonardo da Vinci's practice. On other occasions, he precisely typed his name, then inscribed it as well in ink (fig. 5).

Perhaps it was Cornell's measuring of time by his own perceptions that allowed him to create an infinity of atmospheres within a small space—one of the most endearing qualities of his work.

★

There is a fascination in Cornell's use of glass and mirrors. It not only accentuates depth, but also creates various ambiguities; are we being judged by the stare of a Medici Prince from inside the box (pl. 117), or are we sighting the figure through the hairlines of an imaginary gunsight? Images such as cordial glasses, marbles, and soap bubbles reflect the sensual world—as in the allegory of the Vanitas. But glass also brings to mind Cornell's interest in Dutch masters like Vermeer, in whose work light floods the room through almost unseen windows, creating a marvelous illusion of space and depth within a small painting.

Cornell was fascinated by the sixteenth- and seventeenth-century Dutch masters. Himself of Dutch ancestry, he seemed almost to dream of being a Dutchman in a small house in Amsterdam, producing his small masterpieces, or a Spinoza, grinding his lenses. Although Cornell's choice of intimate scale also reflects the world of childhood, of containment, of the architecture of dollhouses, it also makes reference to Vermeer interiors—with tables, cupboards, maps, globes, light, glass—holding captive a moment in a transient, enclosed world.

Two series that contain playful elements are the Sand Fountains and Sand Boxes (pls. 181-96). They are actually designed to be picked up and the shifting sand allowed to form different, fleeting patterns. They not only lend themselves to chance creation but also suggest hourglasses and tides—still more allusions to time. The slices of nautilus shell in some of the Sand Boxes bring to mind another recurring motif, the spiral. Alluding to life spinning itself out—or, conversely, to the ever-narrowing route from the City of Destruction to the Celestial City in Bunyan's *Pilgrim's Progress*—it also refers to Duchamp's spiraling Rotoreliefs and Precision Optics. Cornell also frequently used the circle motif. It recurs as a map of the sun or the moon, as a glass disk, as the ring confining the pet bird, and as a target, referring back again to Duchamp.

★

In his Aviaries, Cornell created "peaceable kingdoms" populated by parrots and cockatoos (the lively, exotic pets of divas, symbolic, as well, of daylight, tropical warmth, the deeply feminine) and nocturnal owls (metaphors for solitude, passivity, the darker and colder side of nature, the hermit's cave). The birds are Cornell's intelligent collaborators, spiritual as opposed to material, symbols of thought and imagination. The empty Aviaries conjure up images of the dead bird or the empty cage awaiting its victim. There is, of course, an ambiguity in this image as well: perhaps one may rejoice that the trapped bird has flown the cage.

The isolation, the sense of loss in the empty Aviaries is also found in the Palaces and Castles (fig. 1). Cornell's continuing dependence on European culture and history is best exemplified by these grand facades. Symbols of the lost splendor of a Golden Age, they suggest the grandeur of courtly life, a world of princely flirtations, nymphaea, music, banquets, frescoes, tapestries, international intrigue, exotic trade, romance—a world that no longer exists except in fairy tales and in the Romantic ballet.

Cornell maintained a lifelong devotion to the ballet and to its music and its mythology. He loved the world of *Ondine* and *Swan Lake,* but he was also dedicated to the nineteenth-century ballerinas—Lucile Grahn, Marie Taglioni, Fanny Elssler, Fanny Cerrito—and to their attendant legends. He created numerous works in homage to them, such as *Naples* (pl. 94), named for the birthplace of Fanny Cerrito, who was renowned for her dancing of the role Ondine. Cornell also became friendly with some of the great contemporary ballerinas, such as Tamara Toumanova and Allegra Kent, corresponding with them as well as creating works in their honor; the image of Redon's *Pandora* (fig. 6) was the basis of an homage to Toumanova (pl. 99) and Manet's *Bouquet of Violets* (fig. 7) of one to Allegra Kent (pl. 101). This continuing interplay with art history was a touchstone in his art.

Cornell's knowledge of art history came from books illustrating the masterpieces of great collections, and he introduced their images into his collages and constructions. In the 1960s, the Dosso Dossi *Circe and Her Lovers in a Landscape* (fig. 8) from the National Gallery of Art in Washington, D.C., appeared in several collages (pls. 226, 265), just as the image of Bronzino's portrait of Bia di Cosimo de' Medici from the Uffizi Gallery in Florence was the central image in several versions of the Medici Princess (pls. XI, 118, 120) between 1948 and 1954.

Cornell's allusion to so many worlds was facilitated by his involvement with printed matter. As noted earlier, he elaborately collaged the backs of many of his boxes with pages from old books (there are further surprises on the backs of his works; he often included a line of poetry that interested him, occasionally a map, perhaps even noted the music he was listening to when the box or collage was being made). In his constructions, he incorporated maps not only of European cities but also of the South Seas, constellations, the moon, longitudinal lines, and paths of trade winds and rivers. In the 1940 construction called *Object* (fig. 9), he pays homage to the photograph and to its descendant the

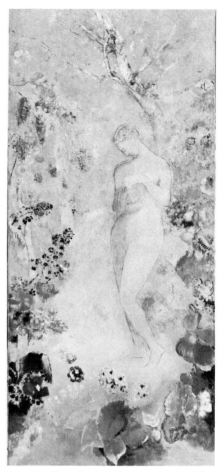

Fig. 6 Odilon Redon: *Pandora.* c. 1910. The Metropolitan Museum of Art, New York

Fig. 7 Edouard Manet: *Bouquet of Violets.* 1872. Formerly collection Rouart

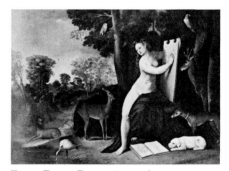

Fig. 8 Dosso Dossi: *Circe and Her Lovers in a Landscape.* c. 1525. National Gallery of Art, Washington, D.C.

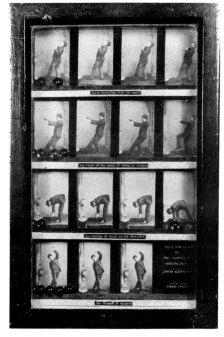

Fig. 9 Joseph Cornell: *Object.* 1940. Construction, 12 x 8 x 2¾ in. Collection Betty Parsons, New York

motion picture. Inscribed "Hotel Theatricals by the Grandson of Monsieur Phot, Sunday Afternoons," it recalls the central figure, a photographer, of Cornell's 1933 Surrealist scenario "Monsieur Phot." From his earliest collages composed of nineteenth-century engravings to his late work incorporating color reproductions from art magazines and travel literature, he was deeply involved with the photograph, the postcard, the photocopy, and the printed reproduction of works of art.

★

Toward the end of the 1950s, Cornell began to lament the dwindling of his source materials, both objects and printed matter, and gradually his production of boxes slowed. He returned to collage—perhaps out of physical necessity as he found the collecting of material and the crafting of his boxes more difficult. The late collages lack the tension of the remarkable constructions, but they are straightforward images with a beauty and simplicity of their own. The sensual preoccupations of his later years are revealed in these works. Many are dedications to starlets or excursions into the world of the glossy magazine. Others follow his usual themes: homages to the Romantic ballet (pl. 100); guides to astronomy, science, and mathematics (pls. 260, 265); and tributes to celebrities of the cultural world such as André Breton (pl. 271) and Susan Sontag (pl. 270).

After his brother Robert's death in 1965, Cornell incorporated reproductions of his brother's drawings in a series of collages (pls. 282–84). He paid further tribute to Robert—who loved toy trains—through his use of Magritte's image of a train emerging from a fireplace in *Time Transfixed* (pl. 246). In *Goya Capricho* (pl. 288), Cornell introduced images of two boys and two girls in a reference to himself and his siblings, adding a sailing ship emblematic of his Dutch sailing ancestors. In *Trista* (pl. 290), there is a tiny photograph of Cornell himself under the quince tree in his backyard.

For Cornell, this tree was his orchard, his white frame house his palace. No longer an habitué of Forty-second Street, he spent most of his time in his studio with his books and his records. The Enchanted Wanderer no longer sought out Hedy Lamarr nor explored the Crystal Palace in search of Berenice. They were now part of a glorious reverie.

★

Cornell produced his first Soap Bubble Set (pl. I) in 1936. It included a circular map, clay pipe, cordial glass, and doll's head, elements that would recur in his work throughout his life. Most remarkable of all was the presence of an egg. It was the egg of the philosopher, the symbol of perfection. In its simple assertion of purity, it provides a key to the oeuvre of Joseph Cornell.

Fig. 1 Installation view of Cornell's "The Elements of Natural
Philosophy" and Soap Bubble Set, "Fantastic Art, Dada, Surrealiam,"
The Museum of Modern Art, New York, 1936–37

THE TRANSCENDENTAL
SURREALISM OF JOSEPH CORNELL

Dawn Ades

Since Joseph Cornell's death at the end of December 1972, a rich hoard of his diaries, memorabilia, and source-material files has become available, although as yet these materials are unedited and unpublished! His public found him an inscrutable man during his life, so these newly revealed writings provide both an invaluable source of information and a clue to his reticence. It was not that he found verbal expression uncongenial or unnecessary; the diaries are vivid and evocative, a mixture of spontaneous, unforced notes as well as passages polished and reworked, for he did not always find writing easy. They also give the reader the uncomfortable sense of eavesdropping on a very private man, whose intense personal life, hitherto glimpsed only through the occasional accounts of his close friends, has now been thrown open to scrutiny. But this posthumous eavesdropping cannot have been entirely unforeseen by Cornell, because some of the entries are clearly composed with an eye to the future — that is, carefully written up and typed (sometimes, disconcertingly, several years after the original logging); others are drafts for statements or even lectures; still others are repeated in source-material files and even in the boxes themselves.

All these writings contain clues — often very explicit — to Cornell's method and to the sources of his imagery. As far as his method is concerned, there is a definite and illuminating parallel between the way his writing suddenly shifts from consecutive prose to scrappy notations and lists — of names, objects, experiences, themes of the boxes — and the way his constructions present material in separate compartments, bottles, and holes. The files, of which there are over one hundred and fifty, contain dossiers on celebrities that are as diverse as Claire Bloom, Jennifer Jones, Tilly Losch, Marie Taglioni, and Vermeer. Others, which he called "source-material files," covered a wide variety of subjects: the circus, Cassiopeia, astronomes, birds, insects, history (more or less "objective"), and other more personal topics related directly to particular works: Crystal Cage, Night Voyage, Celestial Theater, Medici Penny Arcade Machine. Cornell also stored boxes of carefully filed material for inclusion in the works, the physical equivalent of the source-material files. Within this diversity, Cornell spun a complex web of associations, which go to the very heart of his work. It is here that the clue to his reticence lies, for he doubted his capacity to communicate these threads, the extensions and ramifications of their labyrinthine nature. It is as though all this material represented an enormous underground network in which the only visible landmarks were the boxes and collages, and the difficulty of communicating their meaning was a source of both regret and satisfaction. In his diary on April 15, 1946, he wrote: "...satisfactory feeling about clearing up debris on cellar floor — 'sweepings' represent all the rich cross-

currents and ramifications that go into the boxes but which are not apparent (I feel at least) in the final result."[2]

★

Cornell produced his first works in 1931, in the context of Surrealism, for it seems to have been the experience of seeing collages by Max Ernst, in particular the collage-novel *La Femme 100 têtes* (1929), which provoked him to become an artist. What attracted him to these collages was their use of nineteenth-century engravings: images often of an inherent though unwitting oddness providing a natural ground for the exercise of a disorienting imagination. Ernst, for example, turned a nineteenth-century engraving of a "curiosity" constructed from orange peel into an octopoid flying machine. Cornell was long familiar with this kind of material; for years he had haunted the old bookshops on Fourth Avenue, and the bric-a-brac, curio, and record stores between Madison Square and midtown, collecting engravings, old French and German books, postcards, photographs, films, and movie magazines. The decade of the 1920s had been, Cornell later felt, a golden age in Manhattan for the souvenir and culture scavenger.

The encounter that marked Cornell's entry into the New York art world, in November 1931, has been described by Julien Levy in *Memoir of an Art Gallery* (1977). Levy's gallery had just opened with an exhibition of contemporary American photography, but in the back room was a collection of old photographs —and possibly books and periodicals.[3] Cornell was a frequent visitor, and one day lingered to watch Levy crate pictures for the approaching Surrealist exhibition at the Wadsworth Atheneum in Hartford, Connecticut. Levy describes the encounter:

"Closing time," I suggested. But he had already fumbled out of his overcoat pocket two or three cardboards on which were pasted cut-outs of steel engravings. Collages! I glanced hastily at a bundle of collages by Max Ernst only just unpacked and stacked on the bookshelf. But these were not any of those. "Where did you find

these?" Was it not a blessing I hadn't thrown the man out, thought I. "I make them," Joseph said. And showed them to me. There was the image of a fashionable fin-de-siècle young woman being sewn together on a sewing machine table.... [pl. 5][4]

The reference to the Comte de Lautréamont's famous image from *Les Chants de Maldoror*, "as beautiful as the chance encounter of a sewing machine and an umbrella on a dissecting table," which had become an emblem for the Surrealists, is unlikely to have been fortuitous; and it would seem that Cornell, in his oblique way, was offering it as a token of the affinity he felt with the Surrealists. The chance encounters and disorienting juxtapositions of Cornell's early collages conform to the earliest definition of montage in the context of Dada and Surrealism, made by André Breton in his catalog preface to Max Ernst's first exhibition of collages in Paris in 1921, and forming the basis of his later definition of the Surrealist image in the *First Surrealist Manifesto* (1924). Breton wrote: "It is the marvelous faculty of attaining two widely separate realities without departing from the realm of our experience, of bringing them together, and drawing a spark from their contact...and of disorienting us in our memory by depriving us of a frame of reference..."[5]

In Cornell's later constructions, however, it is the process of association rather than dissociation that underlies the bringing together of objects. What he comes to seek is not incongruity so much as a mysterious congruity, a thread of affinities, however intangible, rather than an illuminating spark struck from disparateness. It is already possible to detect this interest in unexpected congruities in the early collages, which Cornell appears to have begun to assemble during 1931.

The best analysis of the relationship between *La Femme 100 têtes* and Cornell's early collages is John Ashbery's, in "Cornell: The Cube Root of Dreams," a review of the exhibition of boxes and collages at The Solomon R. Guggenheim Museum in 1967:

Cornell's collage, surreal as it is, also has extraordinary plastic qualities which com-

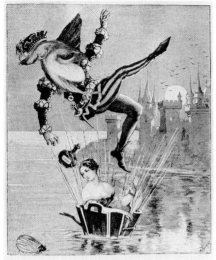

Fig. 2 Max Ernst: *Jeanne Hachette et Charles le Téméraire*. 1929. Collage, 9⅝ x 7⅞ in. Private collection

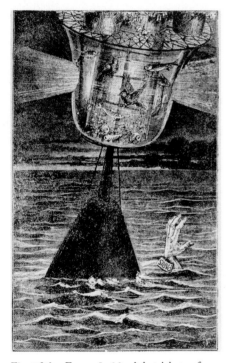

Fig. 3 Max Ernst: *La Mer de la jubilation*, from *La Femme 100 têtes*. 1929. Collage

pete for our attention with its poetic meaning. He wishes to present an enigma and at the same time is fascinated by the relationship between the parallel seams in a ship's sails and the threads of the web, between the smoky-textured rose and the smudged look of the steel-engraved ocean [pl. 2]. He establishes a delicately adjusted dialogue between the narrative and the visual qualities of the work in which neither is allowed to dominate. The result is a completely new kind of realism.[6]

However true this may be of Cornell, it seems unfair not to recognize that the Surrealist imagination can be exercised visually quite as much as verbally, and is, for example, in Ernst's frottages and *La Femme 100 têtes*. Ashbery's criticism of the Ernst collage-novel, which palls, he finds, through overinsistence on our attention, could be more aptly applied to Ernst's slightly later and heavier collage-novels, *Rêve d'une petite fille qui voulut entrer au Carmel* (1930) and *Une Semaine de bonté* (1934), but does not do justice to the ebullient ingenuity, changes in pace, disruptions of scale, and sheer comedy of *La Femme 100 têtes*. In his early collages, Cornell responds to each different kind of scene: an impassive bowler-hatted drummer moves unperturbed through an apocalyptic scene of burning buildings and fleeing rats (pl. 43),[7] as in Ernst's *Roulement de tambours dans les pierres*; Alice in Wonderland children are trapped in strange experiences (pls. 37, 38). As in Ernst's collages, objects out of scale and place float in a landscape; recurrent in several is a trussed turkey, which in one is spitted on an elevated railway.[8] Cornell probably also saw collages such as *Jeanne Hachette et Charles le Téméraire* (1929) (fig. 2), made by Ernst for a projected history of France (never realized), and published in *La Révolution surréaliste* (Paris, December 1929).[9]

There is an element of bizarre humor in Cornell's early collages that is largely absent from his later works and is related very closely to Ernst's. Absent from Cornell from the start, though, is the explicit eroticism and profanity of Ernst; there is no equivalent in Cornell, for example, to Ernst's *Germinal, ma soeur* (1929), an engraving of a prim Victorian girl subverted by the addition of a naked breast to the girl's chest, while caged in the background rages The Eternal Father. Unlike Ernst, who gave elaborate titles to his collages, Cornell left the majority of his untitled. Cornell is not interested in the transformation of objects practiced by Ernst, who, for example, allows a bat's wing to become the blind of a railway carriage or rats climbing the side of a face become the mane of the sphinx. Very rarely does Cornell attempt something of the kind, although in one untitled collage (pl. 45), by cutting and recombining an engraving of a bird to puff it out into a circle and adding a striated ring round its body, he tries to marry it to the forms of the celestial bodies of the night sky, which fill the rest of the engraving. This is not a true example of transformation, however, but an attempt to link in one form the two terms of an image—a comparison between a bird and a star, an image full of significance for his later constructions. More often, and more successfully, Cornell's strategy is to draw a series of subtle verbal, visual, and textural threads of comparison between separate objects. In the first collage he showed Julien Levy (pl. 5), an ear of corn is placed beside a woman lying on a sewing machine as her elaborate dress is being sewn. The corn cob, half-peeled, its long and slightly bulbous sheath repeating the shape of the fin-de-siècle clothes, its silky inner tassels just visible, seems to remind Cornell of the contrast of naked and clothed textures, of the smooth arm of the woman and the pleated and ruched silk and lace.

In Ernst's and in Cornell's own collages are hints of the objects Cornell was shortly to begin to make. The glass diving bell in Ernst's *La Mer de la jubilation* (fig. 3) is reminiscent of Cornell's early glass bells; Cornell incorporated into some of his early collages engravings of the toys and games to which he was to look for inspiration in his three-dimensional constructions. One contains the lens and projector of a magic-lantern set held by disembodied arms (pl. 28); another, an engraving of a shadow puppet box, seen in section;[10] and still another, an image of what looks like part of a wooden board game, into which a ship of the ancient

world is being lowered by a giant hand (pl. 11), its scale transforming the other objects to doll's house proportions. In one of the collages, birds are introduced in conjunction with an engraving of a barometer, its moving needle taking the form of a magician or alchemist figure (pl. 4). Cornell perhaps knew those late eighteenth-, early nineteenth-century diagonal barometers that incorporate various kinds of information into little compartments on or set in the face.

The principle of montage is carried into Cornell's earliest objects, the shadow boxes, for example, and the miniature glass bells, dwarf offspring of the Victorian glass domes containing stuffed birds or animals, dried flowers, or a model ship. As in Magritte's *Ceci est un morceau de fromage* (1936), a transparent cover is placed over a two-dimensional image. One of Cornell's glass bells contains a tiny cutout horse and rider (pl. 23); another contains a hand, which appears three-dimensional, holding a collage of a rose and an eye (fig. 4). Here Cornell has created an entirely original and thoroughly Surrealist image with subtle verbal and visual exchanges: the eye has been placed, conforming perfectly to the contours of the petals, where the heart of the flower should be.

Levy suggests that Cornell's early box constructions might have been inspired by "old French puzzle boxes and watch springs in old containers with transparent covers (backed by views of the Arc de Triomphe)..."[11] which the art dealer had brought out to show him. But the speed with which Cornell thought out and executed these objects, which understandably puzzled Levy, and the suddenness with which he responded to Ernst, prompts one to question whether he had already been tinkering, making such or similar things as part of his lifelong habit of devising games and amusements for his brother Robert, a childlike invalid, barely able to speak or move, but one whose imagination and gaiety were cherished by and at times stimulated Joseph. In later years another gallery owner, John Bernard Myers, recalled a toy landscape constructed by Joseph that filled part of the living

room of his house on Utopia Parkway; an elaborate railway system, with parts that moved or could be lit up, it was operated by Robert from a switchboard; there were also a magic lantern and a movie projector.[12]

<p style="text-align:center">★</p>

Levy was, in the winter of 1931, preparing his own Surrealist exhibition, and not only decided to include works by Cornell, but had him design the cover of the catalog announcement: a collage of a boy blowing a trumpet like an annunciatory lily, formed of an old engraving of a swirling Victorian petticoat, from which flows the word *Surréalisme.* Slightly altered, this image was used again for the cover of Levy's *Surrealism* in 1936. Cornell was not, however, included in "Newer Super-Realism," the very first American exhibition of Surrealism, organized by A. Everett "Chick" Austin at the Wadsworth Atheneum, in November 1931, to which Levy lent a substantial number of works by Ernst, Salvador Dalí, and Giorgio de Chirico. Levy's exhibition, which opened in January 1932, divided works into usual and less usual categories: "Paintings, Drawings, Montages, Photographs, Potpourri, and Books and Periodicals." Cornell contributed to two sections, "Montages," together with Max Ernst, and "Potpourri," a word chosen by Levy to cover an otherwise unclassifiable group of odd objects. This consisted of *Peaches is 24,* Levy's own "frieze of negative photostats, a series of shocking cover-page seriocomic collages from the New York *Evening Graphic,* the yellowest of vulgar journalism and incredible Americana";[13] Man Ray's *Boule de neige,* a paperweight made to his own design containing a photograph of Lee Miller's eye and white flakes to create a snowstorm when shaken; and finally Cornell's *Glass Bell* (fig. 4)![14]

There was nothing at this stage of Cornell's association with Julien Levy and his gallery which suggested that there might not be total congruity between Cornell and Surrealism. Levy himself certainly considered Cornell a find in the context of Surrealism and probably the most brilliant of the new

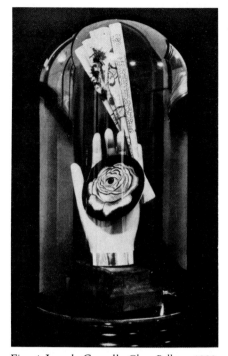

Fig. 4 Joseph Cornell: *Glass Bell.* c. 1932. Construction. Present whereabouts unknown. Reproduced *Minotaure* (Paris), Winter 1937

American initiates. But it would be incorrect to assume that there was then any question of joining or not joining the Surrealist movement in New York, because there was no group to join. Insofar as there existed a loosely defined circle of Surrealist sympathizers in New York, it was centered on Levy's gallery, with its exhibitions, evenings, and film shows where Luis Buñuel and Salvador Dali's *Un Chien Andalou* and *L'Age d'or* and Cornell's own *Rose Hobart* were shown![5] But "Surrealism" was understood in a considerably less rigorous sense here than in Europe. Not only did Levy show painters and photographers who had nothing to do with Surrealism, but, much worse, he included an artist who might in the public mind be dangerously confused with a real Surrealist—Jean Cocteau. As Breton wrote: "the word found favour much faster than the idea, and all sorts of more or less questionable creations tend to pin the label on themselves...thus the unmentionable M. Cocteau has been able to have had a hand in surrealist exhibitions in America...."[16] This is not to suggest that Cornell would have been excluded had definitions been drawn more tightly; on the contrary. But it does suggest a comparative ignorance of the full weight of Surrealist theory and fields of activity. Cornell was clearly attracted initially by what he had seen of the visual side of the movement, and was for a time unaware of the theoretical debates of the Paris Surrealists whose polemics and public manifestations outside the sphere of art would probably have alarmed him.

In November 1932, Levy mounted a joint exhibition of etchings by Picasso and a variety of works by Cornell: "Minutiae, Glass Bells, Shadow Boxes [cutout figures and montages], Coups d'oeil, and Jouets surréalistes [Surrealist toys]." It is uncertain how many works in each category were exhibited, but the list of categories itself is impressive—as though with every new work Cornell created a new category, a new type of construction. Cornell exhibited again in the Julien Levy Gallery in the winter of 1933–34, showing works now grouped under the conventional Sur-

realist designation "Objects," in a mixed show with posters by Toulouse-Lautrec, montages by Harry Brown, and watercolors by Perkins Harnley.

In 1936 Cornell contributed to the major exhibition directed by Alfred H. Barr, Jr., at The Museum of Modern Art, "Fantastic Art, Dada, Surrealism." This show, which traveled to several other cities, not only brought together more Surrealist works than had hitherto been seen in America, but placed beside them works of a fantastic, irrational, or proto-Surrealist character from other periods. Together with Levy's book *Surrealism*,[17] it gave the movement a new notoriety and brought it before a wider public. Perhaps it was for this reason that Cornell felt he had to withdraw from too exclusive an identification with Surrealism and clarify his relationship with it. Just before the opening of "Fantastic Art," he was provoked by what he described as a "misleading and rather silly statement" about his work that appeared in the November 1936 issue of *Harper's Bazaar*, which he asked Barr to correct in the catalog. This article, heralding a New York season dominated by Surrealism, described Cornell as:

...according to Mr. Levy, one of the few Americans who fully and creatively understand the surrealist viewpoint. Cornell does not paint, he "objectifies." If he dreams of a wooden ball with a long needle sticking through it, that is what he puts together when he wakes. Cornell's little surrealist gadgets might be called imagination toys for adults. (That's what Mr. Levy calls them, and nobody in America knows more about Surrealism than he does.)[18]

Cornell, who had intuitively responded to the Surrealist poetic image, verbal and visual, now sharply rejected the idea that his work was founded on Surrealist psychological theories, and wrote to Barr on November 13 asking him to explain that:

I do not share in the subconscious and dream theories of the surrealists. While fervently admiring much of their work I have never been an official surrealist, and I believe that surrealism has healthier possibilities than have been developed. The constructions of Marcel Duchamp who the surrealists themselves acknowledge bear out this thought, I believe![19]

Cornell seemed to be suggesting that he might be developing a kind of alternative Surrealism, one having affinities with and differences from the orthodox kind. However, no statement was made to this effect in the catalog: Cornell was included in the Surrealist section of the exhibition, but described as an "American constructivist."[20] The catalog lists only *Soap Bubble Set* (1936) (pl. 1), which was dismantled and photographed with additional effects by George Platt Lynes. (The same work was reproduced by Levy in *Surrealism*, but assembled in its box.) However, an installation photograph from the exhibition shows that Cornell assembled several objects together (fig. 1). He had written to ask Barr whether he could show another work, and the result was one of his first "theme" exhibits, which Cornell clearly thought of as a whole work, giving it the title "The Elements of Natural Philosophy." It consisted of eighty-seven pieces, described rather curtly in the records as "bottles, plates, glass strips, muslin, and box." Ten miniature glass bells are visible, including one flecked with white paint reminiscent of Man Ray's snowstorm paperweight *Boule de neige*.[21]

The first European Surrealist review to reproduce a work by Cornell was *Minotaure*, which included *Glass Bell* (fig. 4) in the Winter 1937 issue.[22] In 1938 he contributed *objets* (in the plural, though he was assigned only one catalog number) to the great "Exposition internationale du surréalisme" in Paris. In the winters of 1939 and 1940, Levy held two one-man shows of objects by Joseph Cornell. The catalog of the first contained a short essay by Parker Tyler, who was to be, from 1940, a regular contributor to *View*, and from 1944, its associate editor. He suggests that Cornell's objects are like toys "created and presented to the adult world as legitimate objects." Cornell was "master of the world as *Bilboquet*," the old-fashioned cup-and-ball toy illustrated in a nineteenth-century engraving on the cover (bibl. 229).[23] The second exhibition, in 1940, was also labeled "Objects," but it was subdivided again into numerous categories, this time, in what was to be a characteristic

fashion of Cornell, mixing types of constructions with titles descriptive of particular subjects: "Daguerreotypes, Miniature Glass Bells, Shadow Boxes, Homage to the Romantic Ballet, Soap Bubble Sets, Minutiae." They were announced in a folder presided over by Watteau's *Gilles* (c. 1719). A box of 1939, *A Dressing Room for Gille* (pl. 64), contains a cutout of Watteau's Pierrot figure. In December 1942, the second exhibition at Peggy Guggenheim's Art of This Century gallery was a joint show of Cornell "Objects," Duchamp's "Box-Valise" (sic), and Laurence Vail's "Bottles." The following year Cornell showed again in a joint exhibition, at Julien Levy's, with Duchamp and Yves Tanguy: "Through the Big End of the Opera Glass." This time the objects shown were all theme types: "Medici Slot Machines, Roses of the Wind, A Feathered Constellation (for Toumanova), Habitat Parakeets (Shooting Gallery), American Rabbit."

After the end of the war, Cornell was still regularly visible in New York, although, as John Ashbery put it, "the galleries which showed him had a disconcerting way of closing or moving elsewhere, so one could never be sure when there would be another Cornell show."[24] He increasingly gave theme titles to exhibitions, such as "Romantic Museum: Portraits of Women," at the Hugo Gallery (1946), and "Aviary" (1949) and "Night Voyage" (1953), both at the Egan Gallery. He also produced special installations of material, such as "Portrait of Ondine" (1945) at The Museum of Modern Art and Magic Lantern of the Romantic Ballet (1949) at the Hugo Gallery, and even designed special settings for commercial purposes, as in his "From the Dawn of Diamonds" (1946) for an exhibition of Cartier's jewelry.

From 1953 he was regularly included in the Annual at the Whitney Museum of American Art, for which he described his works as "constructions," although in 1955 he called his *Midnight-Carrousel* a "box-construction," and in 1966 called *Celestial Box* "mixed media." In 1962 the Whitney Museum introduced at the Annual what was intended to be a program of small retrospectives for "out-

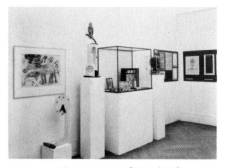

Fig. 5 Installation view of Miró's *Object* next to Cornell's "The Elements of Natural Philosophy" and Soap Bubble Set, "Fantastic Art, Dada, Surrealism," 1936–37

standing artists," and Cornell was the first to be so honored?[25]

Often more at ease with children than with adults, and more confident in them as an audience, at the very end of his life Cornell cooperated in an exhibition of his boxes, "For Children Only," organized by the Cooper Union School of Art and Architecture, perhaps the only occasion on which he answered questions about his work without restraint?[26]

★

Cornell's published utterances about any subject, including his art, during his lifetime are rare, and so his association with and contributions to the periodical *View* deserve special attention. The New York-based *View,* founded in 1940, welcomed the refugee European Surrealists and was a forum for crisp debates concerning Surrealism and its influence in America. Cornell's involvement with it sprang not directly from this, but from his affinities with a group of indigenous avant-garde writers who, like Cornell, had been influenced by Surrealism but kept their distance from it?[27] This group, who had mostly been published by New Directions since 1936, included *View*'s editor, Charles Henri Ford, Parker Tyler, and Montagu O'Reilly.

The second number of *View* comments on Cornell's new interest in the ballet, and quotes his remarks about his new "ice-cube" Taglioni jewel casket: "although not inspired by, it would remind anyone familiar with it of Montagu O'Reilly's 'Pianos of Sympathy.'"[28] The report continues with a version by Cornell of the Taglioni legend:

In the winter of 1835 the carriage of Marie Taglioni was halted by a Russian highwayman, and that enchanting creature commanded to dance for this audience of one upon a panther's skin spread over the snow beneath the stars. From this actuality arose the legend that, to keep alive the memory of this adventure, so precious to her, Taglioni formed the habit of placing a piece of artificial ice in her jewel casket or dressing-table drawer, where, melting among the sparkling stones, there was evoked a hint of the atmosphere of the starlit heavens over the ice-covered landscape.[29]

O'Reilly's "Pianos of Sympathy," first published by New Directions in the '30s and reprinted in his 1948 collection of short stories, *Who Has Been Tampering with These Pianos?,* is a curious romantic-gothic tale with antiquarian overtones, centered on an interpretation of a Renaissance love story involving the painter Andrea Mantegna. It describes how, with the use of a candle and a block of ice, tresses of hair can be made to rise and fall in response to the tonal waves emitted by a piano. The story is told from the vantage point of the years immediately preceding World War I, and breathes the aura of the late-nineteenth-century, fin-de-siècle years Cornell loved. Cornell must also have been intrigued by the use of anecdote to illuminate this atmosphere. Almost all O'Reilly's stories hinge on a strange or extraordinary tale or incident, forming a close parallel to the way Cornell hunted for the significant biographical detail that would bring him closer to the reality of figures like the ballerinas Maria Taglioni or Fanny Elssler, or the composer Rossini. Cornell's published "text-homages" *Maria* (to singer Maria Malibran-Garcia) (c. 1954) and *The Bel Canto Pet* (to Julia Grisi) (1955), follow precisely this technique.

Cornell's love of dance and opera, pursuits far from the Surrealist orbit, being too closely linked with music (which was in Breton's opinion "the most deeply confusing of all forms"), was shared by a number of *View* writers. Charles Henri Ford wrote a poem for one of Cornell's favorite ballerinas, Tamara Toumanova, "Ballet for Tamara Toumanova," which was illustrated in *View* with a tinseled collage by Cornell?[30] He made many keepsakes for her (pls. 95, 99), as well as evocations of long-dead ballerinas of the *belle époque* and earlier, such as Rosita Mauri (pl. 97) and Lucile Grahn (pl. 91), tiny boxes containing a scrap of tulle, a sequin, or a butterfly's wing, as well as collages and larger lidded boxes. Cornell was also at this time devising covers for *Dance Index* (a specialist periodical prominently advertised in *View*), four entire issues of which he put together.

In a special issue of *View* in January 1943 devoted to "Americana Fantastica,"

Cornell contributed a verbal and visual essay called "The Crystal Cage (Portrait of Berenice)," concerning the story of a little girl:

From newspaper clippings dated 1871 and printed as curiosa we learn of an American child becoming so attached to an abandoned chinoiserie while visiting France that her parents arranged for its removal and establishment in her native New England meadows. In the glistening sphere, the little proprietress, reared in a severe atmosphere of scientific research, became enamored of the rarefied realms of constellations, balloons, and distant panoramas bathed in light, and drew upon her background to perform her own experiments, miracles of ingenuity and poetry.[31]

Whether true or not—and Cornell cannily warns that you may not find references to it because it was classed among the famous nineteenth-century hoaxes—this story has haunting connections with Cornell's own preoccupations: infatuation with Europe grounded in native American meadows, scientific experiment as a miraculous toy, constellations and the night sky. One page of "The Crystal Cage" is a stream of words constructed in the shape of the pagoda of Chanteloup (bibl. 196), the crystal cage itself, which builds up an extraordinary flood of associations: "lighthouses constellations of Feu tropical plumage Bouguereau Liszt barometers owls siphons Queen Mab ascensions high noon magic lanterns..." Totally original in form, "The Crystal Cage" is like a fragment of one of Cornell's source-material files, a glimpse of his working method. He proposed to issue in facsimile a portfolio of material, relating to the Crystal Cage, which would contain original material and notes. The idea comparable to this unrealized project is Duchamp's *Box in a Valise* (1935–41) (exhibited together with Cornell's boxes in 1942 and for which Cornell helped collect material) in association with his boxed notes.[32] But whereas Duchamp's *Box in a Valise* contains miniature replicas of his own works, to which the notes provide a textual dimension and a description of working procedures, Cornell's portfolio would have been more like a scrapbook in which one would never be sure where gathering ended

and invention began. A further project, "Joseph Cornell's Celestial Theatre," was announced for the December 1944 *View* but never materialized.

View published a translation of Raymond Roussel's *Impressions d'Afrique* (1910) in three installments in 1943–44, which Cornell certainly read, but characteristically it was a tangential biographical detail about Roussel that caught his attention. Roussel had had a special star-shaped box made to house a cookie from a banquet, and this object was photographed by Dora Maar and illustrated in *Cahiers d'art* in 1936 (fig. 6). Cornell notes this in his diary around 1946, and it would seem as if this bizarre invention of Roussel's is referred to in Cornell's Untitled (Star Game) (c. 1948) (pl.187), a star-shaped box, glazed at the top, with inner compartments housing sand, a shell, a ring, and other objects, linked by small holes through which the smaller objects can pass.[33]

<center>★</center>

Cornell's first works were made in the context of Surrealism, but before examining his relationship with this movement in more detail, it is important to consider briefly his earliest enthusiasms and what bearing these may have had on his final development. One of his files contains some half-finished drafts of letters written in 1968 in response to a question that caused him great anxiety: who were his favorite artists when he was twenty-one. He never came to a definitive answer, and mainly denied any external influence at all. "Admiration for, dedication to, any artist or artists I am certain had no significant bearing upon my work as it gradually and spontaneously unfolded."[34] He does, however, list some early enthusiasms, which are confirmed and supplemented in the diaries, although they do indeed seem to be without direct influence on his work. Cornell was emphatic about Odilon Redon, who was highly esteemed by the Surrealists and whose *The Eye Like a Strange Balloon* and *Silence* were exhibited in the 1936 "Fantastic Art, Dada, Surrealism"; Cornell discovered him through

Fig. 6 Star-shaped box designed to hold a biscuit, supposedly made for Raymond Roussel in remembrance of Camille Flammarion. Reproduced *Cahiers d'art* (Paris), no. 1–2, 1936. Photographed by Dora Maar

the exhibition and sale of John Quinn's collection of nineteenth- and twentieth-century painting in 1926 and '27 (at which he was also impressed by the *douanier* Rousseau) and through the book on Redon by H. Floury. This is significant, for it was neither the first nor the only time that a passion for an artist or a composer was awakened by a book: he lists Delacroix's *Journals*, Vincent van Gogh's *Letters*, and Marsden Hart-ley's *Adventures in the Arts* as early dis-coveries, and in some notes of 1951 in the same file, he recalls the importance of Schauffler's biography of Schubert and Turner's book on Mozart.[35] This confirms the exceptional interest that the biography of a writer, an artist, or a musician had for him. Another early interest is signaled as being of special importance and should be explored in greater detail: Chinese painting, in particular as discussed in Raphael Petrucci's *Chinese Painters* (in connection with which he quotes from Waley's translations of Chinese poetry) and in writings on the Sung Dynasty, "esp. animals, birds, floral, plant subjects…"[36]

The most frequent conclusions to have been reached about Cornell's rela-tionship with the Surrealists could be summarized as follows: that he belonged to the first generation of American artists to be profoundly influenced by the theory and practice of Surrealism,

which he found stimulating and liber-ating, but that he quickly transcended this influence, although retaining to a considerable degree a Surrealist syntax in his works. While this is broadly correct, it still needs some qualifica-tion and elaboration.

To begin with, whereas New York artists such as Jackson Pollock and Willem de Kooning were looking hard at the developments of automatism in painting, Cornell avoided this aspect of Surrealism, both in its psychological implications and its physical manifes-tations. He responded by contrast to that revival of interest in the potential dream image represented by Ernst's 1929 collages and by the paintings of Magritte and Dali reproduced in *La Révolution surréaliste* for the first time in 1929. Among these was Dali's *Illumined Pleasures* (1929) (fig. 8), whose box-compartments, which are perhaps a reference to Breton's dictum that a Surrealist painting should be a window through which one looks onto an inner landscape, prefigure the idea of the box construction by Cornell. The left-hand box contains an oblique homage to de Chirico; Cornell included a color reproduction of de Chirico's *Evil Genius of a King (Toys of the Prince)* (1914–15) (fig. 7) in *Portrait of Ondine* (pl. 93).

Cornell was attracted, not to the purely painterly extensions of automatic

Fig. 7 Giorgio de Chirico: *Evil Genius of a King (Toys of a Prince)*. 1914–15. Oil, 24 x 19¾ in. The Museum of Modern Art, New York, Purchase

Fig. 8 Salvador Dali: *Illumined Pleasures*. 1929. Oil and collage on composition board, 9⅜ x 13¾ in. The Museum of Modern Art, New York, The Sidney and Harriet Janis Collection

processes, but rather to that side of Surrealism which involves the exploration of dreams and visions and the annexing of real objects as material for the free exercise of the imagination. André Breton made his one and only written statement about Cornell in "Artistic Genesis and Perspective of Surrealism," his preface to Peggy Guggenheim's catalog *Art of This Century* (1942). Although Breton's main purpose was to reassert the importance of automatism, he at the same time acknowledged the continuing vitality of the dream: "The sap of Surrealism rises, too, from the great roots of dream-life to nourish the paintings of Richard Oelze and Paul Delvaux, the constructions of Hans Bellmer and Joseph Cornell....At the extreme limits of stereoptic and anaglyphic persepective and of stereotyped vision, Cornell has evolved an experiment that completely reverses the conventional usage to which objects are put."[37] Breton's source of information about Cornell was probably Marcel Duchamp, with whom Cornell shared an interest in stereoptic vision.

Cornell's relationship with Surrealism was, and remained, ambiguous. It was not simply a matter of an initial influence transcended, for although he did back away sharply from too close an identification with the theoretical aims of the Surrealists, he continued to read their poems and writings and formed associations with Matta, Max Ernst, Dorothea Tanning, and Kurt Seligmann, as well as with Duchamp. Although wary of the psychoanalytical use of dreams, he read Breton's great poetic analysis of dreams, *Les Vases communicants* (1932), and describes at the end of his life experiencing "grand 'Vases Communicants' emotions."[38] One of the strongest and most continuous bonds with the Surrealists was a shared love of a particular strand of nineteenth-century literature: Arthur Rimbaud, Aloysius Bertrand, the French Symbolist poets, and, above all, Gérard de Nerval, who opens *Aurélia* with the words: "The Dream is a second life." And yet at the same time he felt distanced from the French "intellectual obsession with art and beauty": "I never really under-

stood Mallarmé or Apollinaire—if any bona fide contact was ever established it was a kind of fool's luck or intuition of a sort too elusive to consciously shape up into words for my own or another's enlightenment."[39]

★

Surrealism's roots are so closely entangled with Dada that it is not surprising that the "object," a central preoccupation of Dada, should have engaged Surrealist attention from the start. Duchamp's Readymades and Assisted Readymades, such as *Why Not Sneeze Rose Sélavy* (1921), had already initiated a philosophical reconsideration of the relationship between art objects and ordinary ones. This informed the Surrealists' early discussions of objects in texts such as Aragon's "L'Ombre de l'inventeur."[40] Aragon's attention was caught by the margin surrounding all useful objects where humor and poetry survive. He described a chopping board he saw in an ironmonger's on the rue Monge, Paris, advertised as "the only one that opens like a book." Useful inventions may have had some other cause than pure utility, and, as Aragon commented after wandering through the annual inventor's fair, "at the moment they are made, these machines of practical life are still unkempt from dreams, have a mad look, unadapted to the world..."[41] Breton, in a more systematic way, anchored the discussion within Surrealism and proposed the actual fabrication of objects seen in dreams in order to "demolish these concrete trophies which are so odious, to throw further discredit on those creatures and things of reason."[42] Both texts emphasized dreams and the imagination, but Cornell was closer in feeling to Aragon than Breton, for it was less the irrationality of dreams than the margin of poetry with which they surround ordinary objects that interested him.

The pages of *La Révolution surréaliste* are scattered with photographs of enigmatic and untitled objects; one spread in the second issue (January 15, 1925) includes, among other things, a black magician's box containing a girl's head

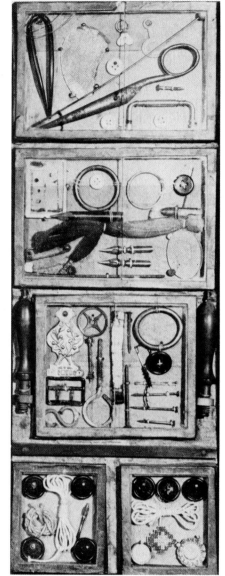

Fig. 9 Objects assembled and mounted by a psychopathic patient on a wooden panel in five small vitrines. 1878. Formerly collection André Breton, Paris. Exhibited in "Fantastic Art, Dada, Surrealism," The Museum of Modern Art, New York, 1936–37

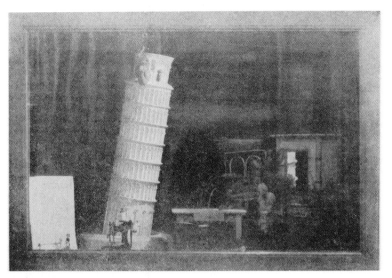

Fig. 10 Louis Aragon and André Breton: *Ci-Gît Giorgio de Chirico.* Surrealist assemblage. Reproduced *La Révolution surréaliste* (Paris), 1928.

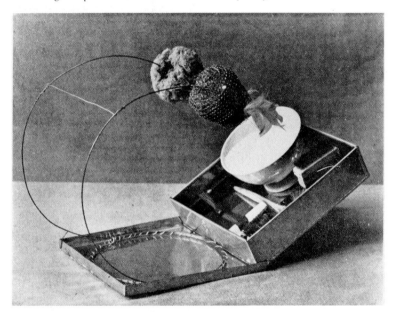

Fig. 11 Gala Eluard: Untitled Surrealist object. Reproduced *Le Surréalisme au service de la révolution* (Paris), 1931.

Fig. 12 Alberto Giacometti: *Taut String.* 1933. Wood, metal, and plaster with string, 21⅞ x 30⅞ x 7¹⁄₁₆ in. Alberto Giacometti Foundation, on loan to Kunsthaus, Zurich

and disembodied arms, perhaps of wax. The eleventh issue (March 15, 1928) reproduces what must be one of the first fabricated Surrealist objects, *Ci-Gît Giorgio de Chirico* (Here lies Giorgio de Chirico) by Breton and Aragon (fig. 10). It looks like a miniature stage set, a framed window-box, but the objects within are hard to make out, with the exception of a model of the Leaning Tower of Pisa and a tiny sewing machine. Among the most interesting from the point of view of a comparison with Cornell are two unidentified and untitled "display boards," or trays, containing objects such as nails, buttons, string, and part of a pair of scissors, arranged with obsessive neatness in compartments (fig. 9).[43]

The range of objects found, made, or interpreted by the Surrealists during the '30s is vast. The Surrealist object was officially launched in *Le Surréalisme au service de la révolution* in December 1931 with the listing of different types (transubstantiated, wrapped, molded), an article on the "symbolically functioning object" by Dalí, and detailed descriptions of five objects by Breton, Dalí, Gala Eluard (fig. 11), Valentine Hugo, and Alberto Giacometti. In the same issue are Giacometti's drawings for *Dumb Mobile Objects*, as well as a photograph of his sculpture *Suspended Ball* (1931), acknowledged by Dalí as the parent of the symbolically functioning object, although different in that it still uses the means proper to sculpture rather than readymade objects. Central to the concept of the symbolically functioning object is obviously actual or potential movement embodying an erotic suggestiveness. Although many of Cornell's objects contain moving parts, they do not function in the same way as the symbolic Surrealist object. Closest is the early book and ball (pl. 63), which, in the absence of any erotic connotations, is left somehow weak and uncertain; it also lacks the aggressive tension of Giacometti's *Taut String* (1933) (fig. 12); rather, its associations lie with the swinging ball of table skittles.[44] Breton chose a similar work to illustrate Cornell in the 1945 edition of *Le Surréalisme et la peinture*, entitling it *Natalità* (1940).[45]

By 1936 the elaborate Surrealist object "functioning symbolically" had largely been replaced with objects that were structurally simpler but symbolically less obvious. The 1936 "Exposition surréaliste d'objets" at Charles Ratton's gallery in Paris divided them into the following categories: natural, natural interpreted, perturbed, found, found interpreted, American, oceanic, mathematical, readymade and readymade aided, and Surrealist. Although Jacqueline and André Breton's *Le Petit Mimétique* (fig. 13) anticipates Cornell's fascination with Habitats, those objects which have most in common with Cornell involve a taxonomic arrangement of a number of small items, like the tray of found objects by Ernst (1930) or Dali's *Tray of Objects* (1936) (fig. 14). Cornell, too, loved compartments with individually disposed trinkets, mementos, objects, scraps, fragments, as in the Compass boxes and in the bottles and sections of *L'Egypte de Mlle Cléo de Mérode* (1940) (pl. V) and other Pharmacies. Connected not by rational or logical sequence, compartments house private and nearly unfathomable associations, almost like a metaphor for the cells of the unconscious mind, separate and yet linked like the divisions of the phrenological heads of the nineteenth century. Dali's composite photograph in the *Minotaure* of December 1933, "Le Phénomène de l'extase" (fig. 17), hints at the deliberate destruction of scientific rationality in favor of poetic association when he includes, among the ecstatic women, photographic series of ears which look as though they come from a treatise on criminal physiognomy. Cornell in Untitled (Medici Slot Machine) (1942) (pl. 117) also uses several series of photographs, pasted on little cubes and disposed in blocks and strips not unlike the Dali, but in his case the image itself in each series is identical, and the variations come from its disposition in relation to the edge of its frame or to the vertical target lines on the glass. In both the Dali and the Cornell there is also the probable influence of film frames. Cornell's Untitled (Black Hunter) (pl. 68) interestingly uses a sequence of images from a film

in a manner more reminiscent of Moholy-Nagy's serial images in photomontages like *The Shooting Gallery* (1925) (fig. 15).

What at first sight appear to be incongruous and unexpected combinations of objects in Cornell's work, based on the same principle as that which informed the Surrealist montage, are usually based, in fact, upon formal or thematic association. In Medici Slot Machine, the target on the circular glass panel at the base is centered on the compass behind it, thus emphasizing their geometrical similarity; there is simultaneously a thematic association between them as they share the concept of direction or aim. The jacks and ball in the lower compartment emphasize the aspect of play. Similar formal and/or thematic associations exist in Cornell's combinations of globes, maps, soap bubbles, constellations, birds, and hotels.

Cornell does, however, sometimes isolate objects or scraps of objects, and these then take on a fetishistic quality. In *Surrealism,* Julien Levy gives this definition of fetishism: "doctrine of spirits embodied in, or attached to, or conveying influence through, certain material objects. In the terminology of psychoanalysis, the transference of the libido from the whole object of affection to a part, a symbol, an article of clothing."[46] When Cornell takes a sequin or a scrap of muslin from a ballerina's dress, this can clearly be described as a fetish; however, other objects he seems to display as fetishes in an enigmatic and almost abstract way, without their being an object of affection.

It has been argued that Cornell's constructions are really three-dimensional collages. But it seems to me that, rather than working according to a collage technique, which implies a process of fragmentation and recombination, Cornell works with whole objects and the object remains emphatically itself, not metamorphosed like certain Surrealist objects. Where a part of an object is introduced, as in the strip of wire netting in *Carrousel* (1952) (pl. 217), it relates structurally and individually to the whole box in the manner that parts of a building relate to the

Fig. 13 Jacqueline and André Breton: *Le Petit Mimétique.* Surrealist object. Reproduced *Cahiers d'art* (Paris), no. 1–2, 1936

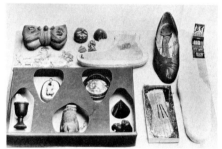

Fig. 14 Salvador Dali: *A Tray of Objects.* 1936. Collection Charles Ratton, Paris

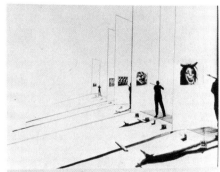

Fig. 15 László Moholy-Nagy: *The Shooting Gallery.* 1925. Photomontage. Galerie Klihm, Munich. Reproduced by permission of the estate of the artist

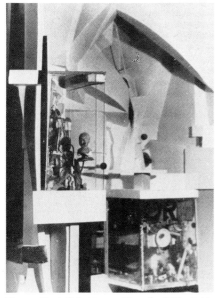

Fig. 16 Kurt Schwitters: Detail of *The Gold. Grotto*, c. 1924–25, from the Hanover *Merzbau*, destroyed 1943. Reproduced *Abstraction-Création Art Non-Figuratif* (Paris), no. 2, 1933

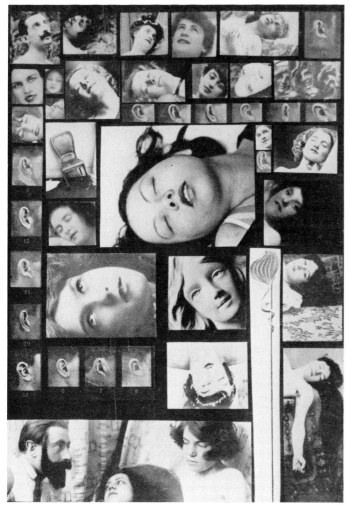

Fig. 17 Salvador Dali: *Le Phénomène de l'extase*. 1933. Collage, 10⅝ x 7½ in. Collection Mme Vercamer, Paris. Reproduced *Minotaure* (Paris), December 1933

whole. De Kooning once commented on the architecture in Cornell's boxes, and this would seem to be a more appropriate comparison.[47] Sometimes the theatrical stage set is evoked: the shallow boxes with cutouts such as *Victorian Parlour Constellation (Paolo and Francesca) Object* (1942) (pl. 109) and *Object* (Abeilles) (1940) (pl. III) are reminiscent of children's puppet theaters with cutout cardboard scenery, while the reference is direct and deliberate in the comic *A Pantry Ballet (for Jacques Offenbach)* (1942) (pl. 65), with its echoes of Alice's lobster quadrille.

Cornell does of course use collage in the boxes, but as a specific technique and quite deliberately, rather than as a basic structural principle. He tends to use it, too (in appropriate reference to Cubism), in the Homages to Juan Gris (pls. XXIV, 144, 145). Painted or printed lettering is sometimes half-obscured, as in a Cubist painting; labels, stamps, advertisements, fragments from the detritus of everyday life are pasted in. Cornell's attitude toward the materials he uses is less challenging, less iconoclastic than that of Picasso and Braque; it is closer to that of the rogue Dadaist Kurt Schwitters in its natural acceptance of more or less anything as material for the making of art (see Schwitters's *Gold Grotto* (fig. 16). As Schwitters wrote in *Merz* (1920): "Every artist must be allowed to mold a picture out of nothing but blotting paper for example, provided he is capable of molding a picture."[48]

The 1953–54 Juan Gris box (pl. 144) is one of Cornell's most deliberately Cubist constructions. The yellowing pages from an old French history book are stuck onto the back of the box like the strips of newspaper on a Cubist collage—though there are significant differences: for example, Cornell generally retains the column width of the book page so that the text is quite legible, except where the shadow of the cockatoo falls across it. The kind of transformation involved in Picasso's Cubist collages, in which a piece of crumpled paper becomes a student's cap or printed wallpaper a flowery tablecloth, is absent. The identity of an object is challenged or elaborated only in terms of the

interplay between reality and representation. In the Juan Gris box a wooden cutout of a cockatoo is papered with a colored print of the bird seated on a branch. The bird is balanced on a piece of real wood as a perch, and behind, pasted on the back of the box, is a fragment of paper printed with simulated wood-graining, "standing for" the wooden perch in the same literal way that Gris himself used collage (see *Breakfast*, fig. 18). The overall papering of the box is also similar to the way in which Gris would first paper over his canvas and subsequently paint it.

<p style="text-align:center">★</p>

Cornell's acknowledged debt to Marcel Duchamp was, as he noted at the time of Duchamp's death in 1968, "real and great." They first met around 1934, and during the war years Cornell visited him fairly frequently in Manhattan; on one occasion Duchamp gave him a readymade, a glue carton labeled "gimme strength."[49] In 1933 Cornell had dedicated the original typescript of his scenario "Monsieur Phot" to Duchamp. This contained five photographs taken from stereoscopic views, and the dedication suggests that Cornell was recognizing their shared interest in optical devices. In 1918-19 Duchamp had made a rectified readymade from a photographic stereopticon slide, a device that was intended to give the illusion of depth. Although less immediately evident in his work, Cornell's fascination with Victorian optical games and instruments finds a parallel in Duchamp's experiments with kinetic machines such as his *Precision Optics ...Rotary Apparatus* of 1920, which was reproduced in *Cahiers d'art* (nos. 1–2, 1936) in both its static (fig. 19) and its moving state. It consisted of a series of rectangular panels, each with parallel gently curving lines, set behind one another along a rod; when spun they formed a circular target. In Cornell's Untitled (The Hotel Eden) (c. 1945) (pl. XXII) there is a reference both to targets and to Duchamp's spinning *Precision Optics*—or more closely to his *Rotorelief* —and the bird appears to hold the machine's flex. Both Untitled (Ameri-

can Rabbit) (1945-46) (pl. 161) and Untitled (Woodpecker Habitat) (1946) (pl. 159) contain similar targets.

Parallels with Duchamp often seem to turn, even if fortuitously, on the techniques, texture, and actual fabrication of the work. The use of glass, for example, becomes as much a part of the medium in Cornell's *Object Daguerreotype* (1935) (pl. 32), *Habitat Group for a Shooting Gallery* (1943) (pl. XXIII), and *Isabelle/Dien Bien Phu* (1954) (pl. 142) as it does in Duchamp's *The Large Glass* (1915-23) and *To Be Looked at...*(1918) (fig. 20)— and it is similarly fractured, though not, in Cornell's case, by chance. Cornell did not, as Duchamp did, systematize chance, but he was happy to accept its effects when it contributed to the spontaneous, natural look of the work. In his diary note for August 15, 1945, he wrote:

Sailor's box uncompleted...brought up from cellar covered with the most perfect application of *mildew* imaginable—like a frosting acquired in cold storage and yellow kind of dust on top cover resembling pollen—glue content was responsible for this—box had been covered with text pages from an old book (French c. 1840) but in *sun* all day drying out. Contrast of chilled cellar and hot (almost Indian summer) sun.[50]

The textural resemblance to the dust gathering on the Sieves in *The Large Glass*, which Duchamp subsequently fixed with glue, is unmistakable.

Duchamp was the first to introduce sound into a work in *With Hidden Noise* (1916). An object was placed in the cavity of a ball of string, which was then sealed with metal plates so that it rattles when shaken. But whereas "hidden noise" has become the subject of this work, the sounds emitted by Cornell's objects are a logical part of them, like the involuntary noises made by toys and games. They are natural and evocative, not like the undisguisable whirrs, buzzes, and clicks of kinetic sculpture, but like the rolling of balls in bagatelle, or the faint metallic ringing of a musical box, or the slight hiss of sand in an eggtimer. Some of the simplest and yet most effective sounding boxes are those such as Untitled (Yellow Bird) (1950) (pl. 155), containing a canarylike bird and metal springs,

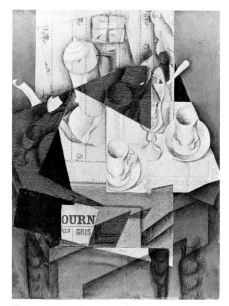

Fig. 18 Juan Gris: *Breakfast.* 1914. Collage, crayon, and oil, 31⅞ x 23½ in. The Museum of Modern Art, New York, Acquired through the Lillie P. Bliss Bequest

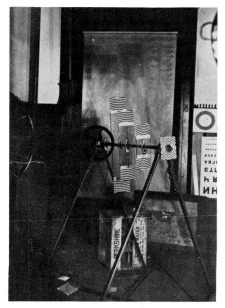

Fig. 19 Marcel Duchamp: *Precision Optics.* New York, 1920. Reproduced *Cahiers d'art* (Paris), no. 1–2, 1936. Photographed by Man Ray

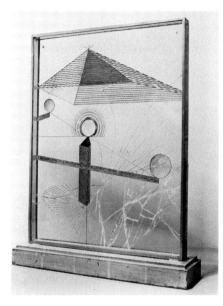

Fig. 20 Marcel Duchamp: *To Be Looked at (from the Other Side of the Glass) with One Eye Close to, for Almost an Hour.* Buenos Aires, 1918. Oil paint, silver leaf, lead wire, and magnifying lens on glass (cracked), 19½ x 15⅝ in., mounted between two panes of glass in a standing metal frame, 20⅛ x 16¼ x 1½ in.; overall height 22 in. The Museum of Modern Art, New York, Katherine S. Dreier Bequest

which jangle gently when moved. Noise can become part of the very texture of the objects, as in the horizontal Sand Boxes such as the untitled work c. 1952 (pl. 189). When these are shaken the sand rustles across the floor of the box. But dispersed in the sand are other objects, such as those you might find on the beach or in a box of bric-a-brac collected on a seaside holiday during childhood and stored away: shells, dried starfish, a ring, a bleached bone. As these are shaken they grate harshly against the sand, with a sound reminiscent of Desnos's poem, "L'Idée fixe":

There the roses and the emeralds are finished
the precious stones and the flowers
The earth crumbles and cracks with the noise of an iron over mother of pearl..[51]

The explicit and implicit references to toys in Cornell's work have been so insistent that they beg further exploration. His objects were described as "jouets surréalistes" as early as 1932, and the analogy has been made so many times since that it has become a critical commonplace. Several aspects of his objects evoke this analogy: his own activity in making them, the spectator's relationship with them, and their own intrinsic iconography and physical qualities. Many invite the spectator's intervention before they can come alive. Drawers must be opened to reveal hidden contents, objects or lids removed to see what is underneath; works can be dismembered, reassembled in a different order, shaken, tilted, listened to, set in motion, and switched on. They invite a rumination on the nature of play and its relationship with artistic activity, human invention, and imagination. "Birds fly, fishes swim, and man invents. He alone possesses imagination..."[52]

In a 1960 diary entry, Cornell suggested that the toy could be used as a definition of the box. Recalling a child's delighted reaction to one of his boxes, he wrote: "perhaps a definition of a box could be as a kind of 'forgotten game', a philosophical toy of the Victorian era, with poetic or magical 'moving parts', achieving even slight measure of this

poetry or magic [illegible]...that golden age of the toy alone should justify the 'box's' existence."[53] One of Cornell's most haunting works is known as Forgotten Game (c. 1949) (pl. 169); its very title is ambiguous: have we forgotten how it works or has it been forgotten and abandoned? Like those vertical slot machines that set a ball in motion down slides behind glass to hit targets or enter trapdoors in its journey, Cornell's shallow vertical box contains a ball that can be rolled from the top right-hand corner, down sloping passages that are boarded up but visible behind porthole windows, through which birds are also half-glimpsed. Its final target is seen through a cracked glass panel at the base, a bell that rings with a faint flawed note as though penetrating a fog at sea. This box embodies nostalgia for the lost games of childhood, but also for the golden age of the Victorian toy, in which scientific invention was blended with pure imagination.

The "philosophical toy" of which Cornell spoke flourished from the middle of the nineteenth century. It was intended to combine a pedagogical function with entertainment, to instruct the child in the laws governing the natural universe while at the same time amusing him. It was a direct result of the great discoveries in science and natural philosophy that had shaken the foundations of the Victorian world—the geological finds, for example, that challenged the story of the creation in the Bible, as described by Samuel Butler in *The Way of All Flesh.* (1903). So the laws governing movement, light, gravity, and so on were all illustrated in toys of remarkable ingenuity, inviting the child to learn by experiment. And although education was the ostensible purpose of these toys, the poetic ingenuity they could awaken, as Cornell noted of Berenice's experiments in "The Crystal Cage," did not pass unnoticed at the time. The scientific toy could, Baudelaire wrote in "La Morale du joujou," "develop in the child's brain the taste for marvelous and surprising effects."[54]

Nineteenth-century engravings of such toys and the closely related parlor

games and experiments of the period, the popular domestic equivalents of Wright of Derby's experiments with an air pump, are quite frequently included in Surrealist collages (by both Ernst and Breton, for example), and by Cornell in his earliest collages. The frontispiece of T. W. Earle's *Science in the Nursery, or Children's Toys and What They Teach* (1876) (fig. 21) shows a selection of such toys, particularly including optical devices illustrating the principles of movement. Among the latter was the phenakistoscope, which consisted of a figure such as a dancer or a juggler drawn in, say, twenty different positions on a strip of paper placed round a drum; then a screen was held at a distance from the drum pierced with twenty windows; the figures were then revolved so that, glimpsed through the windows, they gave the illusion of one moving figure. More sophisicated versions of this were quickly developed, such as the zoetrope, or wheel of life, which could be used to demonstrate the movement of ocean currents or trade winds, and the praxinoscope, which was a similar drum with a picture band—but now enclosed within a circular box with a single peephole—and a central hub inside with mirrors that reflected the turning image. One of the most popular of parlor entertainments, it underwent various refinements, and in 1879 the moving scenes were placed within a proscenium with scenery (fig. 22). Such devices were probably the starting point for Cornell's Thimble Forests and Beehives (pls. 17, 19, 20); there are several versions of these, which consist normally of a circular box lined with mirrors, lidded but with a viewing hole on one side. Inside one or more thimbles balance on long thin pins, so that when shaken they shiver and even tinkle slightly, multiplied backwards and forwards in the mirror.

It was not just the philosophical toys that drew Cornell but all the flotsam and jetsam of childhood, nostalgia for vivid childhood experiences. He would have shared Baudelaire's belief that childhood experience is somehow primary. Toys are neither simple substitutes for reality nor thinly disguised

Fig. 21 Frontispiece from T. W. Earle's *Science in the Nursery,* 1876. Reproduced *Cavalcade of Toys,* 1942

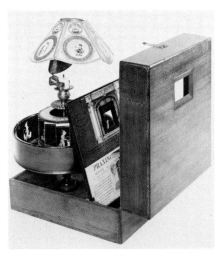

Fig. 22 Praxinoscope Theater. Paris, 1879. The Museum of The City of New York

Fig. 23 Jean Baptiste Chardin: *Soap Bubbles*. 1739. Oil, 36⅝ x 29⅜ in. National Gallery of Art, Washington, D.C., Gift of Mrs. John W. Simpson

educational mechanisms. In its games the child's imagination is convinced by the reality it has made for itself, as Baudelaire argues in "La Morale du joujou":

This facility of contenting the imagination bears witness to the spirituality of childhood in its artistic conceptions. The toy is the first initiation of the child into art, or rather, it is for him the first realization of it, and, when a ripe age has been reached, perfect realizations will not give his spirit the same warmth, nor the same enthusiasms, nor the same beliefs.[55]

The Romantic stress on the primacy of the child's imagination, not yet divorced from pragmatic experience, also infuses much Surrealist thought. "Children set off each day," Breton wrote in the *First Surrealist Manifesto*, "without a worry in the world. Everything is near at hand, the worst material conditions are excellent. The woods are black or white, one will never sleep."[56] Only in dreams can the adult whose world has become subject to gross material demands and whose imagination has been circumscribed recapture something of this freedom: "The mind of the dreamer is fully satisfied with what happens to him."[57]

But Breton knew, as did Cornell, that you can neither stay in nor return to childhood:

At an early age children are weaned on the marvellous, and later on they fail to retain a sufficient virginity of mind to enjoy fairy tales thoroughly. No matter how charming they may be, a grown man would think he were reverting to childhood by nourishing himself on fairy tales, and I am the first to admit that all such tales are not suitable for him. The fabric of adorable improbabilities must be made a trifle more subtle the older we grow, and we are still at the stage of waiting for this kind of spider.[58]

The world through the looking glass must change as the child grows up, and Breton returned to this idea when writing about Picasso in a passage that perhaps inspired the description of Cornell's works as "toys for adults":

When we were children we had toys that would make us weep with pity and anger today. One day, perhaps, we shall see the toys of our whole life spread before us like those of our childhood. It was Picasso who put this idea into my mind....We grow up until a certain age, it seems, and our playthings grow up with us, playing a part in the drama, whose only theatre is the mind. Picasso, creator of tragic toys for adults, has obliged man to grow up..."[59]

For Cornell, of course, the toy is not just an analogy but an explicit part of the imagery. Among the Victorian philosophical toys were also chemistry sets, magic lanterns, sets of nursery tales and natural history slides, and soap bubble devices (patented in 1874). Cornell's Soap Bubble Sets are among the richest of his inventions, and also provide an image of the way in which he seems to see the constructive nature of the imagination at work in games.

Another artist who explored the strange and treacherous thread between the child's and the adult's world is Jean Baptiste Chardin. Many of Chardin's pictures of boys and girls alone, contemplating a house built of cards or a spinning top, their pens and lesson books pushed to one side, contain a delicate ambiguity. Partly, it is true, these are paintings of the transitoriness of pleasure, the frivolity of games. But also they are in themselves a demonstration of the very vividness of transitory delights, which can become the substance of art. Chardin is not a painter who deals, at least primarily, with symbols. In *Soap Bubbles* (1739) (fig. 23) a man leans over a sill, framed as in a Dutch seventeenth-century window picture, utterly absorbed in blowing bubbles, watched longingly by an almost invisible child beside him, to whom, presumably, the bubble pipe belongs. In Cornell's Soap Bubble Sets, where a clay pipe becomes a bubble-blowing pipe, the bubbles themselves become heavenly bodies: the moon in the 1936 version (pl. I), the sun with constellations in the c. 1947–48 set (pl. 81). Cornell sees the exercise of the imagination in playing as something like the first flexing of the creative powers of the human mind whether in science or in art. Games give the mind its first experience of the power it can wield over matter, and contain the first seeds of its ability to construct pattern and meaning out of chaos. The

transformation of the soap bubble into a world is not just a visual pun, but a significant comment on the human imagination.

★

Cosmologies, cosmogonies, sky charts, and constellations are among Cornell's fundamental interests, and their importance to him is beautifully put by Fairfield Porter, whose article was one of the few about his work of which Cornell approved. Comparing a box by Cornell to a ship's cabin, he wrote: "...the view out the window is the stars, the constellations, which, as abstractions of the stars, are constructions of the human spirit,"[60] a creation, or construction, all the more extraordinary since the stars at the same time give man the measure of his smallness in the immensity of the universe: "and behold the night of the stars, how high they are."[61]

The constellations—star maps of the night sky—have been one of the most potent of human inventions. They were fixed before man had discovered the laws governing the movement of the planets, when models of the universe still had earth placed at the center; yet we still picture the sky in the ancient constellations and retain the Babylonian zodiac. Cornell was a frequent visitor to the Hayden Planetarium at the American Museum of Natural History, subscribed to its periodical the *Sky Reporter*, and had over thirty books in his library on astronomy, including Camille Flammarion's *The Wonders of the Heavens* (1871), three editions of H. Elijah Burritt's *The Geography of the Heavens and Class Book of Astronomy* (1838, 1852, 1873), and O. M. Mitchell's *The Planetary and Stellar Worlds: An Exposition of the Discoveries and Theories of Modern Astronomy* (1859).

In some of his earliest collages Cornell incorporates medieval constellation drawings: a Virgin (1930s) (pl. 1) and Andromeda, from the book on astronomy by King Alphonse X of the twelfth century, and Cassiopeia (1930s) (pl. 3) from Bayer's atlas of 1603. He was more interested in the constellations than in such solitary planetary .wanderers as Venus, and was absorbed by their

abstract patterns, like de Chirico's Hebdomeros, who once smashed a vase and watched the fragments fall in "a trapezoidal form, like a familiar constellation. And the idea of the sky upside down had charmed them all to the point of immobility."[62] In one version of the Cassiopeia collage (1966) (pl. 265), the pose of Dosso Dossi's Circe evokes the pattern of the Cassiopeia constellation. But also, of course, the fact that constellations embody figures from myths fascinated him, and Cassiopeia and Andromeda, mother and daughter in Greek mythology, belong, he said, to one of our deepest myths.

Cornell was also intrigued by alternative models of the universe, equally poetic constructions of the scientific imagination. Pasted in many boxes, or partly hidden below movable objects, are old engravings (or photocopies of old engravings) of world systems created before Kepler, "that tortured mystic."[63] He includes the Ptolemaic system (taught until the seventeenth century) with the earth at the center of the world, the sky of fixed stars at the edge and heaven as the outer ring of the circle. The *Object "Beehive"* (1934) (pl. 20) in The Museum of Modern Art contains an old French map with Hell at the center of the world and revolving round it two moons, Venus, the earth, sun, and eventually, at the top of the outer row, "the realm of the happy" (fig. 24). The *Soap Bubble Set* of 1947 (pl. 82) has Copernicus's map of the planets circling in regular orbits round the sun. It is interesting to compare Cornell's uses of constellations and cosmogonies with Ernst's collage (1931) for *Poèmes visibles*, "The sun seen from..." (fig. 25) Ernst has taken one of the illustrations from Camille Flammarion's *Astronomie populaire* (1880) (fig. 26) demonstrating the relative size of the sun as seen from the various planets, and pasted engravings into the sun circles to create an emblematic iconography very different from Cornell's. The porthole structure, however, is similar to that often used by Cornell, as in *Swiss Shoot the Chutes* (1941) (pl. 126).

Cornell's "Night Voyage" exhibition at the Egan Gallery in 1953 contained

Fig. 24 Map, cut from book, of Heaven, Hell, the stars, and planets; placed in interior of box in *Object "Beehive,"* 1934, pl. 20

Fig. 25 Max Ernst: *A l'intérieur de la vue 9.* 1931. Collage with watercolor, 5⅝ x 3½ in. Collection Ernst O. E. Fischer, Krefeld. Illustration for Ernst's and Paul Eluard's *A l'intérieur de la vue — 8 poèmes visibles,* Paris, 1947

Fig. 26 Celestial map according to the Ptolemaic system taught until the seventeenth century. From Camille Flammarion's *Astonomie Populaire, …Paris, 1925;* originally published 1880

the following kinds of works: "Observatories — Night Windows — Grand Hotel du Nord — Carousels [sic] — Taglioni — Penny Arcade — Portraits — Figureheads — Argus — Parmigianino — Andromeda — Camelopardalus." The overall title "Night Voyage" suggests that a particular theme links the works and acts as an interconnecting thread. Since constellations figure so frequently in connection with certain works (Observatories, Night Windows), and less obviously with others (Hotels), they would seem to be a good starting point from which to chart interconnections.

"Constellations" was a particularly suggestive word for Cornell; he used it to describe his own working process. In a handwritten note in the diaries, dated 1957, he muses over his continuous attempt to make a pattern of his own associations and experiences: "What about 'constellations' for experiments in going over past experiences on various subjects, and picking out certain points for a presentation…"[64] He is constantly attempting to chart for himself the otherwise unmanageable richness of association in daily experiences, and the rarer moments of intense delight. From the way in which he discusses them in his diaries, and from the subject files he gathered, it seems that such intense experiences acted as the focus or node for a whole cluster of experiences. Probably the most intense of these was the one he referred to as *GC 44 (Garden Center 1944),* which seems to have been composed of the following elements. Having seen a copious color spread of Jan van Eyck's *Adoration of the Lamb,* he was shortly after powerfully reminded of it by a painted still life on the side of a delivery wagon: "upon contemplation, the van Eyck slows as a beautifully realized, metamorphosed sublimation of the original commercial enseigne of the experience."[65] Also connected was a vivid experience of the country in summer, "with the feeling of the grasses, the field, the flowers and the rarified and spiritual quality of the dream."[66] The process by which this kind of experience was transformed in his works was, he claimed, intuitive and unplanned. "The manner in which all

unsuspectingly the Floral Still Life comes to life naturally, spontaneously, completely, an 'unfoldment' or 'extension' in which the Flemish master has been obligingly pressed into service for the concrete presentation of a vision."[67] He described the file he kept on *GC 44* as "a diary journal repository laboratory, picture gallery, museum, sanctuary, observatory, key…the core of a labyrinth, a clearing house for dreams and visions. It is childhood regained."[68] And the spectator too can join in this process: "invite the spectator to 'chart' further, elicit further dreams and musings if such he might care to do."

Charts and maps extend naturally to the idea of the voyage and thus reach into one of Cornell's richest areas of association. Some Navigation or sailor's boxes have star charts papered on the back wall, in reference to night navigation by star readings. Sometimes the navigation is not across earth's seas but through space. *Navigation Series* has a chart of the orbits of the principal asteroids. Another Celestial Navigation variant, *Sun Box* (c. 1956) (pl. 206), contains references to both sea and space navigation: a piece of driftwood lying on the base of the box, a cork ball suspended on rods, and a chart pasted on the back showing the paths of planets. The iconography of the Navigation and Celestial Navigation boxes overlaps, inevitably, with the Soap Bubble Sets. Untitled (Constellations zodiacales), a Celestial Navigation box (c. 1958) (pl. 208), contains the cork ball and cordial glass from the Soap Bubble Sets, and the asteroid chart *Navigation Series* contains three intact glasses and one broken, a refugee from the Sand Fountains (pls. 194–96), a time marker beside the space charts. One *Soap Bubble Variant,* with Ptolemy's map of the world, has printed on the back: "The Greek geographer Posidonius once travelled to the Atlantic to hear the sun drop with a hiss into the sea."[69]

Cornell once described a very precise source for his Navigation boxes: "original inspiration for sailor's boxes —Bank window 59th. Lex. Exhibition of miscellaneous objects found in trunks of sailors (seaman's home?) shells, toy snake, wales [sic] tooth, beads (exotic)

a butterfly box primitively constructed passepartout with wallpaper, glass broken, paper corner."[70] It is hard not to see many of Cornell's boxes as sailor's sea chests, with contents rich and strange or salvaged from a wreck. The Compass box *Object (Roses des Vents)* (1942–53) (pls. XVII; 198) in The Museum of Modern Art is like a sailor's trunk, each section below the compass tray containing objects and fragments.

Man is not the only voyager: in his Navigation boxes, Cornell refers frequently to birds and to their puzzling directional sense during their epic migratory journeys, an instinct that has been related to the stars. One box contains a soap-bubble pipe, shell, and glass and is called *Celestial Navigation by Birds* (c. 1963). The bird, Cornell ironically suggests, both has its own souvenir chest and belongs in that of the sailor. In a letter of 1949 he describes working on a little Habitat, containing

…a wooden cut-out of a very yellow canary perched upon a piece of knotty driftwood (as though upon a mountain peak)….But it will be left a "white room" for him in which almost the only other effect will be a cork "bulletin board" against the sidewalk, on which will be pinned butterflies, insects, etc. etc. his "souvenirs de voyage." It is a miniature and the outside wood silvery from being washed by the sea. It all looks as though it came from a sailor's sea chest and just "happened" rather than being made in these times.[71]

The tropical birds, the parrots and cockatoos, are themselves the sailor's own *souvenirs de voyage*, evidence of his journey to exotic lands. Miró's *Object* (1936) (fig. 27), which was exhibited beside Cornell in "Fantastic Art, Dada, Surrealism" in 1936 (fig. 5), makes the same connections, with a map pasted round the hat at the base of the bird's perch. However, the construction of Miró's *Object* emphasizes that the diverse elements are brought together through the irrationality of a dream.

Many Constellation boxes, Carrousels, and Soap Bubble Sets contain enigmatic references to birds, with the perch, ring, and sometimes the attached chain common to several bird boxes, but lacking the bird itself, absent on its miraculously navigated migration.

Some of the sparest and most beautiful of Cornell's boxes run to this theme. *Carrousel* (1952) (pl. 217) contains an empty perch with ring, broken wire netting of a cage, a night-window panel, and scattered throughout the box engravings of constellation maps: the Greater Dog, Taurus, Leo. The subtlest is *Observatory Corona Borealis Casement* (1950) (pl. 215), with the empty ring and perch, wire netting (intact so as not to break the geometrical Mondrian-like severity of the construction), and a night-window panel splashed and spotted with white paint to invoke both the stars and the opaque white droppings of birds trailed out to mark their passages across the sky.[72]

The night window also appears in connection with another theme: the Hotel. The untitled box known as Night Skies: Auriga (1954) (pl. 210) has a spare vertical structure and contains the inscription "Hotel de l'Etoile." The hotels for the human traveler in Cornell's dream voyages often have names evocative of the sky and navigation: Grand Hotel de l'Observatoire, Hotel de l'Etoile, Hotel de l'Occident, Hotel des Voyageurs, Grand Hotel de l'Univers, Hotel de la Mer, Grand Hotel Bon Port. The hotels are introduced into Constellation boxes (pl. 211), Sun boxes, or boxes with flown-bird references (*Le Déjeuner de Kakatoes pour Juan Gris*, pl. 145), but almost never into Navigation boxes.

Cornell's was a dream voyage, for he rarely strayed from the axis between his home on Utopia Parkway, Flushing, and Manhattan, let alone across the Atlantic. Yet he knew intimately the geography of the Europe to which he felt so close culturally. The Europe he knew was that of the high, late days of the nineteenth-century Grand Tour, and he was familiar with it not only from postcards, picture albums, and novels, but from maps and guidebooks containing detailed information on hotels, shipping lines, and railways. His extensive library contained, apart from some Baedekers, such volumes as *The Americans' Handbook to Vienna and the Exhibition 1873* complete with hotel and travel information, as well as guides to Paris, Holland, Belgium, Switzerland, the Italian Lakes, and Cook's carriage

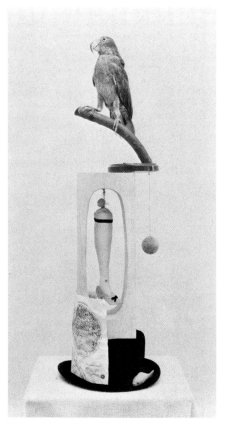

Fig. 27 Joan Miró: *Object*. Barcelona, Spring 1936. Construction, 31⅞ x 11⅞ x 10¼ in. The Museum of Modern Art, New York, Gift of Mr. and Mrs. Pierre Matisse

Fig. 28 Eugène Atget: Taxidermist's shop. 1926–27. Photograph. The Museum of Modern Art, New York, Abbott-Levy Collection, Partial Gift of Shirley C. Burden

Fig. 29 Eugène Atget: *Magasins du Bon Marché.* 1926. Photograph. The Museum of Modern Art, New York, Abbott-Levy Collection, Partial Gift of Shirley C. Burden

drives in Naples and its surrounding antiquities. The peak of the Grand Tour, of course, was a visit to the monuments of Renaissance Italy, Rome and Florence, and it was partly through this that Cornell established his link with Medici Princes and Princesses, cultural totems as precious to him as his Renaissance statues and paintings were to the expatriate American Gilbert Osmond. But it was not just the monuments of the grand picturesque that Cornell knew; he valued as highly, for example, Eugène Atget's photographs of the unpretentious corners of old Paris, the turn-of-the-century shop fronts which have a close link with Cornell's own boxes (figs. 28, 29).[73]

The hotel as a microcosm of life has been explored many times—in Henri Barbusse's novel *L'Enfer (Hell;* 1908), for example. But Cornell was less interested in its psychological potential than its geographical extensions. Cornell admired a passage in Wallace Fowlie's book on Rimbaud discussing the poem "Promontoire," which he quotes in his diary in December 1959: "...a promontory suggests a hotel, which appears as a microcosm of the world."[74] It is as a microcosm of the world rather than of life that Cornell sees the hotel. "Promontoire" displays a sweeping geographical imagination:

The golden dawn and the shivering evening find our brig in the offing opposite this villa and its grounds, which form a promontory as extensive as Epirus and the Peloponnese, or the great island of Japan, or Arabia!...immense views of the defenses of modern coasts...and the curved fronts of Scarborough or Brooklyn "Royals" or "Grands"; and their railways flank, undermine, and overhang the elevations of this hotel, chosen from the history of the most elegant and the most colossal buildings of Italy, of America, and of Asia...[75]

And yet for Cornell the hotel is ambiguous. It is infinitely alluring and rich in historical and geographical extensions, its grand facade often culled from Renaissance palaces, its very name derived from the great private residences of the past, the *hôtels particuliers;* yet at the same time it is hollow and lonely. Many Hotel boxes have deserted perches, hinting at the solitariness of the voyager,

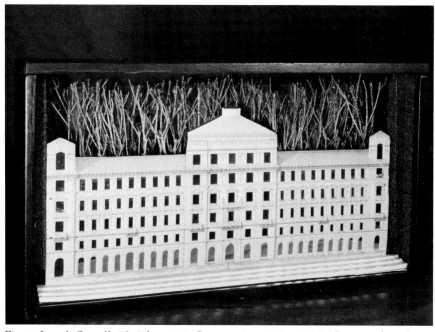

Fig. 30 Joseph Cornell: *The Palace.* 1943. Construction, 10½ x 20¼ in. Present whereabouts unknown

at a state of absence, unlike the suggestion of exotic flight and freedom in the Constellation boxes. Untitled (Hotel de la Clef d'Or) (c. 1959) (fig. 31) contains, among the images clustered at the top of the box, an engraving of a hotel reminiscent in its structure of the wonderful flat facade of the 1943 *Palace* (fig. 30). But the empty perch and cracked and peeling paint tell instead of loneliness and nostalgia. Cornell both longed and feared to travel.

★

Two untitled cockatoo boxes provide an illuminating set of correspondences and contrasts. Cornell had the habit of working on several boxes simultaneously, sometimes putting one away for weeks, months, or even years before bringing it out to be worked on again. It is also hard to date boxes as contemporary on the grounds of the same materials being used, for he both stored his materials (such as the cutout bird, and the shells) and would go out of his way to find stocks of the same material (sandbox glasses, velvet). But these two boxes, Untitled (Cockatoo and Corks) (pl. XXVI) and Untitled (Hotel Beau-Séjour) (pl. 146), do seem to have been worked on almost as pendants to each

other. The similarities begin with the cockatoos themselves, identical wooden cutouts with a pasted colored lithograph on one side, to which Cornell has added yellow paint. But in the former, the green leaf at the end of the branch on which the bird is perched has been cut away. This sets the tenor of the changes, for in the bare-twig box, the lack of greenery, of space, of color, of water, becomes evident. It is a desiccated, bleached box, with the texture of peeling paint, cork, dry wood. A piece of real wood is carefully slotted in to continue the printed perch. The cockatoo holds in its beak a string, which is attached to the base of a glass-walled box holding small corks. It is not immediately clear that this is a game—the string if pulled releases the trapdoor, and a cork is aimed at the tube below. Two corks lie beside it as though the bird had already tried the game and failed. A sense of frustration and constraint is increased by the fact that the container at the base is cut off from the game by a glass top; beside the bird is an object shaped like a miniature fountain bath but holding a ball colored hot red rather than cool blue. In the other box, the sense of extension, freedom, and refreshment is all the more striking by contrast, and greater vividness is built up by small

36

Fig. 31 Joseph Cornell: Untitled (Hotel de la Clef d'Or). c. 1959. Construction, 15⁹⁄₁₆ x 9⁵⁄₈ x 4 in. Castelli Feigen Corcoran

details. Bright yellow paint runs along the cut edge of the bird; the hotel's name holds the promise of exotic voyage; a swan suggests the presence of a lake. The contrast between these two boxes is both iconographical and textural, and its roots lie in Cornell's own ambivalence.

The alternation between the sensation of constraint, of being trapped at home, and then of release when he made the journey to Manhattan, is a constant theme in the diaries, and working on the boxes themselves in his cellar, like a substitute for a real voyage, often induced the same sensations of escape and freedom.

Cornell gives an account of the genesis of the parrot and cockatoo boxes in the draft of a statement called "Parrots Pasta and Pergolesi":

magic windows of yesterday…
pet shop windows splashed with white and
 tropical plumage
the kind of revelation symptomatic of city
 wanderings in another era.

The association of birds with bel-canto singer Giuditta Pasta and composer Giovanni Battista Pergolesi is a natural one, and there are stories of cockatoos able to imitate arias and even entire operas. Cornell continues: "The 'context' 'atmosphere' or whatever the mot juste in which these feathered friends came into being is a warm and rich one…scintillating songs of Rossini and Bellini and the whole golden age of the bel canto…";[76] he digs down, too, to very early recollections of birds: "indelible childhood memory of an old German woman a neighbour's pet parrot may have added to obsession of these …feathered friends."[77]

Beside their associations with flight and with song, the birds are set in habitats with their own resonances. Some have a city atmosphere: pet-shop window, white-washed wall, cage, mirror with connections to sidewalk cafes and crowds and theaters. Some stress the exotic origins of the birds, with foreign stamps and inscriptions: others, in particular the owl boxes, are closer to nature, or perhaps more accurately are "rural." In 1946, Cornell added to the owl boxes he was then working on a

chance find of "a particularly fine example of rotted tree from which a piece of bark and clinging trailing shrubbery branches had fallen."[78] He took home handfuls of the powdery wood and incorporated it into the boxes. On another occasion he brought back grasses from one of his summer bicycle rides in the country; he rubbed and dried the seeds, which he added to bird boxes, giving them, he felt, the feeling of a warm, lined nest. But in many of the owl and other bird boxes there is also the suggestion of an artificially composed habitat, whether that of a Victorian stuffed bird case (*Parrot Music Box*, c. 1945, pl. 131), or a Natural History Museum diorama (Untitled [Habitat with Owl], 1946, pl. 165) carefully composed with real dried twigs, leaves, grasses (fig. 32). He points up the irony of the "habitat" in a comic advertisement offering a comfortable holiday home for owls, full of picturesque associations:

Large SEQUESTERED BOWER — HUMOROUS COMPARTMENTS — LOOK-OUTS; GUEST ROOMS; LOUNGE; IVY COVERED OBSERVATORY FOR EARLY DAWN VIEWS AND romantic sunsets; cheese cellar…moss lined alcoves with dripping water and large variety snails; cool storage of valley — easy walking distance to enchanted lake. Reasonable rates — agent on premises."[79]

Cornell's boxes are neither as innocent nor as devoid of menace as they sometimes appear. The owl is a night bird, a predator, which haunts ivy-covered castle ruins and moonlit woods; it is also the bird of death, the familiar of the memento mori. An anonymous eighteenth-century painting included in the 1936 "Fantastic Art, Dada, Surrealsim" exhibition shows it presiding over a still-life allegory of the transitoriness of earthly beauty (fig. 33).

The owl is never shown as victim, as are the birds in *Habitat Group for a Shooting Gallery* (pl. XXIII), and *Isabelle/Dien Bien Phu* (pl. 142), where they are not only the targets themselves but also stand in some sort of human capacity as victim. The glass is cracked and pierced, and the splashed paint is not only like the colors of exotic plumage, but like blood. Sometimes the glass itself is splashed,

has specific associations with targets. Cornell noted in his diary in March 1960: "...and then there is the extra wall glass with markings like those used in civil defence, charting the oncoming shifting course of the enemy bomber."[80] There is a hint of the identification of bird and human that Ernst made explicit with his bird alter-ego, Loplop. Cornell suggests the association of the bird with human fate. In *The Caliph of Bagdad* (c. 1954) (pl. 135) the birds perch over a drawer containing little tied rolls of paper, like those birds in Eastern bazaars trained to pick out the paper from the fortune teller's store.

<center>★</center>

The more menacing aspects of Cornell's work touch, although are not identical with, the darker side of Surrealism. The Surrealists had long been interested in the gloomier images of Romanticism and the picturesque, and in the 1930s they began to explore the more violent reaches of the human psyche, a natural reaction to the growing threat of Fascism. The life and works of the Marquis de Sade were prominent, and their influence is strong in, for example, Dali and Buñuel's film *L'Age d'or* (1930), which Cornell saw and admired. Black magic and ritual became central interests, as did the more bizarre aspects of the natural world, such as the sexual habits of the praying mantis. These interests tended to grate on the American sensibility, and the distinction between the "black" and the "white" sides of Surrealism is more strongly drawn in the United States than elsewhere. It is often in this context that Cornell's connection with the movement is denied or minimized, and he is described as having "escaped" from the Surrealist nightmare. Harold Rosenberg, in "Object Poems," writes that Cornell: "has more in common with New England spareness and transcendentalism, with Emily Dickinson's 'If I could see you in a year/I'd wind the months in balls/And put them each in separate drawers/Until their time befalls' than with Surrealist diabolism, and he quickly abandoned nightmare..."[81] Cornell himself was apprehensive about the darker side of Surrealism, but did

not for this reason reject the movement. He once wrote to Malitte Matta asking about Jacques Prévert's book of collages, *Fatras:* "If this is in the 'humeur noir' category–NIET! Not too far from the Max Ernst white magic side is my taste."[82] The white magic ("uncanny magic," Rothko called it) of the boxes was the side Cornell consciously emphasized, but it is impossible to ignore the extreme contrast between the gentle fetishism of the Homages to the Romantic Ballet, the violence of the Habitats, and the grim fatalism of the owl boxes.

Cornell is frequently presented as a recluse and sometimes as a naive eccentric, the kind of isolated artist or writer much valued by the Surrealists, like the *Facteur* Cheval, the postman from southern France who between 1879 and 1912 built his Ideal Palace entirely on his own to correspond to a personal and obsessive vision. Cornell was aware of and concerned about the "recluse" label: "The notion that I am unseeable is a wrong notion, a canard, in fact," and again, "this notion of a recluse gets trotted out by people who should know better" for his was "not the run-of-the-mill temperamental or standoffish thing."[83] What he did find difficult to communicate, which also contributed to the image of the isolated artist, were the shifting associational complexities of his thought. He once noted in his diary: "on way to 9:22 the gulls overhead brought a strong evocation of the house on the hill...a 'link'—the 'reassurance' and 'continuity' of a thread so tenuous, so hard at times to keep hold of (or perhaps to communicate to others is what I mean)."[84] He would also have rejected the idea that he was a "pioneer eccentric"; he was certainly not isolated from the mainstream of the art of his time, in the way that Louis Eilshemius, the naive painter discovered by Duchamp, and the *Facteur* Cheval were. Although, because he was rather haphazardly self-taught, he sometimes gives the disconcerting impression in his diaries, and even occasionally in his work, of being a cultural magpie, his was certainly not a "marginal consciousness."

Still, Cornell remains a paradoxical figure on so many levels. He was never

Fig. 32 *Birds That Are Our Friends.* Circulating exhibition from the American Museum of Natural History, New York

Fig. 33 French School: *Memento Homo.* 1769. Oil, 21¾ x 16¾ in. Formerly collection Marie Sterner, New York. Exhibited in "Fantastic Art, Dada, Surrealism," The Museum of Modern Art, New York, 1936–37

committed to Surrealism, and yet his connection with it was not simply reflective of its being the strongest and most vital movement around at the time. He was attracted to visual Surrealism, yet he was probably closer in sensibility to the American Transcendentalist tradition. His diaries reveal him as sensitive to his own experiences and emotions, dreams and feelings, in an almost hypochondriacal degree, and yet his boxes have a studied impersonality.

His anxiety about his ability to express the ramifications of the subjects of his boxes is belied by such comments as this in the Ondine source-material file, which implies a willful obscurity: "...the final distilling where the subject is almost transcended or briefly caught sight of in a window."[85] Themes change and subjects "thicken" as he uncovers more links between them, but these connections are submerged, and the final work stands as a distillation, almost an abstraction. Not a literary artist, he was attracted to a nineteenth-century writer, Aloysius Bertrand. Bertrand (a "surrealist in the past," as Breton described him) recreates in *Gaspard do la Nuit*, through fragmentary flashes of illumination, the medieval and Renaissance past of Dijon. Cornell too sees the past as reconstitutable through fragments; the historical dimension of his imagination is central. Without it being a pessimistic vision, Cornell seems to have perceived an enormous cultural shipwreck, out of which he could salvage things—fragments, ideas, a scrap of text. All his boxes are perhaps sailor's chests, containing his souvenirs of an imaginary voyage.

NOTES

1. This essay has been greatly facilitated by the use of the Joseph Cornell Papers, Archives of American Art, Smithsonian Institution, New York, Gift of Elizabeth Cornell Benton. I am indebted to Judith Cousins, Researcher, Department of Painting and Sculpture, The Museum of Modern Art, New York, for her invaluable insights and information. I would also like to thank Maureen Reid, John Golding, and Nikos Stangos.

2. Cornell Papers, AAA, reel 1059, diary note, April 15, 1946.

3. Levy had brought back from France a number of books and magazines, including Surrealist periodicals, and apparently set up an informal reading room, though at what date is unclear. Levy also had the original collages for La Femme 100 têtes in 1931.

4. Julien Levy, Memoir of an Art Gallery (New York: G. P. Putnam's Sons, 1977), p. 77.

5. André Breton, preface to catalog, "Exposition Max Ernst," Galerie au Sans Pareil, Paris, May 1921; reprinted in Max Ernst, Beyond Painting and Other Writings by the Artist and His Friends, Breton text trans. Ralph Manheim (New York: Wittenborn, Schultz, Inc., 1948), p. 177.

6. John Ashbery, "Cornell: The Cube Root of Dreams," Art News (New York), vol. 66, no. 4 (Summer 1967), p. 56.

7. Sixteen of Cornell's early collages, including this one, were arranged on one page in View (New York), series 2, no. 1 (April 1942), p. 23, as an homage to Ernst, under the title Story without a Name — for Max Ernst.

8. Reproduced in catalog of the exhibition "Joseph Cornell Collages: 1931–1972," Leo Castelli Gallery, New York, May 6–June 8, 1978, no. 25.

9. La Révolution surréaliste (Paris), no. 12 (Dec. 15, 1929), p. 58.

10. Reproduced in "Joseph Cornell Collages: 1931–1972," no. 11.

11. Levy, op. cit., p. 79.

12. John Bernard Myers, "Cornell: The Enchanted Wanderer," Art in America (New York), vol. 61, no. 5 (Sept.–Oct. 1973), pp. 76–81.

13. Levy, op. cit., p. 82.

14. This was, according to Diane Waldman, the glass bell containing the collage of hand and rose. See Waldman, Joseph Cornell (New York: George Braziller, 1977), p. 12. The other exhibitors were Herbert Bayer, Salvador Dali, Pablo Picasso, Pierre Roy, an unknown master, Jean Viollier, Jean Cocteau, Charles Howard, plus photographs by Eugène Atget, Bayer, J.-A. Boiffard, Max Ernst, George Platt Lynes, Man Ray, László Moholy-Nagy, Roger Parry, Maurice Tabard, and Umbo.

15. Among the Cornell papers given to the Anthology Film Archives, New York, by Elizabeth Cornell Benton is the prospectus for the 1932–33 season of the Film Society, of which Julien Levy was president. L'Age d'or was screened March 19, 1933, at 361 West 57th Street (a different location from Levy's gallery at 602 Madison Avenue) and Un Chien Andalou, Oct. 9, 1933. Cornell probably saw both screenings. Rose Hobart was probably shown in December 1936 at the Julien Levy Gallery.

16. André Breton, "Surrealist Situation of the Object" (1935), reprinted in Manifestoes of Surrealism, trans. Seaver and Lane (Ann Arbor: University of Michigan, 1969), p. 257.

17. Julien Levy, Surrealism (New York: Black Sun Press, 1936). This contained an introduction and an extensive number of translated Surrealist texts, poems, and film scenarios, including Cornell's "Monsieur Phot" (1933). English translations of Surrealist writings had already appeared, including a special Surrealist issue of This Quarter in 1932; Cornell also read and wrote French, so that he could have been familiar with Surrealist theory, though there is no evidence that he examined closely its relevance to his own work before 1936.

18. "The Surrealists," Harper's Bazaar (New York), vol. 70 (Nov. 1936), p. 126.

19. Letter dated Nov. 13, 1936, Archives of The Museum of Modern Art, New York.

20. Catalog of the exhibition "Fantastic Art, Dada, Surrealism," ed. Alfred H. Barr, Jr., The Museum of Modern Art, New York, Dec. 7, 1936–Jan. 17, 1937. The 3rd edition (1947) described Cornell as an "American maker of Surrealist objects."

21. Information from original loan form, The Museum of Modern Art, New York, 1936.

22. Minotaure (Paris), no. 10 (Winter 1937), p. 34. This is the same Glass Bell as that exhibited in 1932 at Julien Levy's.

23. Catalog of "Exhibition of Objects (Bilboquet) by Joseph Cornell," Julien Levy Gallery, New York, Dec. 6–31, 1939.

24. Ashbery, op. cit.

25. The catalog announced that "from time to time the Museum intends to recognize the works of outstanding artists in this way," but there was no immediate sequel to this innovation. The Cornell retrospective contained 19 works. From 1960 the Whitney Annual was alternately devoted to painting and sculpture, and Cornell was included in the sculpture shows.

26. Arranged by Dore Ashton, it took place Feb. 10–March 2, 1972. The Albright-Knox Art Gallery, Buffalo, also held a special Children's preview for the Cornell exhibition in April 1972. As early as 1942, Cornell had arranged an exhibition of work by children and himself at the Wakefield Gallery, New York.

27. William Carlos Williams advised View's editors ("View Listens," series 2, no. 2, 1942) to maintain their neutrality: "The thing seems to be that View might become anything: that is what I admire about it. It's not a party organ and has no more relation to SURREALISM than that has to the moment, and no less. When it becomes sold on some viewpoint and fixes itself there, you can have it." Cornell did not contribute to the American Surrealist review VVV; his relationship with the refugee Surrealists would be worth examining.

28. View (New York), series 1, no. 2 (Oct. 1940), p. 4. Montagu O'Reilly was the name under which Wayne Andrews, the architectural historian, wrote his Surrealist short stories. He subsequently became Cornell's lifelong friend. Cornell also borrowed the title of his 1946 exhibition at the Hugo Gallery, "Romantic Museum," from another of O'Reilly's stories, published in a New Directions pamphlet in 1936.

29. Ibid. There are several versions of both the casket and the story, among them Taglioni's Jewel Casket (pl. 87) and Untitled (Taglioni Souvenir Case) (pl. 89).

30. "Ballet for Tamara Toumanova," View (New York), series 2, no. 4 (Jan. 1943), p. 36.

31. "The Crystal Cage (Portrait of Berenice)," View (New York), series 2, no. 4 (Jan. 1943), pp. 10–16.

32. In 1941 a deluxe edition of 20 copies of Duchamp's Box in a Valise was distributed by the Art of This Century gallery. Notes for his The Bride Stripped Bare by her Bachelors, Even were first published in facsimile edition in 1934, under the title The Green Box.

33. Cornell Papers, AAA, 1055, diary note c. 1946. This object has curious and fortuitous associations of a kind that seems

to have haunted Cornell. The banquet was held at the observatory built by Roussel's friend Camille Flammarion, whose widely read *Astronomie populaire* (1880) was one of the sources of Roussel's *Impressions d'Afrique* and also the source of the engravings Ernst used in *Poémes visibles* (fig. 25). It contains considerable material on world systems, stars, and constellations like that used by Cornell, who owned Flammarion's *Wonders of the Heavens*. The heliogravure technique Flammarion used to reproduce his three-hour-long exposures of the night sky, resulting in thick white dots for stars, seems to have inspired Cornell's star-splashed skies in, for example, at least one of his Hotel boxes (pl. 210).

34. Written in response to letter dated March 28, 1968, from Yale student Leslie John Schreyer. Courtesy Elizabeth Cornell Benton.

35. *Ibid.*

36. *Ibid.*

37. André Breton, "Artistic Genesis and Perspective of Surrealism," preface to *Art of This Century*, ed. Peggy Guggenheim (New York, 1942); collected in *Surrealism and Painting*, trans. Simon Watson Taylor (New York and London: Icon Editions, Harper & Row, 1972), pp. 78–81.

38. Cornell Papers, AAA, 1077, Feb. 19, 1972.

39. Diary note (1953?). Schreyer file.

40. Louis Aragon, L'Ombre de l'inventeur," *La Révolution surréaliste* (Paris), no. 1 (Dec. 1924), p. 22.

41. *Ibid.* It was at this same inventors' exhibition, the Concours Lépine, that Duchamp exhibited his *Rotoreliefs* for the first time in 1920.

42. André Breton, "Introduction au discours sur le peau de réalité" (Winter 1924); reprinted in English in *What Is Surrealism*, ed. Franklin P. Rosemont (New York: Pathfinder Press, 1978), p. 26.

43. Both "trays" were in Breton's collection; one was reproduced in *Cahiers d'art* (Paris), no. 1–2 (1936), the special issue devoted to the object, and identified as the work of an *aliéné*, a mental patient; it was also included in Barr's "Fantastic Art, Dada, Surrealism" catalog.

44. In December 1934 Julien Levy held an exhibition of abstract sculpture by Giacometti.

45. There were apparently three versions of the book and ball. *Art of This Century, op, cit.,* lists one and dates it 1934.

46. Levy, *Surrealism*, pp. 98, 99.

47. Cornell refers to the comment in the draft of a letter to de Kooning; Cornell Papers, AAA, 1059, Oct. 15, 1951.

48. Kurt Schwitters, *Merz* (1920); quoted in Robert Motherwell, ed., *Dada Painters and Poets* (New York: Wittenborn, Schultz, 1951), p. 57.

49. Cornell Papers, AAA, 1058, Dec. 21, 1942; entered Feb. 17, 1947.

50. *Ibid.*, 1058, Aug. 15, 1945.

51. Robert Desnos, "L'Idée fixe" (1927), in *Corps et bien* (Paris: Gallimard, 1930), p. 118.

52. Benjamin Péret, "Magic: The Flesh and Blood of Poetry," *View* (New York), series 3, no. 2 (1943), p. 44.

53. Cornell Papers, AAA, 1060, March 1960.

54. Charles Baudelaire, "La Morale du joujou," *Le Monde littéraire*, April 17, 1853; reprinted *Curiosités esthétiques* (Paris: Garnier, 1962), p. 205.

55. *Ibid.*, p. 203.

56. Breton, *Manifestoes of Surrealism, op cit.*, p. 15.

57. *Ibid.*

58. *Ibid.*

59. André Breton, "Le Surréalisme et la peinture" (1928); reprinted in trans. in *Surrealism and Painting, op cit.*, pp. 6, 7.

60. Fairfield Porter, "Joseph Cornell," *Art and Literature* (Lausanne), no. 8 (Spring 1966), p. 120.

61. From the Book of Job, quoted by Cornell in his diary; Cornell Papers, AAA, Aug. 19, 1960.

62. Giorgio de Chirico, "Hebdomeros," trans. Paul Bowles, *View* (New York), series 4, no. 3 (Fall 1944), p. 81.

63. Quoted by Cornell from Arthur Koestler's *The Sleepwalkers* (1959). Cornell Papers, AAA, 1058, undated.

64. *Ibid.*, 1060, 1957.

65. *Ibid.*, 1072, source material file, May 5, 1949.

66. *Ibid.*

67. *Ibid.*

68. *Ibid.*, 1072, Jan. 12, 1947.

69. This calls to mind the episode in *Rose Hobart* when the sun falls from the sky, dropping into a pool before Hobart's eyes.

70. Cornell Papers, AAA, 1058, diary note, April 4, 1943.

71. *Ibid.*, 1059, July 11, 1949.

72. After 1946, a severely geometrical, almost abstract construction was present in the Dovecote and Window Facade series. In a diary note for Aug. 15, 1946 (Cornell Papers, AAA, 1059), Cornell records working on a box with thirty-five identical ¾ inch white cubes, and notes "Mondrian feeling strong." There had been a major Mondrian exhibition at The Museum of Modern Art in Spring 1945. Cornell's use of series—repetitions of objects with asymmetrical breaks, as in *Multiple Cubes* (1946–48), where forty-two identical cubes are placed within a box grid divided into equal compartments, but where some cubes are tilted slightly or placed on end to break the repetitive monotony—is different from Mondrian's system of equilibrium and balance created by the intersections of horizontal and vertical lines. The closest to Cornell's are Mondrian's last two works, *Broadway Boogie Woogie* (1942–43) and *Victory Boogie Woogie* (1943–44).

73. Cornell wrote to Claude Serbanne on March 26, 1946 (Cornell Papers, AAA, 1055), comparing Zecca favorably with Méliès for "working in plein air, leaving a record ATGET-like of so many of the Parisian fin-de-siècle land-marks (the unpretentious ones like the boutique of a charcutier such as I have in my "The man with the calf's head" which Dali liked so much, and in which he [illegible]...a quality of Gérard de Nerval)."

74. Cornell Papers, AAA, 1060, Dec. 28, 1959.

75. Arthur Rimbaud, "Promontoire," *Les Illuminations* (1872); (Paris: 1886).

76. Cornell Papers, AAA, 1060, diary note, Feb. 28, 1960. Consisting of only fragmentary notes, the statement is also interestingly concerned with his relationship to the "current preoccupation with the 'objet trouvé', neo-dada junk assemblages etc. etc...'

77. *Ibid.*

78. *Ibid.*, 1059, diary note, April 15, 1946.

79. *Ibid.*, 1058, diary note, July 10, 1948. A variant of this advertisement is printed on a scrap of paper in Untitled (Habitat with Owl) (pl. 165).

80. *Ibid.*, 1060, diary note, March 1960.

81. Harold Rosenberg, "Object Poems," *The New Yorker*, vol. 43, no. 15 (June 3, 1967); reprinted in *Artworks and Packages* (New York: Horizon Press, 1969), p. 79.

82. Cornell Papers, AAA, 1058, undated.

83. *Ibid.*, 1062, *passim.*

84. *Ibid.*, 1058, Feb. 27, 1945.

85. *Ibid.*, 1074, undated.

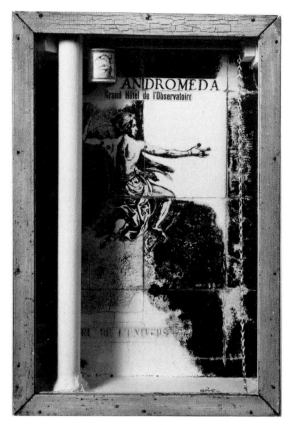

Fig. 1 Joseph Cornell: Untitled Hotel box, 1954, pl. 211

Fig. 2 Josiah Harris House, Castleton, Vermont. Library of Congress Collections.
Photographed by Herbert Weaton Congdon

JOSEPH CORNELL
MECHANIC OF THE INEFFABLE

Carter Ratcliff

Joseph Cornell is a virtuoso of fragments, a maestro of absences. Each of his objects—a wine glass, a cork ball—is the emblem of a presence too elusive or too vast to be enclosed in a box. These missing presences crowd the imagination, for most of his boxes contain a myriad of things. Even the emptiest—the all-white dovecotes and gridworks—look full of departed personages. A feather on the floor of a box evokes the flown bird. The shallow space of a Hotel box evokes the entire room, an entire seaside hotel; and so delicate is the artist's touch with fragments that the white dowel toward the front of the box, a toylike column, is an emblem of all of architecture (fig. 1).

The reproduction of a Bronzino portrait (pls. 118, 120) recalls the artist, his subject, and the social order to which they both belonged—an order we imagine had a wholeness lacking in our own. A seashell suggests the sea and the wholeness of nature, a spiraling watch spring the fullness of time, Cassiopeia the infinity of space. Scale is more than flexible, it is multiple, in Cornell's art. He alludes to elaborate cabinetry with hints of labyrinthine cities. When pages cut from guidebooks include circular plazas as well as gridded boulevards, the eye is led back to spiraling watch springs, and on to wine glasses, miniature urns, and other curves which suggest not only the temples the urns might grace— architecture, once again, with the accent on domes instead of columns— but the night sky and the sweep of orbiting planets. Cornell often pastes charts of their orbits to the back of a box, and all of his works, whether explicitly astronomical or not, tend with a dreamy restlessness to draw infinity inside their narrow confines.

Cornell arranges fragments, so fragmentary views of his art have been convincing. When he showed his first collages, in the 1930s, he was called a homegrown Surrealist. More recently, he has been seen as a belated Symbolist poet who happens to combine objects with "Andromeda," "Hotel du Nord," and the rest of his favorite words. Despite the formal elegance of his boxes, Cornell has sometimes been placed far from Mallarmé, Rimbaud, and other high priests of Symbolism, as if he were a primitive—an inspired magpie who constructs *Wunderkammers* (figs. 12, 20), curiosity cabinets, for our times. Cornell's own insistence on his Americanness leads him to be compared to his countrymen, Charles Bird King, John Haberle, and John Frederick Peto, painters of the last century whose trompe-l'oeil still lifes turn heaps of bric-a-brac into poignant, plain-spoken allegory. In particular, Cornell's Soap Bubble boxes (pl. 81), with their bubble pipes and wine glasses, have a close resemblance to William M. Harnett's pitcher-and-pipe pictures (fig. 3). For Harnett, these objects are emblems of an ideally simple life. Cornell intends his pipes, always made of white clay, to evoke his Dutch forebears and thus establish the firmest

possible claim to his place in American history. That nearly mythical sense of his origins puts him at home in all periods. Some of Cornell's boxes (pls. 215, 217) have a severe grace that echoes the facades of Federal-style houses in New England (fig. 2) and lower Manhattan. The grid boxes (pl. 173), severer yet, suggest the utilitarian design of mills and warehouses, while his most cluttered boxes (pl.94) have the claustrophobic feel of Victorian drawing rooms, bell jars, and terrariums (fig. 4).

None of the standard views of Cornell is entirely wrong, yet they all leave his restlessness untouched. No label applied so far has accounted for the mechanics of his art, the way its fragments launch revery past Surrealist apocalypse, Symbolist absolutes, and familiar allegory to a voyeur's obsession with an enchanted ineffable. Behind Cornell's panes of glass, emblem after emblem of childhood innocence, feminine purity, and unsullied nature initiates a spiritual quest so delicate it hints at a Puritan ambivalence toward all of life. In *Cassiopeia* (1966) (pl. 265) the title figure is represented by a chart of the constellation that bears her name. She is the mother of Andromeda, who was chained to a rock as a sacrifice to a sea monster. Near the star chart, there is a fragment of a picture postcard with the image of a nude woman. She might be read as the blameless Andromeda, save that the postcard is a reproduction of Dosso Dossi's *Circe and Her Lovers in a Landscape* (c.1525). The innocent daughter is blended with Greek myth's most powerfully sexual sorceress. This makes it difficult to decide whether Cornell enchanted his images, as mature artists are assumed to do, or his images enchanted him. As he wandered through Manhattan, collecting the "loot" which reappeared in boxes and collages, did he make conscious choices or was he drawn from image to image, object to object, in a fog of compulsion? When these fragments are successfully assembled, a spell is cast. Anxious need finds the serenity of exalted yearning.

Even the most self-contained box is itself a fragment, a nostalgic emblem of departed wholeness, purity, innocence. It is never clear who or what, in

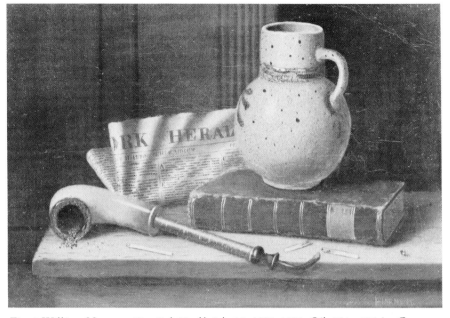

Fig. 3 William Harnett: *New York Herald, July 11, 1880.* 1880. Oil, 5⅜ x 7⅛ in. Courtesy Kennedy Galleries, Inc., New York

Fig. 4 Edward A. Goodes: *Fishbowl Fantasy.* 1867. Oil on canvas, 30 x 25⅛ in. Courtesy Hirschl & Adler Galleries, New York

Fig. 5 Marcus Gherraerts: *America.* c. 1590–1600. Engraving, 8⅛ x 5⅝ in. The Metropolitan Museum of Art, New York

Fig. 6 Berenice Abbott: *Sumner Healey Antique Shop, 942 Third Avenue, Manhattan.* 1936. Photograph. The Museum of the City of New York

Cornell's view, has suffered this loss. Perhaps it is the artist, when he grew beyond childhood; or the feminine, when its sexuality became manifest; or modern life, with its indifference to the "beauty" Cornell seeks! Thus guilt for the fallen, distintegrated nature of experience may be the artist's or it may not. This ambiguity is unresolvable, hence unbearable. Cornell had to run endless errands into the wilderness of Manhattan in search of the images which, properly arranged, transported him in revery beyond his doubts (fig. 6). Then doubts returned and he would leave his house to forage in the wilderness again.

★

When I think of Cornell at work on Utopia Parkway, I am reminded of Henry David Thoreau—"the hermit of Walden,"[2] as Cornell called him. Walden Pond was the center of Thoreau's universe, just as the small white frame house on the Parkway was the center of Cornell's. Both men are known as hermits, yet neither stayed completely isolated for long. Cornell's stretches of solitary work were often interrupted by his mother and his brother Robert. And there were frequent visitors from Manhattan to the house in Queens. Likewise, Thoreau's hut at Walden Pond was a magnet for seekers after the Transcendentalist spirit in action.

Of course, Thoreau was often away, tramping through the Massachusetts woods—sometimes on a surveying job for an employer in Concord, sometimes on the lookout for "tropes and symbols with which to describe his life."[3] He always brought one symbol with him, a compass. As a tool of his surveyor's trade, Thoreau's compass stood for the impulse to bring order to the world—"a clearing in the forest, so much open and enclosed ground."[4] As a device of Thoreau's imagination, his compass helped him create the world anew, so that "Wherever I sat, there I might live, and the landscape radiated from me accordingly."[5] Both of these compasses, the real and the imaginary, recall Cornell's. There is one at the base of *Untitled (Medici Slot Machine)*

(1942) (pl. 117), twenty-one of them set into the *Object (Roses des Vents)* (1942–53) (pl. XVII). And compasses are implied by the radiating lines of his spider-web collage (1931) (pl. 2), his *Surrealist Box* (1951) (fig. 7), and his constantly repeated star maps.

"The roots of letters are in things,"[6] said Thoreau. As he wandered in the woods or along the border between cleared and uncleared land, he looked for natural or Indian-made objects (a flower, a spread of moss, an arrowhead) that might be transformed by his practice of letters into some transcendent insight. The aboriginal region was Manhattan for Cornell. He let himself drift through the streets and avenues, pulled here and there by the hope that the Gotham Book Mart or a second-hand bookshop on Fourth Avenue might present him with a treasurable volume—a cache of maps, illustrations, or simply yellowed pages soaked in the aura of a foreign language. Or a dime store might offer up an irresistible knick-knack, a thimble or an old-fashioned toy. Sometimes Cornell would be led along by the looks of a young girl. Noticing where she stopped to eat, he might stop there, too, and eat what she did. There was a certain cafeteria in Times Square where actresses could be sighted,[7] and of course movie stars could be captured at will, simply by going to a theater.

In the summer of 1941, Cornell noted Marlene Dietrich's performance in *Destry Rides Again.* Nearly three years later he saw her in person: "...in polo coat and black beanie cap on back of hair waiting at curb of Jay Thorpe's for a taxi. First time I'd seen her off screen and [it] brought an unexpectedly elated feeling."[8] No newspaper or fan-magazine image of Dietrich reawakened that feeling, evidently, for none appears in any of Cornell's works. However, photos of Lauren Bacall (pls. X, 111), Hedy Lamarr (page 73), and many, many others do. Starlets (Sheree North [pl. 166], Patty Duke [pl. 238]) shone as brightly for Cornell as full-magnitude stars, perhaps because he read their newness as an emblem of innocence.

All movie actresses are precious for the variety of ways in which they mani-

fest themselves—in person, on the screen, in stills and publicity shots. Though some of these incarnations are infinitely reproducible, each is wreathed in the specific, forever memorable aura of the circumstances in which it first appeared. Thus movie-actress images are especially lush with meaning. They are volatile. They can be linked to just about any other image. A diary scrap from July 15, 1941, reads: "Nat. History museum to trace Indian designs. Hayden Planetarium. (Yesterday I was trying to fit Hedy Lamarr into Dante-Gabriel Rossetti's Pre-Raphaelite garden without success. She was more at one today with the night sky of the Planetarium. I wish she could have done the lecturing, with her wonderful detachment)."[9] There is a link between "Hedy" and "Hayden," between the actress's star status and the constellations projected into the Planetarium sky. More importantly, that cloudless, artificial night draws Lamarr's "wonderful detachment," her unsullied femininity, into those enchanted distances. And Cornell is drawn along in her wake.

Sometimes the trip from Utopia Parkway to Manhattan produced nothing. On July 8, 1947, Cornell recorded a visit to the New York Public Library: "research upstairs but no yield."[10] Other times image-treasures arrived in a flood, creating "impressions intriguingly diverse—that, in order to hold fast, one might assemble, assort, and arrange into a cabinet—the contraption kind of the amusement resorts with endless ingenuity of effect, worked by coin and plunger, or brightly colored pin-balls—traveling inclined runways—starting in motion compartment after compartment with a symphony of mechanical magic of sight and sound borrowed from the motion picture art—into childhood—into fantasy—through the streets of New York—through tropical skies—etc.—into the receiving trays the balls come to rest releasing prizes"—from Cornell's introduction to his show at the Hugo Gallery in 1946.[11]

This passage points to the Penny Arcade Portrait of Lauren Bacall (1945–46) (pl. X) and the Medici series (pls. XI-XIII, 117–21), and in the pointing these boxes are enchanted, transformed into

cities like mechanical gadgets which dispense image-treasures far more reliably than Manhattan ever did. Yet it too is susceptible to enchantment, as Cornell noted in a diary entry from April 5, 1962. At dusk, neon signs and lighted shop windows look to him like a "'penny arcade' symbolizing the whole of the city in its nocturnal illumination—sense of awe and splendor—its over-whelming poetic 'richesse' available for not even a penny—the appealing side of it despite violence in darkness."[12] When Thoreau feared the wilderness, he sought signs that it would be redeemed by the workings of American destiny. Cornell's search was more desperate because the threat to his redemption was so well-suppressed, so unreachably ambiguous.

"Violence in darkness" sounds at first like physical danger on the fringes of Times Square, as if he were always aware that the penny arcade might turn against him or itself—as in *Habitat Group for a Shooting Gallery* (1943) (pl. XXIII). But the phrase may refer as well to Cornell's sense of inward darkness, of a taint that left him susceptible to the most dubious allure of the urban wilderness. With his need to see women as wingéd creatures—ballerinas, sylphs, and stars lofted eternally beyond the claims of sex—Cornell felt more solitary in Manhattan than Thoreau ever felt in the woods around Walden Pond. Only rarely did the city look like a penny arcade. Back in his workshop, very few boxes turned out to be as satisfying as the Medici series. His diaries often took the tone of this passage from July 9, 1959: "Yesterday at home all day—difficult morning but worked through mechanically with a couple of boxes…" Then, "SUN BOX DK blue stain—*brought to life*—pulling out pr. of wine glasses—knocking one—better feelings gradually…"[13]

Shying away from the emotional perplexities that made his mornings difficult and filled his sleep with the anxious, unfocused dreams he so often reported, Cornell would weave his spells in a thick mist of yearning. All he—or any of us—would know with certainty is that he felt compelled to improve his image machines. So he kept working,

Fig. 7 Joseph Cornell: *Surrealist Box.* 1951. Construction, 7⅛ x 10¼ x 2½ in. The Art Institute of Chicago, Gift of Frank B. Hubachek

Fig. 8 Rudolph Burckhardt: *Ads.* 1940. Photograph. Collection the photographer

even when work was reduced to mechanical drudgery. The prizes he brought back from his trips, the redemptive trinkets that drew him into the wilderness and guided him back out again, had to be joined in chains of association reaching farther and farther toward the lost purity and wholeness, the ineffable "beauty," he desired.

Vast leaps from image to image are sometimes made within a single work. The mirrored door of Untitled (Paul and Virginia) (c. 1946–48) (pls. IX, 108) opens to show a lining of pages from an English translation of Bernardin de Saint-Pierre's *Paul et Virginie* (1788). Overlapping blocks of type frame an engraving of the two utterly innocent lovers. Above them and to their sides are scenes from their tumultuous, eventually ruined lives. Paul and Virginia are Cornell's most powerful emblems of pure love doomed. Within the cabinet, a pane of glass opens onto a bird's nest holding a pair of eggs. These echo the pair of lovers, though it is difficult to say how. At the least, Cornell suggests that a possibility of innocent birth survives the deaths of Paul and Virginia. At most, their spirits are being incubated and will someday hatch forth. An equivalence between human and other, perhaps better, orders of life is suggested, and not only by the bird's nest set against an image of a bright summer sky. In the uppermost compartment of the cabinet, a pair of fish swims—Paul and Virginia reunited beneath the waves which drowned her? Cornell's chains of correspondence reach far indeed. He implies the ultimate unity of all innocent life, all sheltering nests and habitats; thus there is no end to the speculations inspired by the small boxes stacked above and beside the bird's nest. Stained sky blue, they all may be inhabited by populations of wingéd, finny, floating spirits.

Each of Cornell's works is joined by its image-chains to other works. Thus the eggs in Paul and Virginia's nest *have* hatched, in a sense, to produce the Aviaries. Innocence persists, sometimes ambivalently. In Untitled (Hotel Neptune) (c. 1953–55) (pl. 147), a cockatoo perches near a label from that establishment. Neptune is the god who sent the sea monster to devour Andromeda. Is the bird similarly threatened? Or, given the cockatoo's use elsewhere as an emblem of Juan Gris (pls. XXIV, 144), is he male and thus an emblem of Neptune as well? Perhaps the bird is the monster sent by the god. Cornell poses these riddles not because they have an answer but because they don't. The imagination is led to a realm where the cockatoo takes on the scale of Andromeda. There, in a night sky made whole by revery, all chance of violence or hints of Andromeda's opposite, Circe, are banished. Not forever, but for as long as the revery lasts. When it fades, new enchantments are required.

Each depends on a series of mirrorings, not coldly accurate—as when one confronts oneself directly in a looking glass—but angled, tangential, centrifugal. Still, for all their elusiveness, these mirrorings are mechanical in spirit, which allows Cornell to adjust them with excruciating delicacy. In the *Inferno*, Dante damned Paolo and Francesca to float forever in the second ring of Hell. Cornell's image of these illicit lovers (1942) (pl. 109) shows them reading the story of Lancelot and Guinevere. This is the Arthurian example that led them to perdition, yet Cornell uses the book as a charm to immobilize them in their prelapsarian state. Nestled quietly within a pair of arches, they are oblique mirror images of the innocent Paul and Virginia. Or it might be better to say that they are shadows of the other lovers, vague emblems, and granted a redemptive innocence of their own by that very vagueness.

All the emblematic images Cornell assembles in his art are shadows, numinous fragments, of an unattainable wholeness. When Ondine, the water nymph, lived in her original home, she was at one with herself and her native element. Then, drawn by love into the air and the light of ordinary day, she saw her shadow for the first time. She fell, like Eve, into knowledge. In Cornell's universe, this is knowledge of life's fragmentary nature, of the need for the spirit to subsist on tangential mirrorings. To look into a Medici Slot

Machine is to be rewarded with one's reflection in the form of an alert young face—a shadow of innocence lost. Yet, like Ondine drifting through the air and light that finally bring her close to death, Cornell must face these shadows. With their oblique linkages, they provide his only hope of a redeeming world elsewhere, a realm where shadow and substance are rejoined. That hope can fade. On February 27, 1945, he wrote: "…A 'link'—the 'reassurance' and 'continuity' of a thread so tenuous, so hard at times to keep hold of (or perhaps to communicate to others is what I mean)."[14]

Sometimes the very joining seems as important to Cornell as the words and images he joins. In 1944, he edited an issue of the *Dance Index*, dedicating it in part to Fanny Cerrito, the nineteenth-century ballerina whose most popular role was that of Ondine (fig. 9). Among his other commentaries is this "Typographical note. Cerito, Cerrito, Ceritto, Cerritto, Cherito,—same person."[15] Cornell was excited to learn that Fanny Cerrito was the great-great grandmother of the French movie star, Jean-Paul Belmondo.[16] In 1969, he noted down the names of seven alumni of Phillips Andover Academy, all of them members of the American art world, all featured in a show at the Academy. He is third on the list (class of 1922), preceded by John McLaughlin ('19) and followed by Cleve Gray ('36).[17] Besides the obvious biographical interest this list must have had for Cornell, it gave general satisfaction to his obsessive desire for series. His star maps focus on Andromeda and her parents, Cassiopeia and Cepheus. Other constellations appear in his art because they are contiguous to this family, and one of them—Cauda Draconis, the Dragon's Tail—is an emblem of contiguity itself (pls. 209, 213). And so are the metal chains suspended from the crossbars of the Aviaries.

★

Yet linkage is not a self-sufficient good. It must always loft femininity into the sphere of the ineffable. Every white column in a Cornell box, like every arched opening, evokes the domed temples of that seventeenth-century, swan-infested Arcadia perfected by Nicolas Poussin and Claude. It is an imaginary world where geometric order is balanced against nature, or, in the wilder Arcadia of Salvator Rosa, geometry is overwhelmed by fast-running rivers, tempests, and crumbling faces of rock. In all its variants, this is a pictorial world, a region of emblems elegantly disposed. One can easily imagine the floor plans of its temples and just as easily see them echoed by the charts of the solar system, even the lunar maps, Cornell often pastes to the backs of his boxes. Moonlight and swans, grottoes and urns, chateaux and nicely placed bits of foliage are all part of the image-chain which leads from seventeenth-century Arcadia to Cornell's art and back to the nymphaeum —the nymph's shrine in the form of a fountain.

Cornell's Sand Fountains (pls. 193–96) are, among other things, emblems of the nymph's departure, as are detached butterfly wings—allusions to the dewinged sylph played by Marie Taglioni, a rival of Fanny Cerrito and perhaps Cornell's second-favorite nineteenth-century ballerina. Deserted perches (pl. 215) evoke the loss of the nymph, as well. Cornell cherishes such losses, for they promise reunion elsewhere. On April 3, 1963, he noted down this definition: "Nympholepsy—a species of demoniac enthusiasm or possession supposed to seize one who had accidentally looked upon a nymph; ecstasy; a frenzy of emotion, as for some unattainable ideal."[18]

Cornell's errands into Manhattan were for the purpose of encouraging such accidents, or "signs," as he sometimes called them.[19] When the sign takes the form of an object, it is brought back to the workshop, perhaps to be joined with others in a progression of shadowy mirrorings toward "some unattainable ideal." But many could never be put to this redemptive use. At his death, Cornell left his house stuffed with unused material. And, in any case, the best signs are events—"unfoldment, expression, *life* vs. aesthetics."[20]

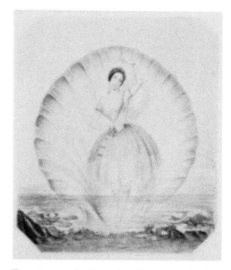

Fig. 9 Joseph Cornell: *Portrait of Ondine*, photocopy mounted on paperboard, from *Portrait of Ondine*, pl. 93

On the day before Christmas 1962, Cornell recorded a visit he had made to Bloomingdale's department store the previous January. Titled "The Fairy Garden: Tentation," this diary note concerns "a forgotten fragment of possibly the most significant day of the year." Wandering about the store, Cornell happened across some "half-dressed display models evoking a tumultuous turn of erotic emotion practically uncontrollable—then through a grace of spirit this tourbillon resolved into a wave of the ineffable."[21] These presences were painted plaster, and yet, in light of his emblematic vision, might as well have been living flesh. Thanks to "a grace of spirit," his nympholepsy lofted him beyond images of forbidden sexual experience to the more bearable unattainability of "the ineffable."

That is the goal toward which all his linked emblems drift, though sometimes he cannot follow them. The ineffable is most convincing when felt in "connection with life as opposed to the confining, aesthetic feeling of limitation experienced too often when working on the boxes." Or a project goes well and Cornell feels an "intense longing to get into the box—this overflowing, a richness and poetry felt when working with the boxes but which has often been completely extraneous to the final product."[22] The task of producing art is enlivening, sometimes, but even then the result can go dead. At those moments, Cornell must shave and get dressed for a trip to Manhattan, a process which in itself inspires "The feeling of creating that often only seems to come when leaving home...."[23] His first task, after all, is to explore the wilderness in search of those emblems—those "gleams of a better light,"[24] as Ralph Waldo Emerson calls them—which lead directly to the ineffable, not by way of aesthetics but on the currents and tides of life.

This saving light is elusive—"a little star-dust caught, a segment of a rainbow I have clutched," in Thoreau's words.[25] Yet there are moments when signs mesh and salvation becomes believable. Like Cornell seeing the city as a penny arcade in 1962, Thoreau in 1858 saw a November dusk as "part of a panorama...a piece of art...infinitely sweet and grand."[26] At these moments, his imagination is the compass and "the landscape radiate[s] from me accordingly."[27] The universe feels whole and he, with his singular fate, is at the center of it. In *Walden*, he says: "Every man has to learn the points of the compass again as often as he awakes, whether from sleep or any abstraction. Not till we are lost, in other words, not till we have lost the world, do we begin to find ourselves, and realize where we are and the infinite extent of our relations."[28]

Free, as he sometimes was, from nightmarish sleep and the trances his friends report, Cornell, too, could awaken fully to his world. Then his boxes are not the dead residues of long, mechanical tasks but enchanted machines, vehicles for transporting the spirit. At such times, which occur most often in the presence of another's sensitive response:

Shadow boxes become poetic theatres or settings wherein are metamorphosed the elements of a childhood pastime [blowing soap bubbles]. The fragile, shimmering globules become the shimmering but more enduring planets—a connotation of moon and tides—the association of water less subtle, as when driftwood pieces make up a proscenium to set off the dazzling white of seafoam and billowy cloud crystallized in a pipe of fancy.[29]

Soap bubbles equal planets equal their orbits equal the entire curving dome of the sky, the universe. Every cork ball, sun face, doll's head, metal ring, circle-disk, and sky chart is brought into the equation (pl. I). Like one of his favorite emblems, the watch spring, Cornell's chains of meaning spiral endlessly from the ecstatic center of his imagination. His art recapitulates Thoreau, who said "the universe is a sphere whose center is wherever there is intelligence. The sun is not so central as a man."[30] Cornell sympathized, too, with Emily Dickinson's comment: "My business is Circumference."[31]

Early in the 1950s, Cornell made a box called *Toward the "Blue Peninsula"*—for Emily Dickinson (pl. XXVII). The word "peninsula" is from the poet's own writings, where it evokes conscious-

ness flaring out from the mainland of that self-contained being she hid away in her family's house in Amherst, Massachusetts.[32] In Cornell's revery, to go "beyond the blue peninsula" may be to arrive at the center of Emily Dickinson's spirit. It was a destination that utterly enchanted him. A constant consumer of candies, cookies, and other sweets, Cornell was familiar with Chocolat Menier. Learning that Dickinson had once written a poem on a wrapper saved from a bar of the same brand of chocolate, he took it as a sign of spiritual affinity. Untitled (Chocolat Menier) (pl. 139) is a box from 1952, and the brand's logo appears there and in many other boxes.

The very slightness of this link seems to have made it precious to Cornell. The world where he wished to live, the spirits he wanted to meet, were so far from ordinary life that he was forced to cultivate obliqueness. His discourse with shadows required common values to be endlessly overturned. Anything outmoded, ephemeral, or simply childish was potentially redemptive in Cornell's eyes. He was always browsing for magical signs, even when eating candy—or mustard. On March 28, 1950, he made this note: "Holding the jagged jar to one's ear as one hears music from a sea shell—tactility of the moutarde Dijon' like a piece in a cubist painting...Week later coming across Dijon mentioned many times in the *Gaspard de la Nuit* section of the book of poems by that name by Aloysius Bertrand. Mallarmé. Caravaggio."[33] In October of that year, Cornell writes that "the box *Moutarde de Dijon* finally in a satisfactory state of completion after countless discarding, rearrangements, etc...." To tinker with a box unsuccessfully is the workshop equivalent of going to the city on the lookout for signs and finding none or only blurry, unconvincing ones. Then, "Suddenly the sense of completeness, poetry....The Gothic feeling seen as a renewal—the exhilaration felt in referring to the Aloysius Bertrand *Gaspard de la Nuit*..."[34]

This "Gothic feeling" is owed, perhaps, to Bertrand's evocations of the Middle Ages. If so, Cornell has linked Gothic cathedrals to Dijon mustard by way of a French Romantic poet. And Bertrand offers another link—his poem "Ondine," which Cornell knew and cherished for its reminder of Fanny Cerrito. Ondine tried to live in the air and love an ordinary mortal, just as Emily Dickinson sent "peninsulas" of thought and feeling out into the larger world. Of course, the naiad could only survive under water. Ondine in her native element is like Emily Dickinson in the darkness beyond the parlor, listening to a family friend play the piano, commenting on the music but never letting herself be seen.

In a note of April 8, 1953, Cornell says: "Unexpected *Canary Box* from two unfinished ones extending Emily Dickinson preoccupation with promise of progress and unfoldment."[35] Two lifeless sets of emblems had suddenly meshed. A pair of confusions is condensed into a single clarity of feeling, and the Dickinson–Chocolat Menier link is obliquely mirrored by a link between the caged songbird of the *Canary Box* and the solitary poet who so often writes of birds and once called her body a "magic Prison."[36] Presumably Cornell felt that both the prison and its inhabitant, Dickinson's spirit, would thrive better on sweets than on birdseed.

Birds lead to butterflies, which lead in any number of directions—to the demure Marie Taglioni, wearing the butterfly wings of *La Sylphide* (pl. 89); to Fanny Cerrito, reviving underwater in the role of Ondine (pl. 92); and to other images of rebirth—the Pleiades, for instance, changed from seven sisters into stars to avoid the love-struck hunter, Orion. He became a constellation, too, and now pursues the Pleiades across the sky forever. Orion, either his name or his starry image (pls. 212, 218), appears in many of Cornell's boxes of the 1950s. Andromeda sometimes joins him, a shadow-substitute for the Pleiades, perhaps.[37] Frozen in orbit, this heavenly couple recalls Paolo and Francesca, Dante's sinful lovers, damned to float forever in the second ring of Hell. Images of Hell summon up Eden—especially the Hotel Eden, whose name is pasted to the back wall of several boxes (pl. XXII). Thus Adam and

Eve are called upon, not to appear but to serve as shadowy mirrorings of other couples.

One of these is Goethe's Werther and Marie, whom Cornell celebrates in his *Sorrows of Young Werther* of 1966 (pl. 261). Another is Thomas De Quincey and the Magdalenlike Ann, of De Quincey's "Ann of Oxford Street," one of Cornell's favorite stories.[38] Of course every couple is an emblem of Cornell and Emily Dickinson together, and Pierrot stands for the artist alone. He appears Watteau-style, thus called Gille, in 1939 (pl. 64). Minus Columbine, he hangs like a puppet in front of diamond-patterned curtains, a reminder of Harlequin's motley outfit. The latter shows up in other boxes, also bereft of Columbine. Cornell seems not to have approved of the commedia dell'arte's basic triangle. Naturally the Circe of *Cassiopeia* (1966) (pl. 265), is shown without Ulysses. Nor, so far as I know, do the heroine and hero of Chateaubriand's Atala and René appear in any of Cornell's works, though he owned a copy of these novels of pure love between noble savages.

With his tendency to shy away from Biblical figures, Cornell grants Paul and Virginia, not Adam and Eve, first place among his emblematic couples. Virginia in the tropic sea, so far beyond the reef that Paul can only stand on the shore and watch her drown, recalls Ondine, and Andromeda (pl. XIV), too, as she waits on her rock for the sea monster sent by a displeased Neptune. In the night sky, it is Orion who threatens Andromeda, so the hunter takes the cockatoo's place as a shadowy mirror image of the sea god. Orion and Neptune appear over and over in the Hotel boxes of the 1950s, filling those empty, moon-white spaces with an atmosphere of threat. Yet one need not be satisfied with atmospherics. The image-chain can be grasped firmly at this point, for Emily Dickinson wrote several poems in which she plays the part of Andromeda swallowed by the monster, an emblem of the sea itself. Wherever one enters the flow of Cornell's images, one can always return to that same point—as in tracing the analemma, a figure-eight form which plots

the sun's path through the sky for an entire year. It is the image of ordinary time and of infinity. Cornell includes it in several works (pl. 202, 204), though his patterns of meaning are mirrored as well by the grids and radiating lines of his maps and charts and city plans.

Cornell finds Emily Dickinson an especially important emblem, for she is an emblem-seeker herself. According to her Puritan heritage, each individual's destiny is singular, determined at the birth of time, and knowable only on Judgment Day. Thus one's eternal fate is hidden in this life. All one can do is search for providential signs of it. Though Dickinson adhered to no orthodox variety of New England Protestantism, she did look deep into questions of destiny and sometimes felt she glimpsed answers. "Emblem is immeasurable," she wrote.[39] To grasp it in full provides what she calls "identity" with all being, an ecstatic moment of sheer existence during which the notion of "One bird, one cage, one flight, one song in those far woods"[40] is not confining. Just the opposite. It expands her image of "Circumference" to the scale of William Wordsworth's radical Protestantism, his High Romantic faith in that apocalypse of the self when the imagination finds an absolute autonomy, creates a fate apart from nature, and then (this is the Dickinsonian moment) joins its creative energies with all of natural creation.

The individual can never be sure this unity has been achieved. Signs may hint that it has. Or, precipitating the despair so often celebrated by Samuel Taylor Coleridge, signs may point toward the utter isolation of the self. One's fate remains in doubt, yet the Romantic-Protestant imagination sometimes arrives at an ecstatic alertness to its own potential. Feeling surrounded by reflections of his creative self, Wordsworth can turn an entire landscape into an emblem of the emblematic faculty—as in the last book of *The Prelude* (1805-6).

A meditation rose in me that night
Upon the lonely mountain when the scene
Had pass'd away, and it appear'd to me
The perfect image of a mighty mind,

Of one that feeds upon infinity,
That is exalted by an underpresence,
The sense of God, or whatso'er is dim
Or vast in its own being…"[41]

In the final version of *The Prelude* (1850), "image" is exchanged for "emblem," as if to insist on that vast poem's debt to Protestant readings of Scripture.

Thoreau's Transcendentalism takes much from Wordsworth, Coleridge, and other English Romantics, including their fundamentally Calvinist search for providential emblems fit to serve as the images of art. When the search goes well, Thoreau feels "the infinite extent of [his] relations" with all things. Yet there is much he would like to shunt aside — evil, for instance. In *Walden*, he says:

I rejoice that there are owls. Let them do the idiotic and maniacal hooting for men. It is a sound admirably suited to swamps and twilight woods which no day illustrates, suggesting a vast and undeveloped nature which men have not recognized. They represent the stark twilight and unsatisfied thought we all have.[42]

This shrinking of his compass, of his "Circumference," sometimes embeds Thoreau too deeply in familiar corners of his woods and psyche. He was conscious of the danger. "I fear chiefly lest my expression may not be *extra-vagant* enough, may not wander far enough beyond the narrow limits of my daily experience, so as to be adequate to the truth of which I have experienced."[43] Cornell wandered within even narrower limits, and his fragmentary signs are emblems of a magical realm far removed from the natural world with which Wordsworth, Dickinson, and Thoreau grappled, often so desperately. Cornell's owl boxes (pls. 162–65) turn that bird into a standard reminder of spookiness, and yet there is an owl perched near the Circe in *Cassiopeia* (pl. 265). Despite his Christian Scientist optimism, Cornell never cut his Dutch Calvinist roots. He acknowledged evil, nature fallen according to the Puritan plan, and like Thoreau, another secret Puritan, he wanted to encapsulate its threat in a familiar symbol.

Yet the persistence of owls and their mirror-shadows is strong in Cornell's art. Some of his boxes generate emotions as intense and unsettling as those felt by Wordsworth in his "spots of time," those carefully delimited regions of childhood where much of *The Prelude*'s meaning originates.[44] Wordsworth's "spots" of remembered landscape are just as fragmentary, just as emblematic, as a Cornell box. Yet they are very different. Like all the images in Wordsworth's major poems, these lead the singular self toward an imaginative contact with all of existence. Cornell's image-chains spiral into vastness, but they never bring him face to face with the world or even himself. Instead, they encourage an escape from individuality and its singular fate. The boxes are vehicles of revery which lead out of this world to the enchanted Other, innocent femininity. And they lead beyond, past Cornell's Puritan doubts about female innocence, to the realm of the ineffable. Once that destination is reached, the torments of the self are banished.

When Thoreau's sense of self falters, he links it to a prophetic vision of the American future. Singular destiny becomes an emblem of national destiny, the push overland to "the eternal city of the west, the phantom city in whose streets no traveler has ever trod, over whose pavements the horses of the sun have already hurried, some Salamanca of the imagination."[45] His Eden is in the wilderness yet to be cleared of its forests and owls, thus "westward is the prevailing tendency of my countrymen. I must walk toward Oregon, not toward Europe."[46] Cornell shunned any reminder of America's western expansion, and his diminutive art is a prim denial of those self-consciously American aggrandizements that produced the New York School sublime.

As he wanders through the streets of Manhattan, a labyrinth on the easternmost edge of the continent, he spies out signs of European culture — high or low, world-famous or obscure (figs. 10, 11), doesn't matter so long as the image radiates some delicacy, some shadow of perfection, unavailable in the ordinary run of American life. And if a toy or greeting card made in U.S.A. has a touch of that redemptive sweetness, Cornell

Fig. 10 William Hogarth: *A Country Dance,* plate 2 from *The Analysis of Beauty.* 1753. Engraving. The New York Public Library, Astor, Lenox and Tilden Foundations

Fig. 11 Johann Zoffany: *The Tribuna of the Uffizi.* 1772–78. Oil, 48⅜ x 61 in. Windsor Castle, Royal Collection, Reproduced by Gracious Permission of Her Majesty the Queen, Elizabeth II

accepts it just as readily as a reproduction of a painting from the Uffizi. It was Cornell, after all, who brought Giorgione and Hedy Lamarr together in *The Enchanted Wanderer* (page 73),[47] a collage so carefully constructed one hardly notices its seams.

In his *Ode* to Lincoln, the Transcendentalist James Russell Lowell puts the matter bluntly: "Nothing of Europe here."[48] Cornell's art is crammed full of Europe, yet his Europe is not the place rejected so thoroughly by Lowell, Thoreau, and Emerson, and once again by the founders of the postwar New York School. Europe, for Cornell, is not a continent one might visit or not (in fact, he never went there), but an imaginary zone whose presiding spirits sometimes send him hints of that peace and innocence from which, as a secret Puritan, he feared himself excluded. So Cornell is never more American than when he browses ritually on Fourth Avenue, alert to any sign—the name of the Hotel Taglioni, a shadow of the sylphide's wings—any hint at all that he is not damned to wander eternally like Coleridge's Ancient Mariner, that one day he will be admitted to his peculiar place among the Calvinist elect.

★

Cornell's Americanness has been hard to see because he first took up an artist's role in the company of the Surrealists, those quintessentially European agitators for the modernist apocalypse. Max Ernst's collage novel, *La Femme 100 têtes,* triggered Cornell's imagination, or so it has been assumed. Yet Cornell may always have scanned old books and the urban clutter for patterns of signs, portents of a singular destiny. If so, then Ernst's example was itself a sign—proof that images juxtaposed in the imagination could be juxtaposed in plain sight, and an audience would take notice.

Cornell's chains of linked images are best followed in a state of revery. The Surrealists weren't interested in such gentle proceedings. They preferred the disjunctions of dream, by which they appear to have meant everything from

genuine nightmare to a carefully culti-vated romance with the absurd. In the first issue of *La Révolution surréaliste* (December 1924), J.-A. Boiffard, Paul Eluard, and Roger Vitrac dismiss knowl-edge and intelligence on the grounds that "the dream alone entrusts to man all his right to freedom. Thanks to the dream, the meaning of death is no longer mysterious, and the meaning of life becomes unimportant."[49] Surrealist dreams are to be generated by violently innovative methods of image-making— "certain forms of association heretofore neglected," as André Breton says in his *First Surrealist Manifesto* (1924). The use of these methods, he claims, will lead "to the permanent destruction of all other forms of psychic mechanisms."[50] Memory will be one of the first targets. Breton "hates memory and the com-bustion it maintains in precisely those places where I wish to see nothing."[51] Robert Desnos wonders if "after all, I have any memories. I have perceived eternity. What good is cataloguing material facts when dream is as mate-rial as action, or as immaterial?"[52]

Cornell is drawn to "material facts"—objects and images—whose preciousness is ratified by memory, and he often calls on popular memory to reinforce his own. His image-chains often run along lines of well-worn cliché—butterfly, swan, ballerina; song-bird, poetess, Circelike enchantress. The Surrealist apocalypse was intended to raze cliché, which Breton and the rest saw not only in habitual styles of twentieth-century bourgeois thought, but in philosophy's and religion's long-pursued discussions of such topics as life and death. Come the revolution predicted by Boiffard, Eluard, and Vitrac in 1924, death's mystery would be extinct. Life might well persist, but it would no longer have the import of a long, tortuous journey to Judgment Day.

That is precisely how life feels to Cornell, the unconscious Calvinist. Thus death remains the ultimate mystery, the unmentionable presence in whose chambers the secret of the artist's predestiny will be told. His art prom-ises no freedom, not on the Surrealist model or any other. Instead, it attempts to conjure from ambivalent signs some hope that the fate promised him at the origin of time is not a horrible one. Beneath his Christian Science opti-mism, he fears that it is horrible beyond imagining. Though he tries to read his nympholepsy as a sign of a yearning for the crystalline ineffable, he suspects it signals a sulphurously evil obsession with mundane sexuality. Terrified by the chance that he is one of the damned, he cultivates reveries of inno-cence and even childishness. In one of his diary notes, "Babylon" is converted to "Babyland" (pl. 286).[53]

Childhood for him, if not for Blake or Freud, is an asexual time. To go backward in life is to take a redemptive pilgrimage. To retrace history from America to Europe, from worldly Man-hattan to the France which produced Paul and Virginia, is to do the same. This reverses the judgment of Thoreau and his fellow Transcendentalists. Looking at the New World through Puritan eyes, they saw the New Eden. Cornell makes his Eden from a romance with the Old World (fig. 12). And of course his determination to see innocence every-where flies gently in the face of the Surrealist desire to cultivate sexual extremes, both in imagery and in prac-tice, as a means to their apocalyptic dream.

Calvinist doctrine is harsh because it permits one to glean providential signs of redemption yet it supplies no means of judging their worth. Hence the search for such signs—whether in seventeenth-century Massachusetts, in the America of Manifest Destiny, or in Cornell's art—inevitably grows frantic. No matter how many emblems of pure American childhood or spotless Euro-pean beauty Cornell can garner, there are never enough. So his works prolifer-ate, obsessively, and their sheer amount provides another seeming resemblance to Surrealism, with its outpouring of images. Cornell's anxiety fastens on the chance that Andromeda is, after all, Circe; that his search for ineffable beauty is, at its heart, a voyeuristic lust. Delicacy, dreaminess, feyness, even coyness have to be sent like an army of sylphs to defeat these possibilities. By the late 1940s, it was widely recognized

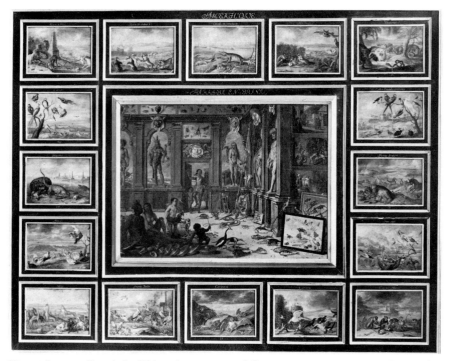

Fig. 12 Jan van Kessel the Elder: *America.* 1666. Oil on copper, 19⅛ x 26⅜ in. Bayerische Staatsgemäldesammlungen, Munich

in the New York art world that Cornell's tone and intent were not very close to the Surrealists', some of whom had let their apocalyptic fervor turn cynical or simply commercial. Yet Cornell continued to hold the Surrealists in awe. They were, after all, European, envoys from a realm of enchanted beauty who had deigned to appear in Manhattan for a time.

So far as I know, Cornell only once acknowledged the events that drove Breton and company to New York— with *Habitat Group for a Shooting Gallery* (1943) (pl. XXIII). Cornell's reaction to World War II was as oblique as Emily Dickinson's to the Civil War. There is, though, his *Isabelle/Dien Bien Phu* of 1954 (pl. 142)—one of his very rare violent works. Perhaps he was willing to take note of this Indochinese debacle because it was inflicted on the French, just as Virginia's watery death is suffered by Bernardin's symbol of a France uncorrupted by Enlightenment cynics.

Breton's official definition of Surrealism demands more of the revolutionary practioner than anyone, even he, could perform. So the boundaries of the word were inevitably smudged. Nowadays, anything even slightly bizarre or dreamy is liable to be called surrealist. One sees this usage starting up in the

early attempts to group Cornell with Ernst and the rest. Cornell objected to this indiscriminate use of the label and so did others, among them some British poets who banded together in the late 1940s under the banner of The New Apocalypse. They had tired of the old, Surrealist one, which placed so much stress on the automatist revelations of the unconscious mind—that is, on the violent dream-strategy promulgated by Boiffard, Eluard, and Vitrac in 1924. Like Cornell, the poets of The New Apocalypse wanted to draw images of a magical nature from ordinary experience and well-tried tradition. And they especially resemble their American counterpart in feeling the allure of fairy tales. Henry Treece, a leading member of the group, begins his poem "Horror" (1942) this way:

Like the fey goose-girl in the enchanted wood
Whose cloth-of-gold hair curtained her swart sin
So that the feckless linnets stricken by her lute
For homage's sake forgot the bodkin bright,
And so lay waxen in among the moss
About her feet.

The poem goes on to an image of an "old traveler" suddenly faced with an enchanted sign of his own death[54]

55

John Bayliss, one of Treece's colleagues in anti-Surrealism, guides his "Seven Dreams" (1942) to another intimation of death, complete with peacocks "admiring themselves in swan's blood."[55] Bayliss published "Seven Dreams" in *View*, a magazine to which Cornell contributed collages on occasion. This establishes no direct link between him and these British poets, yet it does suggest that the Surrealist revolution, whatever else it failed to do, did give twentieth-century artists and writers permission to set loose a torrent of bats and birds, moths and butterflies, enchanted towers and luminous, mysteriously magnetic princesses, to say nothing of entranced princes to follow them down byways of gloomy verdure to courtyards strewn with every manner of emblem, sign, and portent. Cornell, like the poets of The New Apocalypse, added to this flood.

John Ashbery, who himself has had occasion to fight off the Surrealist label, sweetly mocks this persistent iconography of enchantment.

The grass cuts our feet as we wend our way
Across the meadow—you, a child of thirteen
In a man's business suit far too big for you
A symbol of how long we have been together.
. .
I want you to examine this solid block of darkness
In which we are imprisoned. But you say, No,
You are tired. You turn over and sleep.
And I sleep, but in my sleep I hear horses carrying you away.[56]

Ashbery's poem contains plenty of the "magic" that Surrealism inadvertently set adrift in twentieth-century art and literature. Later on, the couple wakes up, "having fallen in the night/ From a high cliff into the white, precious sky." This mirror-shadow of Cornell's (and Dante's) Paolo and Francesca, endlessly drifting in each other's arms, is striking but not necessarily intended.

What Ashbery mocks with his slightly astringent tone is the familiarity of all our princes and princesses and all the enchanted forests where they wander. This iconography is so resilient it can survive even a nicely pointed attack, as Ashbery demonstrates with "the man's business suit far too big." This intrusion does not break the spell. Of course, the poet doesn't really want to break it. Nor do we. The baggage of fairy land and Arcadia is a collection of long-familiar spells and décor. Sent ahead from the late eighteenth-century to the present, by way of the Pre-Raphaelite Brotherhood, the Symbolists, and the Aesthetes of the fin-de-siecle, it is as rich as it is clichéd. Serving as the foundation of Cornell's art, it is what Ashbery celebrates in his poem, "The Young Prince and the Young Princess," and again in his remarks on the artist's work.

In 1967, when The Solomon R. Guggenheim Museum in New York, showed a large group of boxes and collages, Ashbery suggested Cornell's importance to younger contemporaries—chiefly, Robert Rauschenberg. This seems accurate. Rauschenberg remakes Cornell's emblematic clutter at a larger, action-painter's scale. Breezy and brash, Rauschenberg's tone is different from the elder artist's, but his enchanted response to Manhattan's image bank is comparable. Ashbery goes on to a comparison which looks, at first glance, like an enthusiast's mistake. He sees a link between Cornell's spare white gridded boxes of the 1940s and the geometric sculpture that Sol LeWitt, Donald Judd, and Robert Morris were showing in the mid-'60s. If this is wrong, it is because their works are intended to be seen as demystified *things*, while even the most severely Euclidean box by Cornell looks like an inhabited *place*—though its only resident may be the shade of a departed spirit. Yet, as Ashbery saw very clearly, Minimalist sculpture is laden with magic import, for the theory which guides it is a mode of magical thinking. Each stark Minimalist form is an icon of a purity that was—and still is—believable to contemporary audiences at least in part because Cornell's art has sustained the ideal of the pure and the innocent with such compellingly familiar images. His swans and white hotel rooms, his night skies haunted by unravished Andromedas—Cornell's

entire repertoire, in fact—have the power to plunge artists and art lovers into a trance from which very few of us, even the toughest-talking Minimalists, want to awake. Ashbery ends his remarks on Cornell's 1967 show at the Guggenheim by saying: "We all live in his enchanted forest."[57]

Cornell liked this article, naturally, as much as he liked one published the year before in *Art and Literature*, a magazine Ashbery edited. Titled simply "Joseph Cornell," it is by Fairfield Porter, an artist whose paintings are no less Francophilic in their way than any of Cornell's numerous Hotel boxes. Porter evokes the lived-in feel of the space behind Cornell's glass walls: "His favorite colors suggest provincial European hotels: white, parchesi yellow, pink and French blue-gray." Much in Cornell's own style, Porter extends this hint of travel to the comment that each box

is ship-shape even where it is worn, like the many coats of paint that never quite succeed in protecting the iron from the corrosive effects of salt and spray. The reminiscence of a ship cabin brings the suggestion that the room is on a journey. The view out the window is the stars...[58]

Like Ashbery, Porter is careful to leave unbroken the spell which drew him to Cornell's art in the first place. Thus Bronzino is mentioned because Cornell appropriated some of his images. The Surrealists are brought on stage for a moment, so that Cornell's superiority can be implied. But the risk of mentioning contemporary artists is not taken. Porter prefers to compare Cornell to a poet, Gérard de Nerval—rather, he applies the remarks of a Nerval critic, Albert Béguin, to Cornell. It is claimed on behalf of French sonnets and American assemblages alike that "their mystery is of such a unique quality that their emotional power possesses the [spectator] without his wishing to translate their secret into less secret language."[59] This is the height of critical tact, which Dore Ashton reaches, too, with her comment that "Central to Cornell's *oeuvre* is the idea of repetition. His repetition is not the intellectualized notion of serialization, but

more like the ritual repetition of the alchemist."[60]

Or perhaps they are the rituals of a disturbed mind. Ashton glides past this possibility to "the sudden flight of a wild swan in [Nerval's] *Sylvie*," which reminds her of Cornell's *Deserted Perch* (1949).[61] She mentions the artist's hope, expressed in a statement about *Untitled (Hotel de l' Etoile)* (1951–52) (pl. 127), that he has achieved a Nervalian "dream overflowing into life."[62] And she cites Cornell's favorite passage in Nerval's *Aurélia*, where the faces of three adored women seem to flicker in dim light, face, then reappear transformed into one another.[63]

When dream does overflow into life, à la Nerval, it may well demand the layering and linking that join Cornell's emblems in extended, crisscrossing chains—a network of associations. A Surrealist would try to destroy this binding pattern in an apocalyptic leap beyond time to eternity. Cornell is desperate to sustain the network by spinning it out to the far reaches of the historical past and the astronomical future. This staves off Judgment Day, for the very repetitiveness of his art insinuates time into the ultimate status of death—to repeat is to deny change without denying life. The compulsive commandeers death's stillness in the hope that it will make life everlasting. Minute variations of his ritual come to stand for all the richness of a fully lived life, especially since the ritual's contents are determined by the anxieties which drive him to loathe death in the first place.

These anxieties tend to be sexual. Among all the familiar linkages reinforced by Cornell's art, the one which joins sex and death in an eternal embrace (Paolo and Francesca–style) is by far the strongest—and of course the most unconsciously employed. Ashbery, Porter, and Ashton choose to join Cornell in his unconsciousness. The artist they see is very like the artist as seen by himself; thus there is no Thoreau, much less any seventeenth-century forebear, in their Cornell. Ashton brings Edgar Allan Poe into the picture, but only fleetingly—not long enough to suggest that his guilt-

ridden, death-haunted lust for the nubile holds a demonic mirror up to Cornell's sweet-tempered nympholepsy.

★

Ritual is mechanical, so any ritualizing aesthetic must have the power to mechanize the artist's meanings. Poe's mechanisms are his "effects," whose compulsively precise workings are regulated by the theory of the picturesque.[64] As defined by Joseph Addison, Uvedale Price, John Ruskin, and their large, restless crowd of colleagues, the picturesque is first of all a mode of perception. Its theorists presuppose a Lockean mind which draws its structures from the world by way of the senses. To keep this mechanically conceived organ alive requires a constant play of stimuli. As Addison points out, we "find our thoughts a little agitated and relieved at the sight of such objects as are ever in motion and sliding away from beneath the eye of the beholder."[65]

Thought, guided by feeling, learns to join these perceptions in associative chains. Peculiar to each individual, these linkages endow the world with meaning. A properly active mind is drawn to the poems, paintings, and, best of all, landscapes where, to quote Uvedale Price, "the varied effects of light and shadow are promoted by the variety and intricacy of the objects" to be seen there.[66] Picturesque effects don't work unless they lead quickly from one to the next. It is the *pattern* of effects which sustains meaning, so the mind's first concern is to keep its pattern-making mechanisms, its powers of association, in good running order.

A cultivated sensibility is restless. Smoothness suggests repose, according to Price, and has its charms, but roughness is sometimes preferable. It conveys the idea "of irritation, but at the same time of animation, spirit and variety."[67] All this variousness leads sooner or later to architectural ruins—triumphs of rough texture and monuments of intricacy, thanks to the patterns of events, of history, they suggest. And a crumbling building can be seen as an emblem of the mind's own history as it searches out effects, perceptual events

Fig. 13 Pierre Fourdrinier: *Tuscum*, plate from Robert Castell's *The Villas of the Ancients Illustrated*. London, 1728. Engraving. The New York Public Library, Astor, Lenox, and Tilden Foundations

Fig. 14 Hubert Robert: *Ruins of the Grand Gallery of the Louvre.* c. 1796. Oil, 13¾ x 15¾ in. Musée du Louvre, Paris

Fig. 15 Charles Bird King: *The Vanity of the Artist's Dream.* 1830. Oil, 36 x 30 in. Fogg Art Museum, Harvard University, Cambridge, Gift of Grenville L. Winthrop

rich enough to sustain its patterns of meaning and stave off the personal equivalent of cracked masonry and fallen pillars—as in the case of Poe's Roderick Usher, whose looks mirror the morbid state of his mind and his ancestral house. This leap in scale from the personal to the architectural is effortless, in Price's theory: "The picturesque has no connection with dimension of any kind, and is often found in the smallest as in the largest objects."[68] Poe demonstrates this endlessly. In his demonic picturesque, talismans of the minutest sort guide his characters across landscapes that stretch out to an infinite, infinitely horrid sublime—regions that are as likely to exist in the mind as underfoot. Though Cornell's art is gentler, it plays just as energetically with scale. His leaps from the miniature to the vast and back again draw their power from fragmentary emblems just as mechanical in their effects, hence just as picturesque, as any offered up by Poe. Both are historians of the mind's travels through the ruins, partial or complete, of its early innocence.

When history is emblematic, the course of ruin can be put in reverse. If not innocence, then at least republican virtue can be retrieved, as in Robert Castell's *The Villas of the Ancients Illustrated* (1728). His imaginary plan of Pliny the Younger's villa at Tuscum (fig. 13) is as laden with variety as the most crowded of Cornell's boxes (pl. 118). Castell surrounds the main buildings with gardens in three manners—artless, geometrical, and artfully irregular.[69] The overall effect of unity is fragile. Castell's delicate adjustments of style to style seem about to disintegrate into the ruin of an attempt to rescue a ruin. Whether Gothic, as in Mrs. Radcliffe's novels, or cheerfully learned, as in Castell's *Villas of the Ancients,* the picturesque must always work against the decay of meaning threatened by the very distinctness of the effects upon which its meanings depend.

Ultimately, the mode is enchanted by fragmentariness itself, which serves as an emblem of wholenesses to be found in other times and other places. Cornell is obsessed with fragments that evoke an absent perfection, a loved one

flown (pl. 90). Yet the reminder of her flight generates an aura of loss which is as perfect in its own way as reunion would be.

★

Yearning for wholeness, the picturesque grows more agitated amid the early-modern period's numerous complementary agitations—social, economic, technological. Yet ruins come to rest. As new ones threaten, those brought to completion grow a covering of greenery, and this effect of calm is also picturesque. The panic of loss gives way to nostalgia, nowhere more powerfully than in the paintings of Hubert Robert (fig. 14). He shows classical, Renaissance, and even recent Baroque order toppled. More than that, he evokes the ruin of the Arcadia which the Baroque spirit devised from Hellenicized temples, Roman-style urns, nymph-haunted pools, and moonlit swans. Robert builds his style from an elegaic vision of Poussin's unities, and Claude's, fallen to pieces. Self-contained and emblematic, these bits of standardized idealism were available for widespread exploitation throughout popular culture. Cornell doesn't draw any of his picturesque directly from Robert. However, he does appropriate a great deal from the painter and his numerous followers by way of nineteenth-century stage design and book illustration. Fanny Cerrito performed amid the ruin of Robert's ruins.

Still life brings the dignity of architecture to the content of domestic interiors. Like Arcadian harmony, still life's order is subject to ruin—especially in seventeenth-century, Northern treatments of *Vanitas.* Even there, however, compositional poise of a premodern sort remains amid cobwebs and tarnish. Then, toward the beginning of the nineteenth century, Charles Bird King and others began to subject the genre to more thorough ruin. His *Poor Artist's Cupboard* (circa 1815) and his *Vanity of the Artist's Dream* (1830) (fig. 15) show scraps of classical imagery, studio paraphernalia, and even food heaped up in picturesque disarray. Cornell's boxes offer their contents at King's intimate scale and at Robert's

grand one, simultaneously (pl. 94). When Cornell feels the clutter becoming too oppressive, he sweeps it into those compartmented formats which draw on the orderliness of Victorian cabinetry (fig. 23) and the museological devices of natural historians—see *L'Egypte de Mlle Cléo de Mérode* (1940) (pl. V), his Museums (pls. 72–74), his Pharmacies (pls. 75–78), and all the works which tuck images into drawers and vials and grids. Cornell's Habitats (e.g., pl. 165) are often composed of a single space, yet they too evoke the picturesque of the natural history museum. Like the Hotel boxes, they are fragmentary emblems of worlds entire—and of course entirely lost.

Cornell manages to work steadily, even serenely, amid the ruins of his ideal worlds. Thus he resembles Hubert Robert, who built a new calm from the loss of the old. When Cornell is depressed, he is sometimes able to convert his mood into a highly-focused panic. In this, he resembles Giovanni Battista Piranesi, who treasured the instabilities that plagued him and the Rome of his era, a city overrun by Northerners desperate for antiquity. Piranesi is a connoisseur of fragments, which he finds everywhere (figs. 16, 17). Retrieved from the classical past, they are emblems of unities so far distant they can hardly be imagined. Even his most accurate archaeological rendering is charged with an early-modern sense of exile from fully lived history. Piranesi's is the picturesque of spiritual homelessness. Nor does art furnish a resting place. The standardized methods of the beaux-arts schools provide him with bits of pictorial cliché which he spins into the phantasmagorical distances of the *Carceri*. Art is infinite, but never whole. As in Cornell's play with the effects of perspective and scale, Piranesi extends his images endlessly to demonstrate their inexhaustible power to imprison him, to block his path to spiritual wholeness.

Piranesi was phenomenally influential, especially among artists associated with the French Academy in Rome. Many of his patrons were British, enchanted by the Mediterranean flavor he gave the picturesque. In its local forms, this aesthetic dominated British ideas of art in the late eighteenth century. The Romantics—Samuel Taylor Coleridge and William Wordsworth, most consciously—rejected mechanistic models of the mind and perception, but this hardly affected the power of the picturesque. In fact, John Ruskin, the leading proponent of J. M. W. Turner and other Romantic artists, did much to sustain the mode. He was at pains to moralize it, though, for he believed that an alertness to effects tends to isolate the mind in aesthetic detachment. Ruskin presents this panorama of standard décor in *Modern Painters*: "Fallen cottage—deserted village—blasted heath—mouldering castle…" He then goes on to suggest how the adept might find in this chain of images "a sad excitement, such as other people feel at a tragedy."[70] If the picturesque is theatrical (and, indeed, it has ruled stage design for nearly two centuries), then let it attain the Shakespearean heights of drama.

As the picturesque guides the early-modern eye, the mode itself feels the need of guidance. It is always on the lookout for some large concern to prevent it from disintegrating into bits of thought, feeling, and perception. However real that risk might have been, sophisticated intelligences were willing to take it, for the picturesque promises a form of liberty. In a diary note from March 25, 1804, the Englishman Joseph Farington describes a dinner given by Sir George Beaumont, Turner's patron. Coleridge was there, waxing metaphysical, and so was George Dance, architect John Soane's teacher, who spoke to a practical point. Now that architecture had mastered its own history, it was "unshackled."[71] Its styles formed a vast repertoire from which effects could be generated at will.

Soane preferred for nearly a decade to refine a single style, the English neo-Palladian. The result was a narrow range of clarified forms which, as he says in one of his Royal Academy lectures, create their effects with geometrical rigor.[72] Simple means, properly disposed, generate a rich play of oppositions whose intensity Soane stepped up with the complementary play of light bounced off mirrors and

Fig. 16 Giovanni Battista Piranesi: *Essais de différentes frises*, plate 18 from *Opere varie di architettura…degli Antichi Romani*. 1750. Etching with engraving. The New York Public Library, Astor, Lenox, and Tilden Foundations

Fig. 17 Giovanni Battista Piranesi: *Carcere d'Invenzione*, plate 2 from *Opere*. Etching. The New York Public Library, Astor, Lenox, and Tilden Foundations

Fig. 18 Etienne-Louis Boullée: *Project for a Cenotaph to Sir Isaac Newton*; above, *Interior Day Effect*; below, *Interior Night Effect*. 1784. Pen and ink, each c. 15½ x 25½ in. Bibliothèque Nationale, Paris

Fig. 19 John Martin: *Satan Presiding at the Infernal Council*, plate from Milton's *Paradise Lost*. London, 1827. Mezzotint. The New York Public Library, Astor, Lenox, and Tilden Foundations

passing through stained glass. Since, as Price says, the picturesque is not confined to any range of size, it can appear at any scale. This is particularly clear in Soane's geometricized picturesque, and clearer still in the visionary architecture of Etienne-Louis Boullée. His cenotaph for Isaac Newton (fig. 18), designed toward the end of the 1700s, raises the play of circle and square to the scale of a planetarium—or, perhaps, the sky.

Scale floats absolutely free, as it does in John Martin's painting of *Satan Presiding at the Infernal Council* (1824) (fig. 19). In this scene drawn from Milton's *Paradise Lost*, Boullée's geometry has been peopled, with the odd effect of miniaturizing it. And in Martin's *Belshazzar's Feast* (1821), a painting of the Biblical scene where the handwriting appeared on the wall, immense geometrical vistas are compressed with a startling effect that recalls certain Cornellian vistas—as Martin's Satanic dome, like Boullée's Newtonian one, suggest those horizontal boxes of Cornell's which show a moon or star map pasted to the back wall (pls. 79, 80). The clarity of the geometric picturesque is not, it seems, incompatible with emblematic clutter.

Soane saw this, apparently. In 1813, he suddenly accepted the eclectic picturesque that had been earlier proposed by George Dance. For the next quarter-century, Soane transformed two neighboring London townhouses into a museum of architectural styles. With each room done up in a different manner and crammed with artifacts of all periods and provenances, the Sir John Soane's Museum (fig. 20) is like a Cornell box on a monumental scale. Piranesi's oeuvre turns all of Mediterranean culture, its history and innumerable fragments, into a Cornellian fantasy. All three of these collectors fill their art with so many charged bits of so many conflicting sizes, scales, and sorts that infinity is evoked. Eternity remains elusive. Soane's Museum, Piranesi's twenty-two volumes of engravings, Cornell's boxes crowded into that larger box, the house in Queens, are all attempts to equate vastness with permanence. If time's end—that is,

death—can be fended off, then it will always be possible to launch nostalgia on a backward spiral that leads to the times before our fall into modernity, those charmed regions of the past where all images were whole, styles were instinctive and experience arrived spontaneously, not linked in a series of self-consciously cultivated effects.

★

Nothing places the picturesque more securely at the outset of the mechanical age than all the tinkering it requires. Cornell is able to sustain his workshop grind only with the hope that his fragments will, sooner or later, fall into place. Effects will mesh like the very gears of beauty, and he will be conveyed into a realm of the imagination where that machinery is hidden away from view. The picturesque is at its most convincing when its effects extinguish the self-consciousness which produces them. Where Romanticism strives for the spectacle of vision actively permeating all that it sees, the picturesque induces passivity.

In Goethe's *The Sorrows of Young Werther* (1774), one of Cornell's favorite tales of love pure and doomed, the poet has his hero make a drawing in the mode of the rural picturesque. It includes two peasant boys, "the nearest fence, a barn door, and a few broken cartwheels."

[I] realized, after an hour, that I had made a well-composed and very interesting sketch, without having added the slightest invention of my own. This confirmed me in my resolution to keep close to Nature in the future. Nature alone is illimitably rich, and Nature alone forms the great artist.[73]

Instead of operating the image machine, Werther lets the machine—visible Nature—operate him, much as a scientist might let natural law lead him to his version of the truth.

In a passage from Nerval's *Aurélia*, which Dore Ashton includes in her *Album* among "Cornell's Recommended Readings," the narrator sees "heavenly figures" in the hills and clouds. "I wanted to fix my favorite thoughts more clearly, and with some charcoal and a few bits of brick that I collected

I had soon covered the walls with a set of frescoes recording my impressions."[74] Nerval's hero (himself, just barely disguised) accepts the dictates of his madness, just as Werther accepted Nature's. For Thomas De Quincey, Nature is his unconscious. Cornell included a passage from De Quincey's "English Mail Coach" (1849) in his *Portrait of Ondine* (1940s–50s) (pl. 93), partly because the writer's heroine is named Fanny, and thus linked to Fanny Cerrito-Ondine, and partly because the vision in which she appears elaborates itself into "one towering armorial shield, a vast emblazonry of human charities and human loveliness that have perished, but quartered heraldically, with unutterable and demonic natures...."[75]

This dream of emblems, each one in its own compartment, suggests Cornell's Pharmacy (1943) (pl. VI) and other well-stocked grid boxes. And an earlier version of this passage from De Quincy epitomizes the attitude required by the picturesque. He says: "the Dream knows best; and the Dream, I say again, is the responsible party.... [It] is a law to itself; and as well quarrel with a rainbow for *not* showing a secondary arch."[76] The Dream is interior, yet it is a force of Nature. De Quincey must wait for it to appear, rainbowlike and encouraged by opium, just as Cornell waits for the city to light up like a penny arcade and deliver him an image-prize. As the artist drudges, mechanically, to build an arcade of his own in his workshop, a comparable illumination occurs—or it doesn't, and Cornell has one of his frequently recorded bad days. In any case, tinker as he might, he remains a mechanic—though of course a mechanic of the ineffable.

Sometimes, as Cornell ruefully waits for a new book to move him, he seems to have taken up the stance of the Romantic poet who conceives of his imagination as "an instrument over which a series of external and internal impressions are driven, like the alternations of an ever-changing wind over an Aeolian lyre, which move it by their motion to an ever-changing melody"—as Percy Bysshe Shelley puts it in his "Defense of Poetry." Here the poet

Fig. 20 George Bailey: *Sir John Soane's Museum, London: The Dome, Showing Marbles and Casts as Arranged in 1810.* Watercolor, 37⅞ x 24⅝ in. Sir John Soane's Museum, London

seems as passive before Nature in 1821 as the young Goethe's Werther was in 1774. Yet this is not the case. Shelley claims that his lyre-imagination has an active, creative power. It produces "not melody alone, but harmony,"[77] and that harmony is the sign that the Romantic artist has extricated himself from the gears and connecting rods of the picturesque. He stands in an organic not a mechanical relation to the world, thanks to the forming powers of his imagination.

In Book XII of *The Prelude* (1850), Wordsworth describes his struggle to free himself from the rule of "the bodily eye...The most despotic of our senses"[78] — in other words, from that eighteenth-century aesthetic locked in

...a comparison of scene with scene,
Bent overmuch on superficial things,
Pampering myself with meagre novelties
Of color and proportion...[79]

Of course, the picturesque does not find such novelties meager. It finds in them the beginning and the end of experience — the more novelty, within certain import-laden patterns, the better. So the adept of the picturesque cultivates the despotism of "the bodily eye." Even when Price and his colleagues talk of music, they use visual imagery. Life is a waiting for visible emblems to trigger significant effects.

In his search for the most powerfully "emblematical" images of the mysteries that haunt him, Edgar Allan Poe permits himself to be led by "the commonest objects of the universe" in "a circle of analogies." The "survey of a rapidly growing vine" carries him on to "a moth, a butterfly, a chrysalis, a stream of running water."[80] When Poe's grottoes and gardens, his tarns and haunted palaces, are added to the "circle of analogies" that tie each of his obsessive plots to the next, the results are close to an inventory of the picturesque. He turns the mode demonic by turning its mechanisms to an excruciating ambivalence — each of his effects veils and intensifies his erotic horror of death. And that is how Cornell's effects work, though he keeps the most infernal of their image-gears well hidden. Nonetheless, Poe's ravening Puritanism

lures Cornell's closer to the light. That is why the writer must be kept at the edges of a tactful picture of the artist, just as Thoreau must be kept out of it altogether. Both of these sin-haunted forebears imply too much about the purpose of Cornell's enchantments. And there is another figure who is kept off stage — Marcel Duchamp, for the light shed by his art grounds Cornell's ineffabilities in the modern era's techniques of mass production.

★

Boxes are common in Dada and Surrealism. Duchamp is crucial to Cornell because he is the first of the Parisians to make effective use of glass. For Duchamp, glass is the substance of irony, the means by which detachment can be symbolized and effected all at once. Cornell learned from this how to make voyeurism — the despotism of "the bodily eye" — presentable. Even more crucially, he learned from Duchamp how to give aesthetic weight to mechanically replicated images.

In 1935, Duchamp began to produce the *Box in a Valise* (fig. 21). Three hundred of them were planned, each to contain a set of the artist's major works in reproduction — *The Large Glass, Nine Malic Molds,* and others, including the readymade, *Fountain*. Cornell borrowed Duchamp's format for an Ondine portfolio, which he wanted to produce in a very large edition. If the project had gone ahead, each box would have contained reproductions of the images in *Portrait of Ondine* (pl. 93), which Cornell had shown at The Museum of Modern Art in 1945–46. The purpose of this portrait of the ballerina-nymph is not, according to a note by Cornell, "definition. Rather does it actuate the potentialities of a type of image-search akin to poetics."[81]

Along with numerous pictures of Fanny Cerrito as Ondine, and the passage from De Quincey's "English Mail Coach," there is a photostat of an eighteenth-century print of Naples, the dancer's native city. A portion of this image is doubled in an enlargement. Redoubled, it is enlarged again. This effect is familiar from art books.

Here, the pointing to details has the same didactic feel, though no clear point of instruction is made. Instead, the eye is rendered sensitive to the aura of reproducibility. The magnified texture of this quite ordinary print becomes precious not in itself but as a sign of meaning's power to put mechanical forces to work in ensuring its own persistence.

An eighteenth-century engraving, produced in who knows how many copies, has become a photostat. The photostat has been duplicated, manipulated, and—in Cornell's hopes, at least—it was to be mass-produced, perhaps in the form of an offset lithograph. Revery will never lack for guiding emblems, the Ondine portfolio suggests, so long as the mechanics of replication are themselves susceptible to enchantment. The photostats of Sofonisba Anguissola's boy (*Medici Slot Machine*, 1942 [pl. 117]), Bronzino's girl (*Medici Princess*, 1952 [pl. 118]), and of Cornell's favorite constellations—Auriga, Cassiopeia, Cepheus, Orion—are enlarged, reduced, fragmented, or tinted to fit into a variety of image-chains. Always, though, the image preserves its core of meaning, the stability of which is demonstrated by all this copying and variation. When Cornell reverses a photostatic image, he recalls his mirrors, those simplest duplicating machines of all. These are usually set at angles that lead the eye through the sides of a box, as if along an angled corridor in a ramshackle old hotel. Every image in Cornell's art is either the product of mass production or, like a mirror, capable of it. The boxes themselves are handmade, yet there are so many of them and the differences between them are often so slight that they seem the products of a cottage-scale assembly line set up at the outset of the Industrial Revolution.

The contents of Duchamp's *Box in a Valise* demystify the art object, at least for a moment. That moment may be ironically short, thanks to the hints of Duchamp's hermetic alchemy offered by *The Large Glass.* Nonetheless, the fact that each *Box* has been carefully replicated does much to free it of all that conceptually slippery sort of meaning called "ineffable." Yet the mechanically reproduced images of Cornell's Ondine portfolio begin to "actuate the potentialities" of enchantment the moment the lid is lifted. Why shouldn't they? Duplication is not only compatible with enchantment. As Cornell's entire oeuvre demonstrates, to duplicate an image endlessly is often to make its spell all the more binding.

If the differences between Cornell's readymades and Duchamp's are followed far enough, one arrives at an odd vantage point where Duchamp looks otherworldly in his ironic detachment and Cornell, entranced by the flow of mass-produced images, looks like an allegorical figure of The Individual Spirit Confronting the Machine Age. What Cornell confronts and masters is a historical process basic to the development of modern culture. It is a process in which a mechanical model of the mind meshes ever more efficiently with mechanical means of manufacturing goods—including images, of course. The result is the mass production of the picturesque.

There had been engravings of Roman ruins before Piranesi's. Engravings and other means of proliferating images had been available for centuries—woodcuts, for an especially important example. The iconography of Arcadia was long-established by the end of the eighteenth century, as were most of the formal devices that came to be known as picturesque. Mannerist theory of the late 1500s demands variety in art, while artists and theologians of all periods have given the world emblematic readings of one sort or another. As for fragmentation, it perennially threatens society and the mind. Yet all of this took on a new meaning in the light of that eighteenth-century restlessness induced by the advance of secular rationality.

Among the consequences of that advance were the Industrial Revolution, the era's several political revolutions, and a Rousseau-style determination to take the instabilities felt in every aspect of life as signs of man's ascent up the ladder of perfectibility. Less optimistic early moderns contented themselves with some version of Leibniz's remark: "This is the very law of enjoyment, that plea-

Fig. 21 Marcel Duchamp: *Box in a Valise.* 1935–41. Valise containing miniature replicas, photographs, and color reproductions of works by Duchamp. The Museum of Modern Art, New York, James Thrall Soby Fund

Fig. 22 John Haberle: *Torn in Transit.* c. 1890s. Oil, 13 x 17 in. Private collection

sure does not have an even tenor, for this begets loathing, and makes us dull, not happy."[82] Change itself came to serve as a virtue in Uvedale Price's picturesque, which in large part is a justification of all this restlessness. For modern minds, the very fragmentedness of our culture takes on an enchanting aura, as each bit of imagery or thought or feeling evokes a lost (and probably fictitious) wholeness. All this mechanistic emblem-reading, all this automated nostalgia, is only intensified when the emblems we read are produced by those mechanical means which turn even unified images—the *Mona Lisa*, say, or the *Apollo Belvedere*—into segments of potentially infinite series.

Modern culture is spellbound by the reproducible and by the tattered picturesque which best lends itself to reproduction. This enchantment is usually unconscious or an object of satire, as in Flaubert's *Bouvard et Pécuchet* (1881). Having failed at agriculture, this novel's two exemplars of machine-age doltishness "found in their library Boitard's work, entitled *The Garden Architect.* The author divides gardens into an infinite variety of types...the melancholy and romantic...the terrible sort...the solemn...the mysterious ...the meditational..." Each type draws appropriate emblems from the image-bank of the picturesque, which, as Flaubert implies, must itself be infinite. "Faced with this horizon of marvels Bouvard and Pécuchet felt quite dazzled"[83]—as do we all, though not quite so ingenuously as Flaubert's heroes. Most of us feel uneasy with our culture's entrancing emblems of wholeness. Would not wholeness itself be preferable?

By the end of the nineteenth century, the mechanical picturesque was so well established in America that the trompe-l'oeil artist John Haberle could satirize it in a canvas called *Torn in Transit* (fig. 22). This is a painting of a standardly pretty landscape painting. Its vista is seen through a grotto, whose picturesque opening is formed by the torn edges of wrapping paper. Haberle is so relentlessly deadpan it is hard to decipher his feelings toward his subjects or, for that matter, toward his

astonishing mimicry of mechanical replication. Just as modern industrial techniques render machine parts interchangable, so the mechanical picturesque can be adjusted to a variety of tempers—from Haberle's robot irony to Piranesi's frantic cosmopolitanism to Cornell's sweetness.

As Cornell exhorts himself to maintain that quality —"Do a better job," reads one of his notes to himself, "Keep working on elements"[84]—he grows desperate for a sign of success. It might come from the weather or the look of a girl at a counter, but it glows with the brightest aura if it has the providential impersonality of a replicated image. These come to him out of the restless dream of the urban wilderness, that endlessly disintegrating and magically replenished labyrinth of "elements"— his picturesque. By recreating that labyrinth in his own art, Cornell encourages providence to be more generous with its redemptive signs. Thanks to an absolute freedom of scale, the iconography of one region of his world can be displaced to the format of another— birds from a natural history diorama appear in a fragment of a haunted palace. A gridwork that suggests a rolltop desk or an architectural facade is occupied by emblems drawn from astronomy, the enchanted forest, the Romantic ballet, and so on and on, as textbooks, curatorial devices, painting in the nineteenth-century American sublime, jewelry caskets, stage design, presentation cases, fashion photography and more trade images and formats with one another. Every step of the way, Cornell lets himself be guided by the movies—the most picturesque medium of all, with its lighting effects, its sound effects, and, above all, its *special* effects.

Seen as a fragmentation of fragmentariness, Cornell's art looks like an inventory of modern culture's endlessly varied desire for wholeness. Cornell gives his art a narrower purpose—to evoke the absence of the nymph and of the more safely desired ineffable. Edgar Allan Poe adapts the picturesque to a gothic eroticism, which turns finally to a desire for guilt itself, and for the death guilt requires. Cornell deflects his guilt with images of innocence,

each glowing with the aura of a mechanized providence. Since innocence is best preserved at a distance from desire, Cornell learned to desire images of the loved one flown. Though his emptiest works are crowded with absence, his most crowded ones are emptied out by the knowledge that wholeness, purity, innocence is elsewhere.

Obeying the dictates of the mechanical picturesque, Cornell transformed his workshop into an enchanted assembly line. Turning out box after box, each a slight variation on one of a few basic models, Cornell shows something in common with Henry Ford. Yet he is too restless to fit that comparison for more than a moment. His endless tinkering, the sudden sparks of invention that illuminate his mechanical drudgery, remind me more of Thomas Edison. Like Edison's, Cornell's work seems to have been ninety-nine per cent perspiration, one per cent inspiration. Each came up with devices for shedding light, transmitting messages, and rendering memory permanent. They made light, messages, and memory more powerful, and gave us greater control over all three. Both were mechanics. One employed that most elusive mechanical force, electricity. The other channeled the currents of meaning that have pulsed for two centuries through the image-circuits of the mechanical picturesque. Edison's devices—especially the movie camera—gave some of those circuits physical form. Cornell isn't quite so down-to-earth. He is the Edison of the ineffable.

Fig. 23 Joseph Cornell: Untitled collage, 1930s, pl. 11

Fig. 24 Charles Tisch: Rosewood Cabinet. 1884. 93 x 61 x 18½ in. The Metropolitan Museum of Art, New York, Gift of Charles Tisch

NOTES

1. On March 28, 1968, Leslie John Schreyer, then an art student at Yale, wrote to ask Cornell which artists he had especially admired when he was young. In several drafts of a reply, Cornell says that he had no favorite artists as a youth, that none had ever influenced him significantly, and that his own art developed as a "natural and inborn response to beauty in a broad and general way." Courtesy Elizabeth Cornell Benton.

2. Joseph Cornell, "Comment," *Dance Index* (New York), vol. 6, no. 9 (Sept. 1947), p. 203.

3. Henry David Thoreau, *Journals*, V (1852–55), *The Writings of Henry David Thoreau* (1906; reprint, New York: AMS Press, 1968), p 135.

4. Thoreau, "A Walk to Wachusett" (1842), *Excursions, op. cit.,* p. 140.

5. Thoreau, *Walden* (1854), *op. cit.,* p. 81.

6. Thoreau, quoted by Sacvan Bercovitch in *The Puritan Origins of the American Self* (New Haven, Conn.: Yale University Press, 1975), p. 161.

7. According to Howard Hussey, one of Cornell's assistants, in conversation with Judith Cousins, April 8, 1980.

8. Joseph Cornell Papers, Archives of American Art, Smithsonian Institution, reel 1058, Summer 1941 and Spring 1944.

9. *Ibid.,* 1058, July 15, 1941.

10. *Ibid.,* 1059, July 8, 1947.

11. Joseph Cornell, brochure for exhibition "Portraits of Women: Constructions and Arrangements," Hugo Gallery, New York, Dec. 3, 1946; quoted by Diane Waldman in *Joseph Cornell* (New York: George Braziller, 1977), p. 23.

12. Cornell Papers, AAA, 1061, April 5, 1962.

13. *Ibid.,* 1060, July 9, 1959.

14. *Ibid.,* 1058, Feb. 27, 1945.

15. Joseph Cornell, "Typographical Note," *Dance Index* (New York), vol. 3, nos. 7–8 (July–Aug. 1944), p. 122.

16. Cornell Papers, AAA, 1061, Jan. 6, 1966.

17. *Ibid.,* 1058, May 23–July 6, 1969. The exhibition "7 Decades, Seven Alumni of Phillips Academy," Addison Gallery of American Art, Andover, Massachusetts, also included Waldo Pierce, Robert Jordan, Frank Stella and Gary Rieveschl. Cornell's class was 1921, contrary to this notation in his diary and the title page of the exhibition catalog.

18. *Ibid.*, 1061, April 3, 1963.

19. *Ibid.*, Easter Sunday, April 1962.

20. *Ibid.*, April 1962.

21. *Ibid.*, 1061, Dec. 24, 1962.

22. *Ibid.*, Oct. 14, 1956.

23. *Ibid.*, Feb. 20, 1945.

24. Ralph Waldo Emerson, "Nature" (1836), *Works of Emerson* (Boston and New York: Houghton, Mifflin and Company, 1903; reprint, New York, AMS Press, 1968), vol. 1, p. 72.

25. Thoreau, *Walden, op. cit.*, p. 217.

26. Thoreau, *Journals, XI, op. cit.*, p. 273.

27. Thoreau, *Walden, op. cit.*, p. 81.

28. *Ibid.*, p. 171.

29. Joseph Cornell, catalog of the exhibition "Objects by Joseph Cornell," Copley Galleries, Beverly Hills, Calif., Sept. 28, 1948; quoted by Dore Ashton in *A Joseph Cornell Album* (New York: Viking Press, 1947), p. 65.

30. Thoreau, *A Week on the Concord and Merrimack Rivers* (1849), *op. cit.*, p. 373.

31. Emily Dickinson, *The Letters of Emily Dickinson*, eds. Thomas H. Johnson and Theodora Ward (Cambridge, Mass.: Belknap Press of Harvard University Press, 1958), vol. 2, letter 268, to Thomas Wentworth Higginson, p. 412.

32. See especially poem no. 405 in *The Poems of Emily Dickinson*, ed. Thomas H. Johnson (Cambridge, Mass.: Belknap Press of Harvard University Press, 1958), vol. 1, p. 316.

33. Cornell Papers, AAA, 1059, March 28, 1950.

34. *Ibid.*, 1059, Oct. 14, 1950.

35. *Ibid.*, April 8, 1953.

36. Dickinson, *Poems*, vol. 3, poem no. 1601. p. 1102.

37. The box *Orion*, Waldman, *op. cit.*, no. 90.

38. See Ashton, *op. cit.*, pp. 196–202.

39. Dickinson quoted by Northrop Frye in "Emily Dickinson," *Fables of Identity: Studies in Poetic Mythology* (New York: Harcourt Brace Jovanovich, 1963), p. 209.

40. *Ibid.*, p. 208.

41. William Wordsworth, *The Prelude: A Parallel Text*, ed. J. C. Maxwell (Harmondsworth, Middlessex, England, New York, et. al: Penguin Books, 1972), Book XIII (1805–06), lines 66–73, pp.512, 514.

42. Thoreau, *Walden, op. cit.*, p. 125.

43. *Ibid.*, p. 324.

44. Wordsworth, *op. cit.*, Book XI (1805–06), line 258, p. 478; Book XII (1850), line 208, p. 479.

45. Thoreau, *Journals, II, op. cit.*, p. 296.

46. Thoreau, "Walking" (1851–62), *Excursions, op. cit.*, p. 218.

47. Illustration for the essay "The Enchanted Wanderer," *View* (New York), series 1, nos. 9–10 (Dec. 1941–Jan. 1942).

48. James Russell Lowell, "Ode Recited at the Harvard Commemoration, July 21, 1865," *The Complete Writings of James Russell Lowell* (Boston and New York: Houghton, Mifflin, 1904), vol 13, p. 24.

49. J.-A. Boiffard, Paul Eluard, and Roger Vitrac, "Editorial," *La Révolution surréaliste* (Paris), no. 1 (Dec. 1924), quoted in Patrick Waldberg's *Surrealism* (New York: McGraw-Hill, 1965), p. 47.

50. André Breton, *First Surrealist Manifesto* (1924); quoted in Waldberg, *op. cit.*, p. 72.

51. André Breton, "Lettre aux voyantes," *La Révolution surréaliste* (Paris), no. 5 (Oct. 15, 1925), p. 22.

52. Robert Desnos, "Confession d'un enfant du siècle, Part I," *La Révolution surréaliste* (Paris), no. 6 (March 1, 1926), p. 20.

53. Cornell Papers, AAA, 1058, undated.

54. Henry Treece, "Horror" (1942), *English and American Surrealist Poetry*, ed. Edward B. Germain (Harmondsworth, England, New York, et. al: Penguin Books, 1978), p. 166.

55. John Bayliss, "Seven Dreams" (1942), *ibid.*, pp. 171–72.

56. John Ashbery, "The Young Prince and the Young Princess" (1956), *Contemporary American Poetry*, ed. Donald Hall (Penguin Books, 1962), p. 150.

57. John Ashbery, "The Cube Root of Dreams," *Art News* (New York), vol. 66, no. 4 (Summer 1967), pp. 56–59, 63–64.

58. Fairfield Porter, "Joseph Cornell," *Art and Literature* (Lausanne), no. 8, (Spring 1966), pp. 120–30.

59. Béguin, *ibid.*, p. 121.

60. Ashton, *op. cit.*, p. 111.

61. *Ibid.*, p. 95.

62. *Ibid.*, p. 17.

63. *Ibid.*, p. 190.

64. See especially Edgar Allan Poe, "The Philosophy of Composition" (1846). *The Complete Works of Edgar Allan Poe* (New York, 1902), vol. 14, pp. 193–208 *passim.*

65. Joseph Addison, *The Spectator*, no. 412 (June 23, 1712).

66. Uvedale Price, *An Essay on the Picturesque ...* (1794), ed. Sir Thomas Dick Lauder (Edinburgh, 1842), p. 115.

67. *Ibid.*, p. 111.

68. *Ibid.*, p. 96.

69. Robert Castell, *The Villas of the Ancients Illustrated* (London, 1728), see plate following p. 126; see also *The Genius of the Place*, eds. John Dixon Hunt and Peter Willis (New York: Harper and Row, 1975), pp. 187–90.

70. John Ruskin, *Modern Painters* (London, 1843–60), vol. 4, part 5, ch. 1, para. 11.

71. Joseph Farington, *The Farington Diary* (1802–06), ed. James Greig (London, 1923), vol. 2, p. 209.

72. Sir John Soane, *Lectures on Architecture*, ed. Arthur T. Bolton (London: Publication of Sir John Soane's Museum, no. 14, 1929); see especially the comments on "Decoration" and "Composition," Lecture XI, pp. 171–77.

73. Johann Wolfgang von Goethe, *The Sorrows of Young Werther* (1774), trans. Elizabeth Mayer and Louise Bogan (New York: Vintage Book, Random House, 1973), p. 14.

74. Gérard de Nerval, "Aurélia," *Selected Writings of Gérard de Nerval*, trans., Geoffrey Wagner (New York: Grove Press, 1957); quoted by Ashton, *op. cit.*, p. 194.

75. Thomas De Quincey, "The English Mail Coach" (1849), from the passage quoted by Joseph Cornell in his *Portrait of Ondine*; see also *The Complete Works of Thomas De Quincey*, ed. David Masson (London, 1889–90), vol. 13, p. 289.

76. *Ibid.*, p. 292.

77. Percy Bysshe Shelley, "A Defense of Poetry" (1821), *Shelley's Prose, or The Trumpet of Prophesy*, ed. David Lee Clark (Albuquerque: University of New Mexico Press, 1954), p. 277.

78. William Wordsworth, *op. cit.*, Book XII (1850), lines 128–29, p. 475.

79. *Ibid.*, lines 115–18, p. 473.

80. Edgar Allan Poe, "Ligeia" (1840), *op. cit.*, vol 2, p. 252.

81. Joseph Cornell, *Portrait of Ondine*, note.

82. Gottfried Wilhelm von Leibniz, quoted by Arthur O. Lovejoy, *The Great Chain of Being: A Study of the History of an Idea* (New York: Harper Torchbooks, 1960), p. 249–50.

83. Gustave Flaubert, *Bouvard et Pécuchet* (1881), trans. A. J. Krailsheimer (Harmondsworth, England, New York, et al: Penguin Books, 1976), pp. 55–56.

84. From a note in an unfinished box, Estate of Joseph Cornell, Courtesy Castelli Feigen Corcoran.

Fig. 1 *Rose Hobart*, c. 1936. Prince of Marudu and Rose view the volcano

THE CINEMATIC GAZE OF JOSEPH CORNELL

P. Adams Sitney

"My films never really got off the ground," Joseph Cornell observed in 1968, summarizing more than three decades of occasional filmmaking. To assess and analyze his cinematic achievement is a naggingly difficult task. In the first place, one can scarcely take his almost regretful comment as definitive. He was ambivalent about his films, but once they began to find an enthusiastic audience—although they received no critical attention during his lifetime—he began to overcome his reluctance to exhibit them. He had sustained periods of enthusiasm about filmmaking, and even as late as 1965, he briefly contemplated giving up all of his collage- and construction-making to concentrate on cinema.

The cinema had been a crucial factor in the formation of his art. Films, like ballet, music, and poetry, were among the principal generative and sustaining occasions of his life. These were the arts that offered him almost sacred emblems for the weight of experience and its interpretation. Film had a privileged position among them, for although Cornell went passionately to the ballet, collected records, and read avidly, he was neither a choreographer, a composer, nor a poet. Yet he was a filmmaker, as well as a lover and collector of films.[1]

All of Cornell's work speaks of the aesthetic mediation of experience. To encounter anything in its fullness was to come into nearly tangible contact with its absolute absence, its unrecoverable pastness, its evanescence. Contemporary New York, which he loved with passion and with a rare attention to its uniquenesses and peculiarities, both fused with and refused to coincide with nineteenth-century Paris, which he knew through novels, memoirs, and poems without ever traveling to France. If we think of Cornell as a dreamer who walked the streets exploring shops and arcades, fantasizing that he was a *flâneur* out of the pages of Baudelaire and Gérard de Nerval, we lose more of him than we gain. In the resonant complexity of his art, the frailty, and even the absurdity, of such a fantasy declares itself. Yet the art, especially the shadow boxes, is so seductive that its magic too often blinds us to its ironic tensions. Cornell was not a nostalgist, a recluse, or a naïf, even though he knew how to play those three roles expertly and knew their defensive strength. He was a dialectician of experience. A serious consideration of his filmmaking will lead us toward a clarification of his aesthetic mediations.

★

Joseph Cornell made his way toward filmmaking hesitantly and guardedly. We have scripts he wrote and published, montages he made out of bits of films he had collected, and films he actually directed but did not photograph. There seems to be a historical progression in this approach. In 1936 The Museum of Modern Art published his artistic pro-

file in the catalog of "Fantastic Art, Dada, Surrealism":

American constructivist. Born in New York, 1904 [sic]. Self-taught. Author of two Surrealist scenarios. Lives in Flushing, Long Island?

The scenario "Monsieur Phot (Seen through the Stereoscope)" can be dated definitively as 1933,³ but what is the second Surrealist scenario? Howard Hussey has suggested that it is "Theatre of Hans Christian Andersen," which appeared in a special number of *Dance Index* (published in 1945) celebrating the story-writer as a balletomane.⁴ Two problems make this identification puzzling: why did he wait a decade to publish the scenario, and in what sense can it be called "Surrealist"? Research and reflection have brought me to the conclusion that Hussey is probably correct.

"Monsieur Phot" is the more fully developed of the two. It has four detailed scenes and an epilogue. One can readily see in it the influence of contemporary French avant-garde cinema. The oneiric condensations and displacements of the two films of Salvador Dali and Luis Buñuel, *Un Chien Andalou* (1929) and *L'Age d'or* (1930), echo through his intricate repetitions and transformations of the central images, which include a photographer and his apparatus, nine urchins, a harp player, a pianist, a basket of laundry, falling snow that blends with images of shattered glass and a fountain, and, finally, "a pheasant of gorgeous plumage." Cornell comes closest to the Spanish Surrealists in the second scene when he dryly portrays the photographer in the parlor of a Victorian hotel watching the approach of a maid: "As she nears him, she brandishes the duster (the feathers of which are identical in size and color to the pheasant) so vigorously around her white uniform that the amazing coincidence causes the photographer to jump to his feet, dropping the collection of pictures. The maid pays no attention to him and in a few minutes exits to the right, dusting as she goes."⁵ A tradition for this episode was provided not only by Dali and Buñuel but

also by Germaine Dulac, whose *La Coquille et le clergyman* (1928), which she made from Antonin Artaud's script, contains a parallel parade of maids with incongruous paraphernalia.

With Cornell we must consider his distance from Surrealism when we cite his continuities with that potent source. The violence of Dali, Buñuel, and Dulac has no place in his script, nor does their overwhelming eros. The photographer's reaction dramatizes the uncanny coincidence of the pheasant's plumage.

Cornell knew French literature well enough to have no illusions about the novelty of Surrealism. The serendipitous correspondences which Mallarmé describes in his prose poem "Le Démon d'analogie" define a poetic psychology. The "revolution" of Surrealism was largely its insistence that this psychology constitutes a fundamental epistemology. The Surrealists often achieved this shift of emphasis by removing the organizing sensibility of the poet as the poem's center of experience. The reader is thrust into the world of unreconcilable incongruities. Yet Cornell saw an advantage in preserving the poetic mediator, although he consistently stripped him of a biography that might render his emotions rational. Here that mediator is Monsieur Phot, a man very like a camera, yet so sensitive that he is regularly overwhelmed by events in the world outside him (the world before his camera), when those events behave as if they were superior manifestations of the mind.

The disjunctive "plot" of "Monsieur Phot" describes the inadequacy of static images to capture the complexity of an aesthetic epiphany. Just as the photographer, "Phot," is about to snap his composed picture in the opening scene, the extraordinary pheasant rushes into his view. Once he has captured his composition, he is unaccountably moved:

Close-up of the photographer emerging as in a trance from the black sheet. His eyes are moist and he is deeply moved. He remains frozen for awhile in an attitude of gentle ecstasy.⁶

The film finds no visual moment equal

Figs. 2–6 Five stereopticon images inserted by Cornell in manuscript of "Monsieur Phot," 1933

to the photographer's emotion. It can be translated only by music. Of the nine "urchins" he had photographed together, only one remains, playing a harp, unconscious of the photographer's tears. The music continues and repeats itself "until a more transcendently beautiful interpretation is scarcely imaginable,"[7] long after night has fallen and the screen turned almost black. Somehow, in this darkness, Cornell would have us see that snow is falling.

Within the film, the photographer's still images, which he sorts in the hotel parlor, constitute a "Surrealist" narrative, including the hyperbolical image of snow drifting to the hoofs of a monumental equestrian statue, "giving the effect of the horseman riding through the snow";[8] on his outstretched arm rests the broken harp. The gap between Phot's photographic narrative and the intrinsic power of the world to manifest the uncanny can be measured by the photographer's "nonplussed expression" and his "perspiration" when he sees the nonchalant maid and her feather duster.

The pheasant, which appears in every episode of the imaginary film, represents the superabundant plenitude that motivates and yet escapes art. Its every appearance would be in color in this otherwise black-and-white film. We must remember that "Monsieur Phot" was written before the release of Rouben Mamoulian's *Becky Sharp* (the first commercial film in color) in 1935. Cornell was an authority on cinema; he read technical histories as well as fan magazines. He knew that there had been experiments in color cinematography ever since the invention of the medium. He must have seen many hand-painted films from before the First World War, as well as works of the 1920s in various artificial coloring processes. But at the same time, in 1923 he must have been aware of the extravagance of proposing an avant-garde film to be made with four color sections. Of course, "Monsieur Phot" was written not to be made but to be imagined. Its extraordinary alternation of black and white and color indicates the superiority of imaginary cinema over products found in theaters. It points as well to the limita-

tions of the medium in a scenario about the affective power of experience to exceed its sensory stimuli.

The photographer cries because he has confronted the power of his own imagination. It is not the carefully composed images, but rather their ultimate relationship to each other that generates the narrative at which Cornell hints when he describes the sorting of the still shots. When in 1936 Julien Levy published "Monsieur Phot" for the first time in his book *Surrealism,* he printed only the text. There are five stereopticon images (figs. 2-6) which Cornell used in typed copies of the scenario.[9] They not only illustrate the five locations of the film, but they indicate Cornell's creative process, which is reflected in that of Phot himself. The first image shows nine men in Victorian dress standing at the base of an equestrian statue in what appears to be a European civic plaza. Obviously this image, like the other four, preceded the writing of the script. Just as obviously these pictures were the foundation, the static image-ground, upon which Cornell's imagination played. He metamorphosed the men into urchins. A harp and a basket of something covered with a white cloth also appear in the first image. Cornell seized upon these elements as the props for his repetitions and displacements.

In themselves the still images are merely quaint, but Cornell has read a film into them: heard music, introduced colors, and organized a temporal form for them. Yet he inserts them in the script in their naked emptiness; each is half of a stereoptic view, a single two-dimensional photograph. The quaintness of the photographs derives from the inevitable inscription of lost time on such images. The aim of Cornell's art is to animate those scenes without disguising their pastness and stillness. The presupposition of the animation is that nothing can occur there.

In the Epilogue of "Monsieur Phot," the photographer comically approaches the condition of a filmmaker. The action is to be "carried out as in a ballet."[10] With those words, Cornell dramatizes the difference between the illusion of natural movement in a conventional film

and the stylization of dance. The final stereoptic view (fig. 6), a receding stage backdrop, accompanies a description of "an old-fashioned stage setting seen through a portal." The sounds of an unseen orchestra transform the scene into a theatrical performance. Into this setting Monsieur Phot, on roller skates, wheels his still camera forward until it topples offscreen into the orchestra pit where its fall sets off the reverberation of bruised instruments. His quest for the animate has made him a figure of Surrealist slapstick.

Cornell's other published scenario, "Theatre of Hans Christian Andersen," is much more schematic than "Monsieur Phot." Its eleven episodes are printed on just two pages of *Dance Index.* The scenario is presented as a ballet. It contains, nevertheless, distinctive cinematic elements, just as "Monsieur Phot" contains a ballet. Before presenting his elliptical description of the scenes—ten of which represent Andersen stories and the eleventh, simply a "Tableau—finale of all the characters"—Cornell describes the blending of stage and cinema which would give this scenario its imaginary form:

Sometimes the footlights yield to the silver screen in animated cartoon, black and white or Technicolor, this latter tempered by the mellow charm of the colours of the magic lantern. Again, the stage is sometimes a coloured transparency of the stereoscope come to life. There is nothing old fashioned about the mounting of these effects—it is the original "handmade" charm of the Romantic theatre.[11]

"Monsieur Phot" was written in 1933, the year the first Disney cartoons appeared in Technicolor. Cornell's association of the trade name for color film with the idea of an animated cartoon reinforces the supposition that the Andersen scenario, although published in 1945, may have been written at the same time as "Monsieur Phot," or shortly after it. The process by which he created the second scenario is very similar to the first, although the cinematic details are fewer. In the Andersen issue of *Dance Index,* the scenario begins on page 155 with a two-paragraph introduction The eleven

episodes are printed on pages 158 and 159. In between, across the open spread of pages 156 and 157, are printed twelve images, which are to be viewed as a storyboard for the film (fig. 7). The images are mounted in identical frames, or theaters, resembling Andersen's original paper cutouts, reproduced throughout the issue of the magazine. In each frame or theater there is an illustration from the stories. Apparently Cornell has used actual illustrations from the stories without altering them. On the last page a final, isolated illustration appears.

Cornell specifically refers to the cinema in three of the eleven ballets: of the second, "Thumbelina," he writes: "Additional effects of cinema fantasy as the little heroine is pulled along the water on a leaf by a butterfly, the homeward flight of the swallow, etc."; the seventh, "The Wild Swans," has only the following description: "Cinema treatment. The countryside seen from above by Eliza"; finally, the ninth cites a specific cinematic style dear to Cornell: "The Court Cards: A pack of cards comes to life for a frolic reminiscent of the many charming things of this kind done in the earliest French trick and magic films, notably by Méliès."[12] In the extensive collection of films Cornell had assembled for his own amusement and that of his invalid brother Robert was *Hanky Panky Card Tricks,* an early French film, which he misattributed to Méliès—an error he made repeatedly. In it the royal cards come to life: the Jack performs acrobatics, the King and Queen dance.

"Theatre of Hans Christian Andersen" was published as a ballet. There is evidence, as I pointed out, that this ballet was also, or was largely, a film script. In fact, Cornell often associated dance with film, especially when his model for cinematic structure was the style of the French trick film in the first decade of this century. Among the films in his collection from this period were *Unusual Cooking,* in which giant knives and forks take on human arms and legs to dance together; *The Automatic Moving Company,* in which an entire apartment is stripped of its furniture, moved, and elaborately replaced in a

Fig. 7 Twelve images illustrating "Theatre of Hans Christian Andersen," printed in *Dance Index,* 1945

Fig. 8 Cornell's homage to Hedy Lamarr, printed in *View*, 1941–42

new house without human intervention, all through stop-motion photography, which can turn an inanimate object into a graceful ballerina; and *The Danaïf Sisters,* a film about a family of acrobats who spectacularly leapfrog over one another and form hilarious and complex shapes by linking their contorted bodies.

★

When Cornell, as editor of the Andersen issue of *Dance Index,* described in an introduction the characteristics shared by Andersen's tales and the Romantic ballet, he unwittingly cataloged the qualities he also admired in the French trick films of the formative period: "their release, their escape, their flight, their defiance of the limitations of the physical world: their amiability; the subtler sense of light and air...."[13] Furthermore, the distance between those early films and the masterpieces of Surrealism made almost thirty years later was not as decisive as film historians have tended to assume. In the draft of a letter to a French film historian, Claude Serbanne, dated March 26, 1946, he brings the two together: "I like certain parts of 'L'Age d'or' as I remember it I think as well as anything that I could ever see in Méliès."[14] Of Méliès's near contemporary, Zecca, he adds a further observation that enlarges our understanding of his interest in that aspect of cinema:

Still I think we owe him a debt for doing what MELIES seldom did,—working en plein air, leaving a record Atget-like of so many of the Parisian fin-de-siecle landmarks (the unpretentious ones like the boutique of a charcutier such as I have in my "The Man with the Calf's Head" which Dali liked so much and in which he [sic] a quality of Gérard de Nerval. And then again this type of work influenced René Clair in his early work.).[15]

Throughout the letter to Serbanne, despite its fragmentary, unfinished form, Cornell reveals his sensitivity and originality as a viewer of films. At one point, where the letter switches from English to French he extols Jennifer Jones in *Love Letters* (1945) with an encomium

that almost repeats his homage to Hedy Lamarr printed in *View* in 1941–42. Compare the two passages. Of Jones he wrote:

Son visage quelquefois est quelquechose de rare sur l'ecran d'aujourd'hui. Au premier il y a quelque passages ou elle doue les close-ups d'un eloquence à rappeler l'age heroique du silence. Ici des eclats fugitives de [undecipherable] lyrique de Falconetti, pourtant sans le profondeur. A moi-meme, au moins![16]

The homage to Lamarr, entitled "Enchanted Wanderer" (fig. 8), yields the following passage:

Among the barren wastes of the talking films there occasionally occur passages to remind one again of the profound and suggestive power of the silent film to evoke an ideal world of beauty, to release unsuspected floods of music from the gaze of a human countenance in its prison of silver light. But aside from evanescent fragments unexpectedly encountered, how often is there created a superb and magnificent imagery such as brought to life the portraits of Falconetti in "Joan of Arc," Lillian Gish in "Broken Blossoms," Sibirskaya in "Menilmontant," and Carola Nehrer in "Dreigroschenoper."

And so we are grateful to Hedy Lamarr, the enchanted wanderer, who again speaks the poetic and evocative language of the silent film, if only in whispers at times, beside the empty roar of the sound track....

Who has not observed in her magnified visage qualities of a gracious humility and spirituality that with circumstance of costume, scene, and plot conspire to identify her with realms of wonder, more absorbing than the artificial ones, and where we have already been invited by the gaze that she knew as a child![17]

The coincidence of these two texts points to a way of viewing films that supersedes the particular fascination with Hedy Lamarr, Jennifer Jones, or any other actress. From that perspective, two principles of cinema emerge: that facial expression and gesture are its essential language and, more crucially, that the coming of sound has destroyed the immanent spiritual music of films. In some "profound" sense—his term—cinema was over before Joseph Cornell wrote his first scenario or made his first films. In this difficult time for cinema—the era of the sound film—the "poetic and evocative language" can appear only in "evanescent fragments,"

and their "realms of wonder" are necessarily mediated by the memory of silent films. Cornell's odd rhetorical question in "Enchanted Wanderer," "Who has not observed..." defies sense and teases us with its hints of meaning more than it can say. If the "artificial" realms are the scenes and plots of the films in which the actress has appeared, then the "more absorbing...realms of wonder" must be the imaginary reflections which the tawdry movie scenes initiate but necessarily fail to realize. That is fully consistent with Cornell's theory of the imagination: a collapse and failure of the present, which brings with it a poignant and powerful compensation. But what could be meant by "the gaze she knew as a child"?

Here the syntactical contortions disguise a complex play of eros and time. On first reading, one might conclude that Hedy Lamarr's "gracious humility and spirituality" consist in her ability to sustain the concentrated and wonderful stare of a child before the tacky sets in which she performed as an adult. But if that was all that Cornell meant, he could easily have said it with less ambiguity; he was a very good writer.

The formula "the gaze she *knew* as a child" (my emphasis) continues to tease me. As a child she would have gazed at silent films, as indeed Cornell did as a child. The impossibility of sustaining childhood's vision is a persistent topos of Romantic poetry, where it is linked to the equally dreadful impossibility of forgetting its loss. In these terms Cornell's Lamarr is a metaphor for the mediation of the broken and fragmented sound cinema. Identification with her dramatizes the cinephile's eagerness and distance from what is attracting him or her.

Yet there is another sense to "the gaze she knew as a child," which the following paragraph begins to reveal:

Her least successful roles will reveal something unique and intriguing—a disarming candor, a naivete, an innocence, a desire to please, touching in its sincerity. In implicit trust she would follow in whatever direction the least humble of her audience would desire![8]

"The gaze she knew as a child" may not be her own after all. It is, to some extent, the gaze of a grown man, "the least humble of her audience," upon the little girl. These "realms of wonder" veer perilously close to the Wonderland toward which Lewis Carroll steered and there stared upon the child he called Alice.

The cinema then preserves and distances the erotic encounter of the adult and child, just as it incorporates the loss of innocent vision by the adult and the paradoxical thrill of that loss. Along parallel lines the Romantic ballet is not aesthetically superior to the contemporary, but it is inescapably conjoined with the biographies of imaginative balletomanes and their unfulfilled erotic fascinations. The illusionary intimacy and the actual impersonality of cinema necessarily fuse the aspirations and failures of the Romantic balletomane.

★

Cornell's first and most impressive film, *Rose Hobart* (c. 1936), illustrates many of the ideas he later expressed about Hedy Lamarr and Jennifer Jones. The film is essentially a reediting of *East of Borneo*, a 1931 jungle drama from Universal Pictures, with Rose Hobart and Charles Bickford. Apparently Cornell thought that George Melford's talking picture contained "passages to remind one...of the suggestive power of the silent film to evoke an ideal world of beauty."

Today *East of Borneo* seems an undistinguished period piece. In it, the brave and boyish Linda (Rose Hobart) undertakes a dangerous journey to the fictional Indonesian principality of Marudu to find her husband (Charles Bickford), who has become the drunken court physician to the suave and sinister Prince (Georges Renavent). The doctor had abandoned serious medical research upon falling victim to the erroneous obsession that his wife was conducting an affair with a friend of his. In Marudu, Linda proves her fidelity by repelling the advances of the Prince, despite her husband's foul rejection of a reconciliation. The Prince, a Sorbonne graduate

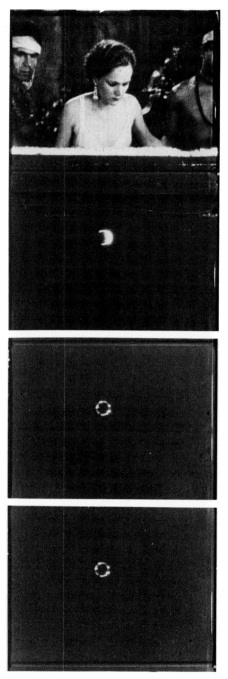

Fig. 9 *Rose Hobart*, c. 1936. Beginning of eclipse sequence

with urbane notions of the superior sophistication of his culture and religion to that of the West, is mystically tied to the fate of the active volcano which looms over his realm. At the end of the film Linda shoots and wounds him just as the volcano is about to erupt. The doctor, after performing his moral duty as royal physician, comes to his senses and escapes with his wife as the eruption destroys Marudu.

It is a cheaply made film with a drolly concocted volcano and an assortment of jungle terrors, including a python, a panther, and a large number of crocodiles. Not very promising material. Nor is Rose Hobart's performance comparable to the achievements elicited from the chief actresses in the great silent films cataloged in "Enchanted Wanderer." Hobart can only make quick, nervous gestures with her hands and quickly shift her expression from terror to laughter at herself when she sees that her fright is unfounded.

For the most part, Cornell has isolated these transitional moments and reorganized them in his montage. He included nothing of the final volcanic destruction and almost nothing of the lengthy and perilous voyage up river to Marudu, which opens the original film. Cornell's montage is startlingly original. Nothing like it occurs in the history of the cinema until thirty years later. The deliberate mismatching of shots, the reduction of conversations to images of the actress without corresponding shots of her interlocutor, and the sudden shifts of location were so daring in 1936 that even the most sophisticated viewers would have seen the film as inept rather than brilliant. Yet Cornell carried this roughness several steps further. He incorporated some continuous passages from the original film — sequences containing as many as eight shots in a row — which serve to remind us of the obligatory fluidity of Hollywood editing during that period, and which make Cornell's reconstruction look all the cruder. His retention of a connective shot here and there (say, the corresponding figure in a conversation with the heroine), underlines his eccentric ellipses. Finally, he has used some shots just as they were fading out

or just as a door was closing, omitting the main action.

Only a collector of films could have made this kind of montage. When one owns a print of a film and shows it repeatedly, accidents happen in the projection and rewinding; passages are damaged and strange ellipses occur in their repair. While most collectors regard these with horror and would prefer to ignore them, perhaps Cornell made these accidents of deterioration the formal model for his first film. The editing of *Rose Hobart* creates a double impression: it presents the aspect of a randomly broken, oddly scrambled, and hastily repaired feature film that no longer makes sense; yet at the same time, each of its curiously reset fractures astonishes us with new meaning. In this first film Cornell did what he would do with many of his boxes: he made the marvelous look easy, almost automatic. Nothing is more difficult than to sustain the illusion of an "accidental" overflowing of meaning.

I have been dwelling on the superficial roughness of *Rose Hobart*. Cornell simultaneously made a number of changes in the original film that give a new unity and dignity to his montage. First, he projected the sound film silently. By stripping it of its dialogue and mood music, he transformed its banality into an oneiric mystery. He not only showed it without the talk, he projected it at silent speed. With the coming of sound in the late 1920s, projectors were set at a uniform mechanical speed in order to reproduce the sound without the wavering pitch experienced when something touches and changes the speed of a record on a turntable. Until then, the projection and shooting speeds of films varied; often they were shot and projected by hand-cranking. By and large, the films of the silent era were shot at about two-thirds the pace of standard sound recording and projection. Therefore, a gear was added to most sound projectors to slow the standard 24 frames-per-second movement to 16 or 18 frames when silent films were shown on them, thus sustaining their illusion of realistic movement. By projecting *Rose Hobart* at silent speed, Cornell retarded the

gestures and action of *East of Borneo*, not enough to make them look like slow motion, but to lend them a nuance of elegance and protraction. Then he filtered the light of the black-and-white beam through a deep-blue glass plate![9] While the now blue-and-white montage unrolled, he repeated, almost hypnotically, a passage of Brazilian music on a record player. The silencing, slowing, tinting, and musical accompaniment provide a unity and a fluidity that the montage style contradicts.

Despite its illusion of crudity, the editing is never haphazard. Cornell meticulously created a new plot by introducing a few shots from other films, probably scientific studies, and by radically rearranging the events of *East of Borneo*. In his letter to Serbanne, he expanded upon his enthusiasm for *Love Letters*, describing the film itself as conspiring "to produce an effect such as seizes one with disturbing emotions."[20]

Rose Hobart deliberately creates a labyrinth out of the banal plot of *East of Borneo*. It generates a seizure of disturbing emotions by reversing the dramatic coincidence of psychological resolution and natural disaster in the original film. The crucial natural event of *Rose Hobart* is an eclipse (fig. 9) which Cornell introduced from another film. The entire montage is organized around it. The eclipse, in fact, is a skillful and startling montage of two very different elements: first, we see the total eclipse of the tiny disk of the sun, which lasts only a few seconds (fig. 9); as soon as the shadow passes over and the radiance of the disk returns, Cornell cuts to an image of a glass sphere falling through the air (the sphere is approximately the size of the sun on the screen and suggests that the eclipse has actually dislodged it from the heavens); the sphere falls into a pool and sends slow-motion ripples through the water (fig. 10). Neither of these shots is from *East of Borneo*.

Cornell prepares us for this solar disaster by starting off his film with a shot (not in the original film) of people staring into the sky. Throughout the nineteen minutes of *Rose Hobart*, he has spaced forebodings of the climactic

event. Early on, the heroine and the prince appear to be watching the imminent eclipse from a balcony. A fragmentary premonition of the splash occurs in this early episode, although the actual eclipse and the fall of the sphere do not. Hobart, at first fearful, quickly overcomes her anxiety and shakes her head, laughing at herself for her overreaction. It is only retrospectively that the darkening sky above the couple on the balcony links up with the slow-motion ripples. Most of the tension in this scene comes from Cornell's selection of a sequence in which Hobart rushes toward the camera along an arabesque corridor and looks down anxiously upon a pool filled with crocodiles. When she sees that they pose no threat to her, she becomes momentarily amused at her own anxiety in this strange new environment. Then Cornell substitutes the reverberating pool for the crocodile pit so that we cannot share her fear. The sequence has to recur at the end of the film, with the extraordinary collapse of the sun represented through montage, for the event to seize us with "disturbing emotions." When it does recur, Hobart does not laugh, but somberly fixes her gaze at the pool in which the sun has drowned.

The thrill of that final montage, towards which the whole film points, comes from the filmmaker's poetic invention of a sun that is literally no bigger than it appears to be when seen from the earth. This shift from figurative to literal scale hyperbolically enlarges the catastrophe that terminated *East of Borneo*. Just as the volcano there had been a patently artificial one, cheaply concocted for the movie, the sun of *Rose Hobart* is nothing more than a more convincing prop. Yet the power of the montage derives from what is left to our imagination. The dreadful consequences of a world which has lost its sun enlarge themselves in the aftermath of the film. In Cornell's reconstruction, the volcano has lost its destructive force because it is merely a natural obstacle. Only a disaster that occurs within the junctures of collage association can poetically induce truly "disturbing emotions" for this artist.

Fig. 10 *Rose Hobart*, c. 1936. Continuation of eclipse sequence as sun falls into the pool

Fig. 11 Film evening organized by Cornell, Norlyst Gallery, 1947

Fig. 12 Film program organized by Cornell, The Subjects of the Artist, 1949

He shows the smoldering and exploding volcano, but in a context that makes it comic; as part of the seduction of Linda, the Prince opens a curtain to reveal the belching crater (fig. 1). Cornell exquisitely times its appearance to suggest a displaced act of sexual exhibitionism: the suddenly uncovered nightscape seems to ejaculate to impress her.

In Cornell's collage-cinema, imagery never carries its full weight. The volcano collapses into a film version of a geological phenomenon and ironically evokes a sexual encounter. Cornell's "world of ideal beauty" is invisible and closer to music than to concrete imagery. The eclipsed sun, the falling sphere, the spreading rings of water are not compelling in themselves. Like isolated notes in a scale, they evoke a melody. They are the points around which the viewer can order his imaginary film of the sun poked out of the sky. Furthermore, it is only that extraordinary and "invisible" event that gives meaning to the otherwise unfocused fears, anxieties, and intimations silently mimed by the heroine throughout the film.

Cornell once told me he was considering changing the title of the film from *Rose Hobart* to *Tristes Tropiques*. I asked if he had been reading Levi-Strauss, but he told me he hadn't. He encountered the title in Susan Sontag's *Against Interpretation*, which attracted his attention after she wrote a review of a newly reissued book on Surrealism in the *New York Herald Tribune*. The words themselves seemed peculiarly appropriate. They had the distance of French, a language he loved; they had alliteration; and perhaps most important, they point to the fundamental sadness underlying the humor and pleasures of his first collage film. I write his "first collage film" only hesitantly. For many years it seemed that *Rose Hobart* was his only cinematic collage.

★

Cornell exhibited *Rose Hobart* on a program he called "Goofy Newsreels" at the Julien Levy Gallery in December 1936. As far as Levy remembers, or anyone can determine, the other films

on the program were from his collection and unaltered by him. The early Zecca film *A Detective's Tour of the World*, praised in his letter to Serbanne for its outdoor views, or the American silent comedy series *Unreel Newsreel*, with brief sketches disguised in the form of a newsreel of *faits divers*, would easily have qualified as "goofy newsreels." Until Cornell's papers have been fully cataloged, it will be impossible to determine how he showed his films in the 1930s and 1940s (figs. 11, 12). Perhaps we will never know.

Much of Cornell's relationship to cinema remains mysterious, but a most extraordinary series of accidents has recently revealed a treasury of collage films that he assembled from bits of his collection. Little is known about them; certainly not when they were made or in what measure of completion he left them. In the summer of 1965, the filmmaker Larry Jordan made a trip from San Francisco to Queens to work as an assistant to the artist. His help seems to have reassured Cornell about the value of his films and to have inspired him, briefly at least, to consider making more.

Cornell was very sensitive to the reaction to his work. Salvador Dali became vicious and violent at the Julien Levy Gallery when he saw *Rose Hobart*. Gala Dali later apologized to Cornell for her husband, explaining that Dali believed Cornell had stolen ideas he had thought about but never executed. Dali's reaction made him wary of showing the film. In 1957, Cornell projected some of his own films and others from his collection at the New York Public Library to entertain the staff of the Picture Collection at Christmas time. He invited the filmmaker Stan Brakhage and the critic Parker Tyler to his screening. When Tyler expressed some reservations about the films after the projection was over, however, Cornell broke off relations with him for a long time. A few years later, in 1963, Cornell was very reluctant to allow the films to be shown by the Film-makers Cinematheque.

Before Jordan returned to San Francisco, Cornell gave him three cinematic collages he had been work-

ing on, with instructions for their completion. He also gave him several other works-in-progress that he wanted Jordan to expand upon however he saw fit. The three nearly complete films were *Cotillion, The Children's Party,* and *The Midnight Party* (as named by Cornell), three versions of approximately the same material. Cornell had made several prints of a film about an elaborate party for children. The presence of a large jack-o'-lantern suggests that it might be a Halloween celebration, but the young revelers are not in costume. At many points this material looks like the "Little Rascals" comedies. Into scenes of apple-dunking, streamer throwing, dancing in couples and in a chorus line, the artist inserts bits of films about stellar constellations, acrobatic acts, and mythological tableaux, perhaps intended as entertainment for the gleeful and overstuffed children.

The construction of these three films is even more eccentric than *Rose Hobart*'s. Some shots are inserted upside down and backwards. Brief bits of silent titles flash by on the screen much too quickly to be read. Often they too are upside down. In his discussions with Jordan about the completion of the films—which meant, essentially, the prolongation of certain shots by freezing the images into still pictures—Cornell explicitly stated that he wanted to keep the strange titles as he had edited them.

This is another transformation of a film collector's phobia into an aesthetic advantage. The 16mm silent film has sprocket holes on both sides of the film ribbon. A mistake in rewinding film or in threading it through the projector can lead to reversing the left and right sides of the image, or even to inserting the whole film upside down. When the film is simply reversed, the image looks normal until a title appears or a word is seen on a street sign or somewhere in the field of vision. One can often watch a film for several minutes before such an occurrence indicates that the image has been viewed in reverse. Of course, when the image is upside down it runs backwards from end to beginning, and the error is immediately visible. Cornell incorpo-

rated such accidents in his collage films after *Rose Hobart,* I would contend. Had it not been for his gift to Jordan, we might never have understood what he was doing in the strangely assembled footage making up those three films.

That is only part of the story. Anthology Film Archives in New York paid the expenses for printing the freeze frames and making projectable copies of the three nearly complete films Cornell had entrusted to Jordan. Cornell was very pleased with the results, but wanted the films attributed to a collaboration between himself and Jordan. *Rose Hobart* was the only film he ever publicly acknowledged as his own without collaboration. The enthusiastic response to his films at Anthology Film Archives brought him more encouragement, and eventually, in 1969, he gave a collection of his films to the Archives. A catalog was made indicating which films were complete, which were projectable, and which were too shrunken or broken to pass through the machine. Cornell seemed very pleased with the preliminary catalog and offered no corrections. After he died, the curator in charge of preservation, Rick Stanbery, examined carefully all of the films, both complete and fragmentary, that Cornell had donated. Stanbery was assisted by Sean Licka, who was preparing a doctoral dissertation on Cornell. They discovered that several of the presumably broken and fragmentary films were actually montages very similar in composition and structure to the three films Jordan had completed. Furthermore, Jordan confirmed that they were of the same type as *Jack's Dream, Thimble Theatre, Carrousel,* and other "unfinished" films Cornell had given him to work with without providing titles. Suddenly there were several new Cornell collage films to be preserved and examined as part of his cinematic output.

Unfortunately there is no information at all about the status of these collages. Titles were given, four of them by Anthology Film Archives, simply to identify them. They vary greatly in intensity and in complexity, but we cannot say for certain which are fin-

Fig. 13 *Bookstalls.* Opening scene

Fig. 14 *Bookstalls.* Young reader travels to the Escurial

Fig. 15 *Bookstalls.* Montage of the sea voyage

Fig. 16 *Bookstalls.* Children of the island of Marken

Fig. 17 *Bookstalls.* Southeast Asian harvest and return to Paris

ished films and which are works-in-progress. Larry Jordan's memory of Cornell's instructions has been the primary guide to the restoration of these films, which is still going on.[21] Because explicit instructions from the filmmaker are lacking, no titles have been added, nor shots changed or prolonged by freeze frames. Several of them are as sophisticated as the three that Jordan completed. The internal evidence suggests that Cornell made them with elaborate and meticulous care. In one case, the overall design is even clearer than that of *Rose Hobart.*

Anthology Film Archives calls that film *Bookstalls;* for, after a brief exposition of the Paris skyline, it opens with shots of browsers at the tiny bookstalls along the Seine (fig. 13). The period seems to be the 1920s, and the young men leafing through the books look remarkably like the "urchins" in the illustrations for "Monsieur Phot." Paris was the center of Cornell's imaginary voyages, and the *flâneur,* who wandered the streets in search of idle amusement, was one of the important mediators of his mysterious encounters, as the same figure had been for Baudelaire.

In *Bookstalls,* a double mediation occurs: as Cornell uses serious and comic travelogs to effect his mental voyage, the urchin-*flâneur* of his film does it with a book. On one of the stalls he opens a volume, which through a sleight of montage shows pictures of a Spanish sight, apparently the Escurial (fig. 14). One of the still images suddenly comes to life as a flock of pigeons bursts into flight. This transition from stasis to motion is something Cornell found rather than constructed with cinematic techniques, but it is so intimately linked to his themes of imaginary travel and the magic of birds that it seems to have been made for him alone. The views of Spain lead into a sequence on the Caledonian channel in Scotland, in which a title prepares us for a swift boat ride (fig. 15). Yet the impossible speed of stop-motion photography hilariously outstrips our most extravagant expectations of natural rapidity. The boat brings us, with geographical abandon and through rough seas, to the island of Marken in

the Zuider Zee, where the children resemble the miniature revelers of the trilogy Jordan had completed (fig. 16). The harvesting labors of the adults of the island blend into similar activities somewhere in Southeast Asia without any preparation for the transition (fig. 17). But that is as far as the travel goes. The young *flâneur* puts away the book and wanders toward another stall, where he continues his perusal, and, presumably, although we do not share them, his imaginary travels.

There is little that is rough in the montage of *Bookstalls.* The pieces are so carefully selected, the timing so acute, and the symmetry so balanced that there can be no doubt that the filmmaker meticulously constructed it. If one of the unidentified reels in his collection could turn out to be a "finished" collage, there is at least the possibility that others are. None of them has the clearcut elegance of *Bookstalls,* but several are remarkable.

One of the most impressive of the recently discovered collage films has been called *By Night with Torch and Spear,* because that is the very prominent title which leads to the film's concluding shot. In this construction the filmmaker gets a powerful effect from the intercutting of tinted film stocks. Yellow images of an iron foundry, scarlet shots of the molten metal in furnaces, and a deep blue image of clouds clash with one another (fig. 18). For a long time the film seems to be on the projector the wrong way. Everything is upside down and moves backwards. But in the middle of the film it shifts to normal orientation. A truck deposits steaming slag down the hill of an industrial dump. The billows of red tinted smoke bridge a quick transition to American Indians dancing before a parallel bonfire, tinted pale yellow (fig. 19). Negative images of a camel caravan (fig. 20) and donkeys in a desert introduce more negative shots of the development of caterpillars from larvae. The titles throughout the film are mere flashes or run upside down until the end, when "By Night with Torch and Spear" appears in bold letters and precedes a black-and-white shot of aborigines night fishing (fig. 21).

After seeing the film, one can project it without rewinding so that the night fishing, caterpillars, and Indians are upside down and backwards, but the refinery appears to operate normally. This eccentric procedure is sanctioned by the precedent of Cornell's own reediting of Stan Brakhage's *Wonder Ring.* Cornell commissioned the film in 1955 to record New York's Third Avenue El before it was torn down. He recognized the beauty of Brakhage's film, but he was not satisfied with it, for Brakhage's kinetic experiences of light patterns and bodily movements on the train were far different from the thrill Cornell received from the momentary glimpses into the environments of strangers, as the train rushed past the glass-enclosed frames (the shadow boxes) of their windows. In reediting Brakhage's materials, Cornell slightly altered the montage, adding more images of people, but transformed the film by flipping it from left to right and projecting it upside down and backwards. At the end he added the title "The end is the beginning" so that it could be read normally.

Cornell's reconstruction of Brakhage's *Wonder Ring* provided a valuable tool for determining the status of some of the unidentified collage films. One of them is simply two halves of a documentary print about the development of butterflies and moths from larvae. It begins upside down and backwards then shifts to a normal orientation. Without the example of "The end is the beginning" or *GniR RednoW,* as it is sometimes called, this collage might have looked like nothing more than a broken print haphazardly spliced and rewound.

Of these palindromelike films, only *By Night with Torch and Spear* has an internal structure that parallels the reversed directions of the imagery. The thematic shift from contemporary steel-making to primitive rituals and exotic scenes occurs immediately after the change of orientation.

<div align="center">★</div>

The Midnight Party, one of the collage films Jordan worked on, opens with the title "The End" appearing on the screen upside down. But as soon as the first image follows the title, the reversal is corrected. We see a shade rise on a window at night and bits of a documentary about stellar constellations; then the montage begins to alternate between vaudeville acts and segments of the very same party that is the basis of *Cotillion.* In this version, the imaginary relationship between the acts and the reactions of the children, which the editing invents, becomes much more explicit. A related film, which Anthology Film Archives called *Vaudeville De-Luxe* on the basis of a title in the film, includes many of the same animal and acrobatic acts but without the children. There is in that one, however, a jolting insertion of a shot from *East of Borneo,* in which Rose Hobart hides a pistol in her purse, and some images from the documentary on steel refining used in *By Night with Torch and Spear.* The economy of images in Cornell's films is almost as great as in his boxes and collages.

The Children's Party, the shortest film in the trilogy and the one with the most varied materials, contains almost nothing of the children who dominate the other two collages. In the middle of this work, the frozen image of a sleeping girl with her doll suggests that it is a dream in which elements from the imaginary parties reappear in new and stranger contexts. The microscopic enlargement of an amoeba and the slow-motion study of birds in flight join with acrobatic and balletic images to suggest a principle of gracefulness and order of which the entertainments are merely one part. An "end" title divides this short film in half. The second part introduces several new images: the sleeping girl, a comet, and what appears to be a representation of Thor from an early film; each time he flourishes his hammer, jagged lightning bolts cross the screen. In the dreamlike montage of the film, his bolts seem to threaten a house, perhaps the very one in which the girl dreams, for firemen are attempting to repair high-voltage wires near a second-story window.

Central to this film is the concluding image of *The Midnight Party,* a girl

Fig. 18 *By Night with Torch and Spear.* Title set against steel foundry

Fig. 19 *By Night with Torch and Spear.* Transition from steel foundry to dancing Indians

Fig. 20 *By Night with Torch and Spear.* The Nomads

Fig. 21 *By Night with Torch and Spear.* Final night fishing image

with long hair riding a horse. This child seems naked, a tableau of Lady Godiva. Her long tresses discreetly cover her body. This playful image has stunning reverberations. It opens an erotic dimension in the films, yet appears in a context both charming and innocent. The complexities of the phrase "the gaze she knew as a child" surround this image. In *The Midnight Party,* it is the climactic revelation; in *The Children's Party* (fig. 22), it immediately precedes the repeated gestures of Thor.

As a mature woman, Godiva knew the respectful gaze of all but one of her subjects, who turned their eyes from her humiliation. There is no correlation in the montage of *The Midnight Party* between the reactions of the children and the entrance of this child on horseback. Yet, an odd scene that precedes it may provide a clue to its meaning. A child's court sits in judgment on two young dancers performing to the playing of trumpets. If a narrative is to be found in the associations of these films, then the horse ride might be a sentence of the court. Perhaps the anger of Thor would be a parallel reaction in the heavens to the same image when it appears as a child's dream fantasy.

In 1936 when preparations were underway for the exhibition "Fantastic Art, Dada, Surrealism," Cornell wrote to Alfred H. Barr, Jr., of The Museum of Modern Art:

In the event that you are saying a word or two about my work in the catalogue I would appreciate your saying that I do not share in the subconscious and dream theories of the surrealists. While fervently admiring much of their work I have never been an official surrealist, and I believe that surrealism has healthier possibilities than have been developed. The constructions of Marcel Duchamp who the surrealists themselves acknowledge bear out this thought, I believe.[22]

What kind of dream is *The Children's Party?* The emergence of repressed associations and images which the Surrealists cultivated made Cornell uncomfortable. He uses the unexpected comparison "healthier" to characterize Duchamp's erotic wit. The eros and wit in Cornell's films are matters of nuance. He takes images as he finds them. He did not

photograph or direct the erupting volcano in *Rose Hobart* or the child Godiva in *The Midnight Party* and *The Children's Party.* He did not even clearly emphasize their erotic exhibitionism. In a way, Cornell's wit is like that of Hans Christian Andersen, who can tell a story about an Emperor who exposes himself to a whole city, and especially to a little girl, without the reader's noticing what is happening in the story. Successive generations of parents have proven the moral of "The Emperor's New Clothes" by seeing only the moral and blinding themselves to the exhibitionism. The children to whom they read it tend to titter; they understand what it is about.

The child Godiva is, in fact, an inversion of the unclothed Emperor. If exhibitionism is the perversion of an implicit pact, then the naked child on the horse would be the fulfillment of the exhibitionistic Emperor's fantasy. But where is the Emperor? Nowhere in the two films that show the child rider; obviously, a figment of critical association. Such stories do not take the form of an economy of responsive exhibitionism: the little girl in Andersen's tale sees, judges, and accuses the Emperor. In Cornell's two films a child judge and an enraged Thor are juxtaposed with the image of the rider.

We cannot be confident of Cornell's meaning when he writes of Duchamp's constructions as guide to the "healthier possibilities" of Surrealism. As a Christian Scientist and reader of Mary Baker Eddy, he would have known the concept of "health" as an ontological rather than just a medical category. In the section of Eddy's *Science and Health* called "Science of Being," Eddy repeatedly couples dreams with physical phenomena as erroneous images of the Divine. For instance, she speaks of the intuition of the senses as "inverted images":

A picture in the camera or a face reflected in the mirror is not the original, though resembling it. Man, in the likeness of his Maker, reflects the central light of being, the invisible God. As there is no corporeality in the mirrored form, which is but a reflection, so man, like all things real, reflects God, his divine Principle, not in mortal body....

The inverted images presented by the sense, the deflections of matter as opposed to the Science of spiritual reflection, are all unlike Spirit, God....Because man is the reflection of his Maker, he is not subject to birth, growth, maturity, decay. These mortal dreams are of human origin, not divine.... That which material sense calls intangible, is found to be substance. What to material sense seems substance, becomes nothingness, as the sense-dream vanishes and reality appears?[23]

The Surrealists sought the liberation of unconscious energies in the juxtaposition of disparate images. They cultivated the disruption of erotic and moral taboos and linked their art to political revolution. Cornell aspired after "the intangible." If the Surrealists practiced free association to uncover the repressed schemata of the mind, Cornell utilized some of the same principles of association to emphasize the false corporeality of images and to help substance become nothingness in order to make the reflection of "the central light of being" the focus of his art.

The synthetic image, created as a sculptural or cinematic collage, necessarily points to the ephemerality of the images culled to make it up. As an illusionist, the maker of collages always exposes all his tricks. The synthesis he creates is an *ad hoc* illusion for the viewer who wants to experience the transfiguration of substance into something less tangible. The very origin of cinema has been in machines, one could almost say toys, with which the viewer could trick himself into seeing still things move. In his essay "La Morale du joujou," Charles Baudelaire extoled the protocinematic device called a phenakistoscope precisely because whoever used it would experience the illusion of movement even though he understood the principle by which it worked. Another nineteenth-century machine for the illusion of movement is the praxinoscope (fig. 23), a drum with slots through which the viewer peeks at images reflected in a circle of tiny mirrors. The revolution of the drum makes the reflected clowns tumble and ballerinas dance. Cornell paid homage to this machine in his Thimble Forests. (pls. 17, 19, 20). They do not move, but when one looks through the drum, the thimbles perched on needles are vastly multiplied by the tiny mirrors. Even the gentlest handling of the object makes the thimbles wobble, and that too is magnified by the mirrors into a storm of shaking thimbles. The charm of the object, like that of the phenakistoscope and praxinoscope, comes from the difference between looking at it as a simple machine and peeking through its slots to experience the transfiguration of its props.

★

There is no definitive chronology for Joseph Cornell's filmmaking. It would seem that he wrote his two scenarios before he edited *Rose Hobart* and the other collage films. Most of the films he directed were made in the middle and late 1950s, but as late as 1965 he was still working on the films Stan Brakhage, Rudy Burckhardt, and Larry Jordan photographed for him. The progression from written scenarios to collage films to films he directed is true to the drift of his filmmaking. The experience with Jordan indicates that he was still working on, or at least thinking about, the collage films in the '60s.

There is a consistency of style in all of the films Cornell directed: *Centuries of June, A Legend for Fountains, The Aviary, Nymphlight, Angel,* and *Seraphina's Garden.* Brakhage, who photographed *Centuries of June,* insists that he was a living machine for Cornell. Everything in the film resulted from the instructions he was given. Burckhardt tells a different story. Their work was a collaboration, "sixty per-cent Cornell and forty per-cent" Burckhardt. Cornell always maintained that Burckhardt should share the credit for the films he worked on. In all of these films the static compositions are very carefully composed, like the elements in the shadow boxes. The camera movements tend to be slow and very deliberate, panning from one dominant point of interest to another of equal weight. They are edited in a leisurely rhythm, except when the cutting jumps to catch the flight of a bird or a butterfly.

Fig. 22 *The Children's Party.* Godiva sequence

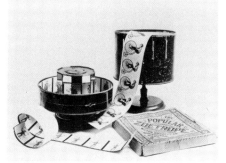

Fig. 23 Optical toys: praxinoscope, left, and zoetrope, right. Reproduced in *American Antique Toys, 1830–1900,* 1980

The films Cornell directed often reflect his intense and personal involvement with poetry. In 1963 the Film-makers Cinematheque showed a film called *A Fable for Fountains*. In 1969 Cornell gave a version of this film to Anthology Film Archives; it was almost twice as long and had been retitled *A Legend for Fountains*. The alteration reflects the difference between two translations of the line "Sí, tu niñez ya fábula de fuentes" from Federico García Lorca's poem "Tu Infancia en Menton" (1929). In his translation of the *The Poet in New York*, Ben Belitt rendered the line: "Yes, your childhood, a fable for fountains now."[24] But in an edition of Lorca's poems I once presented to Cornell—and which he already owned—Edwin Honig translated the line: "Yes, your childhood now a legend of fountains."[25]

The extension of the film itself is remarkable for the introduction of titles after the point where the first version ended. All of the titles are translations of lines from the poem, but Cornell selected phrases from both translations. His experience of Lorca's poem had been so personal and intense that he carefully examined both renderings for words which fitted his experience of it. From Belitt came the lines "Your solitude, shy in hotels, and your pure mask, in another sign" and "it is mine to seek out the scorpion's stone,"[26] while from Honig he quotes "tokens and traces of chance."[27] The other forty-odd lines of the poem are uncited. The subtitle of the film "(fragments)" acknowledges this ellipsis.

Lorca wrote "Tu Infancia en Menton" while he was in New York as a special student at Columbia University. It is a vivid cry against the loss or betrayal of love. I imagine that Cornell was intrigued by the idea of Lorca walking the streets of New York—seeing many of the same sights that the artist saw in the late '20s and could even continue to see in certain neighborhoods in the '50s—while suffering loneliness and the sense of erotic loss for someone in Spain.

Cornell's black-and-white film follows a young woman through New York's Little Italy and parts of the Lower East Side (fig. 24), where little has been done to disturb the look of shops since Lorca visited New York. She seems timid, lonely, perhaps poor, and alternately appears breathless in the winter chill, as if running somewhere, or without anything to do but gaze in store windows, as if they were composed as shadow boxes.

In the film she is both the poet and the beloved. The aesthetic experience for Cornell is the experience of others. It entails the voyeurist desire to be invisible, so absent that the solitude of whomever he observes is not disturbed. Cinema generally effects an illusion of intimacy, and the camera, as an inflexible mechanical observer, reinforces the counterthrust of distance to that intimacy. In the films Cornell directed, the camera often organizes its sights as if it were a lonely wandering consciousness. In fact, Cornell was an important influence on the development of a crucial phase of the American avant-garde cinema I have elsewhere called the lyrical film.

In lyric poetry the poet's language mediates between the raw and often aggressive presence of the natural world and the moral consciousness of the poet. The words bear the burden of simultaneously representing the environment or situation in which the poet finds himself and his precarious autonomy in relationship to it. In the great lyrics that Cornell loved passionately, the poems of Mallarmé, Keats, Dickinson, Laforgue, and Lorca, the poetic text emerges from a crisis that it somehow both prolongs and attempts to resolve. The Romantic dialectic of self and nature in these poetic forms uncovers a disturbance caused by superimposition of two contradictory dimensions of language itself. The exteriority of words, as objects and names of objects, does not coincide with the intimacy of those very words as emblems of the self. This tension molds from within the imagery of Romantic lyrics; the complexity of the imagery derives from its innate inadequacy to totalize or to resolve the tension. Therefore the Romantic lyric takes the shape of an obsessive series of images qualifying and finally surrendering a hope of reconciling mind and nature.

Poets turn repeatedly to a fixed point of reference—a season, a time of day, a specific location—to find a ground for the encounter in language of an exterior world and a consciousness that seeks to organize it or to make it somehow sufficient. By denying the convenience of a fictional protagonist, someone invented to weather or at least contain the crisis from which the poem originates, the lyric poet puts the reader in the position of reconstructing the encounter from the logic of the image-sequences and from the rhythms of the words.

The lyrical poem is so familiar a literary form that we often ignore the complexity of its premises. The lyrical film, however, posed an enormous challenge to both filmmakers and viewers as it emerged as a vital cinematic form in the 1950s. Its success owes much to the genius of Stan Brakhage, whose orchestration of imagery, camera movement, and editing brought to maturity the film-without-a-protagonist—or one whose protagonist is the fiction of the filmmaker behind the camera. In this development Brakhage was exposed to two significant influences: the filmmaker Marie Menken and the artist Joseph Cornell. When Cornell commissioned Brakhage to make a film of the Third Avenue El in 1955, he provided the funds and indeed the first opportunity for the young filmmaker to make a film without a protagonist. Later that same year, Cornell engaged Brakhage as the cameraman for the film which eventually became *Centuries of June*. It was the filmmaker's first lesson in organizing a film of silent images to evoke the poignancy of the loss of those very images which the film preserves. Working with Cornell provided Brakhage with his first practical experience in the dialectical organization of filmic images. In the films Cornell directed, the occasional protagonist plays an ambiguous role. The young woman of *A Legend for Fountains* and the little girl of *Nymphlight* stand for, and therefore mediate, the artist's experience of the world they encounter. Yet they are the center of *his* encounter. This ambivalence generated alternate versions of the film. *Cloches à travers les feuilles/Claude Debussy*

is a print of *Nymphlight* without the girl and her broken parasol. The reel called *Mulberry Street* is a montage of material from and related to *A Legend for Fountains* without the young woman. In *Centuries of June*, *Angel* and *The Aviary*, the subjectivity of the films is not mediated by a protagonist at all; they describe the encounters of the camera with special places.

Even with *A Legend for Fountains*, the ambivalent status of the woman in relation to the organizing sensibility structures the two parts of the film. As soon as the titles appear in the second half, the use of the second person in "Your solitude, shy in hotels…" surreptitiously reflects an unnamed "I" who does not appear, but nevertheless controls the dialogue. Cornell's selection of translations and elliptical fragmentation of Lorca's cry against the loss of love reduces the poem to these lines:: "Your solitude, shy in hotels…/ …pure mask in another sign…/… tokens and traces of chance…/…to seek out the scorpion's stone…" Lorca's often repeated word "love" does not appear in the titles. Instead of translating

¡Amor de siempre, amor, amor de nunca!
¡Oh, si! Yo quiero. ¡Amor, amor! Dejadme?[28]

the artist *finds* the inscription of love in the graffiti on the wall in Little Italy. The camera sweeps again and again past a chalked heart in which only the words "I love" remain visible. Eventually the panning discloses that this vestigial expression of love had been written on the wall of the apparently defunct "Monarch Doll Company." The filmmaker thus brings together the themes of lost childhood and eradicated love by rhythmically dwelling upon the graffiti and postponing the revelation of the curious site of its inscription.

These signs are the "tokens and traces of chance," in Lorca's translated words. They take on meaning when the camera, and by implication the wandering woman, reads them and returns to them. Even the shop windows can be read as compositions of meaningfully juxtaposed items, as if they were there to indicate what the solitary woman,

Figs. 24, 25 *A Legend for Fountains (fragments)*, 1954 or 1957. Above, Suzanne Miller in Little Italy; below, mannequin looking out on Grand Street

and the errant camera, lacked and sought. In one window the beaming graphic sun of "Il Sole" antipasto evokes a cheerful, hopelessly foreign dawn, imported into the winter cityscape. Cornell often used those very antipasto labels in his construction (pls. 128, 129).

Near the end of the film, he shoots the street from inside a shop. Frozen in the window display and peering out with us is a mannequin in a wedding dress (fig. 25), eternally poised in anticipation of emotional and erotic union like the figures Keats found on a Grecian Urn. The camera focuses beyond the static bride at the street, at what she would see if she could. The pane of glass catches reflections of passersby and records them as translucent ghosts. The dummy is more real, more weighty than the people who look at her and at her dress from outside.

In his version of their collaboration in Little Italy, Rudy Burckhardt has made a film called by the very Cornell-like title *What Mozart Saw on Mulberry Street*. Mozart, here, is a bust of the composer fixed in the window of a designer's shop. The title and the montage reverse the relationship of seer to seen. The statue stands for the controlling consciousness of the film. Such a reversal is an important phase of *A Legend for Fountains*. The film stands enmeshed in an exchange of impossible glances: what Lorca would have seen in New York in 1929, effaced by the passage of twenty-five years; what the wanderer sees when, like Lorca, she goes "to seek out the scorpion's stone" or as the alternate translation makes less ambiguous:

I'll search the stones for scorpions
and your childlike mother's clothes,
midnight lament and ragged cloth
that tore the moon out of the dead man's
 bow.
Yes, your childhood now a legend of foun-
 tains.[29]

It is also what the antipasto sun, the eternal bride, and a boxed doll see every day. Through this labyrinth of sightlines, Cornell passes unseen with Burckhardt's camera, recording a present moment, an often repeated walk, in which everything seeing and seen reflects the tension between duration and change. Even the structure of the film itself, first edited by Burckhardt, with the second part edited a decade later by Larry Jordan according to the artist's instructions, attests to the ambiguity of the cinematic process, which begins with a pure affirmation of here and now in the moment of shooting the film and allows for endless reconstruction in the acts of editing.

★

The organization around the glance of any eye, the interplay between seer and seen, is the common thread that unites the very different style of filmmaking encountered in *Rose Hobart*, *Bookstalls*, and *A Legend for Fountains*. The most perfect example of the mediation of Cornell's glance is the use of the beautiful little girl in *Nymphlight*. Dressed in a frilly white party dress, carrying a broken parasol, she rushes to Bryant Park behind the New York Public Library (fig. 26). We watch her watching the parades of pigeons, the rhythms of a water fountain, old men on benches, and finally another little girl. This is the most clearly narrative of Cornell's films. As our attention is directed from the presence of the girl to what she sees, she gradually withdraws from the film. She is the spirit of the place, and once the film has heightened our attention to its orders, making her way of seeing ours, she vanishes. In the mystic hint of the title, there is a clue that she has returned to the fountain which dominates the park. Only her discarded parasol remains, in a wastebasket missed by a sanitation man in his rounds.

The story of *Nymphlight* is a version of metamorphosis. In *Centuries of June*, *The Aviary*, *Angel*, and *Seraphina's Garden*, the cinematic occasion is an act of invocation to the spirits of places consecrated in Cornell's experience. Those spirits do not appear in the flesh and carry parasols, but in each of those films, the inanimate gestures toward the observer and offers up an image of mediation or a series of such images. In the vacuum created by the withdrawal of a protagonist, another image is drawn out of the flux and comes to stand, if

only momentarily, for the tenuous situation of the observer in the film. Nowhere is this clearer than in *Cloches à travers les feuilles/Claude Debussy*; there Cornell has edited the human "nymph" out of *Nymphlight*. Suddenly a second little girl, who in the other version had been observed by the girl with the parasol, looms up. The numerous acts of attention which compose the film center on her and through her.

★

In 1955 Cornell had asked Brakhage to photograph an old house that was about to be torn down. A public screening of his films at the Film-makers Cinematheque in 1963 inspired Cornell to reconsider his cinematic achievement. His sister, Elizabeth Cornell Benton, found the following note among his papers. It is dated November 15, 1963: "digression—not realizing until reviewing 'Tower House' film how beautifully—how fully the spirit of Emily Dickinson was caught."[30] The same note to himself suggests an editing change in *Angel* and a collective title, *The Lonesome Glory* (from Dickinson's poem, "Gathered into the Earth" [1370]) for both it and *Seraphina's Garden*. It would have been later that he gave the "Tower House" film its final title, *Centuries of June*. This, too, comes from Dickinson:

There is a Zone whose even Years
No Solstice interrupt—
Whose Sun constructs perpetual Noon
Whose perfect Seasons wait—

Whose Summer set in Summer, till
The Centuries of June
And Centuries of August cease
And Consciousness—is Noon.[31]

In the film, piles of fresh dirt and barechested workers intimate the coming destruction of the house, to which the camera repeatedly pans, even haltingly approaches as the cameraman takes a few steps toward the porch. In the insistence upon recording the house, filming the view from its windows, even through the slats under its porch as if seen by a hiding child, there is an urgency which forebodes its loss.

The association of the poem with the film was an afterthought. Cornell

never set out to illustrate Dickinson's text. Nevertheless, when Cornell quoted it in retitling his film, he left us with a valuable clue to the dialectical structure of his imagery. Ironically, he also provided the possibility of a mundane and cheerful dismissal of his work at the same time; for Dickinson, like Cornell, has been repeatedly misread, and the elusively difficult logic of her poems has been ignored and domesticated.

The presence of the old house recedes, becoming a backdrop to the incessant movements of butterflies and moths first and children later, signs of the prolongation of a moment which "constructs perpetual Noon." The children are as indifferent as the insects to the temporal destiny of the house. The rhythm of the film reverses the relationship inscribed in the images: the house appears as the static center of a world in which everything else is in flux; but the structure of the film insists upon the uniqueness of the house and its coming destruction, while the insects and children will be repeatedly replaced. That recognition marks the moment when the center shifts to what Dickinson calls "Consciousness," the Force through which "The Centuries of June/ And Centuries of August cease."

In *The Aviary*, Cornell filmed a statue of a mother with two children and edited it into a film of bird movements and playing boys, as if she watched over and protected their isolation in Union Square. But the statue and the children are foils for the congregation of birds, who seem to endow the barren trees and other statues of the park with a meaning by settling on them. The transformation, in this case, is simply identified by the film's title.

We see a park, its human scale defined by statues, trees, and buildings that tower above our eyes; but for the birds, the ruling spirits of the place, it is a contained arena of tranquillity, an aviary and a sanctuary.

Each of the films Cornell directed involves some shift of perspective, which the film invites us to make without insisting upon it. In the cemetery film, *Angel*, Cornell has organized a series of

Fig. 26 *Nymphlight*, 1957. Gwen Thomas in Bryant Park

shots which dramatize the presence of the statue of an angel, as if the stone were responsive to the moods of its viewer. The film is a masterpiece of tonal nuance.

The statue appears at first in a brilliant autumnal light. Filmed beside a fountain in a graveyard, she seems at first a stone prop, a simple marker to denote the place where the film occurs. But when the montage returns to her after showing the pool of a fountain, on which float orange leaves, disturbed by a light rain, the angel seems to brood upon the seasonal change and mourn the passing of Persephone. So long as the camera frames the statue head-on, it appears diminutive and tied to the earth, as if it rose from the ground like the flowers beside the pool. But at the end of the short film, Cornell frames it from below without the trees to dwarf it. In shadow, the stone wings fill the bottom of the image, leaving only the turbulent cloudy sky visible above. Suddenly, she is a massive creature of the sky, descended onto earth.

The shifting aspect of the angel gathers winter into fall, sky into earth, and links gravity and flight. The angel is just stone, a conventional funereal statue, but the composition and rhythm of the shots animate it without letting us forget its dumb heaviness. The images of water prepare for the transformation of the angel; the pool reflects the sky, thereby making one image of the two. Within the frame joining sky to earth, dead leaves float beside the living flowers. The iconography is simple. Yet Cornell makes this natural specularity the visible half of another reflection in which the reassurance of seasonal alternation is matched by its contrary, "the lonesome glory" of mortality. In Dickinson's poem, "awe" defines the inadequacy of imagery:

Gathered into the Earth,
And out of story —
Gathered to that strange Fame —
That lonesome Glory
That hath no omen here — but Awe — [32]

Joseph Cornell worked in awe of the power of cinema to show what can and what cannot be shown.

★

Joseph Cornell's cinema remains the central enigma of his work. His films have a roughness and an insidiousness that the constructions and collages never exhibit. A convenient attitude to take toward them would be to undervalue them, as many have done, including the artist himself.

There is a central critical tradition which supersedes all others. It is inscribed in the works of artists who respond creatively to their predecessors. For all of his privacy, despite his reluctance to show his films publicly until decades after they were made, Cornell exerted a powerful influence on other filmmakers. The "accidents" of personal encounters with him and his films significantly affected the filmmaking of Stan Brakhage, Larry Jordan, Ken Jacobs, Jack Smith, and Jonas Mekas. Just as Cornell himself was an intuitively brilliant reader of the poets he admired, seeing complexities and tensions in their expression which could inform his visual dialectics, so these filmmakers quickly apprehended hints and directions in Cornell's films that they could explore on their own.

The examination of Cornell's cinema is just beginning. There are still collages in the Anthology Film Archives that have not yet been restored. A cemetery film, which apparently Larry Jordan photographed, seems to have disappeared since Cornell's death. Jordan has several collages he is about to restore. *Seraphina's Garden*, which Burckhardt photographed in the mid-'50s, has been rediscovered and is being preserved by The Film Department of The Museum of Modern Art. Slowly, and always in a maze of ambiguities, these works keep reappearing to testify to a passion and a genius for cinema that stubbornly persists in undermining our expectations and challenging our certitudes, by hinting that the very experience of cinema might have a dimension we would rather overlook.

FILMOGRAPHY

COLLAGE FILMS

Rose Hobart. (c. 1936). Composed of sequences from George Melford's *East of Borneo* (Universal Pictures, 1931) and other materials. Black and white, projected through deep-blue filter, 19 min. at 16 frames per second (fps). Sometimes shown by Cornell at 24 fps. Cornell selected purple filter for composite color print made by Anthology Film Archives, New York, 1968. Sound on record or tape: "Forto Allegre" and "Belem Bayonne," from *Holiday in Brazil* by Nestor Amaral and Orchestra. First shown Julien Levy Gallery, New York, December 1936. In 1960s, Cornell considered changing title to *Tristes Tropiques.*

Cotillion, The Children's Party, The Midnight Party. (c. 1940s–1968). Three collage films composed of footage from documentaries, old Hollywood films; considerable material duplicated in first two. Silent, black and white with tinted sections. *Cotillion,* 8 min. at 18 fps. *The Children's Party,* 8 min. at 18 fps. *The Midnight Party,* 3½ min. at 18 fps. Given by Cornell to Larry Jordan for completion 1965; finished 1968 (Jordan's work consisted largely of repairing splices and making freeze frames where Cornell indicated; Cornell, however, said edited films should be attributed to Jordan).

Jack's Dream, Thimble Theater, Carrousel. (Dates unknown). Three of several films Cornell gave Larry Jordan for completion in 1965. Titles assigned by Cornell (others untitled). Editing in progress (few instructions for completion given by Cornell).

Ten untitled collages. (Dates unknown). From Cornell's private film collection given Anthology Film Archives, New York, by artist in 1969, and discovered by Sean Licka and Rick Stanbery in 1978. Four restored and titles assigned by Anthology Film Archives. Silent, tinted black and white, 16 mm., no indication of projection speed.

1. Reel 64: *Bookstalls.* 11 min. at 18 fps. Restored 1978.

2. Reel 165: *Vaudeville De-Luxe.* 12 min. at 18 fps. Restored 1978. Contains material from Cotillion series and one shot from *Rose Hobart.*

3. Reel 169: *By Night with Torch and Spear.* 9 min. at 18 fps. Restored 1979. Dramatic use of tinted stock and negative.

4. Reel 126: *New York–Rome–Barcelona–Brussels.* 10 min. at 18 fps. Restored 1979.

5. Reel 160: 175 ft.

6. Reel 108: 160 ft.

7. Reel 163: 100 ft.

8. Reel 166: 150 ft.

9. Reel 101: 250 ft.

10. Reel 135: 250 ft.

FILMS DIRECTED OR EDITED BY CORNELL

The Aviary. Photographed by Rudy Burckhardt 1954. Black and white. Two silent versions: one, 11 min., and other, 5 min. at 24 fps.; sound version distributed by Burckhardt with music chosen by Cornell ("Winters Past," by H. Barlow), 5 min. Jonas Mekas dates photographing of film December 1955, but Film-makers Cooperative Catalogue dates it 1954.

Joanne, Union Sq. Photographed by Rudy Burckhardt c. 1954. Silent, black and white, 7 min. at 24 fps. Presumably unfinished. Found in Joseph Cornell Collection at Anthology Film Archives. According to Burckhardt, Cornell was not satisfied with footage.

A Legend for Fountains. Photographed by Rudy Burckhardt 1954 or 1957 (latter date assigned by Jonas Mekas). Several versions of film exist:

1. *A Legend for Fountains (fragments).* With Suzanne Miller. Silent, black and white, 17 min. at 24 fps. Completed 1965 with assistance of Larry Jordan. Cornell recommended that Erik Satie's "Trois Gymnopédies" be played with first part of film; after title "…your solitude, shy in hotels…" Glière's "Symphony No. 3: Ylya Murametz" to be played.

2. *A Fable for Fountains.* With Suzanne Miller. Sound, 6 min. Edited by Burckhardt. Corresponds to first part of *A Legend for Fountains;* Satie music on soundtrack.

3. *Mulberry Street.* Silent, 9 min. at 24 fps. Edited by Larry Jordan 1965.

4. *What Mozart Saw on Mulberry Street.* Sound, 6 min. at 24 fps. Edited by Burckhardt; both Cornell and Burckhardt consider this wholly Burckhardt's film.

5. *Children.* Silent, 8 min. at 24 fps. Variant of *Mulberry Street,* edited 1965.

GniR RednoW. Version of *Wonder Ring,* made by Stan Brakhage 1955 and commissioned by Cornell; Cornell's version runs backwards and contains material Brakhage rejected in his editing. Final title, "The end is the beginning," added by Cornell. Silent, color, 4½ min. at 24 fps. First shown in 1970.

Centuries of June. Photographed by Stan Brakhage 1955. Silent, color, 10 min. at 24 fps.

Nymphlight. Photographed by Rudy Burckhardt 1957. With Gwen Thomas. Silent, color, 7 min. at 24 fps. Cornell wanted Claude Debussy's "Cloches à travers les feuilles" played with film. Another version exists:

Cloches à travers les feuilles/Claude Debussy. Silent, color, 4½ min. Version without Gwen Thomas.

Angel. Photographed by Rudy Burckhardt 1957. Silent, color, 3 min. at 24 fps. Second version exists in which Cornell removed one shot.

Seraphina's Garden. Photographed by Rudy Burckhardt 1958. Silent, color, 8 min. at 24 fps. Cornell's diary note from Dec. 2, 1958 (Archives of American Art) indicates he was working on the film then.

Flushing Meadows. Photographed by Larry Jordan 1965. Silent, color, 8 min. at 24 fps. Present whereabouts unknown.

Note: Dates throughout are approximate and subject to revision. Additional films in possession of the Estate of Joseph Cornell not available for examination at time filmography was prepared.

NOTES

1. Everyone interested in Joseph Cornell's cinema is indebted to his sister, Elizabeth Cornell Benton, whose concern and generosity led to the saving of several of his films. Rick Stanbery, the director of preservation at Anthology Film Archives has been exceptionally helpful to me throughout the preparation of this article. Howard Hussey gave me several suggestions, which I have incorporated here. I have also benefited from textual suggestions by Carole and Anthony Pipolo, Marjorie Keller, and Jane Fluegel.

2. Catalog of the exhibition "Fantastic Art, Dada, Surrealism," ed. Alfred H. Barr, Jr. (New York: The Museum of Modern Art, 1936), p. 266. Biography presumably based on a questionnaire (now lost) completed by the artist. His birth date is, of course, 1903.

3. Published in Julien Levy, *Surrealism* (New York: Black Sun Press, 1936), pp. 77–88; reprinted *The Avant-Garde Film: A Reader of Theory and Criticism*, ed. P. Adams Sitney (New York: New York University Press, 1978), pp. 51–59.

4. *Dance Index* (New York), vol. 4, no. 9 (Sept. 1945), pp. 155–59.

5. "Monsieur Phot," *Avant-Garde Film*, p. 54.

6. *Ibid.*, p. 52.

7. *Ibid.*, p. 53.

8. *Ibid.*

9. The five images appeared in the copy of the scenario Cornell gave to Marcel Duchamp (The Art Institute of Chicago). At least three other copies of the manuscript with stereopticon views exist.

10. "Monsieur Phot," *Avant-Garde Film*, p. 58.

11. *Dance Index*, pp. 155, 158.

12. *Ibid.*, pp. 158–59.

13. *Ibid.*, p. 139.

14. Draft of a letter to Claude Serbanne, March 26, 1946. Joseph Cornell Collection, Anthology Film Archives, New York. This collection contains letters, film stills, and books related to cinema given to the Archives by Cornell's sister, Elizabeth Cornell Benton, after the artist's death. In 1969 Cornell himself gave the Archives a collection of his films, both those he made and those he assembled for his own amusement and that of his brother Robert. The collection contains many of the early French trick films described.

15. Letter to Serbanne, *loc. cit.* Annette Michelson makes a similar observation in her analysis of René Clair's *Paris qui dort* in "Dr. Crase and Mr. Clair," *October* (Cambridge, Mass.), no. 11 (Winter 1979). Michelson has written an important study of Cornell's cinema in "Rose Hobart and Monsieur Phot: Early Films from Utopia Parkway," *Artforum* (New York), vol. 11, no. 10 (June 1973), pp. 47–57.

16. Letter to Serbanne, *loc. cit.* The French passage may be translated: "Sometimes her face is something rare on the screen today. At first there are some passages where she endows the close-ups with an eloquence that recalls the heroic age of silent cinema. Here there are rare flashes of the lyrical [undecipherable] of Falconetti[,] however without the depth. For myself, at least."

17. Joseph Cornell, "'Enchanted Wanderer': Excerpt from a Journey Album for Hedy Lamarr," *View* (New York), series 1, nos. 9–10 (Dec. 1941–Jan. 1942), p. 3.

18. *Ibid.*

19. Much controversy has arisen over the printing of *Rose Hobart*. When Cornell showed the film, he projected it through a deep-blue glass plate. Yet when Anthology Film Archives offered to make a color print, he selected a purple tint. The difference between the early primitive blue and the very late composite color copy in purple is one of many of Cornell's ambivalences.

20. Letter to Serbanne, *loc. cit.*

21. The restoration has taken place in part with a grant from the National Endowment for the Arts and with the generous support of Elizabeth Cornell Benton.

22. Letter dated Nov. 13, 1936, Archives of The Museum of Modern Art, New York.

23. Mary Baker Eddy, *Science and Health* (Boston, 19–; reprint, 1971), pp. 305, 312.

24. Federico García Lorca, "Your Childhood in Menton," *The Poet in New York*, trans. Ben Belitt (New York: Grove Press, 1955), p. 13.

25. Federico García Lorca, "Your Childhood in Menton," *The Selected Poems of Federico García Lorca*, eds. Francisco García Lorca and Donald M. Allen, trans. Edwin Honig (Norfolk, Conn.: New Directions, 1955), p. 111.

26. *Poet in New York*, p. 13.

27. *Selected Poems*, p. 111.

28. *Poet in New York*, p. 14.

29. *Selected Poems*, p. 113.

30. Dated note, Nov. 15, 1963, Cornell Collection, Anthology Film Archives.

31. Emily Dickinson, "There is a Zone whose even Years," *The Complete Poems of Emily Dickinson*, ed. Thomas H. Johnson (Boston: Little, Brown, 1960), p. 481.

32. Dickinson, "Gathered into the Earth," *ibid.*, p. 590.

Fig. 1 Joseph Cornell, c. 1940. Joseph Cornell Study Center, National
Collection of Fine Arts (NCFA), Smithsonian Institution, Washington, D.C.

JOSEPH CORNELL: A BIOGRAPHY

Lynda Roscoe Hartigan

In 1969 Joseph Cornell wrote: "Anyone who has shown any…concern…with my work & [who] has not been moved or inspired to become involved somehow or other with the humanities in a down-to-earth context…has not understood its basic import."[1] "Down to earth"—a quality rarely ascribed to a man characterized as reclusive and eccentric or to a body of work associated with the realms of poetry and dreams. Yet the expression, as used by Cornell to connote an unpretentious, compassionate engagement with life, bears directly on his pursuit of knowledge and the manner in which he lived and worked.

Cornell himself often focused on the personal and professional traits, biographical circumstances, and historical contexts of creative individuals to enhance his understanding of their ideas and accomplishments. Thus, the retirement of the pioneering Romantic ballerina Marie Taglioni prompted him to speculate: "…was she consoled then by her earlier days or did they mock her from the past?"[2] In many cases Cornell also identified with historical figures, deriving insight, inspiration, and, at times, reinforcement and consolation from their experiences and feelings. In pondering Emily Dickinson's armchair appreciation of foreign places, Cornell once queried: "Is there a similar clue here in the ecstatic 'voyaging' through endless encounters with old engravings, photographs, books, Baedekers, varia, etc.?"[3]

Sensitive to daily events and natural phenomena, deeply attached to his family, and acquainted with numerous contemporaries, Joseph Cornell was very much involved in the world around him. Paradoxically, his impulse to communicate was as real as his need for privacy, and his ability to create magical relationships was as natural as his suspicion of attempts to interpret and classify them. Although Cornell maintained that "preoccupation with my seclusion in the mass media and critiques is based upon misconceptions, repeated parrot-like by those who should know better—until it has acquired a semblance of fact," he refrained nonetheless from offering the order of intimacy and detail sought by historians and critics.[4] A compulsive diarist and collector, Cornell fortunately provided for the preservation of his papers and source materials. With the assistance of his documents and of his family and friends, the much-needed reconstruction of Joseph Cornell's biography can now begin.[5] That the "down-to-earth" context, or realm of cumulative daily experience, provided both impetus and frustration emerges as a significant element in his life.

★ NYACK, 1902–1918

Joseph Cornell was born in Nyack, New York, approximately twenty-nine miles north of New York City along the Hudson River's western shore. During the middle of the nineteenth

century, Nyack was a thriving ship-building and trading center. Known for its river, mountain, and woodland scenery, it also became a popular summer resort. After 1870 river traffic began to diminish when the Erie Railroad was completed, later enabling residents to commute to New York City. Although Nyack's heyday had passed, the village continued to prosper during the first two decades of the twentieth century (fig. 2). For its approximately 4,400 residents, Nyack supported many specialty shops and hotels, private and public schools, churches of the major denominations, several newspapers, and a library. Along its well-kept streets were handsome Victorian houses, many with mansard roofs and spacious porches facing the river. Winter sports, boating, golf, and baseball provided popular local pastimes during the period.[6]

Cornell's parents, Joseph I. Cornell and Helen Ten Broeck Storms, were married in Nyack on November 12, 1902.[7] Like many of the area's residents, they were both descended from old Dutch families.[8] One of four children, Cornell's father was born on March 4, 1875, in nearby Closter, New Jersey. As a teenager he entered the employ of George E. Kunhardt, a prestigious wholesale woolen manufacturer; during his twenty-odd years with the firm's Manhattan office, Cornell's father advanced from selling to buying and designing textiles for menswear. Cornell's mother, Helen, was an only child born on August 21, 1882, in the Greenpoint section of Brooklyn. A 1901 graduate of the Packer Collegiate Institute in Brooklyn, she also studied at Miss Jenny Hunter's Training School in New York in 1902. Marriage, however, preempted her plans to teach kindergarten. Mrs. Cornell's maternal grandfather, Commodore William R. Voorhis, had been one of Nyack's wealthiest, most prominent citizens, having founded its water company and persuaded the Erie Railroad to include the village in its system.[9] To the Commodore's great grandchildren were handed down stories of his hospitality to Mr. and Mrs. Tom Thumb, experiments with a steam-operated passenger catamaran, and prize-winning racing yachts.

The Cornell's first child, the sixth Joseph I., was born in their house at 288 Piermont Avenue on December 24, 1903.[10] In the same house on Piermont was born their daughter Elizabeth, on February 5, 1905. A year later Helen was born on February 21 in the family's second house at 138 Piermont Avenue. Mrs. Cornell delivered her second son, Robert, on June 6, 1910, and within the year the family moved to "the big house on the hill" at 137 South Broadway (fig. 3).[11]

Prosperous by turn-of-the-century standards, Cornell's parents were an active couple. The elder Joseph Cornell, as remembered by his children, presided with authority and humor and displayed elegant manners and a flair for stylish clothing. A sportsman, he hunted and fished in the Adirondacks and golfed at Pinehurst. After 1910 Cornell's father maintained a woodworking shop in the family stable, where he carved boats and made furniture. Although his children were aware of his hobby, he did not instruct them in its practice.[12] Cornell's mother ran the household with the help of servants and nurse-maids. An avid reader of contemporary books and magazines, including The Mentor, she also wrote movie scenarios as a hobby some time between 1906 and 1910.[13] Both parents enjoyed acting and were musically inclined—he was a fine tenor, she a pianist—and consequently were active in Nyack's amateur arts club. On Sundays they gathered the family around their Victrola to listen to recordings by Metropolitan Opera stars such as Enrico Caruso and Geraldine Farrar.

Cornell retained indelible impressions of his childhood in a close-knit family, and in subtle and direct ways his art contained reverberations of his childhood interests and experiences (figs. 4–7). His papers also attest to the manner in which adult events triggered "...something deep—unfathomable—something akin to childhood—or dreams of...."[14] The children enjoyed a warm relationship with their maternal grandparents, especially when they lived next door between 1906 and 1910. The family celebrated birthdays and holidays with great sentiment and many

Fig. 2 South Broadway, Nyack, New York, c. 1900. The Nyack Library

Fig. 3 Cornell residence, 137 South Broadway, Nyack, New York, c. 1915. Joseph Cornell Study Center, NCFA

Fig. 4 Cornell at age of two, 1905. Joseph Cornell Study Center, NCFA

customs, including elaborate paper dec-
orations made by his mother and a
candlelit tree at Christmas. Cornell
later recalled: "I am peculiarly prone to
Christmas, from childhood, in the con-
text of New York, snow, magical store
windows, [Christmas] Eve, etc., no
matter how thin the personal mystique
gets hammered out by the world condi-
tion."[15] In the summer, Cornell eagerly
awaited the arrival of itinerant hurdy-
gurdy players, as well as the Shakers,
who sold their crafts in the area. He
also enjoyed watching the hot-air bal-
loons released along the Hudson River
on the Fourth of July.[16] The family
vacationed at Asbury Park on the New
Jersey Shore, the Adirondacks in New
York, and Lake Mooselookmeguntic,
Haines Landing, Maine, and regularly
visited metropolitan New York. Cornell
particularly remembered their excur-
sions to Coney Island's penny arcades,
the Hippodrome's extravaganzas, and
the Palace's vaudeville showcases.

After 1910, Cornell spent so much
time reading that his mother often
encouraged him to play outdoors. Raised
on fairy tales by Hans Christian
Andersen and the brothers Grimm, he
was also fond of the Red, Green, and
Blue Fairy Book series, a collection of
international folklore popular since the
1890s. Like many of his peers, Cornell
favored *The Book of Knowledge* and *St.
Nicholas: Scribner's Illustrated Magazine for
Girls and Boys*.[17] Both benchmarks of
American children's literature, they
introduced him to short stories, poetry,
and essays by noted authors on a wide
range of subjects: history, biography,
art and music appreciation, science,
and natural history. Both publications
also featured riddles, games, and
"do-it-yourself" projects, such as making
shadow boxes. By 1914 he was old
enough to haunt the movies in Nyack,
where he saw *Cabiria*, a lavish Italian
film based on an original screenplay by
Gabriele D'Annunzio. In the family
stable in August 1917, Cornell and a
friend staged a play, for which his
typed tickets read: "COMBINATION
TICKET/ENTITLES BEARER TO: 'The
Professional Burglar'/Relic Museum/
Candy/Shadow Plays/..."[18] Reflected is
his youthfully astute observation of

Fig. 5 Cornell and his sister Elizabeth, Nyack, New York, c. 1907. Collection Elizabeth Cornell Benton, courtesy Joseph Cornell Study Center, NCFA

Fig. 6 Cornell family, c. 1915. Left to right, Elizabeth, Helen, Cornell's father, Cornell's mother with Robert, and Joseph. Joseph Cornell Study Center, NCFA

Fig. 7 Cornell's parents at home, c. 1914. Joseph Cornell Study Center, NCFA

arcade, vaudeville, and nickelodeon programs. Cornell received no training in the visual arts as a child, unlike his sister Elizabeth, who studied drawing and painting with Edward Hopper around 1915![19]

Family life took on a different dimension after 1910 as it became apparent that Cornell's brother, Robert, suffered from an elusive, progressive illness. Seemingly healthy at birth, by the age of one he displayed the first symptoms of muscular and neurological difficulties, later thought to have been caused by cerebral palsy.[20] In their unsuccessful search for a cure, Robert's parents consulted numerous doctors, including an Austrian surgeon who persuaded the family around 1911 to spend a summer in Sharon, Connecticut, where he maintained a physical therapy program. From the outset the family lovingly thought of Robert as a "beautiful little laughing boy, completely alert," and included him in their activities as much as possible.[21] Although he mastered several walking devices as a child, partial paralysis confined him to a wheelchair by the late 1920s.

Approximately a year after the onset of Robert's condition, Cornell's father became chronically ill with leukemia. The family's circumstances, however, were not dramatically altered until his death on April 29, 1917, after which his debts, the absence of a will, and a swindle by a family friend depleted their resources. Mrs. Cornell, although unused to handling financial matters, proved to be a very strong figure. Placing the family on a stringent budget, she at first took on part-time jobs, which included making cakes and sweaters for sale in New York. Later she invested in the stock market, thereby providing a small but steady income for several decades. Over the years, her children remembered her efforts to make life pleasant for them in the face of their reduced circumstances, as well as the discipline with which she impressed upon them their familial responsibilities. During the summer of 1917, Mrs. Cornell, counseled by her late husband's employer, George Kunhardt, prepared to send Joseph to Phillips Academy in Andover, Massachusetts. Unable to maintain their home in Nyack, she moved her family to rented quarters in Douglaston, Long Island, in the fall of 1918. Through correspondence and visits with their relatives and friends, however, the Cornells maintained their hometown ties for many years.

★ ANDOVER, 1917–1921

On September 18, 1917, Cornell entered Phillips Academy. The oldest preparatory school in America, the Academy was founded in 1778 to educate students from diverse economic backgrounds. Many of its graduates have attended Ivy League schools; Yale was especially popular in the 1920s. During Cornell's enrollment, the school struck a balance between strict academic standards and comparatively liberal student policies.[22]

Electing the scientific rather than the classical program, Cornell studied algebra, plane geometry, physics, and general science.[23] His liberal arts courses included biblical subjects and four years of English, during which he read stories by Thomas De Quincey, who became one of his favorite writers.[24] Cornell also studied several foreign languages—four years of French, three of Latin, and one of Spanish—and consequently began reading foreign literature, typically introduced in first-year language courses at the Academy. As a Latin student Cornell became familiar with Virgil, and his Spanish textbooks included short stories and plays.[25] However, the French literature he read at Andover is currently unknown.

Although he passed the requisite entrance examination, Cornell did not distinguish himself as a student.[26] In September 1919, his headmaster suggested extending his enrollment "to enable him to enter college at a somewhat later date and with increased maturity which should be helpful in making the college course a success."[27] Cornell's teachers advised against doing so, however, believing that he would perform best within the prescribed four-year program. Although Cornell remained at the Academy until June 17, 1921, he did not complete the required courses and consequently was not awarded a diploma (fig. 8).[28]

Fig. 8 Cornell's yearbook picture, Phillips Academy, Andover, Massachusetts, 1921. Collection Elizabeth Cornell Benton, courtesy Joseph Cornell Study Center, NCFA

Fig. 9 Madison Square, New York, 1929, looking southeast to 26th Street and Madison Avenue. Library of Congress Collection

There is no evidence to suggest that Cornell was interested in studying art while at Andover. Reminiscing many years later, he noted the absence of an art program when he attended Phillips; the school's Addison Gallery of American Art did not open until 1931.[29] While working in Massachusetts in the Kunhardt textile mill in Lawrence during the summer of 1919 or 1920, Cornell scoured the area of Sandwich for examples of the town's famous glass, probably the first significant indication of his acquisitive nature.[30] The glassware contributed to his burgeoning awareness of the American past as he explored parts of New England. Also noteworthy was the appearance of Mutt and Jeff caricatures in his letters to the family, although his predilection for embellishing correspondence with collage and inserts did not reveal itself until the 1930s.

That Cornell's years at Andover were difficult for him is evidenced not only by his academic problems. His sister Elizabeth recalls an incident that occurred at home during one of his Christmas vacations: "Late one night he woke me, shivering awfully, and asked to sit on my bed. He was in the grips of panic from the sense of infinitude and the vastness of space as he was becoming aware of it from studying astronomy."[31] Prone to nightmares and stomach problems, Cornell was perceived as a sensitive youngster who needed special attention, as the headmaster informed his mother during a visit to the school.[32] Cornell's brief entry in the 1921 yearbook mentions no extracurricular activities, although according to the school newspaper he participated in intramural track; as a scholarship student, after 1918, he also waited on tables. Before going to Andover, Cornell had never been away from his family for any significant length of time. His regular correspondence and vacations with them notwithstanding, the separation shortly after his father's death and his concern for the family's welfare undoubtedly affected him during this period.

★ NEW YORK, 1921–1931

In 1921 Cornell returned to Bayside, Long Island, to which his family had moved in 1919.[33] Although his mother remained the head of the household for several decades, he assumed responsibility for the family's support at the age of seventeen.[34] Family connections, rather than personal inclination, directed Cornell to the textile industry for his first job. Hired in the fall of 1921 by William Whitman Company, Inc., a wholesale textile company, he peddled woolen samples in lower Manhattan's mercantile district until 1931. The events in the interim, especially his exploration of New York and his conversion to Christian Science, figured prominently in shaping his personal life and artistic sensibility.

Temperamentally unsuited for his job, Cornell dreaded the daily encounters with customers. His "mercantile canvassing," however, greatly expanded his childhood familiarity with the city's neighborhoods, landmarks, and resources. By virtue of the Whitman Company's location, Madison Square became the heart of the area which he began exploring in his spare time (fig. 9).[35] Cornell's sensitivity to street scenes and merchandise displays in store fronts and on sidewalks surfaced quickly. He retained, for example, vivid impressions of the wholesale flower district on West Twenty-eighth Street, passed daily en route to Whitman's, and the windows of caged tropical birds in a pet shop encountered once by surprise. Later, Cornell acknowledged his memories of the shop as a touchstone for his Aviary series in the 1940s.[36]

Cornell's acquisitive nature also blossomed in the course of his canvassing. Stores between Second and Sixth avenues became frequent haunts from which grew his network of sources for books, records, photographs, prints, and other ephemera. In the Oriental shops between Twenty-fifth and Thirty-second streets, he bought Japanese prints and the first boxes for his objects.[37] The most richly mined area was "that section of Manhattan where extends one continuous line of secondhand bookstalls from the fringes of the Bowery up Fourth Avenue to Union Square..."[38] In one such shop, The Sign of the Sparrow (at 42 Lexington Avenue), Cornell

made his first literary purchase in 1921, a 1913 issue of the Parisian periodical *Musica*. Some years later he wrote this description of the shop:

For over 25 years a sanctuary and retreat of infinite pleasures, through many fluctuating phases of my life....

The strong sense of the past through these experiences, enhanced by the physical atmosphere of the shop—autographed photos and drawings on the walls, the statue of Rachel, bric-a-brac, the stove, the back room (allowed in there once or 2)....

To the end it remained a "hole in the wall," purposely, and many were the well-known authors, writers, theatrical people etc. who frequented it for its quiet charm....While preserving the amateur standing of the shop its dealer was actually tops in the first edition field...[39]

Cornell's acquisitions began to expand into all the arts—music, dance, theater, film, and art—as his interest in them grew. Buying standing-room tickets, Cornell and his sisters frequently attended the Metropolitan Opera, where he heard Geraldine Farrar before her retirement in 1922. His family soon noticed that he was collecting librettos.[40] Between 1924 and 1926 he began to acquire the first available recordings of Emmanuel Chabrier, Claude Debussy, Maurice Ravel, and Erik Satie.[41] Cornell also became interested in Spanish composers such as Isaac Albéniz and performers such as Raquel Meller. In 1926 Cornell and his sister Helen attended a Meller performance during her much-celebrated appearance in New York. From his souvenirs of this "event of purest joy" evolved one of his first dossiers dedicated to a performer.[42]

As a child, Cornell had seen the Hippodrome's water ballets and dance spectacles. However, he first encountered classical dance in opera ballets at the Metropolitan Opera House, where he saw Anna Pavlova several times during her farewell tour of 1924–25. Cornell's theater experiences included both legitimate productions, such as *Rain* with Jeanne Eagels in 1922, and popular entertainment, such as Maurice Chevalier's review in 1930.[43] Eagels's memorable performance and tragic death in 1929 ultimately inspired an extended series of collages in 1963. Early in the decade family connections in Bayside helped to establish Cornell's first known contacts in the theater business: John Golden, a prominent producer, and Perriton Maxwell, an editor of *Theatre Magazine*.

Although Cornell became a knowledgeable student of theatrical history, from the 1920s on he greatly preferred going to the movies. Captivated by "the profound and suggestive power of the silent film to evoke an ideal world of beauty," he found memorable such films as *Broken Blossoms, Sumurun, Ménilmontant, The Passion of Joan of Arc,* and *Dreigroschenoper.*[44] Cornell's enthusiasm was not limited to the silver screen, for he enjoyed the fact that silent film stars such as the Talmadge sisters lived a few blocks away in Bayside, and that during the early 1920s Bayside was used for location shooting by the New Jersey-based movie industry.[45] Although he began acquiring movie memorabilia, his collection of old films and stills does not appear to have grown significantly until the 1930s.[46]

Recalling experiences he considered important to his art, Cornell stated: "I feel that in a more subtle manner (and a healthier one) I was more influenced by the work of the modern French in painting and music at least a dozen years before doing creative work."[47] His introduction to Odilon Redon, Paul Cézanne, and others during the 1920s was based primarily on contemporary publications such as the yearbook *Ganymed* (Munich, 1919–25), in which reviews, articles, and excellent reproductions of modern European art were edited by the German art historian Julius Meier-Graefe. Cornell was familiar with the criticism of James Huneker, whom he described as the first American to write about modern French art and music. He also read Marsden Hartley's *Adventures in the Arts* (1921), which he characterized as "a beautiful and highly sensitive book of appreciations...to which I owe an eternal debt of gratitude. Redon, Cézanne, Emily Dickinson, vaudeville artists, Walt Whitman, many others, all came in for aesthetically stimulating appraisals."

In January 1926 Cornell attended the memorial exhibition of John Quinn's

Fig. 10 Cornell with his sister Helen and mother on Fourth Street, Bayside, New York, c. 1928–29. Joseph Cornell Study Center, NCFA

collection at the Art Center in New York. He particularly remembered Georges Seurat's *Le Cirque* (a reproduction of which was incorporated in Cornell's cover design for *Dance Index* in June 1946), Henri Rousseau's *Sleeping Gypsy*, Pablo Picasso's *Mother and Child Seated by the Sea*, and André Derain's "best known WINDOW STILL LIFE." Whether Cornell attended other exhibitions of modern French painting and sculpture in New York during the 1920s is currently unknown, as is the context of his discovery of Giorgio de Chirico's work—perhaps he saw de Chirico's first one-man show in America at the Valentine Gallery in January 1928.[48] During a "vanished golden age of gallery trotting," Cornell frequented exhibitions organized by Alfred Stieglitz, although he did not identify them or specify whether they took place at the Anderson Galleries, Intimate Gallery, or An American Place, with which Stieglitz was associated after 291 closed in 1917. At all three, Stieglitz had continued his pioneering efforts to establish photography as an art form and to introduce and sustain avant-garde American art. Cornell's interest in twentieth-century photography in particular probably emerged in this context. His awareness of contemporary American art was also cultivated by visits to the Daniel Gallery, where he saw paintings by Charles Demuth and the first one-man show of Peter Blume in 1930. At the Whitney Studio Club Cornell attended a dinner party and art auction around 1927–28 at the invitation of Alexander Brook, its assistant director.[49] He later recalled that artists such as Preston Dickinson, Yasuo Kuniyoshi, George C. Ault, and Niles Spencer had provided works for the auction. Although Cornell never actively collected American art, his brief contact with Brook, as an "outsider," culminated in his purchase of several drawings and paintings by such contemporaries as Ault and Peggy Bacon, then Brooks's wife.[50] Oriental culture, especially "...imagists such as Hiroshige, Hokusai and the writers of hokkus..." rounded out Cornell's emerging artistic interests of the period. He read Paul-Louis Couchoud's collection of essays, *Japanese Impressions* (1921), and visited the Oriental collection at the Brooklyn Museum around 1929.[51]

Immersion in these activities, however, did not dispel completely the tension generated by Cornell's work in the "'nightmare alley' of lower Broadway."[52] From the early 1920s he experienced recurring nightmares and severe stomach attacks. His sister Helen, who worked at Whitman's after 1923, witnessed his unhappiness as he often sat in Madison Square Park moaning with anxiety.[53] Encouraged by a coworker to investigate Christian Science, Cornell consulted a practitioner and began studying Mary Baker Eddy's writings. After a significant healing experience around 1925, he joined the Mother Church in Boston and the First Church of Christ, Scientist, in Great Neck, New York.[54]

Central to Christian Science is a belief in the transforming truth, power, and goodness of God as Divine Principle. According to Mary Baker Eddy, "this scientific sense of being, forsaking matter for Spirit, by no means suggests man's absorption into Deity and the loss of identity, but confers upon man enlarged individuality, a wider sphere of thought and action, a more expansive love, a higher and more permanent peace."[55] To attain the scientific sense of being, a Christian Scientist follows a way of life which includes daily prayer and study of Eddy's writings and the Bible, augmented by regular attendance at church services and lectures. When contemplating his relation to God and life, a Christian Scientist is also encouraged to explore both the religious and metaphysical dimensions of Eddy's discussion of subjects such as spirit, reality, truth, and beauty.[56]

After 1925 the practice of Christian Science became an integral part of Cornell's life. His papers contain numerous references to his daily readings and church attendance, as well as testimony to the religion's sustaining effect: "...one thing is certain [,] vigilance and consecration must be scrupulously practiced to eliminate reversals,...gratitude exercised, the 'heart and soul' of Christian Science appreciated for the natural,

wholesome, healing and beautiful thing that it is."[57] In the wake of such feelings over the years, Cornell frequently found it easier to work. Christian Science also strengthened his bonds with his brother Robert and sister Elizabeth, to whom he introduced the religion after 1925. Cornell's mother and sister Helen did not share Joseph and Elizabeth's interest in the religion's potential for curing Robert.[58]

Between 1925 and 1931, several events altered the family's circumstances. In 1925 they moved to rented quarters for the fourth time in seven years, again in Bayside (fig. 10). A year later Cornell's maternal grandfather joined them, remaining with the family until his death in 1934.[59] In May 1929 the family settled in Flushing, in Queens, having purchased a modest wood frame house at 3708 Utopia Parkway (fig. 11). The area, named after a Long Island Railroad stop, was relatively undeveloped at the time; over the years, Cornell lamented its gradually "cheapened" character.[60] His sisters Helen and Elizabeth married in June 1929 and August 1931 respectively and moved to neighboring communities. In 1931 Cornell lost his job at Whitman's because of the Depression.

Unemployed, Cornell continued to explore Manhattan, as well as Brooklyn and Long Island, and to visit museums and galleries. Shortly after its opening in November 1931, he discovered the Julien Levy Gallery, established by Levy as a center for studying and exhibiting historical and contemporary photography, modern painting, and experimental film. Inspired in part by the example set by Stieglitz, Levy subsequently forged an important link in the short chain of dealers and collectors then supporting European and native vanguard art in the United States. Interested in photography, film, and modern art, Cornell was understandably attracted to such a promising new gallery. There he first encountered Surrealist art and literature when, in November 1931, he watched Julien Levy unpack the Surrealist works destined for the Wadsworth Atheneum's landmark exhibition, "Newer SuperRealism," in Hartford, Connecticut. Shortly there-

Fig. 11 Cornell house at 3708 Utopia Parkway, Flushing, New York, c. 1963–64. Joseph Cornell Study Center, NCFA

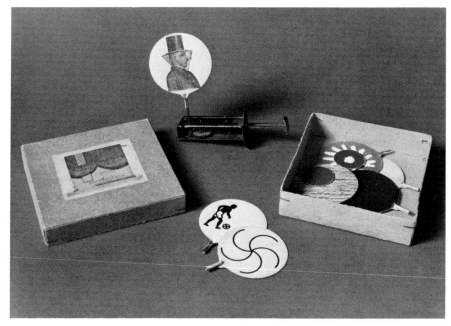

Fig. 12 Joseph Cornell: Surrealist toys. c. 1932. National Collection of Fine Arts, Smithsonian Institution, Washington, D.C., Gift of Mr. and Mrs. John A. Benton

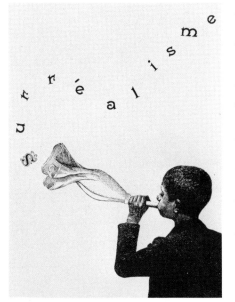

Fig. 13 Cornell's design for exhibition announcement of "Surréalisme," Julien Levy Gallery, New York, 1932

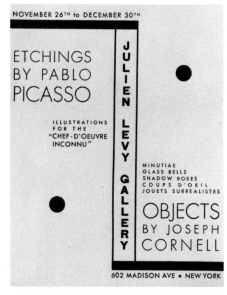

Fig. 14 Exhibition announcement for "Objects by Joseph Cornell," Julien Levy Gallery, 1932. Exhibition of Picasso etchings held simultaneously

after, Cornell returned to the gallery to show Levy several "montages," as he called his two-dimensional collages until the late 1940s. He was concerned about their resemblance to those by Max Ernst he had seen in the gallery.[61] Although Cornell's decision to show his collages to Levy changed the course of his life, a certain degree of ambiguity still surrounds his transition from collecting ephemera to fabricating an intimately scaled art. Thus, for example, whether Cornell had been on the verge of cutting and recombining graphic images or had already done so when he first saw Ernst's work remains unknown.

Sensitive to the dynamics of New York during the 1920s, a vital transitional period in American culture, Cornell found his sphere of interests and became involved with aesthetic concerns in an untutored, instinctive fashion. As noted earlier, he valued his exposure to modern French painting and music and other experiences prior to the 1930s as germinal influences for his creative work. Some time between 1925 and 1929 he had also tried briefly to make batik, his earliest known experiments with materials and techniques.[62] Most important, however, was the fact that Cornell had been "thinking about spontaneity and naturalness before SURREALISM and before working in art of thinking too much about box as box rather than experience of beauty in making."[63] It would appear then that Cornell was confronting the immediacy and force of his responses to the arts before 1931. In so doing, he may have turned to the writings of Mary Baker Eddy, who frequently noted the role of spontaneity and naturalness in perception and inspiration[64] That Christian Science indeed provided an important frame of reference was acknowledged by Cornell in a recollection of his early visits to the Levy Gallery: "My Science and healthy thoughts about the unconscious in Surrealism (about which I knew nothing) combined to give me extraordinary emotions."[65] Although Surrealism proved to be a necessary catalyst, Cornell was not aesthetically or intellectually unprepared for his experiences at the Levy Gallery.

★ EARLY CAREER, 1932–1940

Encouraged by Levy, Cornell entered a period which he later described as a "revelation [,] world of surrealism—a golden age—one of white magic without which I don't know where in the world I'd be today."[66] While supporting his family during the Depression, he became increasingly involved in making art and in meeting other artists and writers. By 1940 his commitment to a career in art was complete.

In January 1932 Cornell made his debut at the Julien Levy Gallery in "Surréalisme" (fig. 13), the first exhibition surveying the movement in New York. Then twenty-eight years old, he was represented by several collages and an object (page 18), a bell jar under which a Japanese fan and a collage of an eye in a rose rested in a mannequin's hand.[67] Although Cornell continued to work with collage throughout his life, his interest in assembling and containing objects surfaced quickly. The variety of his early experiments with three-dimensional formats is demonstrated by the works in his first one-man show (simultaneous with one by Picasso) at the Levy Gallery in November 1932.[68] Included were further studies of the bell jar and small objects such as "jouets surréalistes," mechanical toys modified by collage (figs. 12, 14)[69] Also in the show were the first works designated by Cornell as shadow boxes: palm-sized, rectangular and round paperboard cases holding loose or mounted engravings, straight pins, and other ephemera, under glass (pl. 33). Between 1932 and 1936 Cornell experimented with various containers for his constructions: round pine boxes (pl. 20), prefabricated paperboard boxes, and antique wood chests. The paperboard boxes, embellished with patterned papers and paint, contained mounted figurative cutouts behind glass, as in Untitled (Snow Maiden) (c. 1933) (pl. 24). They appear to be the immediate predecessors of his early constructions encased in hand-made wood boxes, of which Untitled (Soap Bubble Set) (1936) is the earliest example (pl. 1). Although Cornell modified paper-based found containers throughout his career, he concentrated on the more substantial, crafted format

of the wood box after 1936.

Placing the early phase of his career in perspective, Cornell wrote: "...even the Max Ernst influence was quickly transcended in favor of the shadow box technique and into a different world than Ernst."[70] If familiarity with work by other artists contributed to that transition, Cornell never acknowledged it. Instead he attached significance to experiences such as an encounter with a collection of compasses in the window of an antique shop:

I thought, everything can be used in a lifetime, can't it, and went on walking. I'd scarcely gone two blocks when I came on another shop window full of boxes, all different kinds....Halfway home on the train that night, I thought of the compasses and boxes, it occurred to me to put the two together.[71]

He also examined assorted old French boxes owned by Julien Levy, who occasionally proposed various structural and conceptual possibilities for Cornell's consideration. However, as Levy recalled: "...you would never know from his expression whether he was considering or resenting another's idea. Or had he already accepted or accomplished the matter?"[72]

Central to Cornell's move toward making rather than appropriating boxes was the acquisition of carpentry skills, his only known attempt to seek training in materials and methods. Between 1932 and 1935 he enlisted the assistance of Carl Backman, a next-door neighbor whose hobby was woodworking. Backman recalls:

Since Joe was not inclined toward making boxes his projects were more or less at a standstill. Since he was aware of my modest shop, he asked me to cut various pieces of wood which he took and somehow managed to assemble some boxes. As time went on and I realized what he was trying to do I offered my help in instructing him to use my circular saw and to design wooden boxes for his projects.[73]

Once proficient, Cornell worked regularly in his neighbor's basement shop until he acquired his own equipment in the mid-1940s.

As he became increasingly involved in making art, Cornell's metropolitan explorations assumed a vital creative dimension. Experiences, interests, and materials became valued not only for their intrinsic appeal but also for their role in the inspiration, research, and execution of his artwork. In 1934, for example, Cornell began acquiring documents and photographs pertaining to the "Pagode de Chanteloup" "that curious relic of scientific research in the nineteenth century," which grew into his portfolio project "The Crystal Cage (Portrait of Berenice)," presented as a layout in the "Americana Fantastica" issue of View in January 1943.[74] On one of several trips to the New York World's Fair, held in Flushing in 1939 and 1940, Cornell purchased quantities of Dutch clay pipes, many of which were later used in his Soap Bubble Sets and their variants. At the Fair, Cornell also visited the Masterpieces of Art Building, which housed an ambitious international selection of sculpture and paintings, including Dosso Dossi's canvas Circe and Her Lovers (c. 1525). Reproductions of the work became the centerpiece of his collage series Mathematics in Nature (pl. 226), initiated around 1964.

During the 1930s Cornell's interest in film also moved in new directions, although much remains unknown about the events and personalities involved. In 1933, concurrent with his efforts to make collages and objects, he wrote "Monsieur Phot," the scenario for a sophisticated but unrealized film about a photographer. Reflecting Cornell's love of photography, New York, and music, the scenario and the very thought of its writing may have been influenced also by his burgeoning knowledge of experimental films. In March and October 1933, for example, Cornell saw the Surrealist films L'Age d'or and Un Chien Andalou, both by Salvador Dali and Luis Buñuel, when they were screened by the New York Film Society.[75] Then one of the few forums for showing such work in New York, the Society had been founded by Julien Levy (fig. 15), Iris Barry (who became Curator of The Museum of Modern Art Film Library in 1935), Raoul de Roussy de Sales, and Nelson Rockefeller. Cornell's access to the historic, foreign, and experimental films shown by the Society, as well as

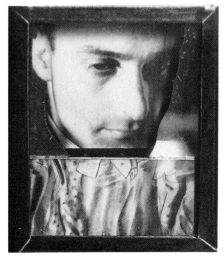

Fig. 15 Joseph Cornell: Untitled (Julien Levy). c. 1933–35. Construction, 7/8 x 5½ x 4½ in. Collection Mr. and Mrs. Julien Levy, Bridgewater, Connecticut

Fig. 16 Walter Murch: *Portrait of Joseph Cornell*. 1940–41. Oil, 10⅛ x 8 in. National Collection of Fine Arts, Smithsonian Institution, Washington, D.C., Gift of Mr. and Mrs. John A. Benton

Fig. 17 Joseph Cornell: Textile design, c. 1934–40. Tempera. National Collection of Fine Arts, Smithsonian Institution, Washington, D.C., Gift of Mr. and Mrs. John A. Benton

his love and knowledge of popular silent movies, undoubtedly inspired him to experiment at home with film montage techniques. Drawing upon his growing collection of commercial and educational films, Cornell produced *Rose Hobart*, perhaps the first of his early efforts, by December 1936.

The open, innovative atmosphere of the Julien Levy Gallery also greatly accelerated Cornell's transition from observer and student to member of New York's then small but intense cosmopolitan circles. His shyness and familial responsibilities notwithstanding, he began cultivating an extensive network of contacts and friends during his almost daily visits to the city. From the 1930s to the late 1950s, Cornell had a greater freedom, and certainly more than has been previously ascribed to him, to spend evenings in New York, entertain at Utopia Parkway, or travel. From the outset, however, he seldom participated in communal social activities and preferred one-to-one relationships maintained through personal visits and correspondence. Although a thoroughgoing roll call and examination of his relationships must be reserved for another occasion, a sampling of the photographers, artists, and writers whom Cornell knew by 1940 is enlightening.

Lee Miller, the American model and photographer, met Cornell in 1932 or 1933.[76] Interested in portraiture, she photographed him, and he in turn fashioned at least one photomontage portrait from pictures of Miller in his collection (pl. 269). In 1933 or 1934 Cornell acquired Salvador Dali's painting *Myself at the Age of 10 When I Was the Grasshopper Child*.[77] Only casually acquainted with Dali, Cornell was shocked and perplexed when he became the target of Dali's rage at the screening of Cornell's film *Rose Hobart* at the Levy Gallery in December 1936; evidently the film's concept paralleled one that Dali had in mind but hadn't executed.[78] Although Cornell first saw Marcel Duchamp at the Brummer Gallery during the Brancusi exhibition organized by Duchamp in the fall of 1933, their formal introduction probably occurred at the Levy Gallery; the two men struck up a friendship which

flourished after 1942 and lasted until Duchamp's death in 1968.[79] Cornell shared his interest in literature, film, and dance with the poet Charles Henri Ford, the critic Parker Tyler, and the painter Pavel Tchelitchew, who encouraged him to pursue his work throughout the 1930s and 1940s.[80] Friendly with Walter Murch from the late 1930s, Cornell gave the Canadian painter old photographs and found objects during visits to his studio on Riverside Drive.[81] On one such occasion in 1940 or 1941, Cornell sat for a portrait which he later returned because "He thought it made him look too thin"[82] (fig. 16).

As Cornell's career unfolded during the Depression, he continued to be faced with the necessity of earning a living. After selling refrigerators door-to-door for a brief time after 1931, Cornell was prevented from working for an unknown period of time by a serious eye inflammation which reduced him to walking with canes.[83] Around 1934 he was hired by his mother's friend Ethel Traphagen to design textiles at the Traphagen Commercial Textile Studio in New York. Cornell had no previous training for the work and did not seek any at its affiliate, The Traphagen School of Fashion, which offered courses in fashion, textile, and theater design. Cornell's designs, executed in tempera on paper, were based on tracings and enlargements of motifs illustrated in books and magazines; the extent to which they were translated into textiles is unknown (fig. 17).[84] Although Cornell appreciated the opportunity (remaining with the firm until 1940), he considered the work tedious, a reaction similar to, yet less agonizing than, that engendered by his earlier work at the Whitman Company. As in the 1920s, his rummaging provided an avenue of escape, as did his trips to the New York Public Library at Forty-second Street and Fifth Avenue, where he often researched his designs and listened to recordings in the Music Room.[85] Cornell also associated his interest in dance, especially the ballerina Fanny Cerrito, with his "Traphagen days when everything was transformed in the quest of the Romantic ballet."[86] The establishment of the Dance Archives, based

on the Lincoln Kirstein collection, by The Museum of Modern Art in October 1939, as well as his discovery of a nineteenth-century lithograph of Cerrito in the summer of 1940, galvanized his nascent interest in dance. By December 1940 Cornell translated his enthusiasm into several small boxes inspired by the Romantic ballet, including *Taglioni's Jewel Casket* (pl. 87).

During the late 1930s Cornell also began accepting freelance assignments from magazine editors and authors who were interested in his artwork and aware of his collections of ephemera and his ability to locate visual documents. His magazine assignments may have been obtained initially with the assistance of photographers such as George Platt Lynes, who exhibited at the Levy Gallery and whose work was often featured in American fashion magazines. In January 1937, *Harper's Bazaar* reproduced two of Cornell's collages (pls. 5, 6) as illustrations for a fashion column. In the same year, he assembled photographs for the book *The Movies Come from America* by the critic Gilbert Seldes, and also worked intermittently in the New York art department of Columbia Pictures doing "hack montage work,...'Lost Horizon', Grace Moore, etc., (never used...)...."[87] Although Cornell "himself was just above the poverty line," he never considered the federal art projects as an alternative, principally because he did not believe in accepting public assistance.[88] His still evolving perception of himself as an artist, lack of formal art training, and solitary working habits may have deterred him also.

In a family which placed great value on sentiment and communication, Cornell worked out patterns during the 1930s that helped him integrate and separate his artistic pursuits and personal life. After his sisters married, regular correspondence and visits served to maintain the family's close ties. In 1932 or 1933, for example, Cornell composed *Goop Joe's Poultry Pages*, weekly broadsides sent to his sister Elizabeth and her husband, who owned a chicken farm (fig. 18).[89] Parodying country newspapers and almanacs, the series demonstrates his sometimes pungent, some-

times homespun sense of humor shared most openly with his family. Although not meant as artworks, the *Pages* are among his earliest efforts to integrate collage and text. During the summer or fall, Cornell and his brother, Robert, generally vacationed with their sisters in the rural area near Long Island's south shore, where they lived. Likening its landscape and architecture to that of New England, Cornell greatly enjoyed exploring Long Island's wooded and coastal areas and hunting for antiques and specimens of nature. During their frequent visits to Utopia Parkway, Cornell's sisters and their families helped with household responsibilities and the care of their brother, Robert.

Confined to a wheelchair, Robert Cornell nonetheless led an active life in which his brother played an integral role. One of their strongest mutual interests was the movies, which they frequently attended in Bayside and Flushing from the 1920s on. While building his film collection in the following decade, Cornell also began showing old films at home, often only for Robert and himself, and occasionally for gatherings of the family and other guests.[90] As a young adult, in the 1930s, Robert pursued a variety of other hobbies, such as music, drawing, train collecting, short wave radio receiving, and reading, all with the assistance and encouragement of his family, especially his brother, Joseph.[91] Cornell, for example, often assembled Robert's train accessories and also helped him design and build an elaborate, portable layout for his train sets.[92] The project may have contributed to the belief that Cornell's art evolved from a desire to entertain his brother.[93] From the outset Robert was familiar with Cornell's collected materials and enjoyed watching him work in the kitchen and dining room. Cornell's artistic impulse, however, grew independently, out of a strong desire for self-expression.

During the 1930s, then, Cornell tried to juggle a variety of activities, as he would throughout his life. He pursued his art on a nightly and weekend basis, especially when working full-time at Traphagen's, which later prompted him to state that "things were done in a

Fig. 18 Issue of "Goop Joe's Poultry Page," c. 1932–33. Collection Elizabeth Cornell Benton, courtesy Joseph Cornell Study Center, NCFA

Fig. 19 Joseph Cornell: Cover design for *House and Garden*, November 1948. © Condé Nast Publications

kind of Sunday spirit."[94] Nonetheless he mustered enough work to appear in three one-man and three group shows at the Julien Levy Gallery by December 1940.[95] Through Levy's sponsorship came Cornell's first invitation to appear in a major museum exhibition, "American Painting and Sculpture of the 18th, 19th, and 20th Centuries," at the Wadsworth Atheneum, Hartford, in 1935. It was through Levy, as well, that the first sale of his work to a museum was arranged: the Wadsworth Atheneum bought the 1936 Soap Bubble Set (pl. I) in 1938. Clearly Cornell derived benefits from his crucially timed association with the gallery that few other American artists of his generation enjoyed during the emerging years of their careers.

The American press, however, granted his work relatively slight notice and concentrated on the concept of his objects as toys; a review of his one-man show at Levy's in December 1939 described it as "a holiday toy shop for sophisticated enjoyment,...intriguing as well as amusing."[96] Cornell never considered his work in such terms, maintaining instead that "as long as I have been making the objects my feeling has been a more serious one than of mere 'amusement,' a category into which they have been shoved too often in the 57th Street galleries."[97] In publications such as Julien Levy's *Surrealism* (1936) and the Galerie Beaux-Arts' *Dictionnaire abrégé du Surréalisme* (1938), as well as in The Museum of Modern Art's historic exhibition "Fantastic Art, Dada, Surrealism" (1936), Cornell was presented as a Surrealist, which also irritated him. Corresponding with Alfred H. Barr, Jr., who was directing the "Fantastic Art" exhibition in 1936, Cornell wrote: "...I do not share in the subconscious and dream theories of the surrealists. While fervently admiring much of their work, I have never been an official surrealist, and I believe that surrealism has healthier possibilities than have been developed."[98] Both interpretations of his work, coupled with an inherent modesty about it, laid the groundwork for Cornell's lifelong disavowal of critical scrutiny. At this crucial point in his career, however, he was basically heartened by the budding interest in his work, which increasingly absorbed his time and attention. Thoroughly aware of his family responsibilities, Cornell resolved his conflict about devoting himself to his art projects and related activities in discussions with his mother. Although just when this happened remains unclear, Cornell's decision probably coincided with the termination of his employment at Traphagen's in 1940.[99]

★ AT WORK, 1941–1950

During the 1940s Cornell accelerated his work on numerous overlapping projects at home and his search for inspiration, materials, and contacts in New York and elsewhere. In his notes on these activities, their symbiotic relationship emerges clearly, as does their impetus: "the transformation of persons, places, objects, etc. in the exaltation of experience...the importance of recapturing its meaning in its context and full flavor."[100] Evident also is the erratic yet persistent fashion in which Cornell worked. His fluctuating moods, triggered by weather conditions, irregular sleeping habits, or encounters with music, literature, and people, are characterized by his observation: "A day of mixed strains—familiar depression and exasperation relieved by definite periods of 'clearing' with encouraging feeling of progress."[101] His "seesawing" frame of mind (as Cornell termed it) became an integral part of his working process and affected the progress and events of his mature years.

Although his time was more his own after late 1940, Cornell sporadically found work to defray his personal expenses and to augment the family's meager income; his income from the sale of his work during the 1940s was very modest. He continued to freelance for magazines such as *Vogue* and *House and Garden* until 1957, researching illustrations and designing layouts and montages for covers, features, and advertisements (fig. 19).[102] Alexander Liberman, as the Art Director for *Vogue* after 1943, was largely responsible for retaining Cornell. Partly as a patriotic gesture, Cornell worked on the assembly line of a radio manufacturer, Allied Control Company, Inc., from May to November

1943.[103] Although he observed his coworkers with great interest and compassion, Cornell himself found the routine confining.[104] Between the spring and winter of 1944 he sold merchandise and did handiwork at the Garden Center, a large nursery in Flushing, owned by a Christian Science practitioner with whom he was friendly. Subsequently he conceived *GC 44*, a collection of notes, books, and mounted colorplates dedicated to his experiences associated with the nursery's Arcadian atmosphere.[105] In the fall of 1945 Cornell unsuccessfully applied for a grant from the John Simon Guggenheim Memorial Foundation, his only known attempt to obtain official support for his art.[106]

Central to Cornell's efforts was the organization of his basement studio, undertaken in 1941.[107] By 1948 he was able to characterize his hopes for its function: "Had elated feelings...about fixing up cellar better toward workshop–gallery—laboratory combination inviting people out, etc."[108] As activities overtook the entire house, Cornell chafed under the difficulty of fulfilling this concept, but the cellar remained his principal work space. In its privacy he tried to prepare his materials and projects on a daily basis, often early in the morning or late at night. On April 15, 1946, for example, he wrote:

One of best days at home (feeling right without having to get away). Carried over with little sleep from Sunday worked late on owl box in cellar....Had satisfactory feeling about cleaning up debris on cellar floor—"sweepings" represent all the rich cross-currents ramifications that go into the boxes but which are not apparent (I feel at least) in the final result. See "watchmaker's sweepings" in MacAgy Cabinet of vials—unfoldment better in 'Night Portrait'...added powdered wood to *Natural History* boxes (working materials)....Also got out LAUREN BACALL box which seemed appropriate to work on again. Had constructive feeling about same, unusual as the box has lain dormant for months...[109]

Finding it difficult to work at home on other occasions, Cornell often spent the better part of a day running errands, visiting friends, and browsing:

Starting out to dentist—fairly calm feelings—bus with Marianne Moore's "nevertheless" poems and on subway....Photostats of material for "Beautés de l'Opéra" to McNally....Wandered down B'way...Swiss book for 10¢ To *View* for "Soap Bubble Set." Met John Myers. To Ballet Caravan. Had talk with Tennessee Williams & Donald W[indham]. To Hampton Cafeteria for lunch. Danish and coffee. Argosy, found Maeterlinck's "Old-Fashioned Flowers," French "Petit de Thèmes," "Italian Lakes..."[110]

Engaged in these activities, Cornell sought the "usual stimulating feeling of release and perspective on my work that comes from getting into town."[111] He also explored Flushing, Bayside, and sections of Long Island, particularly after he acquired a bicycle in 1944. Around abandoned home sites, in fields and along the beach, Cornell collected "flotsam and jetsam" for his work: driftwood, piston rings, wine glasses, picture frames, architectural molding, and even junked films.[112] He also derived great inspiration from the "beautiful country feeling through rural roads still unspoiled by developments."[113]

In the context of such patterns, Cornell was working at this time principally on his boxes. Several developments or concerns about them are worth noting. As early as 1941, Cornell addressed the problems inherent in using aged and breakable materials in a handcrafted, fragile format: "As I progress with the objects I am learning more and more how to get them foolproof from casualties over what I hope will be a long life for most of them."[114] The compendium of personalities, objects, places, and events in "The Crystal Cage (Portrait of Berenice)," published in *View* in January 1943, can be cited as evidence of Cornell's rapidly developed, extensive repertoire of subjects and interests.[115] Furthermore, a tendency pursued tentatively in the 1930s, that is, working with cross-references, variations, and series in the imagery and themes of his boxes, also became more pronounced early in the 1940s. Cornell's exploration of an idea in multiple examples or variants is perhaps best characterized by an observation he made in 1946: "...I have been discovering in the most unexpected & delightful manner...that it is possible to see 'lightning strike in the same place' more than once."[116]

Fig. 20 Joseph Cornell: Cover design for *Dance Index*, June 1946

The most significant development, however, was Cornell's investigation of other forms of expression. Over the years his writing most consistently took the form of correspondence and notes. However, encouraged by friends such as Charles Henri Ford and Parker Tyler during the 1940s, Cornell pursued it in more formal terms. Between 1941 and 1947 he was given the opportunity to do so principally in the magazines *View* and *Dance Index*. Founded by writer Charles Henri Ford in 1940, *View* featured contemporary art and literature by Americans, such as Florine Stettheimer and William Carlos Wiliams, and European expatriates, such as Max Ernst and André Breton. Cornell's essay and photomontage entitled "'Enchanted Wanderer': Excerpt from a Journey Album for Hedy Lamarr," published in the December 1941 issue of *View*, remains his most lyrical integration of text and imagery (page 73). *Dance Index*, founded by Lincoln Kirstein, Baird Hastings, and Paul Magriel in 1942, was a landmark publication in its devotion to dance appreciation and scholarship. Kirstein, aware of Cornell's balletomania and allusions to dance in his constructions, immediately recruited him to design montage covers for *Dance Index*. Encouraged by one of its editors, Donald Windham, Cornell also developed the concepts of four issues, although he found it difficult to complete each project, wanting to retain the option for change and embellishment.[117] Consisting of Cornell's commentary, visual documents, and literary excerpts, the issues were completed under the editorial direction of Windham and his successor, Marian Eames (fig. 20).[118]

Cornell's interest in finding an alternative to the box, however, received its fullest expression in his "explorations." During the 1930s, he had started files of related photographs, prints, and other memorabilia; from this practice grew his massive assembly of folders, envelopes, and cartons marked according to subjects and series, such as Castles and Nostalgia of the Sea, and working materials, such as Owl Cutouts. Cornell often referred to the folders and envelopes as dossiers and portfolios. In a spirit akin to assembling Victorian albums, he deposited in them loose or mounted photographs and photocopied reproductions, clippings from books and periodicals, postcards, notes, and other materials. In the concept and format of both the dossier and portfolio, Cornell believed he had found a more inclusive, open-ended means of working than the distillation involved in making a box allowed. Cornell's attachment to this alternative was dramatically demonstrated in his exhibition, "Portraits of Women: Constructions and Arrangements by Joseph Cornell," held in December 1946 at the Hugo Gallery in New York. Included were box-constructions such as *Untitled (Penny Arcade Portrait of Lauren Bacall)* (pl. X) and *Souvenirs for Singleton (Jennifer Jones in Love Letters)* and layouts of the documents and ephemera comprising portfolio explorations, such as *Portrait of Ondine* (pl. 93), dedicated to the Romantic ballerina Fanny Cerrito. His complementary work on the formal constructions and the more fluid "explorations" or "arrangements" was pursued consistently thereafter, although Cornell met with little success in his efforts to exhibit them in the following decades.

During the 1940s Cornell's circle of friends and contacts continued to expand as he became increasingly involved with several galleries, publishing concerns, and interests such as the dance and film. A great admirer of the Russian ballerina Tamara Toumanova, he met her late in 1940 or early in 1941 when Pavel Tchelitchew brought her to Utopia Parkway on a surprise visit.[119] Cornell attended many of Toumanova's performances before she moved to California in 1942, and he created several boxes and collages in her honor (pls. 52, 95, 99). By 1942 Cornell also met Matta, probably at the Levy Gallery; Matta recalls their warm friendship:

I was very fond of Jo Jo (he loved to be called in this french [sic] distinction). ... He spent often weekends at Sneden's Landing where I lived during the war, he used to arrive always with a surprise; a suitcase filled with objects, old films, photos, etc. ... I remember one weekend that I spent at Utopia Parkway, the first thing he showed me as a 'promise' of *good* weekend was the ice-box—it was packed with cakes, ice cream, and all sorts of sweets....[120]

Through Matta Cornell met Robert Motherwell, with whom he discussed "nineteenth century culture, particularly ballet, Mallarmé, small hotels, Berlioz and Erik Satie, whiteness,..." primarily between 1942 and 1947.[121] Although they never talked about Abstract Expressionism, in December 1949 Cornell presented Motherwell with an inscribed box (pl. 140) made in what "he conceived to be an Abstract Expressionist style"—poster paints splattered on an interior of newspaper, cardboard, and wood dowels.[122] Before March 1942, Peggy Guggenheim, then organizing her gallery, Art of This Century, in New York, acquired two boxes and an object from Cornell, who was brought to her attention by Duchamp. She also included Cornell in her opening exhibition in October and in a three-person show with Duchamp and Laurence Vail in December of the same year.[123] Cornell first met Max Ernst at Art of This Century; over the years he maintained an amicable relationship with Ernst and his wife Dorothea Tanning through correspondence and their visits to Utopia Parkway.[124] Crossing paths because of their association with *View*, Cornell and Marianne Moore corresponded, principally during the 1940s, when he also visited Moore and her mother in Brooklyn.[125]

By the mid-1940s, Cornell was a recognized member of the network of people collecting, trading, and restoring old films; one of his most valued contacts was Francis Doublier, the pioneering cameraman for the Lumière brothers in Paris in the 1890s and an expert film technician who, until his death in 1948, restored and made prints of films in Cornell's collection. Cornell had also become increasingly interested in screening selections from his collection. At the Norlyst Gallery in March 1947, for example, he staged "a two-hour program of selected rarities from the collection of Joseph Cornell. Shown with special music."[126] Thereafter, Cornell frequently conducted such programs himself, equipped with his records, battered phonograph, and projector. In October 1950, Cornell and the photographer Ernst Beadle went to Rochester, New York, to see James

Card, a film collector and staff member of the George Eastman House, Inc. In Card's home they screened examples from their respective holdings, including some of Cornell's own experiments with found footage.[127]

Cornell remained affiliated with Art of This Century and the Julien Levy galleries until they closed in the springs of 1947 and 1949 respectively. During the late 1940s, however, exhibitions at several other galleries were landmarks in his career. On September 28, 1948, Copley Galleries in Beverly Hills, California, presented "Objects by Joseph Cornell." William N. Copley and his brother-in-law John Ployardt, founders of the gallery, were meeting with little success in their effort to champion Surrealism in California, where collectors and dealers interested in twentieth-century art were then relatively rare.[128] During the six months of the gallery's existence, they presented ambitious, although commercially unsuccessful, one-man exhibitions by René Magritte, Cornell, Matta, Yves Tanguy, Man Ray, and Ernst (the latter being Ernst's first retrospective). Having met Cornell through Alexandre Iolas at the Hugo Gallery, Copley and Ployardt arranged a show of forty-two works, which provided the first representative survey of Cornell's romantic, often literary series from the 1930s onward.[129]

On November 14, 1949, the Hugo Gallery, where Cornell had exhibited in the company of Dali, Tanguy, Tchelitchew, Eugene Berman, and others since 1944, opened tandem shows, "La Lanterne Magique du Ballet Romantique of Joseph Cornell" and "Décors for Ballets Choreographed by Roland Petit." In October, Petit's company, Les Ballets de Paris, had opened in New York at the Winter Garden Theater, offering *Carmen* as its major ballet, with Renée (Zizi) Jeanmaire dancing the title role. Cornell attended a performance of *Carmen* with Alexandre Iolas, formerly a dancer and then director of the Hugo Gallery, ·who arranged for Cornell to visit Jeanmaire in her dressing room. He consequently made at least three boxes and three collages featuring photographs of her in *Carmen* and other ballets (pl. 103). Several of

Fig. 21 Installation view of exhibition "Aviary by Joseph Cornell," Egan Gallery, New York, December 1949. Photographed by Aaron Siskind

these works, and objects dedicated to dancers such as Tamara Toumanova, comprised Cornell's show, dramatically installed against the blue-velvet walls of the Hugo Gallery. For him the high point of its opening was the praise of Petit and the appearance of Jeanmaire, whose affectionate greeting in the French manner delighted him. The exhibition, the last devoted to his dance-inspired works, marked, more importantly, the last occasion on which Cornell exhibited in a commercial gallery associated with Surrealism's heyday in New York.

In December 1949, on the heels of his show at the Hugo Gallery, the Egan Gallery opened "Aviary by Joseph Cornell," an exhibition based on a series Cornell had worked on since around 1946. Having visited the gallery often since its opening a few years before, he approached its owner, Charles Egan, in the spring of 1949 about the possibility of showing his Aviary constructions.[130] In need of representation after the demise of Levy's and Guggenheim's galleries, undoubtedly Cornell also sensed that his new boxes—more abstract and painterly—should be presented in a different context. In selecting Egan, he allied himself with a dealer whose early support of Franz Kline and Willem de Kooning, among others, contributed greatly to the recognition of the New

York School as the dynamic force in American art at midcentury. The twenty-six Aviary boxes in Cornell's show incorporated mounted cutouts of colorful birds, mirrors, springs, and drawers starkly ordered in luminously painted containers (fig. 21). The show was reviewed by Thomas B. Hess, who noted: "These new works of sunbleached and whitewashed boxes...have a strict honesty, a concentration on texture and ordering of space, that raise them far above the older, velours-lined jobs."[131]

Cornell's expanded formal concerns were confirmed by the Observatories and other boxes in his second one-man exhibition at the Egan Gallery, "Night Songs & Other New Work—1950, by Joseph Cornell" in December 1950 (fig. 22). In modifying the direction and mood of his boxes, however, Cornell did not lose sight of his abiding dilemma: "The intense longing to get into the boxes this overflowing, a richness & poetry felt when working with the boxes but which has often been completely extraneous in the final product."[132]

★ AT WORK, 1951-1961

In April 1958, Cornell noted his "recognition of importance of 'at home' experiences as satisfying vs. frustration of getting boxes done with the generally attendant frustration of inadequacy of the medium, opposed to freshness &

spontaneity about life and people."[133] Having first experienced this seesawing attitude as his work matured in the 1940s, he dealt increasingly with its personal and professional aspects during the 1950s.

Early in 1951 Cornell suffered his first prolonged period of "...varying pressures in spine, right leg, etc.," and consequently found it difficult to work.[34] He frequently recorded the disruptive, at times incapacitating effects of similar attacks, as well as those of migraine, insomnia, and vertigo, which recurred until his death. Although his eagerness to pursue new ideas generated by his exhibitions at the Egan Gallery had been temporarily interrupted, Cornell resumed his efforts in the spring and summer of 1951. In September he and his brother, Robert, spent approximately a month at their sister Elizabeth's farm in Westhampton, Long Island—one of Cornell's lengthiest separations from his Utopia Parkway home until the spring of 1972. Walking in the woods, he observed "this ethereal magic of simplicity in the commonest aspects of Nature."[135] An inveterate stargazer, he was prompted to write about "the expansiveness of the heavens, the song of nature, the breezes, the fragrances of the grasses—like a great breathing, deep, harmonious, elemental, cosmic."[136] Not coincidentally, during this period natural order emerged as an important concept in his work.

The change in Cornell's activities and attitudes was gradual but noticeable during the early 1950s. Although trips to the city in search of materials and experiences remained an integral part of his routine, he lamented the scarcity and declining quality of books and other items previously available in rich supply on Fourth Avenue (he considered the problem an aftereffect of wartime destruction in Europe). Cornell also reacted strongly to the demolition of cherished landmarks such as the Third Avenue El in 1955 and the Bible House on Astor Place in 1956. The areas surrounding Grand Central Station and Times Square assumed greater importance in his searches, as did resources such as the annual antiques fairs at the New York Armory and Madison Square Garden. Flushing's libraries and variety stores (Woolworth's and Fischer Beer's on Main Street) also began to figure more prominently in his life. Concerning the latter development, Cornell wrote: "—suddenly that intense and sheer delight in the commonplace, the dingy, the banal, etc....Here a kind of resolution, a felicity found increasingly nearer home than the former obsession to escape further afield for this sort of experience."[137] Still collecting at an unrelenting rate, for the first time he expressed regret that much of the material would never be used, begrudging the time, effort, and space consumed in storing and classifying it, while, on other occasions, speaking of the acquisition and organization of material as sufficient and stimulating activities.[38]

After 1951 Cornell was particularly sensitive to his "often experienced dissatisfaction with the medium of the boxes no matter how successful in working on—their cumbersomeness, immobility, loss of lustre having passed into collectors' hands..."[139] His frustration and health problems notwithstanding, Cornell's production of boxes during the 1950s was considerable. Creating an abundance of new series and their variants—the Dovecote, Hotel, and Sun boxes, among others—he also devoted considerable effort to reinterpreting and refining older concepts and individual works, such as the Soap Bubble, Medici Slot Machine, and Sand boxes.

Cornell's ambivalent attitude toward the constructions continued to stimulate other creative activities.[40] After 1951 he periodically expanded and revised *Portrait of Ondine*, *GC44*, and other portfolios, adding mounted illustrations, notes, and literary excerpts and experimenting with ways of exhibiting them.[41] Often feeling that their format and contents fell short of his expectations, he never realized his plans for preparing boxed editions of these compilations in the manner of Duchamp's Valises. However, at his own expense, Cornell published limited editions of two pamphlets, *Maria* (1954) and the *Bel Canto Pet* (1955). Conceived in the manner of French *feuilletons*

(serialized stories), the pamphlets contained literary excerpts dedicated respectively to the nineteenth-century opera singers Maria Malibran-Garcia and Julia Grisi.[142] Cornell added individual collage inserts and inscriptions when distributing them, primarily to friends.

Early in the 1950s, the accidental damage to a box in his cellar workshop provided Cornell with "...a generous glimpse of possibilities into working in the freer medium of collage & 'painting' (rubbing, scraping, etc.) on flat mounts—masonite or plywood."[143] Initially his discovery was utilized in his boxes, particularly in the series dedicated to Juan Gris (pls. 144, 145) and in those containing details of Italian Renaissance paintings such as *La Bella* by Parmagianino (pl. 122). In the fall of 1955, however, Cornell resumed making collages as independent, two-dimensional works. Among those produced at this time were the first in the series based respectively on John Singleton Copley's painting, *Daniel Crommelin Verplanck* (1771), and Friedrich Hölderlin's verse, "Home, poor heart, you cannot rediscover if the dream alone does not suffice" (the series persisted into the following decade; see pls. 285 and 241). Unlike his earlier "montages," derived from original and reproduced black-and-white engravings and woodcuts from turn-of-the-century books, Cornell's later collages were based on clippings from colorful contemporary books, magazines, and commercial art reproductions. His stockpile of periodicals such as *Arizona Highways*, *National Geographic Magazine*, and *Art News* was thereafter supplemented by multiple copies bought in the back-number shops along Forty-second Street and elsewhere. Although Cornell made most of his collages in the following decade, he readily mastered the mechanics (including clipping, mounting, staining, and framing) and poetics (developing themes and iconography) of collage by the late 1950s. During this period, Cornell enjoyed a working relationship with his sister Elizabeth, who had started making collages, stimulated by her appreciation of her brother's work as well as by their discussions about art, including collage. They frequently exchanged source materials and criticism, and Cornell mounted, framed, and sometimes modified his sister's collages.[144]

His search for alternatives undoubtedly also affected Cornell's film activities during the 1950s. He continued to screen films at home for the family and guests and to stage special programs, notably in Woodstock, New York, in August 1952 at the invitation of Julio de Diego.[145] He also renewed his interest in making films, although his orientation shifted from editing found footage to working on location with other filmmakers. His subject matter may have been responsible in part for this change: during the early 1950s, he was particularly sensitive to the architecture and monuments in neighborhoods explored since the 1920s. Revisiting the Fourth Avenue bookstores, for example, he noted that "lately the past has been coming back with an amazing upsurge even though the buildings are dustier and grimier than ever."[146] The nostalgic drive to preserve is evident in films such as *GniR RednoW* and *Centuries of June* (both 1955), based on landmarks scheduled for demolition, the Third Avenue El and a Flushing homestead, respectively. Always concerned with New York's flow of humanity, Cornell also focused on individuals in the films—the numerous young women he recruited to react to the city, children playing on Mulberry Street, the elderly sitting on park benches. Untrained and disinterested in using a camera, he subsequently sought the assistance of filmmakers Rudy Burckhardt and Stan Brakhage.[147] Although Cornell had approached Burckhardt as early as 1952, having met him through Robert Motherwell in 1949, they filmed primarily between 1954 and 1962; Brakhage's work was concentrated in 1955, after they had met through Parker Tyler in 1954. With the exception of the Third Avenue El film, shot by Brakhage, and *What Mozart saw on Mulberry Street*, edited by Burckhardt, they photographed under Cornell's eye and did not edit the footage. Stan Brakhage characterized the making of *Centuries of June* in the following manner:

In torment (similar to that which had prompted him to ask me to photograph the

3rd Avenue El before it was destroyed) he suggested we spend the afternoon preserving "the world of this house," its environs. It would be too strong a word to say he "directed" my photography, and yet his presence and constant suggestions (often simply by a lift of his hand, or eyebrow even) made this film entirely his. He then spent years editing it, incorporating "retakes" into the film's natural progress, savoring and lovingly using almost every bit of the footage. And then he gave it to me, "in memory of that afternoon."[148]

Once again, Cornell experienced a certain degree of dissatisfaction: "love of humanity — no matter how much might be taken on film this urge might not be satisfying — there is [sic] always the things that the camera cannot catch — still gratitude should be shown for the fine work done so far."[149] Ultimately, his frustration was a function of his intense expectations rather than of the medium in which he worked.

Throughout the 1950s, Cornell continued to discuss his work and ideas with old friends such as Donald Windham and with new acquaintances such as Willem de Kooning, Mark Rothko, and Piero Dorazio![150] Matta had provided the latter with a letter of introduction to Cornell, who received him at Utopia Parkway in June of 1953![151] Subsequently, Dorazio and his wife Virginia enjoyed a warm friendship with Cornell, visiting him especially between 1960 and 1962. Dorazio, in turn, arranged the first meeting between Cornell and the Chicago collector Edwin A. Bergman in September 1959; Bergman and his wife Lindy had already begun to collect Cornell's work at that time.

Looking back on the decade, Cornell observed that "the Egan period [1949–57] was the only time I really belonged."[152] This somewhat surprising attitude — in light of his interaction with artists and writers in New York since 1931 — can be attributed to several factors. At the Levy, Hugo, and Art of This Century galleries, Cornell had moved in European-dominated circles, where he was welcomed as a curiously kindred American spirit. Conversely, his contact with American artists during the same period was limited, in part because he did not participate in the federal art projects.

Exhibiting at the Egan Gallery after 1949, Cornell was unobtrusively but quickly drawn into the context of the American avant-garde. It was there that he shed his image as a maker of adult toys and received increasing attention from museums and galleries actively involved in presenting advanced tendencies in American painting and sculpture. In January 1951, The Museum of Modern Art acquired the box *Central Park Carrousel — 1950 — in Memoriam* (pl. 212) from the Egan Gallery show "Night Songs and Other New Work." Late in 1951, Dorothy Miller asked Cornell to participate in "Fifteen Americans," scheduled to open in April 1952 as one in a series of influential American group shows she was organizing at The Museum of Modern Art. They discussed the possibility of his making a gallery into a complete environment, but Cornell decided there was not enough time to do what he wanted and declined the invitation![153] Between 1953 and 1956 the Whitney Museum of American Art regularly included him in its Annuals. In July of 1953 the Walker Art Center in Minneapolis organized his first one-man show in an American museum. In the same year the Allan Frumkin Gallery in Chicago presented an exhibition that introduced Cornell to Chicago collectors. In 1954 and 1957, he appeared in the invitational annual exhibitions of painting and sculpture at Eleanor Ward's Stable Gallery in New York, where the work of many first- and second-generation members of the New York School was presented. Cornell maintained an association with the Stable Gallery until 1960, having introduced several new box series there in exhibitions such as "Winter Night Skies by Joseph Cornell" (1955). Among the major museum surveys in which he was included was "The Art of Assemblage" (1961–62), organized and circulated by The Museum of Modern Art. The show in which Duchamp, Schwitters, and Cornell were most extensively represented, it made the first significant attempt to place Cornell's work in a context other than Surrealism.

Although Cornell genuinely appreciated opportunities to exhibit and sell his work, he often found it difficult to

Fig. 22 Exhibition announcement, Egan Gallery, December 1950

Fig. 23 Cornell's workroom, 1969. Photographed by Hans Namuth

contend with dealers and collectors. However, he also distinguished between "gallery trotters" and the great anonymous array of people who commanded his curiosity and compassion. From the outset, they composed the audience he wished to cultivate.[154] He increasingly remarked on "this always potent reminder of reaching people[,] the difficulties seemingly in art galleries etc." and on his particular desire to communicate with young people through his artwork.[155] Expecting to publish or exhibit his explorations— portfolios and dossiers—he thought that their "état brut" and variety of materials could provide possibilities for others to pursue.[156] He also initiated efforts to place his boxes in libraries, most notably the New York Public Library, and schools such as Bennington College in Vermont, where the exhibition: "Selected Works by Joseph Cornell: Bonitas Solstitialis and an Exploration of the Colombier" was presented in the winter of 1959.[157]

As the strength of his mother and brother began to decline during the late 1950s, Cornell found it increasingly difficult to work and handle his responsibilities at home.[158] Consequently, he explored various means of obtaining housekeeping and nursing services, and by 1958, also began hiring young people, generally recruited through friends or by advertising in Flushing's newspapers, to help reorganize his work and storage areas in the house.[159] In the past Cornell had referred to both the joy and tedium of the manual aspects of making the boxes; now having access to helpers with carpentry skills, he asked several to build the wood shells of boxes. Cornell, however, never completely relinquished this aspect of his work, reminding himself of his "appreciation of doing own work vs. helper with carpentry but a good physical working is the thing (spells of inertia—maddening) old wood—very personal feeling—esp. reclaiming aspects."[160] By 1961 he had also established the practice of hiring assistants to help scout for materials, sort his papers and books, and even clip magazines for his collage work, as indicated by his anonymous advertise-ment in a Flushing newspaper: "Girl Over 16 Fine Scissors Work on Pictorial Clippings Assisting Artist—limited Part Time."[161]

★ FINAL DECADE, 1962–1972

Of the several phases of Cornell's life, it is perhaps the last in which the problem of unraveling his experiences and attitudes is most difficult. Although increasing references to his mythic seclusion provoked Cornell, public scrutiny by way of exhibitions and publications during the 1960s did little to produce substantive information on his life and work. Believed to have ceased making boxes, Cornell in fact was trying to sustain many of his projects in the face of difficult personal circumstances.[162] It is clear, however, that he fluctuated between periods of diminishing energy and activity and those marked by almost compensating vigor.

Reminiscing in January 1964 about the exhibition "The Art of Assemblage," Cornell noted the existence of an "impasse since then [fall 1961]— domestic sit[uation] slowing down of work—M[other's] shut-in condition, etc."[163] Although he often lost sight of his progress and accomplishments, during the early 1960s the increasing dependency of his brother and aging mother clearly affected his ability to work.[164] Required to spend more time at home, for example, he began modifying his metropolitan schedule, relying increasingly on assistants to run errands or locate materials (fig. 23). Although his trips to New York and Flushing became more irregular, they still provided the release and perspective he had always sought in making them. His excursions also continued to provide inspiration for artwork, particularly his collages. Despite their declining character, Times Square and Sixth Avenue, for example, assumed a heightened mystique as he recalled their associations with his childhood and the 1920s.[165] In his collages after 1962, the abundant variations on the themes of the Penny Arcade and Jeanne Eagels (pls. 247, 257) reflect his renewed interest in the vicinity.

Cornell also identified Times Square with his friendship with Joyce Hunter,

a waitress and struggling actress whom he had first encountered in a Sixth Avenue coffee shop in February 1962 after a filming session with Rudy Burckhardt. Taken with "the adorable friendliness of the teener who picked out a number for me on the jukebox & the kind of 'theater' she unconsciously supplied for an audience of one," Cornell gradually befriended her, showing her his work and worrying about her welfare.[66] Since the 1920s, he had patronized modest restaurants — cafeterias, diners, and automats. Like commuter trains, 5-&-10¢ stores, and the city streets themselves, they had provided him with numerous opportunities to observe the "ineffable beauty" and "pathos of the commonplace" in the lives of people in the city. Often singled out in this context for his contemplation and inspiration were young working girls who waited on him in Woolworth's and other stores, or who, like Suzanne Miller, appeared in his films such as *Legend for Fountains* (1957). Dossiers, boxes, collages, and mementos were dedicated and sometimes given to them, particularly during the late 1950s and throughout the '60s. Joyce Hunter, commemorated in notes and collages after 1962 as "Tina" (a name Cornell applied to his feminine ideal), was a prominent example (pl. 260)![67] On one level, Cornell's interest in Joyce personalized his efforts to reach otherwise anonymous young or underprivileged people through his art and other means. In addition to contributing generously for many years to organizations such as the Lighthouse for the Blind, he often spoke of his "desire of sharing warmth and richness of home potentialities, etc. with city youth living in austerity and worse..."[68] That Cornell often paid a price for his unappreciated assistance or misplaced trust was most dramatically demonstrated in September 1964, when Joyce Hunter and two friends were arrested for stealing nine boxes from Cornell's home![69] On another level, the powerful attraction he felt for Joyce Hunter epitomizes the degree to which Cornell's idealized empathy for women impelled him to cultivate many women as confidants during the 1960s.

A great admirer of Susan Sontag, he corresponded with her before and after meeting her in January 1966 and made at least one collage, *The Ellipsian* (pl. 270), in her honor. Her review of Maurice Nadeau's book on Surrealism (newly translated from the French) rekindled Cornell's memories of André Breton, whom he had met after Breton's arrival in New York in 1941![70] Subsequently making collages based on reproductions of a Man Ray photograph of Breton (pl. 271), he gave one of the collages to Sontag. Allegra Kent, a ballerina with the New York City Ballet, sought out in the mid-1950s to appear in his films, sporadically corresponded and visited with him throughout the decade. Having dedicated several boxes to her after 1956, Cornell continued to express his admiration in collage (pl. 252), including at least two in his series Puzzle of the Reward. Also fond of her children, he dedicated and gave to her daughter Trista one of the major boxes he made during the late 1960s (pl. 199).

Although increasingly housebound, Cornell selectively visited and corresponded with his friends. His contact with Walter De Maria and Robert Whitman, for example, led to the first showing of Cornell's early and later films as a group in April 1963 at their artists' space, 9 Great Jones Street, in New York. On June 25, 1963, Charles Henri Ford brought Robert Indiana, James Rosenquist, and Andy Warhol to Utopia Parkway, where Cornell, quite excited about the visit, showed them through the house![71] In October of the same year, Cornell received Richard Hamilton, whose comments on R. B. Kitaj's practice of writing on the back of his canvases caught Cornell's attention because of his own evolving habit of inscribing the collages on the reverse![72]

Throughout the decade Cornell worked in an increasingly fitful manner. Generally, his most consistent efforts were directed toward making collages, the numbers and variations of which rival those of the boxes produced since the inception of his career. As his production of boxes began to decline during the early 1960s, he often refurbished earlier attempts or refined and simplified

previously established themes, such as the numerous space-oriented series. Nonetheless, his papers indicate that he had shells of boxes made by his assistants according to his specifications as late as 1971, thereby implying his intention of working on them.

In need of further scrutiny is the role of his numerous assistants, whose tenures frequently overlapped (without their knowledge), ranging from several days to several years. In 1962, reflecting upon his difficulty in working over a period of years, he noted the importance of helpers: "...how many breaks have come through the help of a young person..." In other instances he remarked on the "futility from expectancy of right kind of assistance" and his attempts to counteract his "...tendency toward 'rejection' of anyone who tries to help me."[173] While most of his helpers provided companionship and performed sundry secretarial and household duties, Cornell was also impelled by a strong desire to work with young people whom he could teach![174] Subsequently, some of his assistants, art students from local universities or practicing artists such as Larry Jordan (also a filmmaker) and Terry Schutté, were selectively trained in his methods and resources and contributed to the execution of boxes and collages in varying degrees. Others were permitted or asked to photograph various parts of the house, his artworks, specially arranged setups of materials, or subjects in New York and Flushing. Cornell subsequently incorporated some of the photographs in collages, primarily after 1964, as in *How Many Miles to Babylon?* (pl. 286), in which Eve Propp's photograph of a yard across the street from Cornell's house is transformed. While working with Larry Jordan in 1965, Cornell allowed Jordan to film him and individual works in the cellar and other parts of the house. With the footage, Jordan produced in 1978 a nine-minute color film, *Joseph Cornell, 1965,* in homage to the artist and his experiences with him.

During the periods in which he found it difficult to work, Cornell reviewed and collated his source materials and papers, while also adding to them. Between 1963 and 1967, for example, he engaged in "splurges, binges, compulsions...with respect to long-playing records sense of records bought wildly, yes,—actually so—as new found friends to fill a void."[175] Cornell escalated his persistent recording of his activities and observations, and he remained concerned about the "perennial problem" of doing so: "—a delicate yet significant nuance almost smothered to death—the 'artist doesn't come through' in these jottings enough to send on to (even) a confidant—and yet the 'quest' the forever striving to give form to wondrous but different experience."[176] Largely responsible for Cornell's frustration with the validity of his diarying at this time were his efforts to write about his dreams. Attentive to his hypnagogic and other dream states since the 1920s, he experienced dreams with greater frequency and intensity during the last decade of his life, particularly after 1964.

Between 1964 and 1966 Cornell was deeply affected by several events in his personal life. On December 18, 1964, Joyce Hunter, to whom he had remained sympathetic despite the robbery, was murdered in New York. Cornell's sense of loss was profound. Shortly after her death, Cornell began inscribing his collages, particularly those in his Penny Arcade-cum-Times Square series, with her name and related observations, and also "sketched out a collage film as a memorial—to counteract sadness..."[177] At Cornell's request, in 1965 Larry Jordan filmed scenes in the Flushing graveyard where Joyce Hunter had been buried.

The principal disruptions in Cornell's life at this time, however, were the deaths of his brother on February 26, 1965, and his mother on October 19, 1966; both had lived with his sister Helen in Westhampton, New York, since December 1964. Despite the understandably trying aspects of their domestic situation over the years, which Cornell had felt acutely during the late 1950s and early '60s, he had deeply loved Robert and his mother and consequently found it difficult to adjust to their loss. Even before Robert's death, Cornell had often written about his admiration

for his brother's courage and talents: "after much penning of a possibly unneccessary nature and quantity about others, etc....the essential nature of R[obert] is something too deep & dif[ficult] for adequate expression."[178] In 1965, in an effort to memorialize Robert's accomplishments, Cornell dedicated some of his own collages to him, as in the series Time Transfixed (pl. 246), and also began working with his brother's drawings. Although he had deliberately shied away from drawing as a means of expression, Cornell had encouraged Robert's hobby, which had produced since the 1920s a voluminous body of pencil and ink drawings based on imaginary characters, family events, and works by other artists. Sensitively colored and often humorous in tone, most were naively but painstakingly rendered. Just as Cornell had appropriated and transformed reproductions of works by other artists in both his boxes and collages, he similarly developed at least a dozen collage series based on photostats of his favorite drawings by Robert. In most examples, he modified the images with staining, penciled designs, or paper cutouts, as in The Heart on the Sleeve (1972) (fig. 24). Although not collaborative efforts in the strictest sense, Cornell generally affixed a facsimile of Robert's signature on the verso of these collages; then he documented his role in the drawings' transformation through inscriptions on each work. Highlighting Cornell's efforts to honor his brother was the memorial exhibition of Robert's drawings and Cornell's related collages at the Robert Schoelkopf Gallery in New York (1966).

His personal life radically altered during the mid-1960s, Cornell thereafter increasingly addressed the past and the future in his activities. His autobiographical recall became particularly strong in his diaries, dreams (as reported in his diaries), and artworks, as in the various collage series based on family photographs and Robert's drawings. Visiting New York infrequently, especially as his strength declined, Cornell noted a shift in his feelings about the city: "I've been in a strange physical state with regard to traveling into town. Quite wonderful rapport in the time [before this] all my life. It may be the time. Terrible things going on in the world."[179] He also experienced a "terror of encroachment of piled-up concrete in the city vs. remembered sites."[180]

Increasingly concerned about the security and disposition of his work, he began consulting collectors, curators, dealers, lawyers, and personal friends about the fate of his works and source materials. Intersecting with this concern was his intensified desire to communicate with young people. Consequently, between 1965 and 1972, several museums and university art galleries, such as the Walker Art Center, Minneapolis, and the Herbert F. Johnson Museum of Art, Cornell University, received sizable groups of boxes and collages as "sanctuary" loans for exhibition and study.

Coinciding with Cornell's own examination of the "status quo" were, in 1967, his first retrospective exhibitions in American museums, at the Pasadena Museum of Art, directed by Walter Hopps, and The Solomon R. Guggenheim Museum, directed by Diane Waldman. In 1968, he was triply recognized for his contributions to American art, receiving awards from Brandeis University, the American Academy of Arts and Letters, and the First Indian Triennale of Contemporary World Art. Since 1936, Cornell had stressed his lack of formal art training, natural talent, and the role of the metropolitan context in his work![81] Essentially modest about his efforts and recalcitrant about acknowledging any relationship between his life and work, Cornell summarized his reactions to the examination of his art during his lifetime in 1967:

ART & LITERATURE #8 carried the only decent thing yet published on my work. There have been quite a few irrelevant and misleading pieces done and in these what you might call 'highlights' of my 'past life' have been of no significance with reference to the created work.

I never expected the so-called 'objects' (from Surrealist lingo) to become so typed as sculpture. Extended preoccupation with ballet, motion picture, music, etc. in the context of city (NY) exploration from the twenties to the present has taken expression and shape in great diversity, some of it transitory in nature![82]

Fig. 24 Joseph Cornell: The Heart on the Sleeve. 1972. Collage, 11⅜ x 8¼ in. National Collection of Fine Arts, Smithsonian Institution, Washington, D.C., Gift of Mr. and Mrs. John A. Benton

114

Fig. 25 Joseph Cornell, 1969. Photographed by Hans Namuth

After 1969, Cornell often described himself as being semi-retired, although he maintained a fairly full schedule, working with his assistants, meeting with friends, dealers, and collectors, and occasionally visiting New York and Flushing (fig. 25). After undergoing surgery early in June 1972, however, Cornell's activities were greatly curtailed. While convalescing with his family in Westhampton and Northport, he worked only sporadically on collages. He did, however, remain involved in preparing and approving limited editions of prints based on four of his collages, to be included in a portfolio with prints by R. B. Kitaj, James Rosenquist, Adolph Gottlieb, Ellsworth Kelly, David Hockney, and Alex Katz published for Phoenix House, a drug rehabilitation center in New York. On October 27 in Northport, Cornell signed 300 prints in the presence of Henry Geldzahler, who had selected the portfolio, and Brooke Alexander, who had produced it for Phoenix House. Always concerned about the future, he prepared to return to Utopia Parkway in October, writing: "If the Utopia house is going to loom up and [be] too much to care for: consid[eration] of progressively relieving it of deposits, various to be collated, organized etc. for poss[ible] re-entry in the future in the event that Utopia house might become a home museum and/or exper[imental] workshop."[183] Still corresponding with old friends, later in the month he wrote to Allegra Kent: "Do you remember the old pop tune: 'Everybody's Making Money But Tchaikovsky?' I feel that way so isolated & the prices dealers get for my things. But there's a bright side. And when I get my strength b[ac]k I want to feel an upsurge of inspiration for the Stern's [sic]—do something special...."[184]

On November 6, Cornell returned to Utopia Parkway, hoping to resume his activities on a modified basis. Attending a testimony meeting at the First Church of Christ, Scientist, in Bayside during the last week of December, Cornell rose to state "that he was grateful for Christian Science and for membership in our church"—the only occasion on which he had given testimony in the church to which he had belonged as a founding member since 1952![185] Still considerably weakened, Cornell died at home from heart failure on December 29, 1972, at the age of sixty-nine. Earlier that morning he called his sisters and niece; to his sister Elizabeth he had wistfully commented: "I wish I had not been so reserved."[186]

In a diary note of 1957, Cornell described his intention in revising the Ondine portfolio: "...Decreasing personal biography/;/...accentuates rather ...imaginative pictorial research akin to image-making of poetry."[187] In his years of accumulating photographs and other material about Fanny Cerrito, the great Romantic ballerina known for her dancing of Ondine, he had deemphasized the "nuances of details" about her so as to evoke far more than a "personal biography." Similarly, Cornell tried to separate the details of his own life from the contemplation of his works. This was a contradictory posture, for it is by virtue of our exploring his sensitivity to the experiences of life and their memories that we gain further insight into the selectivity and inclusiveness of his art.

NOTES

1. Elizabeth Cornell Benton Collection, Aug. 7, 1969. Cornell's thoughts were headed, "Rationale (tent) J. C. artwork," and ended with the summary, "the heart of its message (of the work) has not come across."

2. Joseph Cornell Papers, Archives of American Art (AAA), Smithsonian Institution, gift of Elizabeth Cornell Benton, reel 1066: frame 148, undated, but may have been written in 1948 when Cornell considered writing an essay on Taglioni.

3. Ibid., 1059: 588, Oct. 10, 1952.

4. Benton Collection, an undated notation, recorded by Cornell in the late 1960s.

5. The author's research was conducted in part with the assistance of a grant awarded in 1976–78 by the National Endowment for the Humanities.

6. Isabelle K. Savell, Senior Historian, Historical Society of Rockland County, in letters and conversations with the author, April 1980.

7. Much of the information about Cornell's family life was obtained in interviews with his sister Elizabeth Cornell Benton in 1976–80 and his sister Helen Cornell Jagger and her daughter Helen Batcheller in 1977–80.

8. According to Elizabeth Benton, their mother was descended from Steven Coerten Van Vorhees, who settled in New Amersfoot, later named Flatlands, Long Island, in 1660. Research on the Cornell line thus far suggests a connection to Guillaume Cornell, who settled in the Flatbush section of Brooklyn, New York, around 1640 (Somerset County Historical Quarterly, vol. 2 [1913], p. 178, courtesy New York Genealogical and Biographical Society).

9. Cornell Papers, AAA, 1055: 261, undated.

10. The Cornell family does not know the significance of the initial "I" in the lineage of the six Joseph Cornells. In the 1930s Cornell dropped it in correspondence and never used it in signing his work.
Cornell's birthplace at 288 Piermont Avenue was dedicated as an historic landmark in Nyack in July 1977.

11. Helen Jagger to her daughter Helen Batcheller in a recorded conversation, 1978.

12. Ibid.

13. Elizabeth Benton to the author in an interview, April 21, 1978. The scenarios are no longer extant.

14. Joseph Cornell Study Center, National Collection of Fine Arts (NCFA), Smithsonian Institution, Washington, D.C. Notation dated March 3, 1963, after seeing a house which reminded him of those in Nyack.

15. Cornell Papers, AAA, 1055: 126, undated letter drafted to Eva Marie Saint c. 1960.

16. In 1937 Cornell began working on a box, Parrot Music Box, which he associated with hurdy gurdies (pl. 131). After 1934 he fashioned Thimble Forests in Shaker boxes, and steadily collected Shaker artifacts. Cornell also collected books on the history of flight from which he extracted steel line engravings of balloons for montages (pls. 7, 51).

17. Benton interview, April 21, 1978. All of the children, including Robert, learned to read at an early age and all enthusiastically read fairy tales.

18. Cornell Study Center, NCFA. The remaining text on the ticket provided the date and address of the event. The play, as recalled by his sisters, centered on an old metal safe that contained a chained loaf of bread.

19. Benton interview, April 21, 1978.

20. Helen Jagger to the author in an interview, July 11, 1977. After the age of six months, Robert's difficulty in sitting up was diagnosed as "summer complaint."

21. Benton interview, April 21, 1978.

22. Bartlett Hayes, Jr., art historian and classmate of Cornell, in conversations with the author, March 28, 1980.

23. Information based on school transcripts, courtesy Phillips Academy.

24. Specifically, Cornell read De Quincey's Joan of Arc and The English Mail Coach, R. Adelaide Witham, ed. (Boston: Houghton Mifflin Company, 1906). Cornell Study Center, NCFA.

25. Bartlett Hayes; Cornell Study Center, NCFA.

26. According to Cornell's transcripts, he earned grades of C and below.

27. Principal Alfred E. Stearns to George E. Kunhardt, Sept. 18, 1919, courtesy Phillips Academy.

28. According to his transcript, Cornell lacked credits in history, solid geometry, and trigonometry, and he did not take college qualifying examinations.

29. Nikki Thiras, Addison Gallery of American Art, in conversation with the author, March 28, 1980; she organized the exhibition Decades, "7 Alumni of Phillips Academy" (1969), in which Cornell was included.

30. Benton interviews, April 21, 1978, and April 10, 1980.

31. Benton interview, April 21, 1978.

32. Jagger interview, July 11, 1977.

33. In 1919, the family moved from Douglaston to a rented house on Montauk Avenue in Bayside, and in 1920, to First Street, also in Bayside.

34. Cornell's mother, however, continued her part-time efforts, and his sisters quit high school to start working.

35. The Whitman Company was first located at 25 Madison Avenue, near 23rd Street, and later at 261 Fifth Avenue, near 29th Street. Cornell remembered the Square from childhood visits to Wanamaker's with his father; Cornell Papers, AAA, 1058: 890, Jan. 4, 1943 (entered Feb. 17, 1947).

36. Ibid., 1062: 868, April 29, 1967; 1076: 1, early Jan. 1947.

37. Benton interview, April 22, 1978. Also noted in Diane Waldman, Joseph Cornell (New York: George Braziller, 1977), p. 11. Neither the character of the boxes nor a more specific date for the purchases is known at this time.

38. Cornell Papers, AAA, 1076: 7, undated, on verso of letter dated Jan. 15, 1941.

39. Ibid., 1059: 150, Nov. 26, 1948. Cornell also noted that the owner was a recognized authority on Walt Whitman, Lewis Carroll, and Ada Isaacs Mencken "for documentary information, collected items, etc."

40. Benton interview, April 21, 1978.

41. Cornell Papers, AAA, 1059: 833, in a letter drafted July 20, 1953, but never sent to Hans Huth, Research Curator of The Art Institute of Chicago. In the draft Cornell noted his estimation and approximate dates of experiences in the 1920s that affected his artwork. Cornell placed his contact with foreign recordings as c. 1924, at the time of the John Quinn Memorial Exhibition, which, however, did not take place until 1926. The dates he assigned to events in this decade, as recalled in his papers during the '40s and later, are frequently off by a year or two.

42. Ibid.; Cornell Study Center, NCFA, Cornell's dossier of Meller memorabilia.

43. Benton and Jagger interviews, April 21, 1978, and July 11, 1977, respectively.

44. Joseph Cornell, "'Enchanted Wanderer': Excerpt from a Journey Album for Hedy Lamarr," View, series 1, nos. 9–10 (Dec. 1941–Jan. 1942), p. 3. The dates, country of origin, and stars of the films cited are Broken Blossoms, 1919, U.S., with Lillian Gish; Sumurun, 1920, Germany, with Pola Negri; Ménilmontant, 1924, France, with Nadia Sibirskaia; The Passion of Joan of Arc, 1928, France,

with Falconetti (first reviewed in America, 1929); *Dreigroschenoper,* 1930, Germany, with Carola Neher (first reviewed in America 1931).

45. Cornell Papers, AAA, 1055: 405, from a letter dated March 3, 1946, to French film historian Claude Serbanne. According to Cornell's sisters, Robert Cornell watched D. W. Griffith at work in Bayside while Cornell was at Andover, probably during 1919 or 1920.

46. See note 87.

47. Cornell Papers, AAA, 1059: 833, July 20, 1953. Unless otherwise noted, the information in the two following paragraphs are derived from this source.

48. Among the numerous opportunities to see such art in New York in the 1920s were the exhibition of Odilon Redon at The Museum of French Art (April 1922); the Tri-National Exhibition, organized by De Zayas in 1925, at Wildenstein (Jan. 26–Feb. 15, 1926); "French Art of the Last Fifty Years" at Knoedler's (Jan. 1927); and the selection of modern French art from the Chester Dale collection at Wildenstein (Oct. 1928).

49. *Cornell Papers, AAA,* 1058: 673, undated. Cornell recalled the date as c. 1928, on another occasion as c. 1927.

50. Peggy Bacon, Untitled, 1926, pencil on paper; inscribed on verso in Cornell's hand: "bought from Whitney Museum/ from Alexander Brook/ then Peggy Bacon's husband/ ca. 1927/ by Joseph Cornell." George C. Ault, *Jefferson Market Tower,* 1927, watercolor. Formerly Benton collection.

51. Cornell Papers, AAA, 1059: 832, July 20, 1953; and 1056: 27, Labor Day 1964.

52. *Ibid.,* 1058: 231, undated.

53. Benton and Jagger interviews, April 21, 1978, and July 11, 1977, respectively.

54. Ruth VanDyne, First Church of Christ, Scientist, Bayside, in a letter to the author, April 9, 1980, about Cornell's church history.

55. Mary Baker Eddy, *Science and Health with a Key to the Scriptures* (Boston: The First Church of Christ, Scientist, 1875, © 1971), 265: 10.

56. For information on the religion's practices, teachings, and beliefs, see DeWitt John, *The Christian Science Way of Life* (Boston: The Christian Science Publishing Society, 1962).

57. Cornell Papers, AAA, 1059: 845, July 29, 1953. Cornell participated in noon services at the Fifth Church, Manhattan. In 1952 he became a founding member of the First Church of Christ, Scientist, in Bayside. He regularly

read all of Eddy's works, especially *Science and Health,* and publications such as *The Christian Science Journal, The Manual of the Mother Church,* and *The Christian Science Monitor.*

58. Benton interview, April 21, 1978. While the family lived on First Street, Bayside, from 1920 to 1925, Robert experienced his first epileptic seizures. Shortly thereafter, under a doctor's care, he suffered a serious gangrenous attack that left his legs permanently shrunken. Over the years, his speech also became increasingly impaired. During the 1940s Cornell's mother forbade the use of practitioners in caring for Robert, who nonetheless derived support from Christian Science throughout his life.

59. From 1925 to 1929 the Cornells lived on Fourth Street in Bayside.

60. Cornell Papers, AAA, 1059: 494, May 18, 1952.

61. Julien Levy in an interview with the author and Walter Hopps, July 17, 1976. Levy had acquired the individual montages that comprised Ernst's collage-novel, *Rêve d'une petite fille qui voulut entrer au Carmel,* some of which appeared in his "Surréalisme" exhibition of Jan. 1932; see reproduction in "Freudian Psychology Appears in First American Surrealist Show," *The Art Digest,* vol. 6, no. 8 (Jan. 15, 1932), p. 32.

62. Benton and Jagger interviews, April 21, 1978, and July 11, 1977, respectively. Both recall one occasion on which Cornell's experiments caught fire in their house on Fourth Street. He worked with batik at home for a matter of months.

63. Cornell Papers, AAA, 1055: 1705–06, Jan. 15, 1959.

64. See *A Complete Concordance to the Writings of Mary Baker Eddy Other Than Science and Health with a Key to the Scriptures* (Boston: Trustees under the Will of Baker Eddy, 1915 and 1934) for references to spontaneity and naturalness.

65. Cornell in a letter to Mina Loy, poet, artist, and Christian Scientist, Nov. 11, 1946, courtesy Mrs. Joella Loy Bayer.

66. Cornell Papers, AAA, 1058: 231, undated.

67. Waldman, *op. cit.,* p. 12, and Levy interview, July, 17, 1976.

68. Levy interview, July 17, 1976, and confirmed in a letter to the author, June 1980. Early in the history of his gallery at 602 Madison Avenue, Levy began mounting simultaneous, small one-person shows in his two-room space. He considered them separate shows because the combinations of artists were not

meant to demonstrate comparisons or contrasts. The exhibition of Picasso's etchings was hung in the second room at the time of Cornell's show in November 1932.

69. The announcement for the exhibition lists "Minutiae, Glass Bells, Shadow Boxes, Coups d'Oeil, Jouets Surréalistes."

70. Cornell Papers, AAA, 1059: 833, July 20, 1953. Earlier in the same passage Cornell cited Ernst's *La Femme 100 têtes* as a specific influence, although the date of his first encounter with the volume remains unclear.

71. Quoted in David Bourdon, "Enigmatic Bachelor of Utopia Parkway," *Life,* Dec. 15, 1967, p. 63. According to Benton, Cornell indicated that the idea for working with boxes occurred to him while crossing Flushing Creek on the train one day in the early '30s, (Benton interviews, Sept. 9, 1979, and April 10, 1980). Whether the encounter with the display of compasses and boxes was the sole or one of several experiences that led to his experimenting with boxes is not known. In the early 1940s, Cornell created at least one box, *Object (Roses des Vents)* (pl. 198), in which compasses were the dominant motif.

72. Julien Levy, *Memoir of an Art Gallery* (New York: G. P. Putnam's Sons, 1977), pp. 77–79. Levy had bought "old French puzzle boxes and watch springs in old containers with transparent covers (backed by views of the Arc de Triomphe)" in the Marché aux Puces in Paris.

73. Carl Backman in a letter to the author, Nov. 5, 1979, and in conversation April 9, 1980. Backman lived next door to the Cornells from 1932 to 1941, when he married and moved away. Cornell continued to use the shop after 1941.

74. Joseph Cornell, "The Crystal Cage (Portrait of Berenice)," *View,* series 2, no. 4 (Jan. 1943), p. 12. Cornell collected material related to the Crystal Cage throughout his career, and considered making a boxed edition, a sample of which was presented in his exhibition "Portraits of Women: Constructions and Arrangements by Joseph Cornell," Hugo Gallery, New York, Dec. 1946.

75. Program for the former and a season's prospectus for the latter on deposit in Anthology Film Archives, New York.

76. Miller returned to the United States in Oct. 1932 and presented a photograph of herself in *Sang d'un poète* to Cornell in Sept. 1933. Cornell Study Center, NCFA.

77. Cornell lent the painting to the Dali

exhibition at the Julien Levy Gallery, Nov. 1934 (Dali exhibition announcement inscribed by Cornell, Benton Collection), to the traveling version of "Fantastic Art, Dada, Surrealism," 1937, and to the Dali exhibition at The Museum of Modern Art, 1941. In a letter dated July 30, 1941, regarding the Dali show, Cornell indicated that he had never had the painting in his possession. It is now in the A. Reynolds Morse Collection, Cleveland.

78. Levy, *op. cit.*, 1977, pp. 230–31.

79. Cornell Papers, AAA, 1056: 679–80, October 8, 1968. The Brancusi exhibition dates are Nov. 17. 1933–Jan. 13, 1934.

Allen Porter, a Levy gallery assistant, remembers introducing them (Dore Ashton, *A Joseph Cornell Album*, New York: The Viking Press, 1974, p. XI). After Duchamp returned to the United States in June 1942, Cornell was one of several people enlisted to assemble *Valises*.

80. Cornell met Ford and Tchelitchew after their arrival in New York in 1934 (Ford to the author in an interview, Dec. 10, 1979). They undoubtedly introduced Cornell to their friend Parker Tyler.

81. Daniel Robbins, catalog of the exhibition "Walter Murch," Museum of Art, Rhode Island School of Design, Providence, 1966.

82. From Murch's 1966 inscription on verso of painting, now in the National Collection of Fine Arts, Smithsonian Institution, Washington, D.C.

83. Jagger to Batcheller, 1978.

84. According to Helen Jagger, some of his designs were used for bedspreads.

85. Cornell·Papers, AAA, 1059: 588, Oct. 10, 1952. According to Benton, Cornell began using the library for this purpose during the 1930s.

86. Cornell Papers, AAA, 1059: 310, July 7, 1951.

87. Cornell in a letter to Ruth Ford, May 21, 1941, courtesy Ruth Ford. In his acknowledgments to *The Movies Come from America* (New York: Charles Scribner's Sons, 1937), p. VIII, Seldes wrote: "Particular thanks are due to Mr. Joseph Cornell, who has worked indefatigably on the collection of the illustrations, for the use of the sometimes unique subjects from his private collection...."

88. Robert Motherwell in a letter to the author, Nov. 15, 1977, and in a conversation, May 26, 1980.

89. The Cornells were fond of giving each other nicknames; "Goop Joe" was one of several held by Cornell as a child. The term "Goop" is derived from Frank Gelett Burgess's stories and poems about naughty children known as the Goops.

90. Benton interviews, April 21, 1978, and April 10, 1980. Although the specific date he began showing films to the family is unknown, Benton recalls that it started several years after the birth of Cornell's niece Helen in 1931.

91. The two brothers often listened to records together. Cornell encouraged Robert to develop his talent for drawing. Robert corresponded with a network of train enthusiasts, and closely followed current events and sports.

92. Interested in trains as a child, Robert pursued his hobby primarily after the family moved to Utopia Parkway; the layout was begun sometime in the 1930s.

93. See Levy, *op. cit.*, 1977, p. 224, and John Bernard Myers, "Cornell's L'Erreur d'Âme," in the catalog of the exhibition "Joseph Cornell," ACA Galleries, New York, 1975, p.4.

94. Quoted in Brian O'Doherty, *American Masters: The Voice and the Myth* (New York: Ridge Press Book, Random House, 1974), p. 279.

95. One-man: "Joseph Cornell: Minutiae, Glass Bells, Shadow Boxes, Coups d'Oeil, Jouets Surréalistes," Nov. 1932; "Exhibition of Objects (Bilboquet) by Joseph Cornell," Dec. 1939; "Exhibition of Objects," Dec. 1940. Group: "Surréalisme," Jan. 1932; "Objects by Joseph Cornell, Posters by Toulouse-Lautrec, Watercolors by Perkins Harnley, Montages by Harry Brown," Dec. 1933; and "Surrealist Group Show," Feb. 1940.

96. "Playful Objects; *The New York Herald Tribune*, Dec. 10, 1939, section VI, p. 8.

97. Cornell in a letter to J.B. Neumann, Oct. 25, 1946, in the Neumann Papers, Archives of American Art. Smithsonian Institution; see Ashton, *op. cit.*, p. 5.

98. Cornell in a letter to Alfred H. Barr, Jr., Nov. 13, 1936, Archive of The Museum of Modern Art.

99. Benton interview, April 21, 1978, and April 10, 1980.

100. Cornell Papers, AAA, 1059: 172, undated comment on envelope postmarked Dec. 12, 1948. The deleted passage reads: "necessity of the realization of the mental nature of this—the significance of its spiritual nature."

101. *Ibid.*, 1059: 72, Aug. 17, 1947.

102. After receiving a check for $425 for a magazine assignment, Cornell wrote: "the largest amount I've received at one time since leaving Mr. Whitman in 1931"; Cornell Papers, AAA, 1058: 921, Feb. 26, 1945.

103. Cornell worked at the company's plant in Long Island City until Aug. 1943, when it relocated to Fulton Street in New York. According to his sister, Cornell's "war work" was motivated as much by patriotism as economic need (Benton interview, April 10, 1980).

104. Cornell Papers, AAA, 1067: 573, Summer 1943.

105. *GC 44*, intended to approximate the format of his portfolio *Portrait of Ondine*, became a lifelong pursuit.

106. Ashton, *op. cit.*, p. 85.

107. Cornell Papers, AAA, 1058: 881, July 15, 1941: "Mixed lime for fixing up my new workshop in the cellar." During the 1930s Cornell had begun working in the family's garage and various parts of the house: the kitchen, dining room, cellar, and bedrooms. The more formal arrangement of the basement, however, was not undertaken until the early 1940s. As noted previously, Cornell also took advantage of his neighbor's woodworking shop until the mid-1940s.

108. *Ibid.*, 1059: 121, May 5, 1948.

109. *Ibid.*, 1059: 8-9, April 15, 1946.

110. *Ibid.*, 1058: 917-18, Oct. 11, 1944.

111. *Ibid.*, 1058: 936, Aug. 24, 1945.

112. *Ibid.*, 1067: 477, copied March 22, 1950. Cornell especially enjoyed cycling to nearby places such as College Point, Corona, and Elmhurst.

113. *Ibid.*, 1058: 913, Oct. 10, 1944.

114. Cornell in a letter to Ruth Ford, May 24, 1941, courtesy Ruth Ford.

115. For example, Waldman, *op. cit.*, p. 23, and John Bernard Myers, "Cornell: The Enchanted Wanderer," *Art in America*, vol. 61, no. 5 (Sept.-Oct. 1973), p. 80.

116. Cornell in a letter to Mina Loy, Nov. 1, 1946, courtesy of Joella Loy Bayer.

117. "Le Quatuor Danse à Londres par Taglioni, Charlotte Grisi, Cerrito et Fanny Elsler [sic]," July-Aug. 1944; "Hans Christian Andersen," Sept. 1945; "Clowns, Elephants and Ballerinas," June 1946; "Americana Romantic Ballet," Sept. 1947.

118. Donald Windham in Letter to the Editor, *New York Times Book Review*, Feb. 2, 1975, p. 28, and in an interview with the author, Feb.20, 1978.

119. Tamara Toumanova in an interview with the author, July 25, 1977.

120. Matta in an undated letter to the author, received Oct. 12, 1976.

121. Robert Motherwell in a letter to the author, Nov. 15, 1977.

122. *Ibid.*, Nov. 1, 1977.

123. Cornell in a letter to Peggy Guggenheim, March 12, 1942, the Peggy Guggenheim Collection, The Solomon R. Guggenheim Foundation, New York. That Cornell was included in the

inaugural exhibition is based on information in the forthcoming PhD. dissertation, "Peggy Guggenheim's 'Art of This Century': The Surrealist Milieu and the American Avant-Garde, 1942-1947," by Melvin P. Lader, University of Delaware.

124. According to Peggy Guggenheim, Ernst met Cornell at Art of This Century (Guggenheim in an interview with Melvin P. Lader, April 1978). See Ashton, *op. cit.,* p. 73, for a description of one visit with Ernst in the late '40s.

125. Ashton, *op. cit,* p. 85, and Cornell Papers, AAA, 1055: 425, n.d., c. 1946.

126. Announcement, "Film Soirée (at Norlyst)," Cornell Study Center Collection, NCFA.

127. James Card in a letter to the author, March 3, 1978.

128. The collectors Vincent Price and Walter Arensberg and the dealers Frank Perls and Earl Stendahl were the notable exceptions in Southern California at this time.

129. The show's brochure lists works such as Taglioni Jewel Case, Soap Bubble Set (Moon Map), Owl (Habitat Setting), Book with Marble, Paolo and Francesca (Romantic Paysage), Beehives, and Palace of Windows.

130. Charles Egan in interview with the author, Jan. 18, 1978.

131. Review in *Art News* (New York), vol. 48, no. 1 (Jan. 1950), p. 45.

132. Cornell Papers, AAA, 1059: 276, Oct. 14, 1950.

133. *Ibid.,* 1060: 639, April 24, 1958.

134. *Ibid.,* 1059: 310, May 8, 1951, "period of three months or so incapacitated...."

135. *Ibid.,* 1059: 356, Sept. 26–27, 1951.

136. *Ibid.,* 1059: 352, Sept. 21–22, 1951.

137. *Ibid.,* 1059: 702, April 8, 1953.

138. *Ibid.,* 1059: 324, June 16, 1951, and 1059: 1064, March 1, 1954, for example.

139. *Ibid.,* 1059: 338, Aug. 20, 1951.

140. For example, "With the questioning attitude about the boxes...as vs. some possible translation into other techniques (research, exploration, etc.)." (*ibid.,* 1059: 390, Nov. 4, 1951).

141. After initially exhibiting the former at The Museum of Modern Art in "Portrait of Ondine: Dance and Theater Design," Nov. 28, 1945–Feb. 17, 1946, Cornell presented the material in revised form at the One-Wall Gallery, Wittenborn, New York, Nov. 1956.

142. *Maria* is based on translated excerpts from the writings of German author, Elise Polko; *The Bel Canto Pet* on excerpts from the writings of the American, Nathaniel Parker Willis.

143. Cornell Papers, AAA, 1076: 30, Dec. 5, 1952.

144. Benton in an interview with the author and Walter Hopps, Nov. 1976.

145. Announcement of program, "Julio de Diego Presents Joseph Cornell's Collection of Early Classic Films," Aug. 16, 17, 1952 (private collection).

146. Cornell Papers, AAA, 1059: 368, Oct. 15, 1951.

147. When Burckhardt once suggested that Cornell learn to use a camera, he replied that he had no interest in doing so since it was too technical (Burckhardt in an interview with the author, Jan. 4, 1978).

148. Stan Brakhage in a letter to the author, Nov. 26, 1977. He also notes that he met Cornell through Parker Tyler.

149. Cornell Papers, AAA, 1060: 324, Dec. 2, 1956.

150. Cornell met artists such as de Kooning at the Egan and Stable galleries.

151. Piero Dorazio in a letter to the author, August 30, 1976.

152. Ashton, *op. cit., p. 82.*

153. Dorothy Miller in a letter to the author, Feb. 10, 1977.

154. Benton interview, April 21, 1978, and reiterated frequently in Cornell's papers.

155. Cornell Papers, AAA, 1060: 367, Dec. 20, 1956; 1059: 1053, Feb. 9–10, 1954.

156. Quoted in O'Doherty, *op. cit.,* p. 279.

157. For example the New York Public Library and Danish Information Office organized an exhibition honoring the 150th anniversary of the birth of Hans Christian Andersen, presented in the Library's Central Children's Room, April–June 1955. Cornell also periodically lent boxes to the Library for informal display in various departments.

158. Benton interviews, April 24, 1978, and April 10, 1980.

159. Cornell Papers, AAA, 1060: 699, June 24, 1958, for example.

160. *Ibid.,* 1060: 889, Dec. 2, 1958.

161. *Ibid.,* 1056: 1751, May 1960, and letter to Elizabeth Benton, Aug. 1961.

162. In his article "The Enigmatic Collages of Joseph Cornell," *The New York Times,* Jan. 23, 1966, section II, p. 15, critic Hilton Kramer stated that Cornell had "stopped making boxes," and Cornell's own remarks gave rise to that impression.

163. Cornell Papers, AAA, 1061: 1188, Jan. 17, 1964.

164. Benton interview, April 21, 1978.

165. Cornell Papers, AAA, 1061: 413, March 1962, and 1061: 949, Aug. 20, 1963.

166. Cornell in an undated letter, private collection.

167. Although Cornell indicated that the name applied to more than one person, his "Tina" experiences, particularly from 1962 to 1964, refer to Miss Hunter.

168. Cornell in an undated letter, private collection

169. *The New York Times,* Sept. 18, 1964.

170. Miss Sontag's review of Nadeau's *History of Surrealism* (originally published in French in 1946 but appearing in English translation in 1965) was published in *The New York Herald Tribune Book Week,* Nov. 21, 1965, p. 4.

171. Charles Henri Ford in an interview with the author, Dec. 10, 1979.

172. Cornell Papers, AAA, 1061: 1077-78, Oct. 20, 1963.

173. *Ibid.,* 1061: 368, Jan. 23/24, 1962; 1061: 1641, July 15, 1965; and 1063: 1448, Jan. 1, 1970.

174. Notes on a conversation with Cornell, Jan. 13, 1966, courtesy Betty Freeman.

175. Cornell Papers, AAA, 1063: 104, July 9, 1968.

176. *Ibid.,* 1061: 378, Feb. 26, 1962.

177. Cornell in a letter to Rudy Burckhardt, April 26, 1965, courtesy Rudy Burckhardt.

178. Benton Collection, Feb. 15, 1962.

179. Quoted in O'Doherty, *op. cit.,* p. 279.

180. Cornell Papers, AAA, 1063: 339, Oct. 9, 1968.

181. Ashton, *op cit.,* p. 4.

182. Cornell in a letter to Elizabeth Fairbank, Herbert F. Johnson Museum of Art, Cornell University, March 12, 1967, courtesy Herbert F. Johnson Museum of Art. The article to which Cornell referred was Fairfield Porter's "Joseph Cornell," published in Spring 1966.

183. Cornell Papers, AAA, 1064: 683, Oct. 3, 1972.

184. Cornell in a letter to Allegra Kent, Oct. 30, 1972, courtesy Allegra Kent.

185. Ruth VanDyne in a conversation with the author, April 3, 1980.

186. Benton interview, April 21, 1978.

187. Cornell Papers, AAA, 1074: 643, undated.

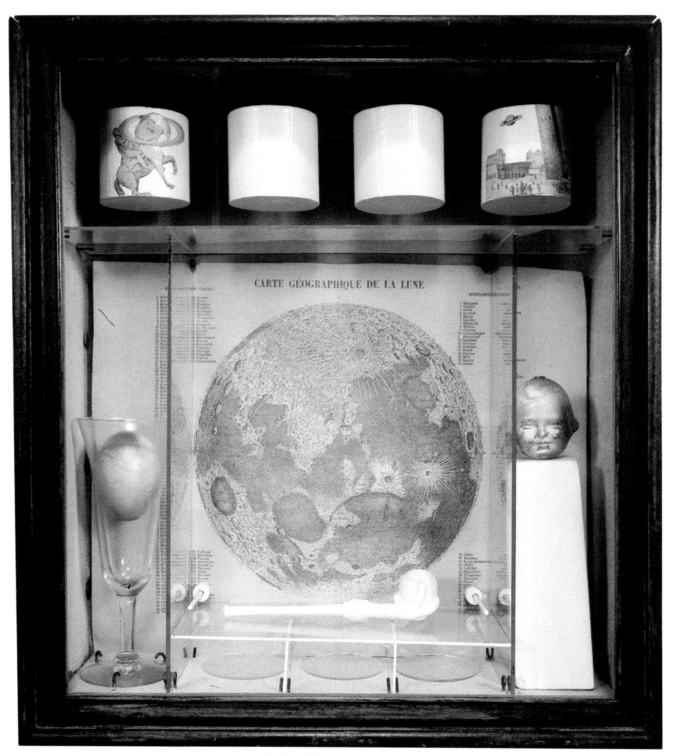

I. Untitled (Soap Bubble Set). 1936
Construction, 15¾ x 14¼ x 5⁷⁄₁₆ in.
Wadsworth Atheneum, Hartford, Connecticut,
The Henry and Walter Keney Fund

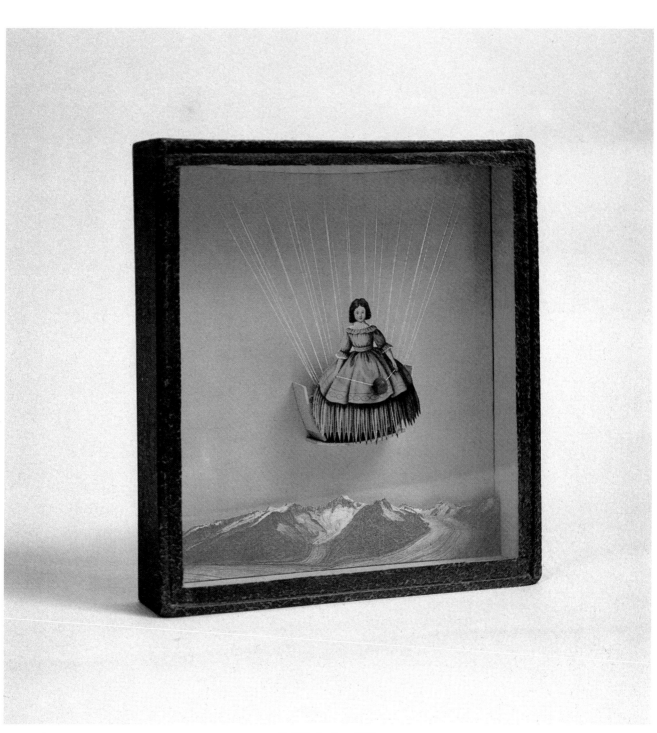

II. *Tilly Losch.* c. 1935
Construction, 10 x 9¼ x 2⅛ in.
Collection Mr. and Mrs. E. A. Bergman, Chicago

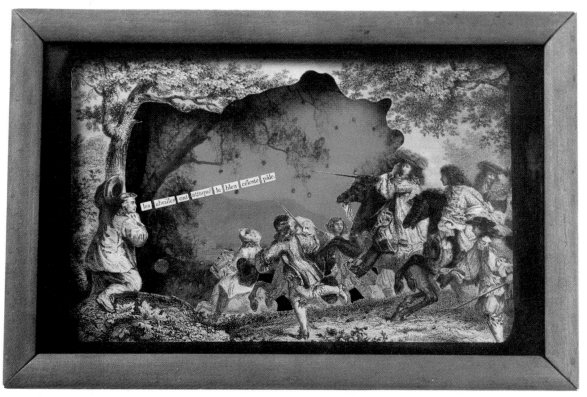

III. *Object* (Abeilles). 1940
Construction, 9⅛ x 14⅛ x 3⁷⁄₁₆ in.
Collection Mr. and Mrs. Frederick Weisman, Beverly Hills, California

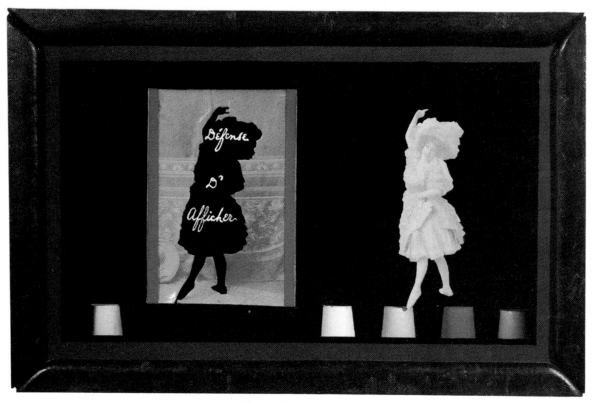

IV. *Défense d'Afficher Object.* 1939
Construction, 8¹⁵⁄₁₆ x 13¹⁵⁄₁₆ x 2⅛ in.
Collection Denise and Andrew Saul

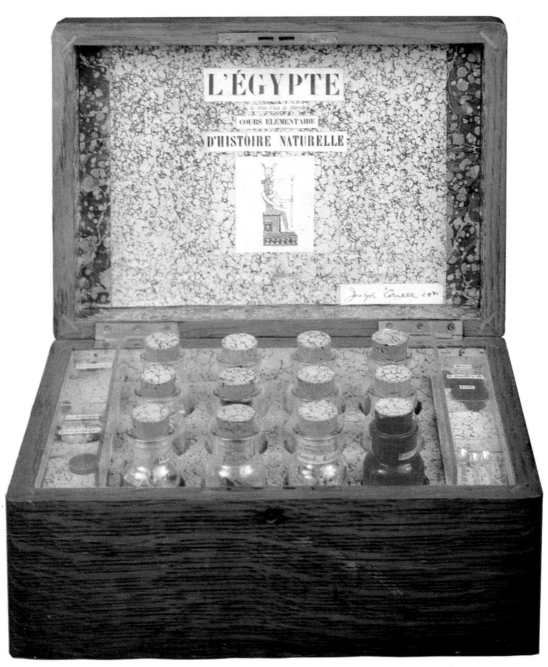

V. *L'Egypte de Mlle Cléo de Mérode cours élémentaire d'histoire naturelle.* 1940
Construction, 4¹¹⁄₁₆ x 10¹¹⁄₁₆ x 7¼ in.
Collection Richard L. Feigen, New York

VI. Untitled (Pharmacy). 1943
Construction, 15¼ x 12 x 3⅛ in.
Collection Mrs. Marcel Duchamp, Paris

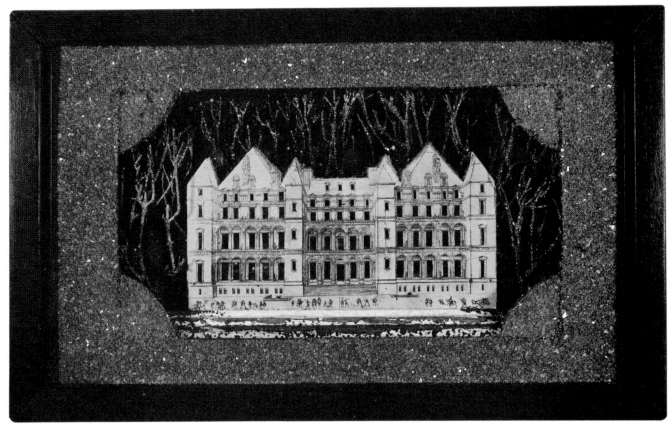

VII. Untitled (Pink Palace). c. 1946–48
Construction, 10 x 16⁷⁄₁₆ x 3¾ in.
Private collection, New York

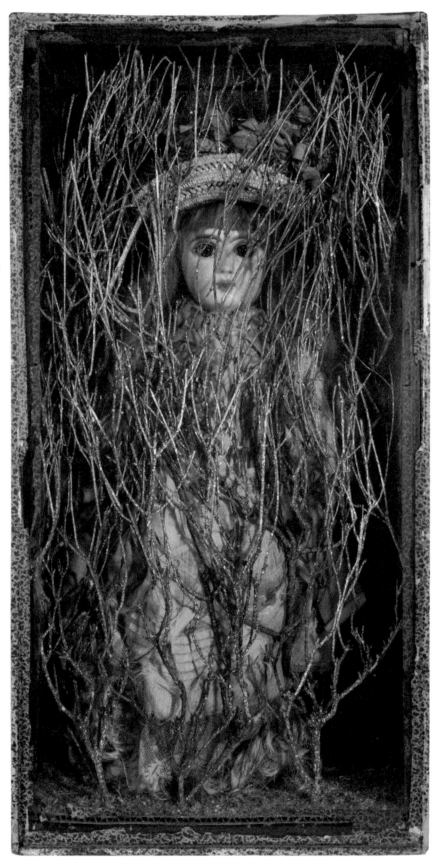

VIII. Untitled (Bébé Marie). Early 1940s
Construction, 23⅜ x 12⁵⁄₁₆ x 5¼ in.
The Museum of Modern Art, New York, Purchase

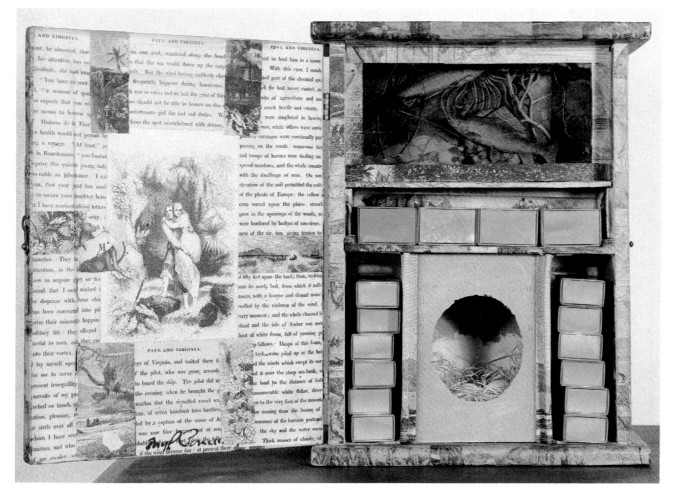

IX. Untitled (Paul and Virginia). c. 1946–48
Construction, 12½ x 9¹⁵⁄₁₆ x 4⅜ in.
Collection Mr. and Mrs. E. A. Bergman, Chicago

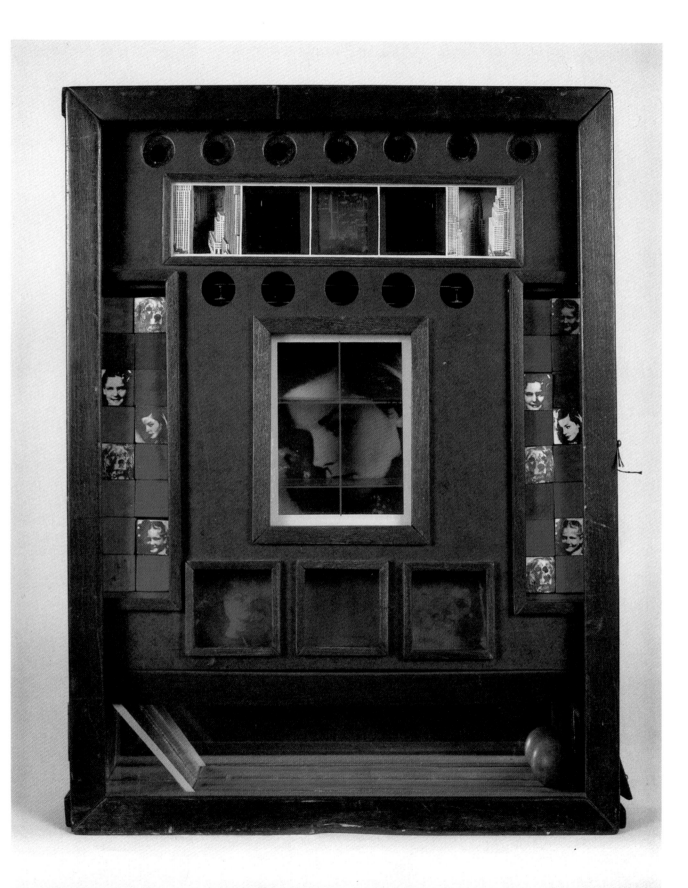

X. Untitled (Penny Arcade Portrait of Lauren Bacall). 1945–46
Construction, 20½ x 16 x 3½ in.
Collection Mr. and Mrs. E. A. Bergman, Chicago

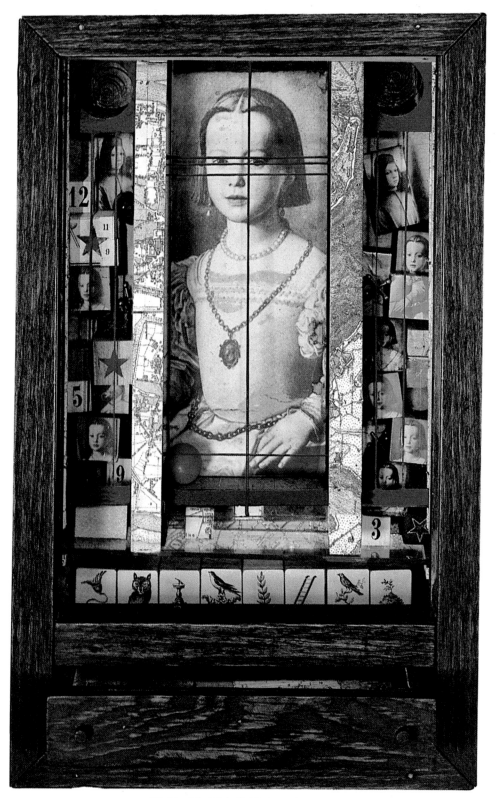

XI. Untitled (Medici Princess). c. 1948
Construction, 17⅜ x 11⅛ x 4⅜ in.
Private collection

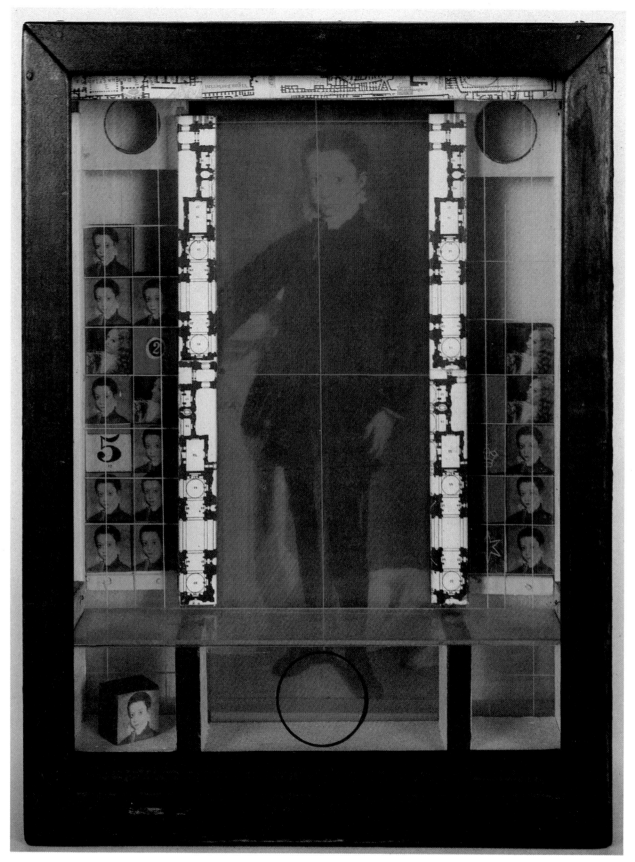

XII. Untitled (Medici Prince). c. 1952
Construction, 15½ x 11½ x 5 in.
Collection Mr. and Mrs. Joseph R. Shapiro, Oak Park, Illinois

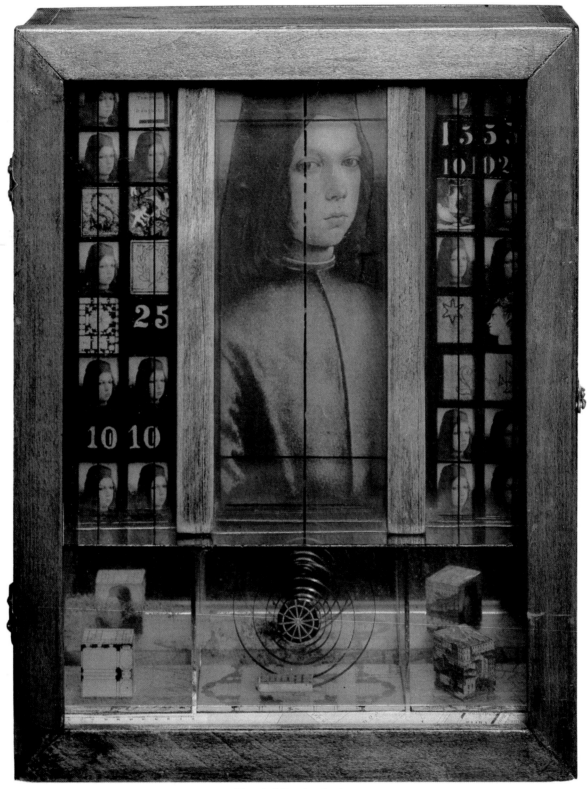

XIII. Untitled (Medici Boy). 1942–52
Construction, 13¹⁵⁄₁₆ x 11³⁄₁₆ x 3⅞ in.
Estate of Joseph Cornell,
Courtesy Castelli Feigen Corcoran

XIV. Untitled (Hotel du Cygne). c. 1952–55
Construction, 19³⁄₁₆ x 12¾ x 4½ in.
Castelli Feigen Corcoran

XV. Untitled (Apollinaris). c. 1954
Construction, 15¹⁵⁄₁₆ x 9¾ x 4⅜ in.
Collection Mr. and Mrs. E. A. Bergman, Chicago

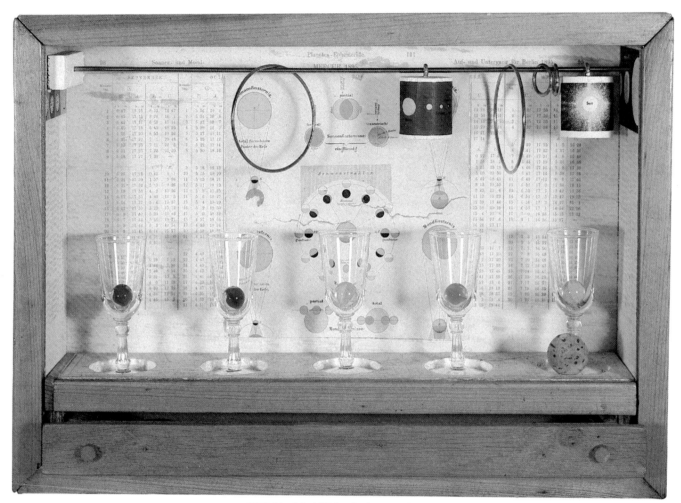

XVI. Untitled (Solar Set). c. 1956–58
Construction, 11½ x 16¼ x 3⅝ in.
Collection Donald Karshan, New York

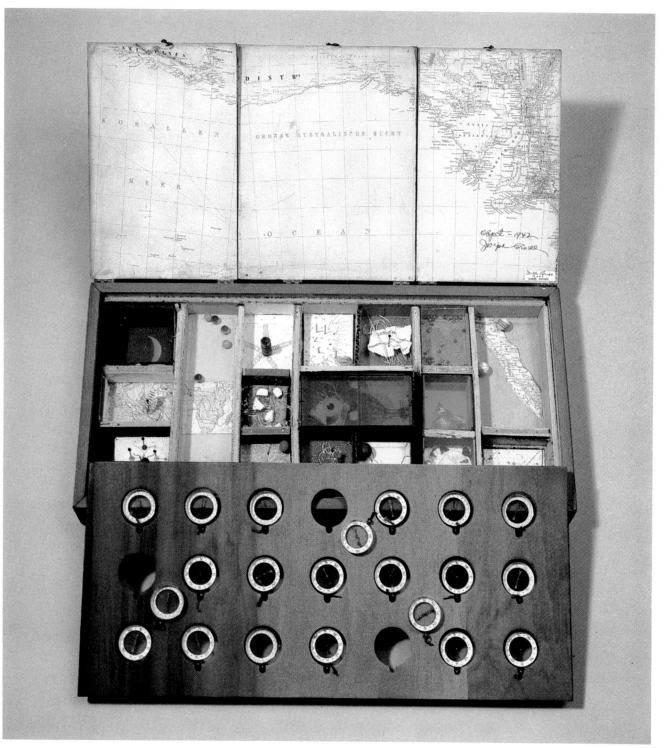

XVII. *Object (Roses des Vents).* 1942–53
Construction, 2⅜ x 21¼ x 10⅜ in.
The Museum of Modern Art, New York,
Mr. and Mrs. Gerald Murphy Fund

XVIII. Verso of *Cassiopeia #1*, pl. XIX

XIX. *Cassiopeia #1.* c. 1960
Construction, 9⅞ x 14⅞ x 3¾ in.
Estate of Joseph Cornell,
Courtesy Castelli Feigen Corcoran

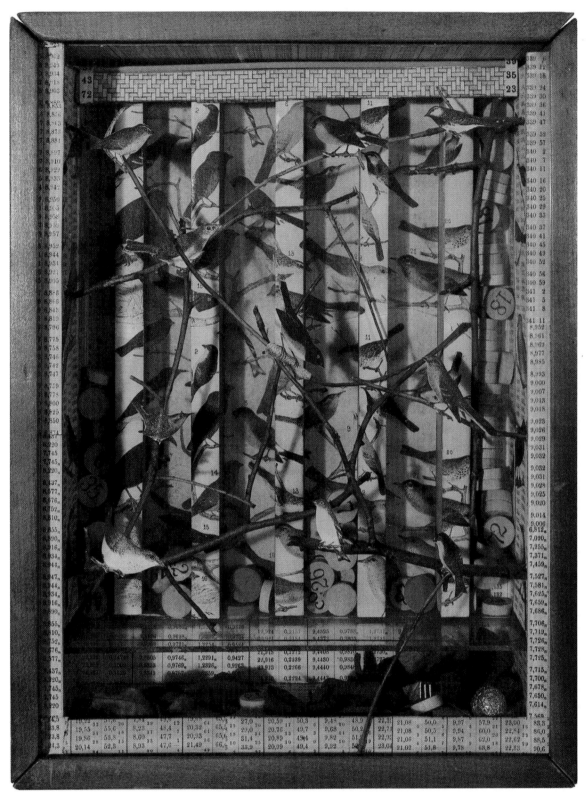

XX. Untitled. 1942
Construction, 13⅛ x 10 x 3½ in.
Private collection, New York

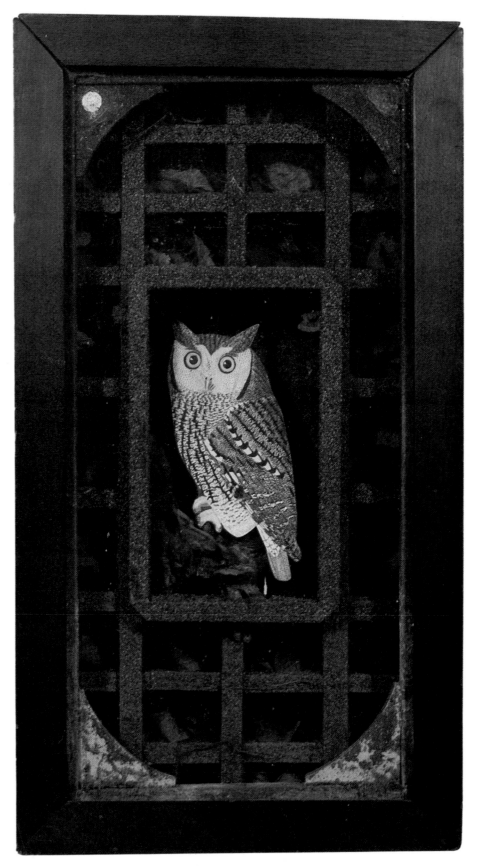

XXI. Untitled (Grand Owl Habitat). c. 1946
Construction, 24 x 13⅛ x 4¹³⁄₁₆ in.
Collection Mr. and Mrs. Richard L. Kaplin, Toledo, Ohio

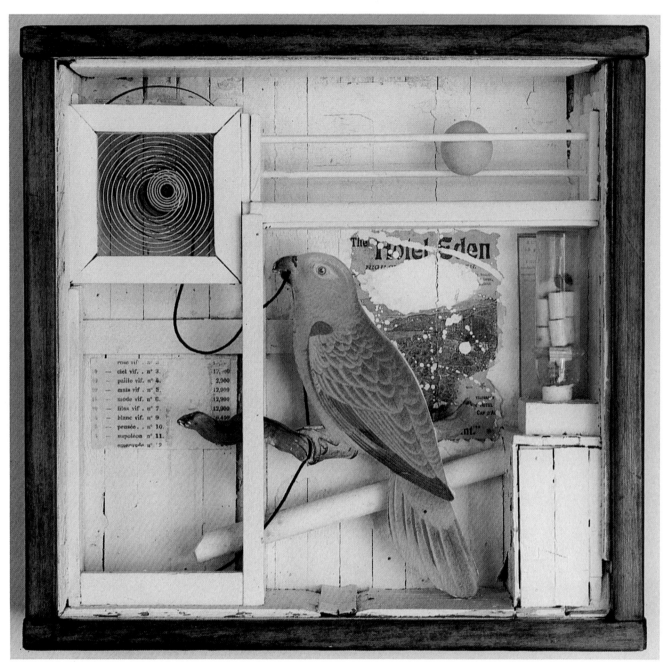

XXII. Untitled (The Hotel Eden). c. 1945
Construction, 15⅛ x 15¾ x 4¾ in.
National Gallery of Canada, Ottawa

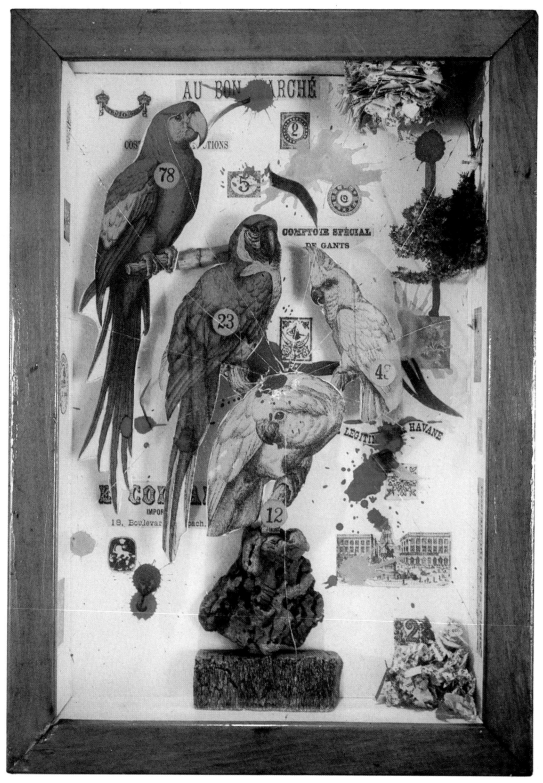

XXIII. *Habitat Group for a Shooting Gallery.* 1943
Construction, 15½ x 11⅛ x 4¼ in.
Des Moines Art Center, Coffin Fine Arts
Trust Fund

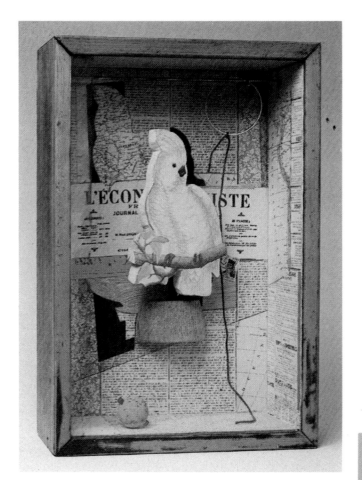

XXIV. *A Parrot for Juan Gris.* Winter 1953–54
Construction, 17¾ x 12³⁄₁₆ x 4⅝ in.
Collection Paul Simon

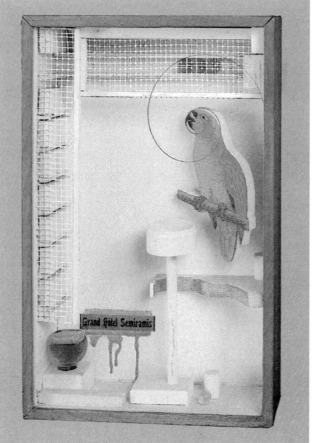

XXV. *Grand Hotel Semiramis.* 1950
Construction, 18 x 11⅞ x 4 in.
Private collection, New York

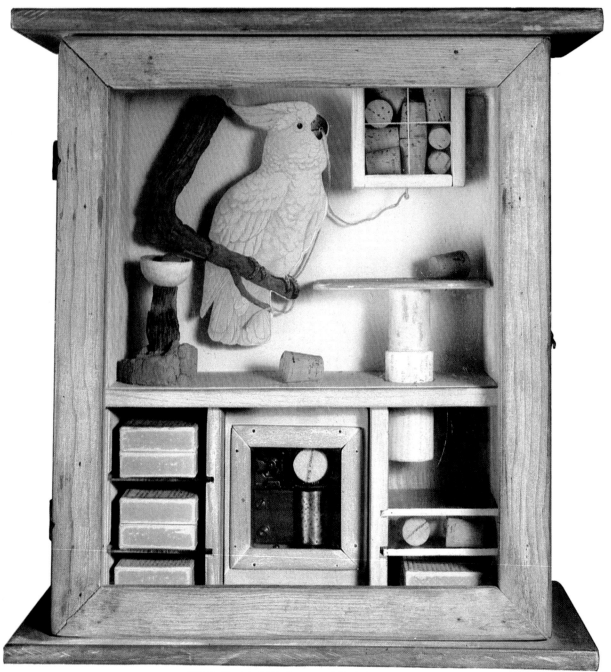

XXVI. Untitled (Cockatoo and Corks). c. 1948
Construction, 14⅜ x 13½ x 5⅝ in.
Private collection

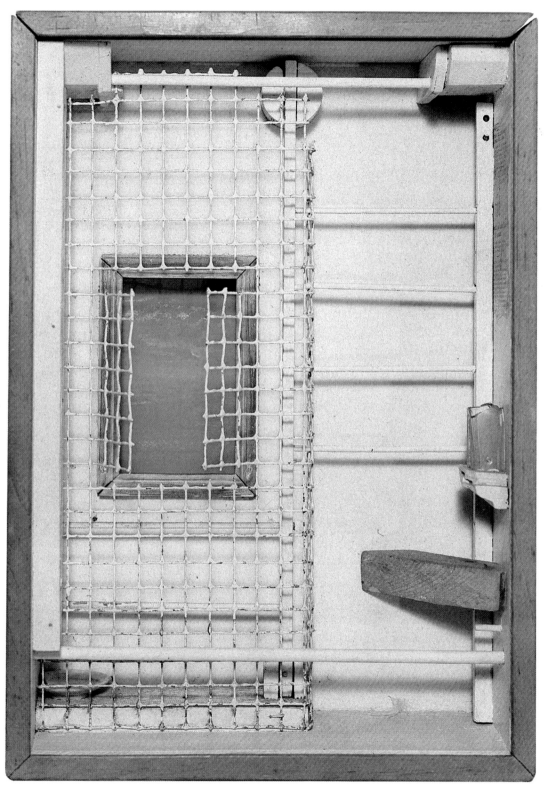

XXVII. *Toward the "Blue Peninsula."* 1951–52
Construction, 10⅝ x 14¹⁵⁄₁₆ x 3¹⁵⁄₁₆ in.
Collection Daniel Varenne, Geneva

XXVIII. Untitled (Vierge Vivace). 1970
Collage, 14 x 12¹⁄₁₆ in
Estate of Joseph Cornell,
Courtesy Castelli Feigen Corcoran

XXIX. *The Tiara.* c. 1966–67
Collage, 8¼ x 11¹⁵⁄₁₆ in.
Collection Mr. and Mrs. E. A. Bergman, Chicago

XXXI. Untitled. Early 1960s
Collage, 8⅝ x 13¾ in.
Estate of Joseph Cornell,
Courtesy Castelli Feigen Corcoran

XXX. Untitled (Penny Arcade with Horse). c. 1965
Collage, 11½ x 8⅜ in.
Estate of Joseph Cornell,
Courtesy Castelli Feigen Corcoran

XXXII. *Portrait of the Artist's Daughter by Vigée Lebrun.* c. 1960
Collage, 10½ x 13⅜ in.
Collection Mr. and Mrs. Donald B. Straus, New York

1. Untitled. (La Vierge). 1930s
Collage, 3³⁄₁₆ x 3 in.
Estate of Joseph Cornell,
Courtesy Castelli Feigen Corcoran

2

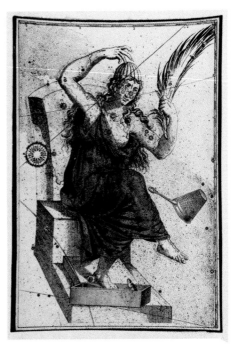

3

4

2. Untitled (Schooner). 1931
Collage 4½ x 5¾ in.
Collection June Schuster, Pasadena, California

3. Untitled (La Cassiopée). 1930s
Collage, 7³⁄₁₆ x 5 in.
Estate of Joseph Cornell,
Courtesy Castelli Feigen Corcoran

4. Untitled. 1930s
Collage, 4¹¹⁄₁₆ x 7¹⁄₁₆ in.
Estate of Joseph Cornell,
Courtesy Castelli Feigen Corcoran

5. Untitled. 1931
Collage, 5¼ x 8⅛ in.
Estate of Joseph Cornell,
Courtesy Castelli Feigen Corcoran

6. Untitled. 1930s
Collage, 5⅜ x 8¹⁵⁄₁₆ in.
Estate of Joseph Cornell,
Courtesy Castelli Feigen Corcoran

7. Untitled. 1930s
Collage, 6⅛ x 8¹⁄₁₆ in.
The Museum of Modern Art, New York,
Purchase

5

6

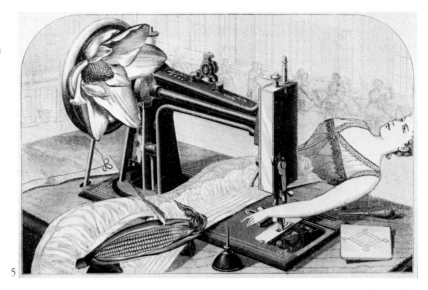

7

Amiral, ne crois pas dé'choir
En agitant ton vieux mouchoir.
C'est la couteume de chasser
Ainsi les mouches du passé.
R. Radiguet

8. *Mouchoir.* 1933
Collage, 10 x 7⁷⁄₁₆ in.
Estate of Joseph Cornell,
Courtesy Castelli Feigen Corcoran

9. Untitled. 1930s
Collage, 8¾ x 6¹¹⁄₁₆ in.
Estate of Joseph Cornell,
Courtesy Castelli Feigen Corcoran

10. Untitled. 1933
Collage, 6¹⁄₁₆ x 4¹⁄₁₆ in.
Estate of Joseph Cornell,
Courtesy Castelli Feigen Corcoran

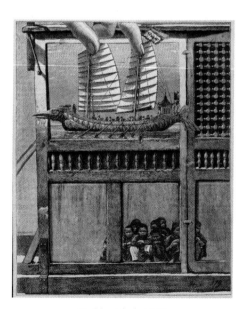

11. Untitled. 1930s
Collage, 7¼ x 5¹¹⁄₁₆ in.
Australian National Gallery, Canberra

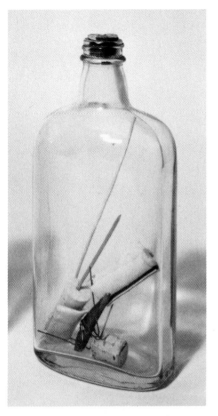

12. Untitled (Grasshopper Bottle). c. 1933
Construction, 8⅛ x 3½ x 2¼ in.
Castelli Feigen Corcoran

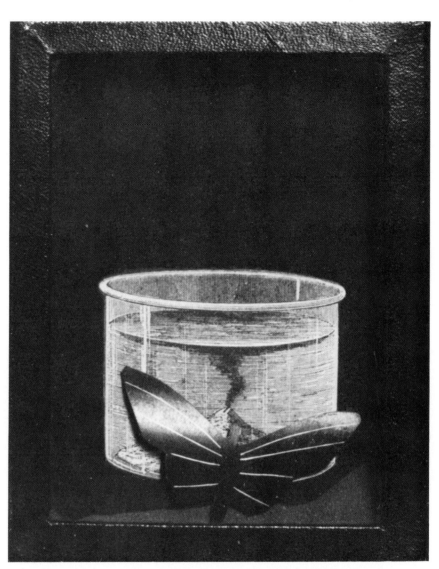

14. Untitled (Object). c. 1933–35
Construction, ⅞ x 4⅝ x 3⅝ in.
Collection Mr. and Mrs. Julien Levy,
Bridgewater, Connecticut

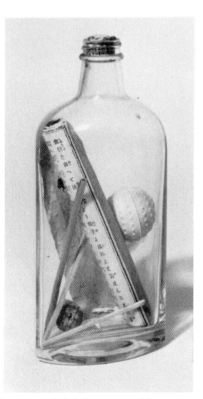

13. Untitled. (Chinese Bottle). 1933
Construction, 8⅛ x 3½ x 2¼ in.
Castelli Feigen Corcoran

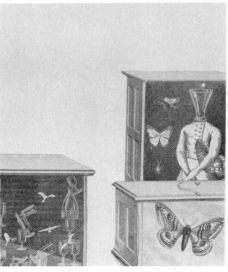

15. Untitled. 1930s
Collage, 9¹⁵⁄₁₆ x 7⁵⁄₁₆ in.
Private collection, New York

16. *Monsieur Claude.* 1930s
Collage, 4¹³⁄₁₆ x 5⅝ in.
Collection Mr. and Mrs. E. A. Bergman, Chicago

17. Untitled (Beehive; Thimble Forest). 1948
Construction, 3¹¹⁄₁₆ x 7¹¹⁄₁₆ in. (diam.)
Collection Mr. and Mrs. E. A. Bergman, Chicago

18

18. *Le Voyageur dans les glaces.* c. 1932
Construction, 1⅛ x 3¾ x 3¹¹⁄₁₆ in.
Collection Mr. and Mrs. E. A. Bergman, Chicago

19. *Jardin de Marie Antoinette.* 1949
Construction, 1⅞ x 4¼ in. (diam.)
Estate of Joseph Cornell
Courtesy Castelli Feigen Corcoran

19

20

20. *Object "Beehive."* 1934
Construction, 3⅝ x 7¾ in. (diam.)
The Museum of Modern Art, New York,
Gift of James Thrall Soby

21. Untitled (Bell Jar). c. 1939
Construction, 9¼ x 8¼ in. (diam.)
National Collection of Fine Arts, Smithsonian Institution,
Washington, D.C.,
Gift of Katherine Sergava Sznycer,
in memory of Bernard W. Sznycer and Eugene Berman

22. Untitled. 1930s
Collage, 6⅝ x 5⁵⁄₁₆ in.
Collection William Kistler III, New York

23. Untitled (Horse and Rider). c. 1932
Construction, 2¹⁄₁₆ x 1¹³⁄₁₆ in. (diam.)
Collection Mr. and Mrs. E. A. Bergman, Chicago

24. Untitled (Snow Maiden). c. 1933
Construction, 13¼ x 13¼ x 2½ in.
Collection Mr. and Mrs. E. A. Bergman, Chicago

25

26

27

28

29

25. Untitled. 1930s
Collage, 7¹¹⁄₁₆ x 5¹¹⁄₁₆ in.
Estate of Joseph Cornell,
Courtesy Castelli Feigen Corcoran

26. Untitled. 1930s
Collage, 7⁷⁄₁₆ x 4¹⁄₁₆ in.
Estate of Joseph Cornell,
Courtesy Castelli Feigen Corcoran

27. Untitled. 1930s
Collage, 3³⁄₁₆ x 3¹⁵⁄₁₆ in.
Estate of Joseph Cornell,
Courtesy Castelli Feigen Corcoran

28. Untitled. 1930s
Collage, 6¹³⁄₁₆ x 5³⁄₁₆ in.
Estate of Joseph Cornell,
Courtesy Castelli Feigen Corcoran

29. Untitled. 1930s
Collage, 3¹⁵⁄₁₆ x 2¹³⁄₁₆ in.
Estate of Joseph Cornell,
Courtesy Castelli Feigen Corcoran

30. Untitled. 1930s
Collage, 5⅝ x 3⁹⁄₁₆ in.
Estate of Joseph Cornell,
Courtesy Castelli Feigen Corcoran

31. Untitled. 1930s
Collage, 8¾ x 6 in.
Estate of Joseph Cornell,
Courtesy Castelli Feigen Corcoran

30

31

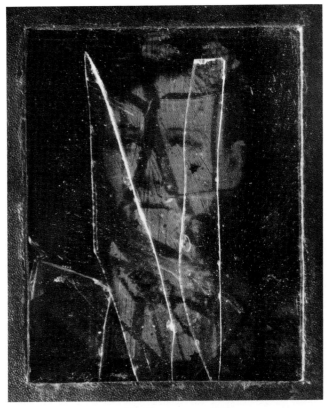

32. *Object Daguerreotype.* 1935
Construction, ⅞ x 5⅛ x 4³⁄₁₆ in.
Private collection, New York

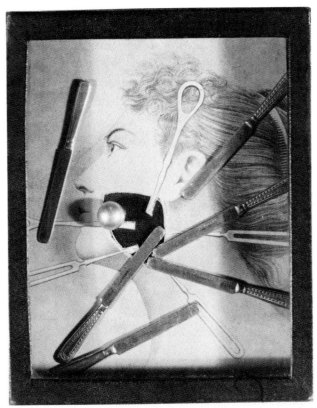

33. Untitled (Object). c. 1933
Construction, ⅞ x 5 x 4¼ in.
Private collection, New York

34. Untitled (Object). c. 1933–35
Construction, ¹⁵⁄₁₆ x 5¼ x 6⅛ in.
Collection Mr. and Mrs. Julien Levy, Bridgewater, Connecticut

35. Untitled (Object). 1933
Construction, ⅞ x 5⅛ x 4³⁄₁₆ in.
Castelli Feigen Corcoran

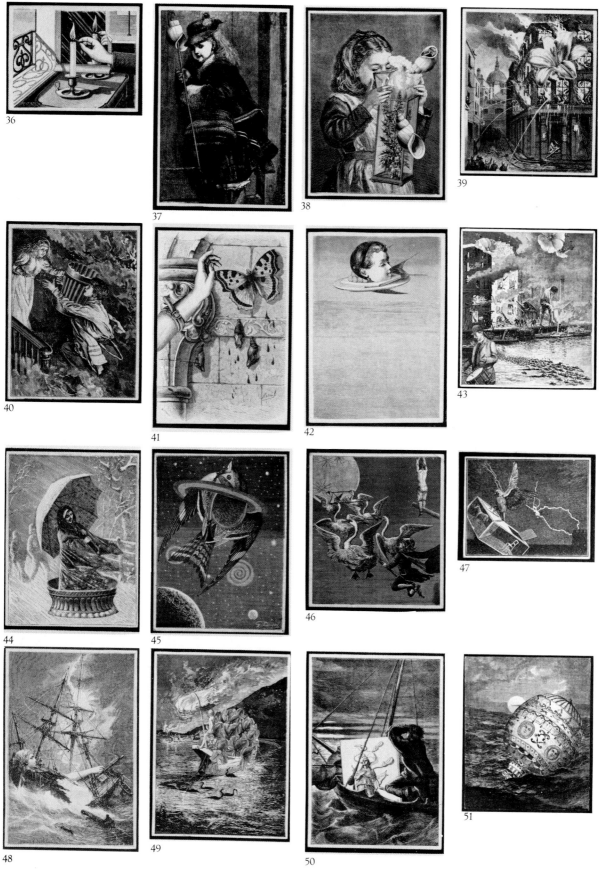

36-51. Sixteen collages for *Story without a Name—for Max Ernst.* 1930s
(published in *View,* April 1942). Collage, 3 x 3¾ in. to 7⁷⁄₁₆ x 6⁷⁄₁₆ in.
Private collection, New York

52. Top: *Boucle d'oreille pour Tamara Toumanova.* 1940
Left: Untitled. c. 1940. Right: *Object.* 1940
Constructions, top and left, ½ x 1³⁄₁₆ in.;
right, ⅝ x 1¼ in. (diam.)
Estate of Joseph Cornell,
Courtesy Castelli Feigen Corcoran

53. Top: *Object Earring Set for Marie Blachas Albino.* 1939
Left: *Object.* 1933. Right: *Object.* 1940
Constructions, top and left, ½ x 1³⁄₁₆ in.; right,
⅝ x 1¹¹⁄₁₆ in. (diam.)
Estate of Joseph Cornell,
Courtesy Castelli Feigen Corcoran

54. *Le Caire.* c. 1940
Construction, 1⅞ x 5⅛ in. (diam.);
aver. size of paper tubes, 1½ x ⅞ in. (diam.)
Estate of Joseph Cornell
Courtesy Castelli Feigen Corcoran

55. Untitled (Mona Lisa). c. 1940–42
Construction, 1⅜ x 3 in. (diam.)
Estate of Joseph Cornell,
Courtesy Castelli Feigen Corcoran

56. Untitled. c. 1939–40, c. 1957
Construction, 1⅜ x 3 in. (diam.)
Private collection, New York

57. Top: *Object.* 1940 Bottom: *Object.* 1940
Constructions, ⅝ x 1¹¹⁄₁₆ in.; ⅝ x 1¼ in. (diam.)
Estate of Joseph Cornell,
Courtesy Castelli Feigen Corcoran

58. *Object.* 1940
Book construction, 8⅞ x 5⅞ x 1½ in.
Estate of Joseph Cornell,
Courtesy Castelli Feigen Corcoran

59. Untitled (Rosalba; Book with Marble). c. 1945
Construction, 7⁷⁄₁₆ x 4⁷⁄₁₆ x 1⅝ in.
Collection Felix Landau, Los Angeles

60. Untitled (A Keepsake for John Donne). c. 1935–39
Construction, 5¾ x 2¾ x 1½ in.
Private collection, New York

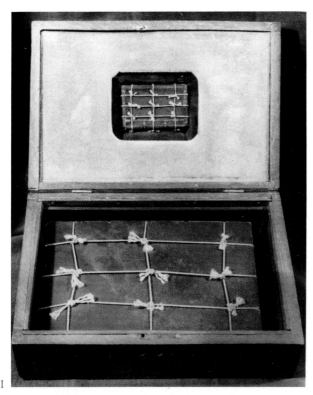

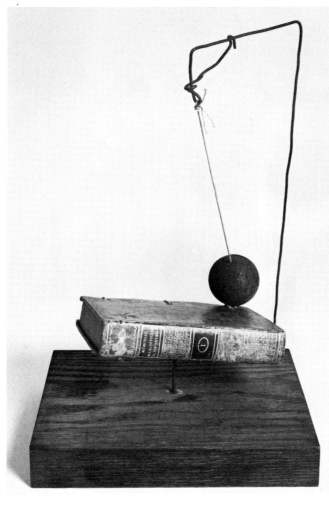

61. Untitled (Book Box). c. 1939–40
Construction, 3⅜ x 9 x 6¹⁄₁₆ in.
Private collection, New York

62. Untitled (Book with Window). c. 1945
Construction, 6½ x 4 x 1¾ in.
Collection Felix Landau, Los Angeles

63. Untitled. c. 1936–40
Construction, overall, 17⁷⁄₁₆ x 8⅜ x 11¾ in.
Estate of Joseph Cornell,
Courtesy Castelli Feigen Corcoran

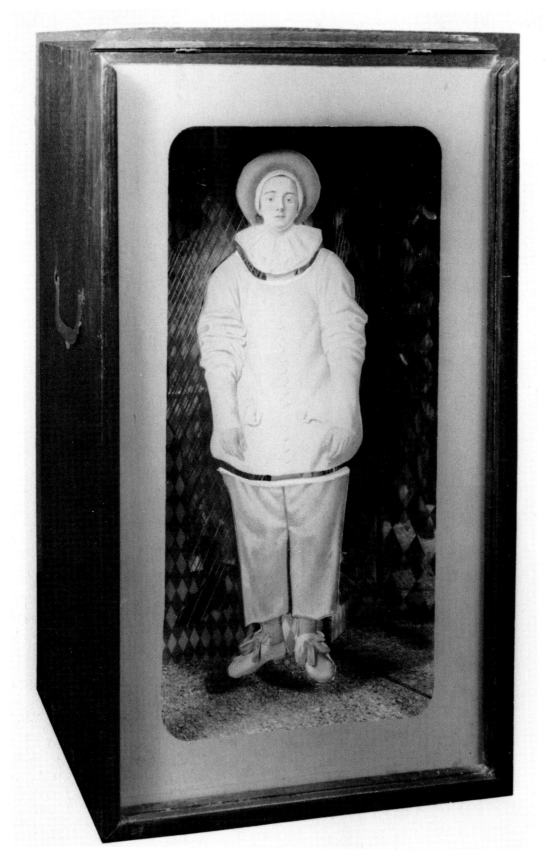

64. *A Dressing Room for Gille.* 1939
Construction, 15 x 8⅝ x 5¹¹⁄₁₆ in.
Collection Richard L. Feigen, New York

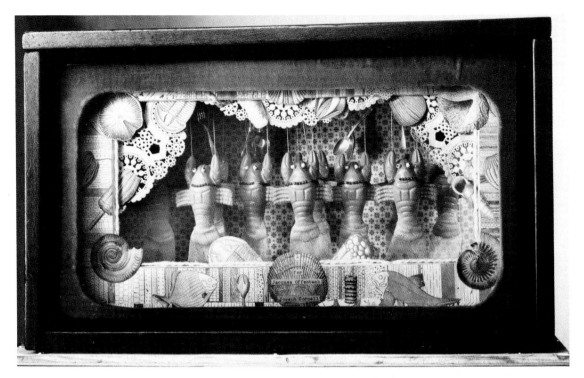

65. *A Pantry Ballet (for Jacques Offenbach).* Summer 1942
Construction, 10½ x 18⅛₆ x 6 in.
Nelson Gallery–Atkins Museum, Kansas City, Missouri,
Friends of Art Collection

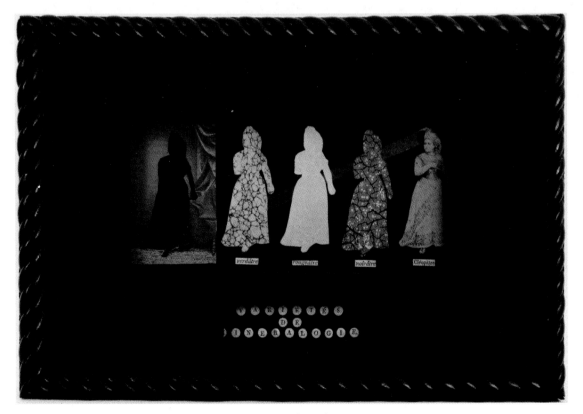

66. *Variétés de Minéralogie Object.* 1939
Construction, 9⅜ x 14¼ x 2¼ in.
Private collection, New York

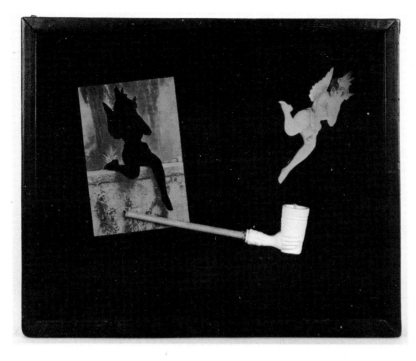

67. Untitled. 1945
Construction, 10⅝ x 13⅛ x 2 in.
Collection Mr. and Mrs. E. A. Bergman, Chicago

68. Untitled (Black Hunter). c. 1939
Construction, 12 x 8 x 2¾ in.
Collection Mr. and Mrs. E. A. Bergman, Chicago

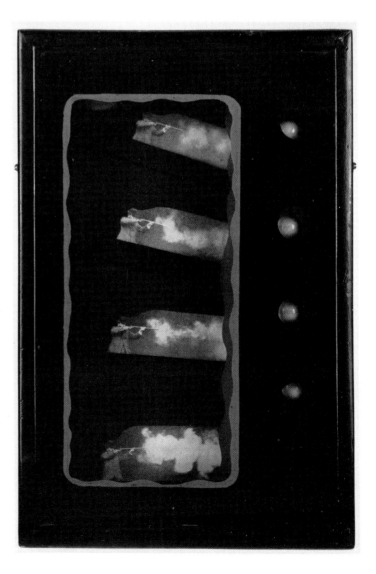

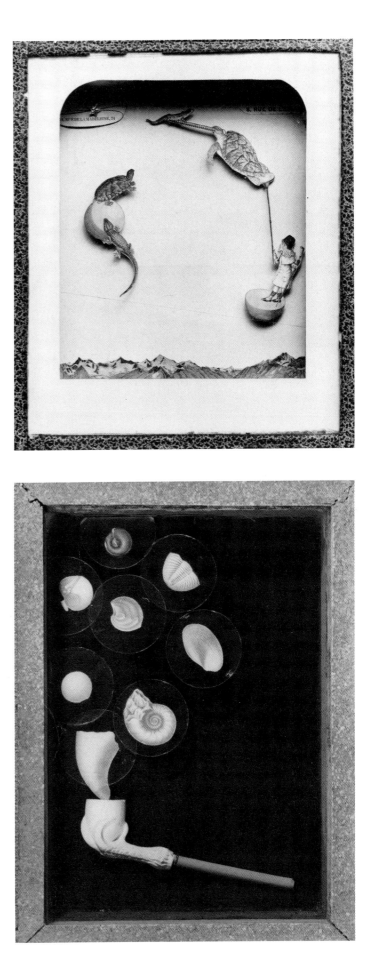

69. *La Bourboule.* c. 1933
Construction, 14¼ x 12³⁄₁₆ x 2⁵⁄₁₆ in.
Collection Mr. and Mrs. E. A. Bergman, Chicago

70. *Object.* 1940
Construction, 11³⁄₁₆ x 8½ x 2⅝ in.
Private collection, New York

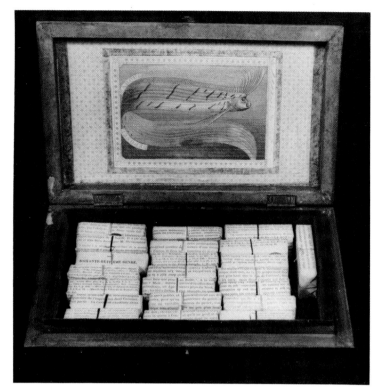

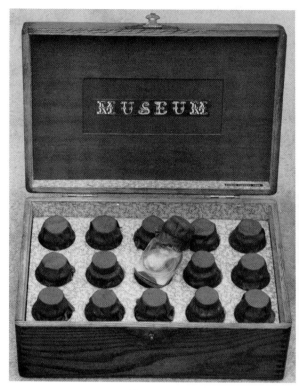

71. Untitled (Marque déposée). c. 1942
Construction, 2½ x 10 x 6 in.
Private collection, New York

72. *Museum.* 1943
Construction, 3¾ x 9 x 6 in.
Collection Mr. and Mrs. Orin Raphael

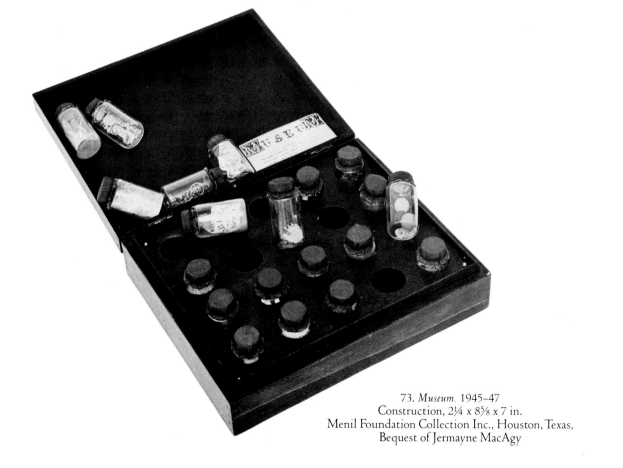

73. *Museum.* 1945–47
Construction, 2¼ x 8⅝ x 7 in.
Menil Foundation Collection Inc., Houston, Texas,
Bequest of Jermayne MacAgy

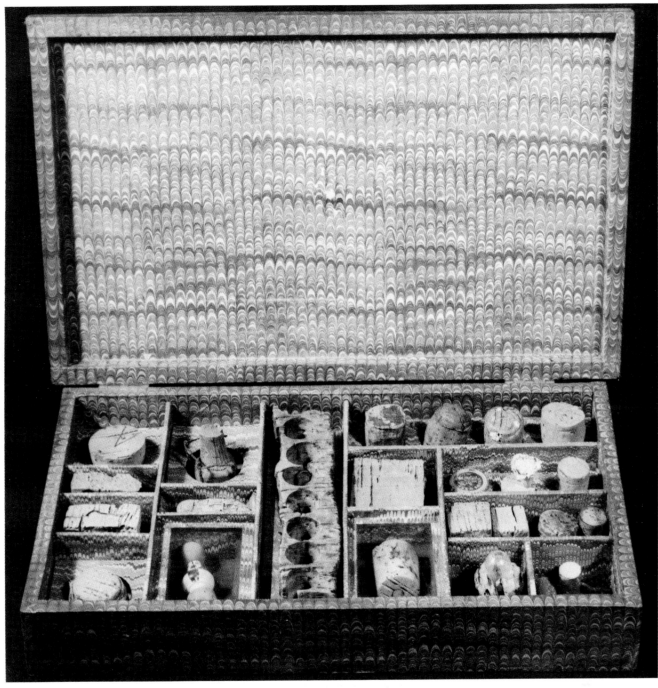

74. Untitled (Cork or Varia Box). c. 1943
Construction, 2½ x 17⅛ x 10⅜ in.
Collection Mr. and Mrs. E. A. Bergman, Chicago

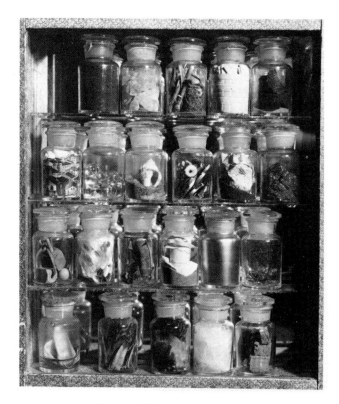

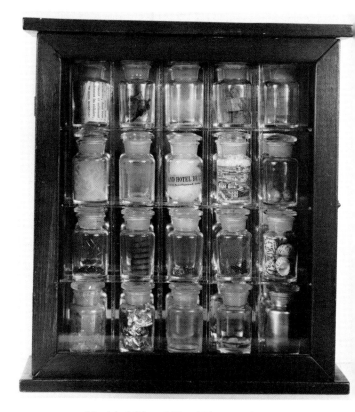

75. Untitled (Pharmacy). c. 1942
Construction, 14 x 12 x 4⅜ in.
The Peggy Guggenheim Collection, Venice,
The Solomon R. Guggenheim Foundation

76. Untitled (Grand Hotel Pharmacy). c. 1947
Construction, 14 x 13⅛ x 4⅜ in.
Collection Mr. and Mrs. Billy Wilder, Los Angeles

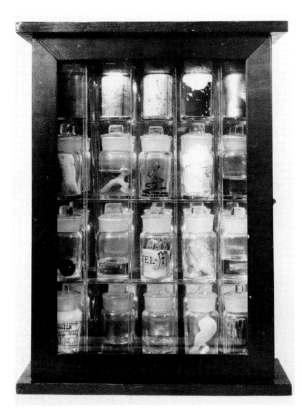

77. Untitled (Pharmacy). 1950
Construction, 15⅞ x 10½ x 3⅞ in
Private collection, U.S.A.

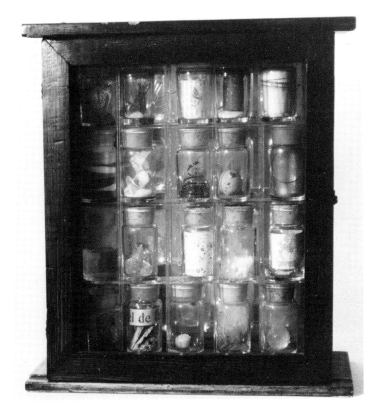

78. Untitled (Pharmacy). 1952–53
Construction, 14¼ x 13¼ x 5¼ in.
Collection Muriel Kallis Newman, Chicago

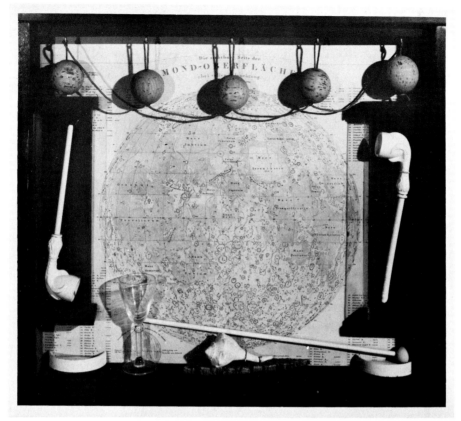

79. Untitled (Mond-Oberfläche). 1955
Construction, 15⅜ x 17³⁄₁₆ x 2⅜ in.
Collection Michael Scharf, Jacksonville, Florida

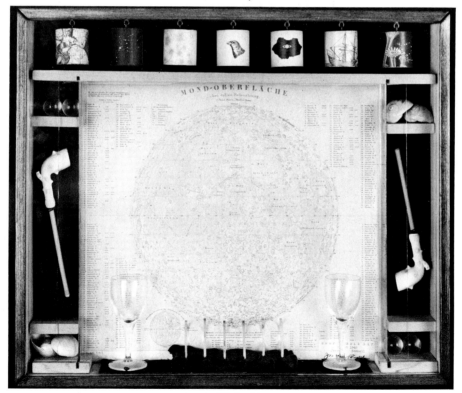

80. *Soap Bubble Set Object.* 1940
Construction, 18 x 22 x 3¼ in.
Collection Mr. and Mrs. Orin Raphael

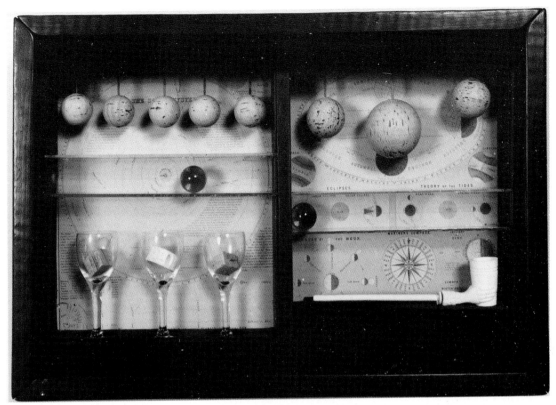

81. *Soap Bubble Set.* 1947–48
Construction, 12¾ x 18⅜ x 3 in.
Collection Stefan Edlis

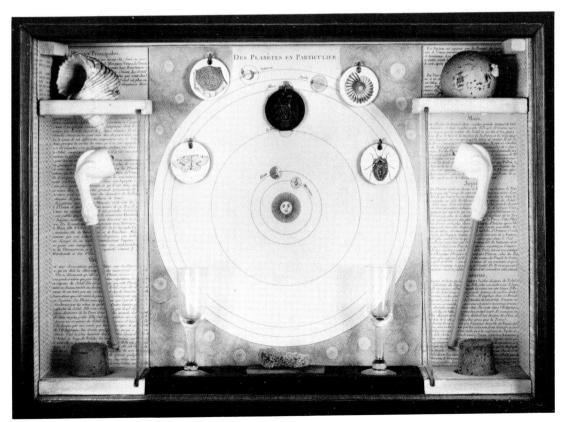

82. *Soap Bubble Set.* 1947
Construction, 12⅞ x 18⅛ x 3¾ in.
Collection Mr. and Mrs. Carl D. Lobell, New York

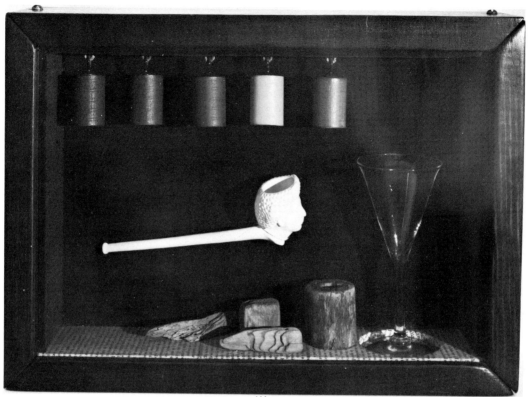

83. *Soap Bubble Set.* 1947
Construction, 9¹¹⁄₁₆ x 13 x 3⅛ in.
Gatodo Gallery, Tokyo

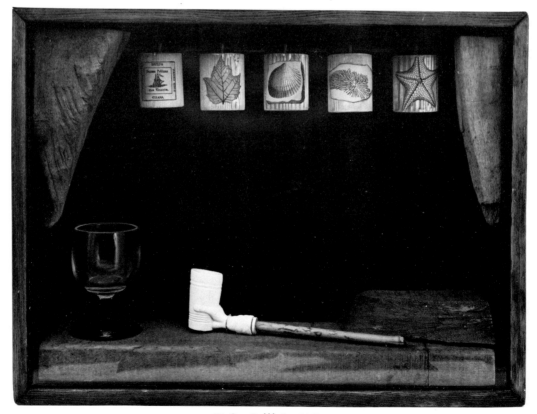

84. *Soap Bubble Set.* 1948
Construction, 10⅛ x 14⅛ x 3½ in.
Private collection, New York

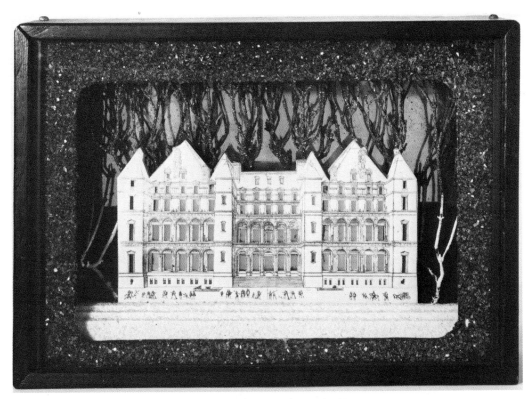

85. *Le Chant du Rossignol.* c. 1946–48
Construction, 9 x 13⅛ x 3¾ in.
Private collection

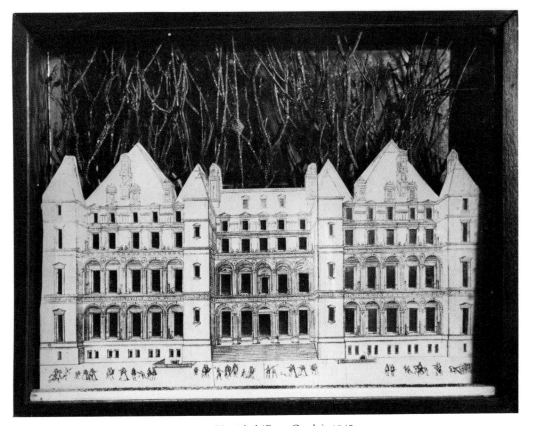

86. Untitled (Rose Castle). 1945
Construction, 11½ x 15 x 4 in.
Whitney Museum of American Art, New York,
Bequest of Kay Sage Tanguy

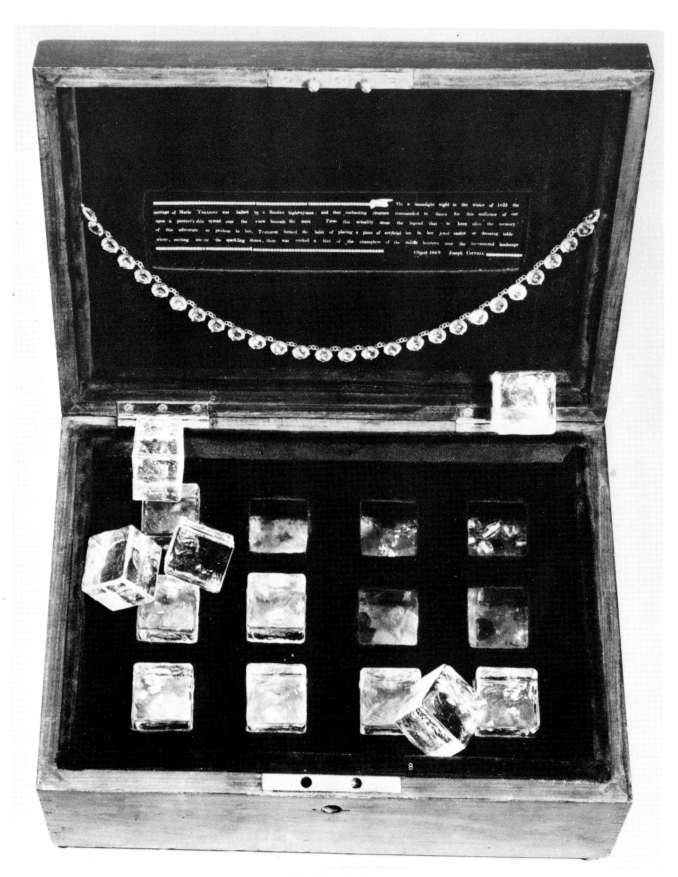

87. *Taglioni's Jewel Casket.* 1940
Construction, 4¾ x 11⅞ x 8¼ in.
The Museum of Modern Art, New York,
Gift of James Thrall Soby

88. *Homage to the Romantic Ballet.* Christmas 1947
Construction, 1⅝₁₆ x 3¹³⁄₁₆ x 2¾ in.
Estate of Joseph Cornell,
Courtesy Castelli Feigen Corcoran

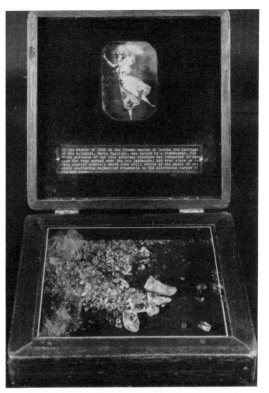

89. Untitled (Taglioni Souvenir Case). c. 1940
Construction, 1¼ x 4¼ x 4⅛ in.
Private collection, New York

90. *Little Mysteries of the Ballet (Homage to the Romantic Ballet)*
1941. Construction, 1¼ x 4½ x 3½ in.
Estate of Joseph Cornell,
Courtesy Castelli Feigen Corcoran

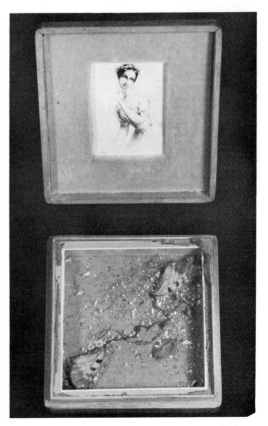

91. Untitled (Homage to the Romantic Ballet)
c. 1940–42. Construction, 1¼ x 4⅜ x 4⅜ in.
Estate of Joseph Cornell,
Courtesy Castelli Feigen Corcoran

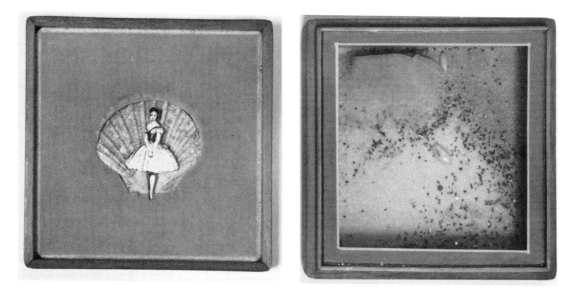

92. Untitled (Sylphide Souvenir Case). c. 1940–42
Construction, 1⅛ x 4⅛ x 4⅛ in.
Estate of Joseph Cornell,
Courtesy Castelli Feigen Corcoran

93. *Portrait of Ondine.* 1940s–50s
Paperboard box containing various paper materials,
slipcase: 2½ x 10¾ x 12¾ in.; box: 2 x 10³⁄₁₆ x 12 ⁵⁄₁₆ in.
Estate of Joseph Cornell, Courtesy Castelli Feigen Corcoran

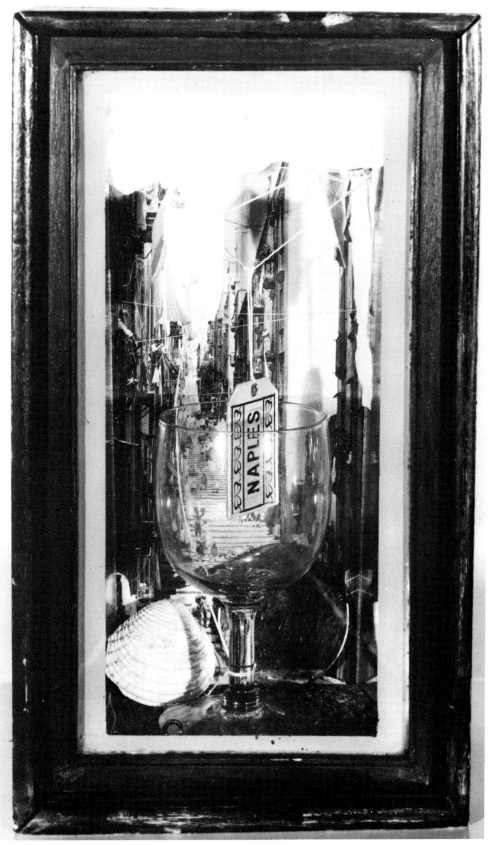

94. *Naples.* 1942
Construction, 11¼ x 6¾ x 4¾ in.
Collection Mr. and Mrs. Philip Gersh, Beverly Hills, California

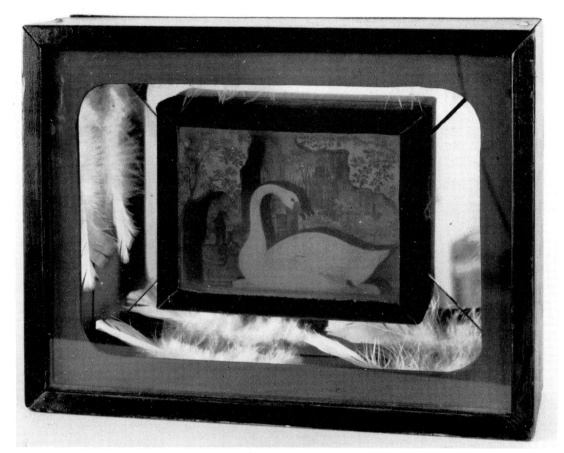

95. *A Swan Lake for Tamara Toumanova.* 1946
Construction, 9½ x 13 x 4 in.
Private collection, U.S.A.

96. *7 Tears of Lucia, for Anna Moffo.* 1964
Construction; paperboard box: 3¼ x 3¹³⁄₁₆ x 3⅞ in.
Estate of Joseph Cornell,
Courtesy Castelli Feigen Corcoran

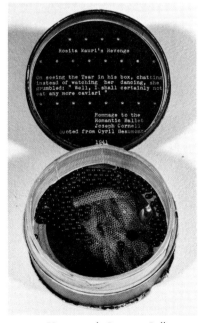

97. *Homage to the Romantic Ballet
(Rosita Mauri's Revenge).* 1941
Construction, 1⅜ x 3¹⁄₁₆ in. (diam.)
Collection Mr. and Mrs.
E. A. Bergman, Chicago

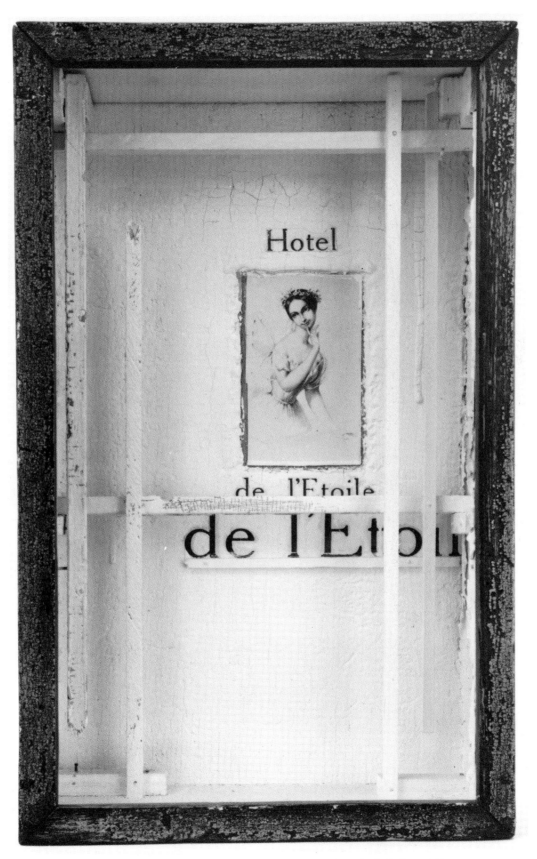

Hotel

de l'Etoile

de l'Etoi

98. Untitled (Hotel de l'Etoile: The Diplomacy of Lucile Grahn). c. 1953
Construction, 18½ x 11⅜ x 4¼ in.
Collection Christophe de Menil

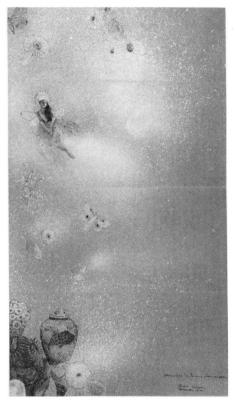

99. *Hommage à Tamara Toumanova.* December 1940
Collage, 15⁷⁄₁₆ x 9 in.
Collection Mr. and Mrs.
E. A. Bergman, Chicago

100. *Homage to the Romantic Ballet (pour Philoxène Boyer).* c. 1967
Collage, 9³⁄₈ x 7³⁄₈ in.
Collection Jeffrey Horvitz

101. *L'Apothéose La Taglioni.* c. 1969
Collage, 11½ x 8⁹⁄₁₆ in.
Estate of Joseph Cornell,
Courtesy Castelli Feigen Corcoran

102. Verso of *L'Apothéose La Taglioni,* pl. 101

103. Untitled (Renée Jeanmaire in "La Belle au Bois Dormant"). 1949
Construction, 14½ x 11¾ x 7 in.
Private collection, New York

104. Untitled (The Life of King Ludwig of Bavaria). c. 1941–52
Paperboard valise containing various paper materials and objects,
3⅝ x 14½ x 11 in.
Estate of Joseph Cornell,
Courtesy Castelli Feigen Corcoran

105. *Les Trois Mousquetaires.* c. 1948
Construction, 11¼ x 9⅝ x 6¹⁄₁₆ in.
Collection Richard L. Feigen, New York

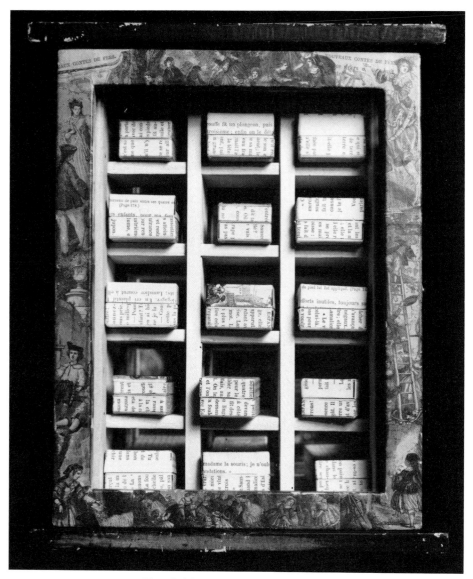

106. Untitled (Nouveaux contes de fées). c. 1948
Construction, 12⅝ x 10¼ x 5⅞ in.
Collection Mr. and Mrs. E. A. Bergman, Chicago

107. Untitled (Rattle and Music Box). Late 1950s
Construction, 3⅛ x 10⅛ x 7¼ in.
Menil Foundation Collection Inc., Houston, Texas,
Bequest of Jermayne MacAgy

108. Untitled (Paul and Virginia), pl. IX, with door closed

109. *Victorian Parlour Constellation (Paolo and Francesca) Object.* 1942
Construction, 12⅝ x 9½ x 2⅞ in.
Collection Richard L. Feigen, New York

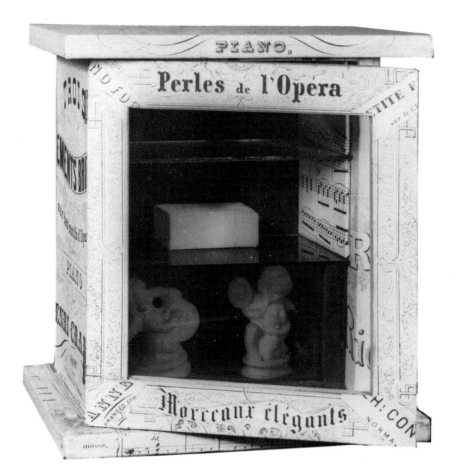

110. *Perles de l'Opéra.* c. 1948
Construction, 9 x 8⁷⁄₁₆ x 4⁷⁄₈ in.
Estate of Joseph Cornell,
Courtesy Castelli Feigen Corcoran

111. *Penny Arcade Portrait of Lauren Bacall* (Dossier)
1946 (added to after 1946)
Paperboard folder containing photographs and various paper materials;
folder: ¾ x 11¹⁵⁄₁₆ x 8¹¹⁄₁₆ in.
Collection Mr. and Mrs. E. A. Bergman, Chicago

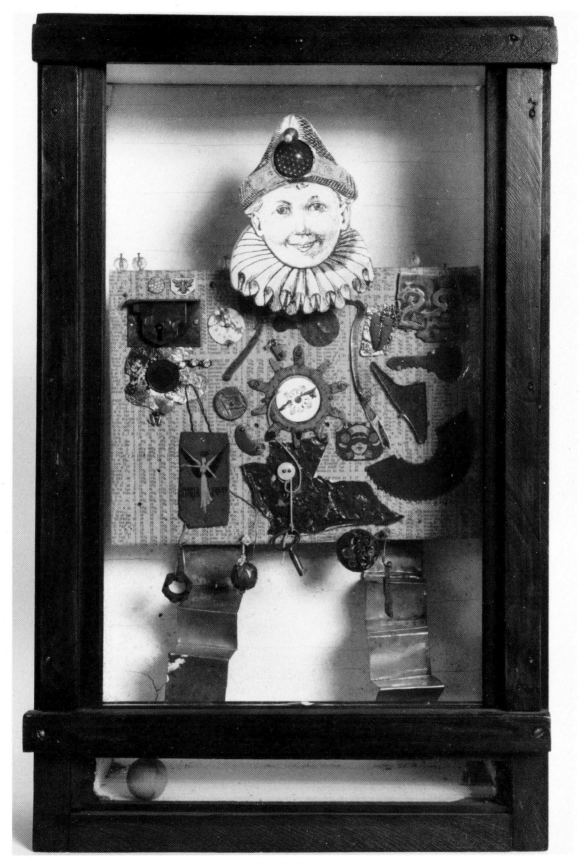

112. Untitled. c. 1951–53
Construction, 17⅞ x 11¹¹⁄₁₆ x 4¾ in.
Estate of Joseph Cornell,
Courtesy Castelli Feigen Corcoran

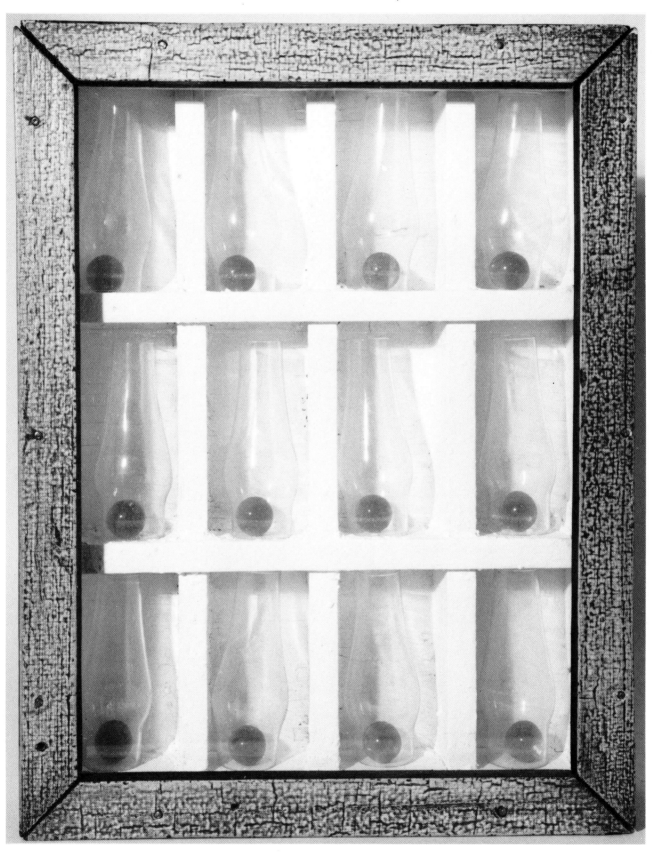

113. *An Image for 2 Emilies.* c. 1954
Construction, 13¹¹⁄₁₆ x 10½ x 2¹¹⁄₁₆ in.
Estate of Joseph Cornell,
Courtesy Castelli Feigen Corcoran

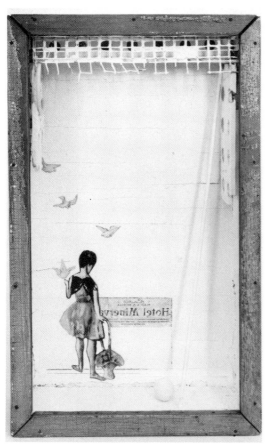

114

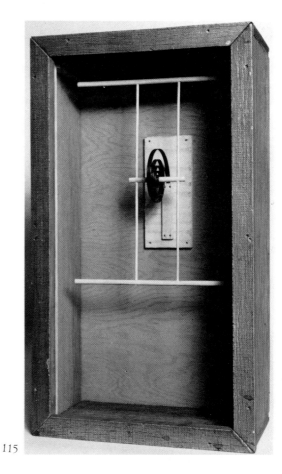

115

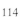

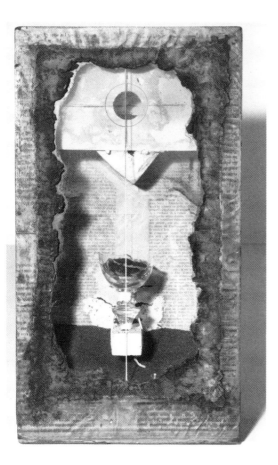

116

114. *Variétés Apollinaires (for Guillaume Apollinaire).* c. 1953
Construction, 18⅛ x 11⅞₁₆ x 4⅝₁₆ in.
Castelli Feigen Corcoran

115. *Blériot #2.* c. 1956
Construction, 19 x 11 x 4¹⁵⁄₁₆ in.
Estate of Joseph Cornell,
Courtesy Castelli Feigen Corcoran

116. Untitled (Sand Fountain "pour Valéry"). c. 1955
Construction, 14½ x 7¾ x 4 in.
Des Moines Art Center, Coffin Fine Arts
Trust Fund

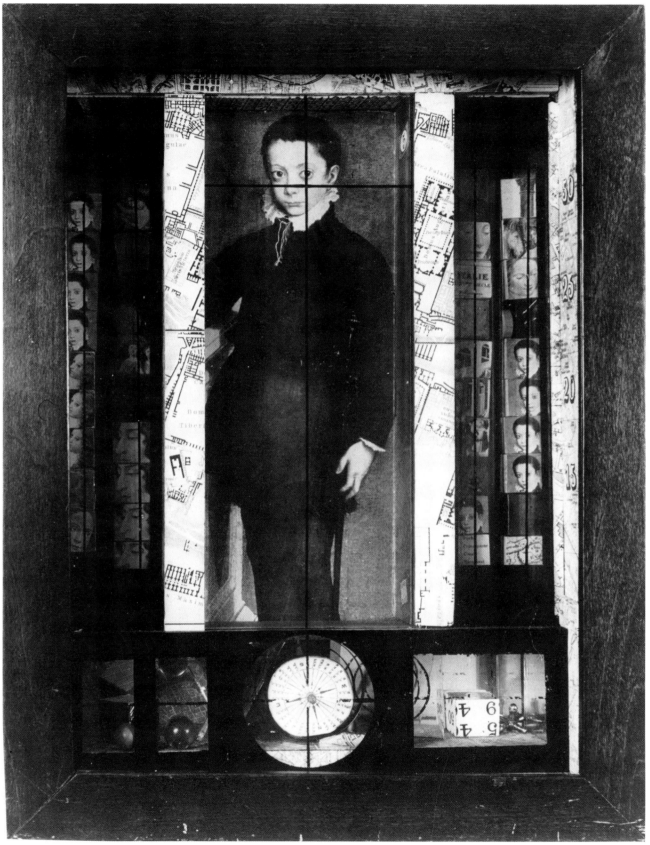

117. Untitled (Medici Slot Machine). 1942
Construction, 15½ x 12 x 4⅜ in.
Private collection, location unknown

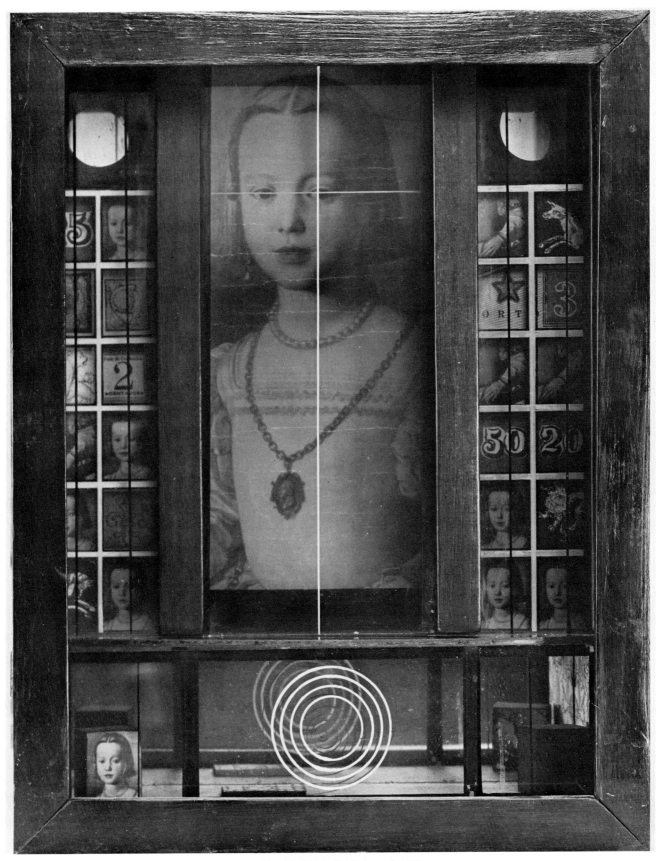

118. Untitled (Medici Princess). 1952
Construction, 14 x 11 x 3⅞ in.
Collection Mr. and Mrs. E. A. Bergman, Chicago

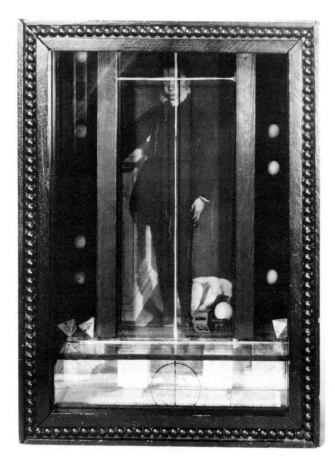

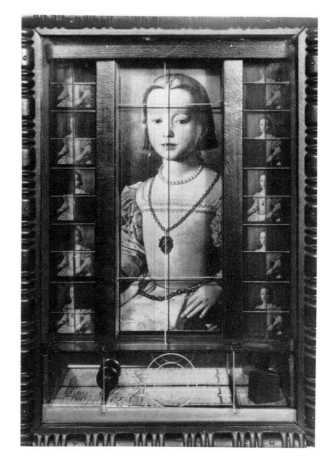

119. Untitled (Medici Prince). c. 1952–54
Construction, 15¼ x 11 x 5 in.
Private collection

120. Untitled (Medici Princess). c. 1952–54
Construction, 18½ x 11⁷/₁₆ x 4⁷/₁₆ in.
Gatodo Gallery, Tokyo

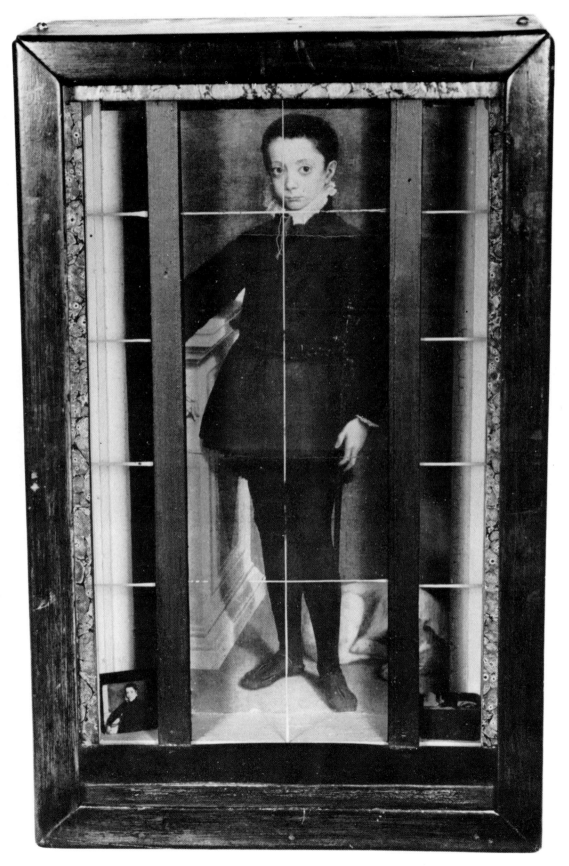

121. Untitled (Medici Boy). c. 1953
Construction, 18¼ x 11½ x 5¾ in.
The Fort Worth Art Museum, Benjamin J. Tillar Memorial Trust Fund

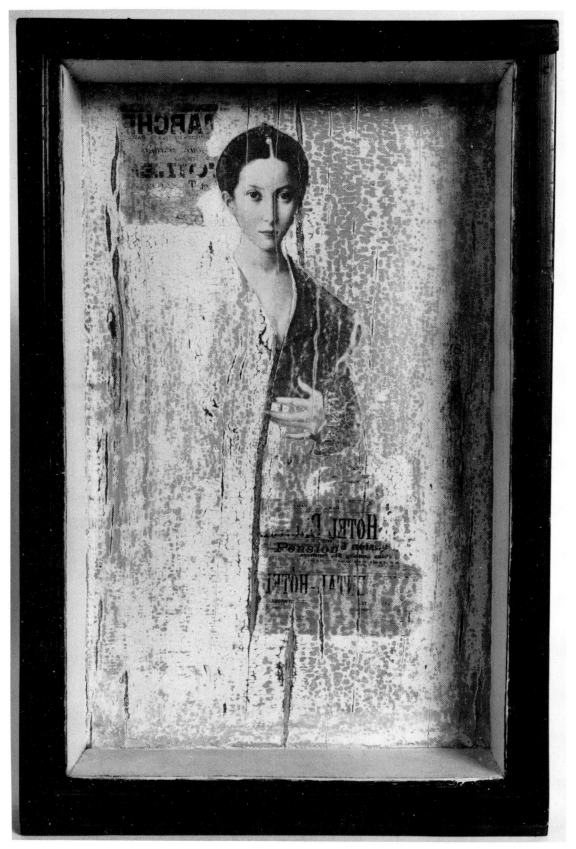

122. Untitled (La Bella). 1950
Construction, 18¾ x 12⁷⁄₁₆ x 3¼ in.
Estate of Joseph Cornell,
Courtesy Castelli Feigen Corcoran

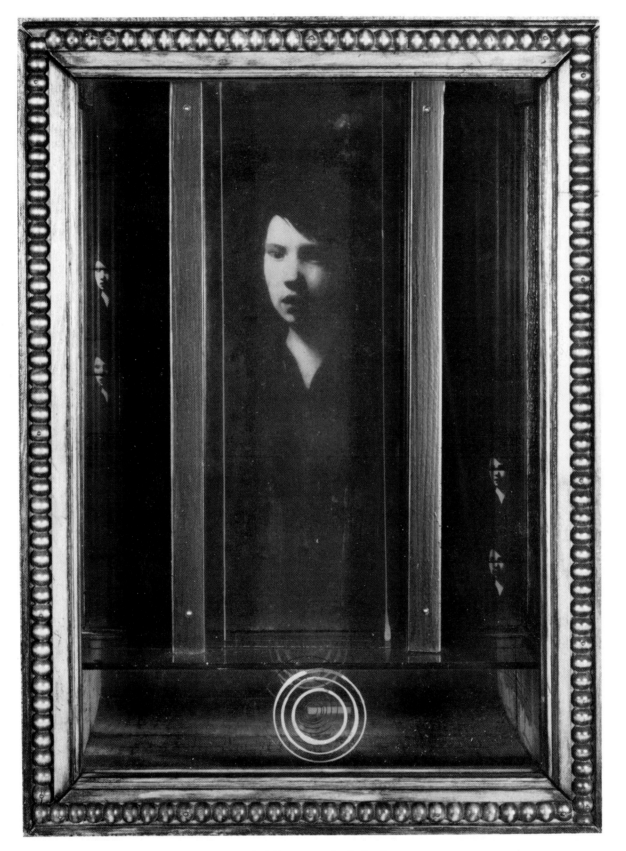

123. Untitled (Caravaggio Boy). October 1955
Construction, 14⅜ x 10⅜ x 5¼ in.
Private collection, New York

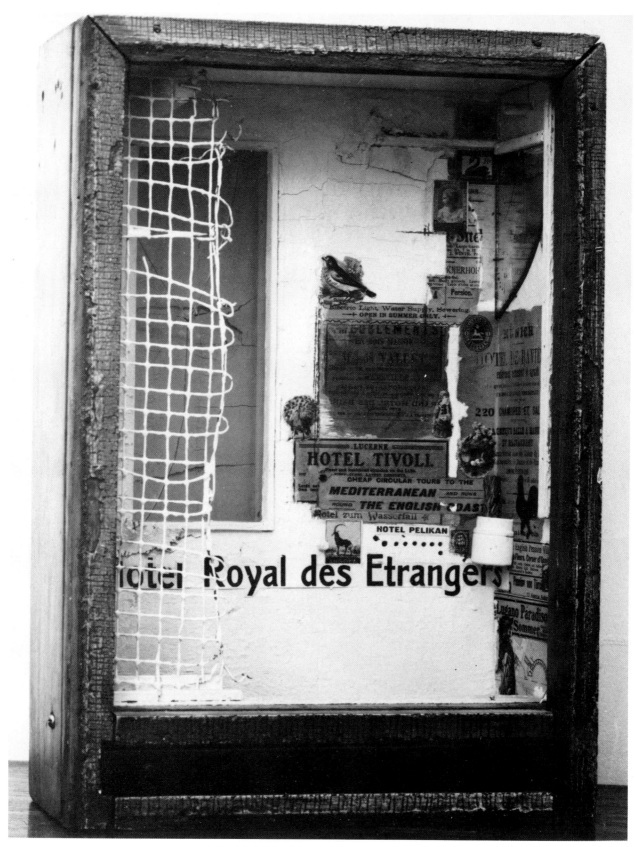

124. Untitled (Hotel Royal des Etrangers). c. 1952
Construction, 17¼ x 12 x 6¼ in.
Collection Diane and Paul Waldman, New York

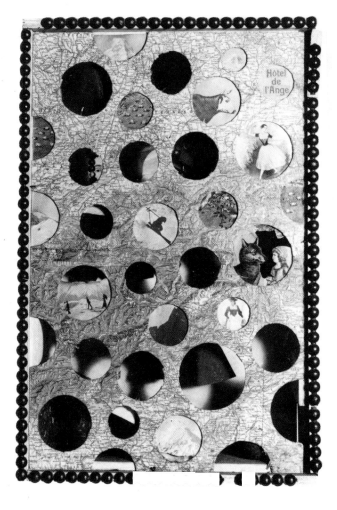

125. Verso of Untitled (Hotel Royal des Etrangers), pl. 124

126. *Swiss Shoot the Chutes.* 1941
Construction, 21³⁄₁₆ x 13⅞ x 4⅛ in.
The Peggy Guggenheim Collection, Venice,
The Solomon R. Guggenheim Foundation

127. Untitled (Hotel de l'Etoile). 1951–52
Construction, 19½ x 11½ x 4½ in.
ACA Galleries, New York

128

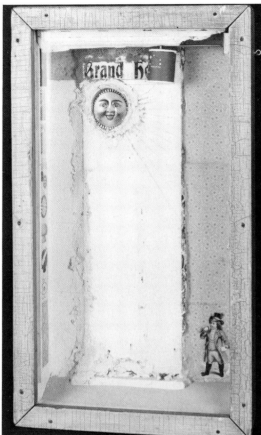

129

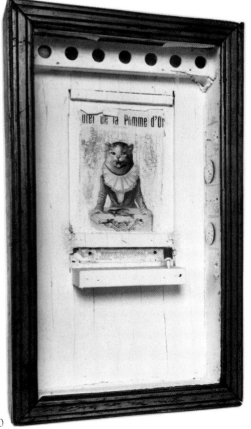

130

128. Untitled (Hotel Sun Box). c. 1956
Construction, 17 3/16 x 11 1/4 x 4 3/4 in.
Castelli Feigen Corcoran

129. Untitled (des Voyageurs). c. 1956
Construction, 18 1/4 x 10 5/8 x 3 5/8 in.
Private collection, New York

130. Untitled (Hotel de la Pomme d'Or). c. 1954–55
Construction, 18 x 10 11/16 x 3 3/4 in.
Estate of Joseph Cornell,
Courtesy Castelli Feigen Corcoran

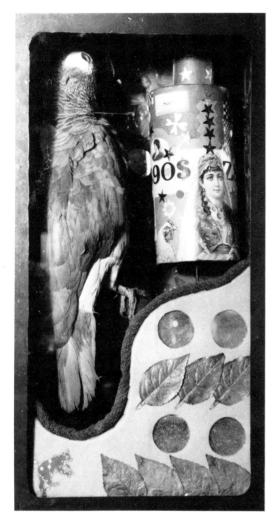

131. *Parrot Music Box*. c. 1945
Construction, 16 x 8¾ x 6¹¹⁄₁₆ in.
The Peggy Guggenheim Collection, Venice,
The Solomon R. Guggenheim Foundation

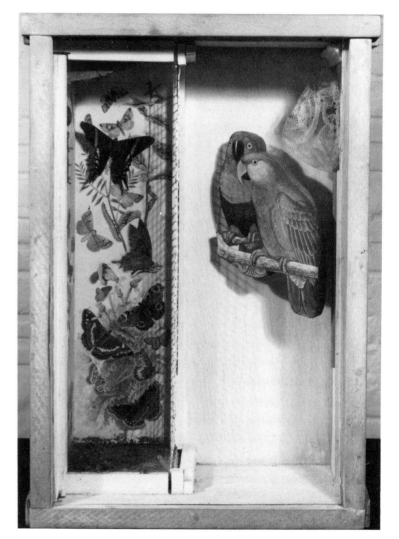

132. Untitled (Parrot and Butterfly Habitat). c. 1948
Construction, 19⅝ x 13⅝ x 6½ in.
Private collection , Tokyo

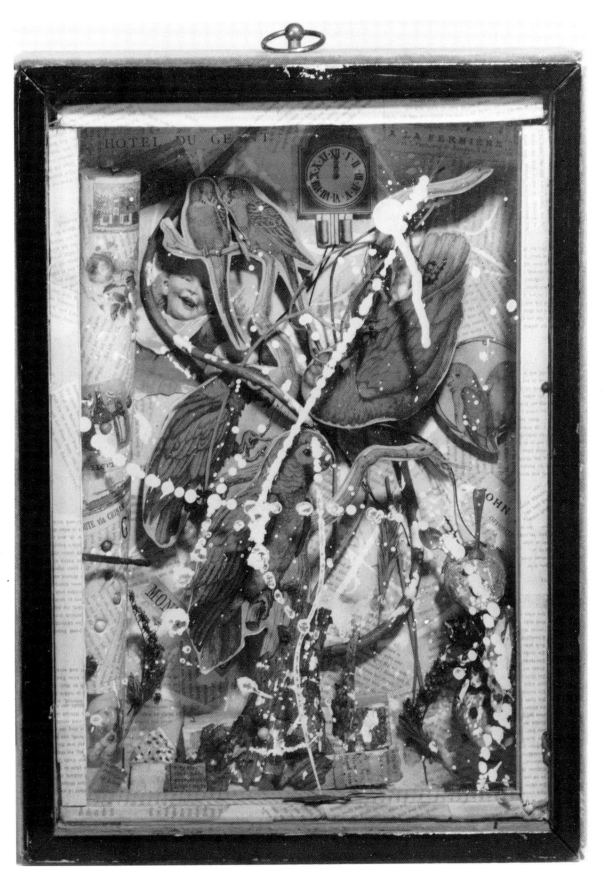

133. *Object.* 1941
Construction, 14½ x 10½ x 3½ in.
Collection Richard L. Feigen, New York

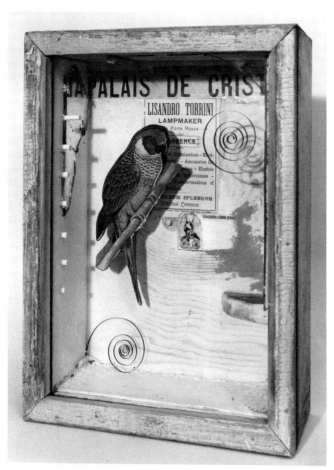

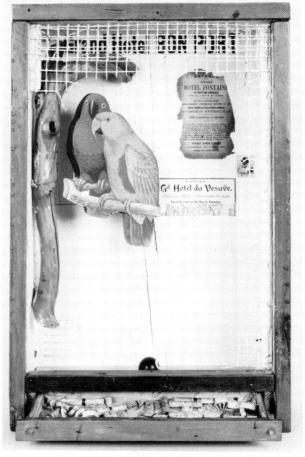

134. Untitled (Palais de Cristal). c. 1953
Construction, 12¹⁵⁄₁₆ x 9¼ x 4³⁄₁₆ in.
Collection Mr. and Mrs. Edward R. Hudson, Jr., Fort Worth, Texas

135. *The Caliph of Bagdad.* c. 1954
Construction, 20⁷⁄₁₆ x 13¾ x 4½ in.
Collection Mr. and Mrs. E.A. Bergman, Chicago

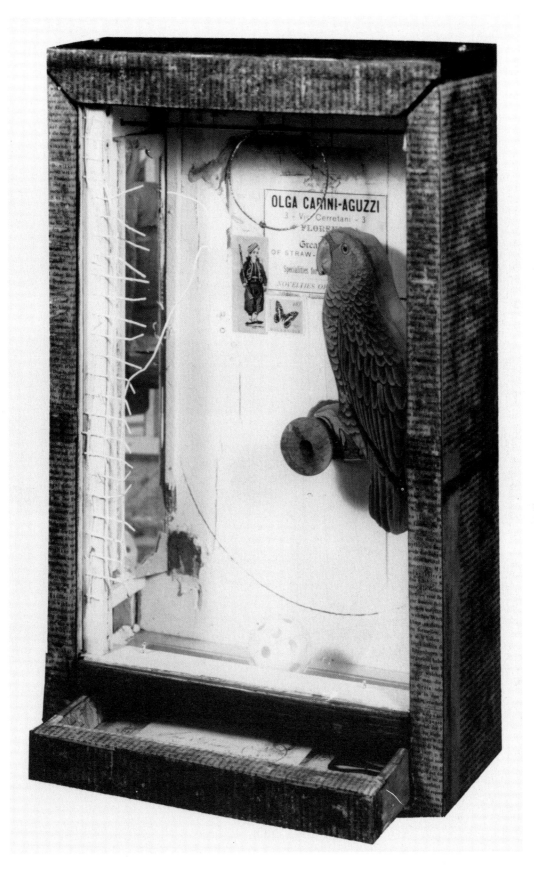

136. Untitled (for Mylene Demongeot). c. 1954
Construction, 17 x 11 x 4½ in.
Barbara Mathes Gallery, New York, and
John C. Stoller and Company, Minneapolis

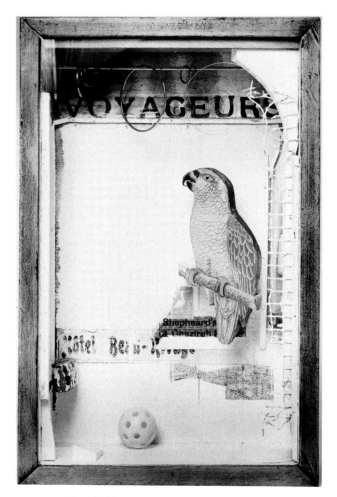

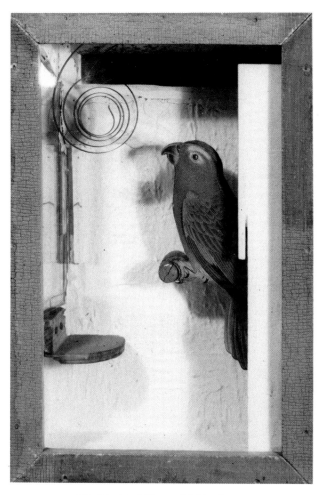

137. Untitled (Green Parrot; Hotel Voyageurs). c. 1953
Construction, 18 x 12 x 4⅝ in.
Collection Dr. and Mrs. Joseph Gosman

138. Untitled (Parrot Habitat). c. 1953
Construction, 17⅛ x 11⅛ x 5 in.
Collection Tony Berlant, Santa Monica, California

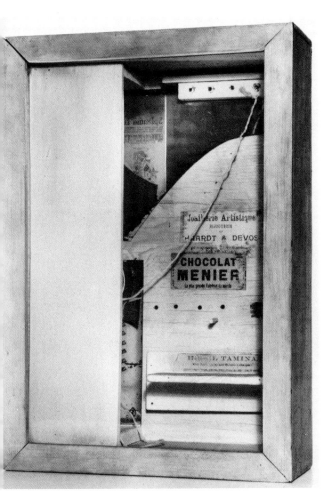

139. Untitled (Chocolat Menier). 1952
Construction, 17 x 12 x 4¾ in.
Grey Art Gallery and Study Center, New York University

140. Untitled (A Suivre). 1949
Construction, 17¼ x 12¼ x 4⅜ in.
Collection Robert Motherwell

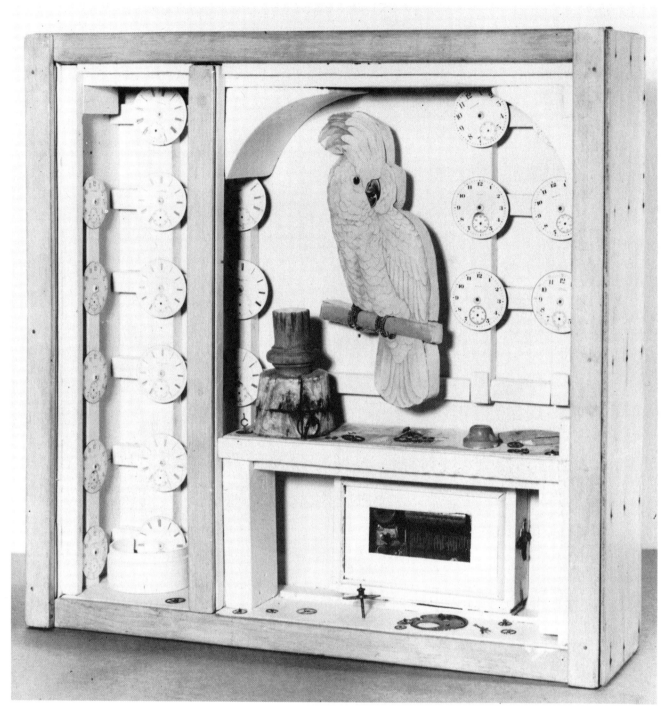

41. Untitled. c. 1948–50
Construction, 16¼ x 17 x 4⁷⁄₁₆ in.
Collection Mr. and Mrs. E. A. Bergman, Chicago

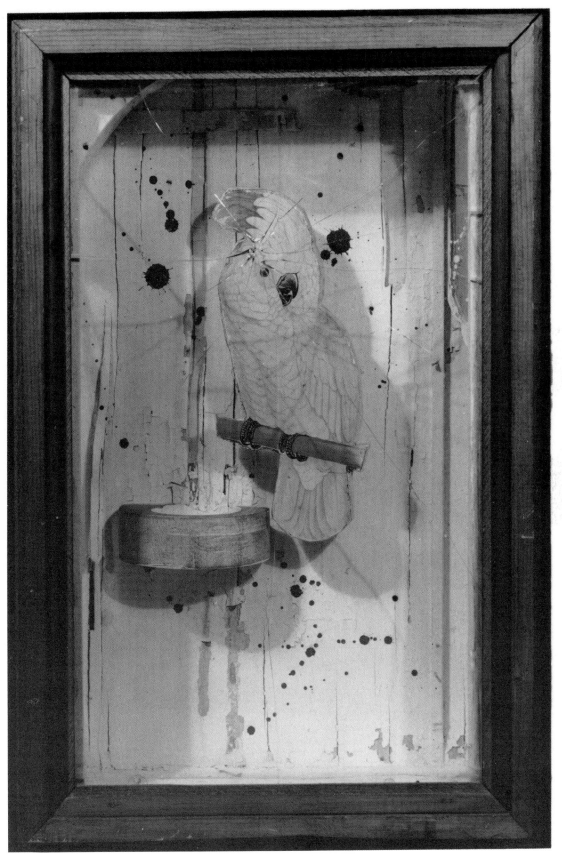

142. *Isabelle/Dien Bien Phu.* 1954
Construction, 18 x 12 x 6 in.
ACA Galleries, New York

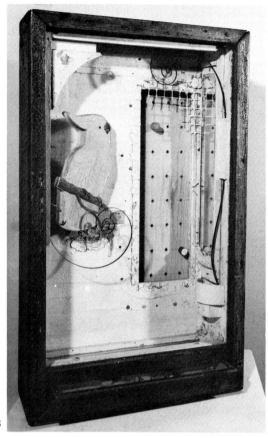

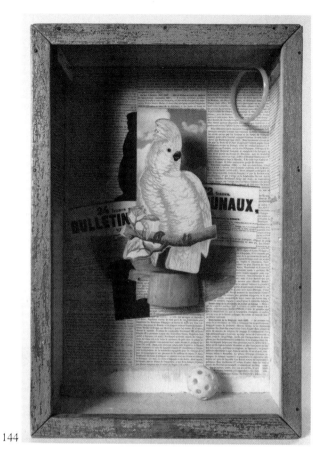

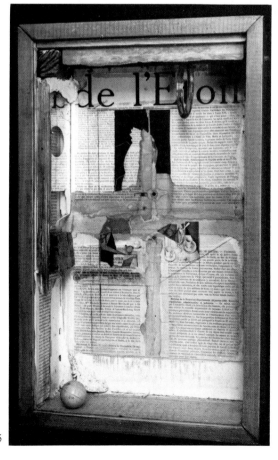

143. Untitled. 1950–52
Construction, 20 x 12 x 4 in.
Collection Allan Stone, New York

144. Untitled (Juan Gris). c. 1953–54
Construction, 18½ x 12½ x 4¾ in.
Philadelphia Museum of Art,
John D. McIlhenny Fund

145. *Le Déjeuner de Kakatoes pour Juan Gris (Juan Gris Cockatoo Series)*. c. 1953–55
Construction, 19⅝ x 12 1/16 x 4⅜ in.
Collection Mr. and Mrs. E. A. Bergman, Chicago

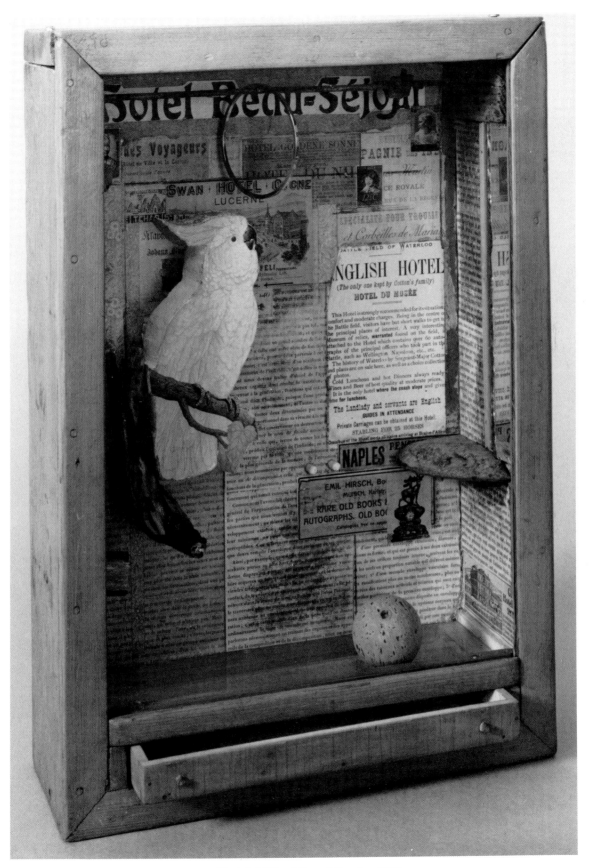

146. Untitled (Hotel Beau-Séjour). c. 1954
Construction, 17¾ x 12¼ x 4½ in.
The Museum of Modern Art, New York,
Promised Gift of an Anonymous Donor

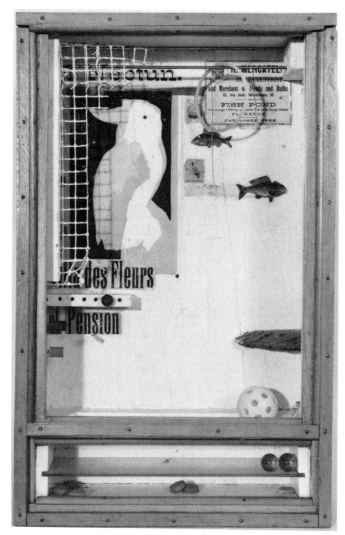

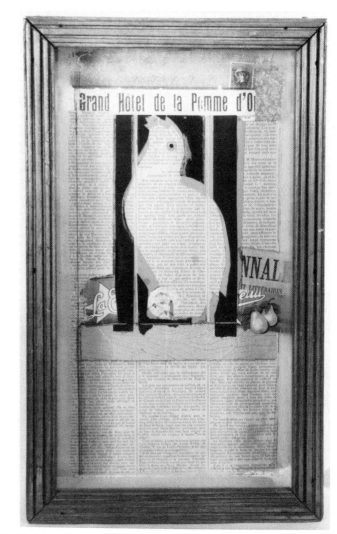

147. Untitled (Hotel Neptun). c. 1953–55
Construction, 19½ x 12¼ x 4 in.
Estate of Joseph Cornell,
Courtesy Castelli Feigen Corcoran

148. Untitled (Parrot Collage; Grand Hotel de la Pomme d'Or). c. 1954
Construction, 18¹⁵⁄₁₆ x 10¹¹⁄₁₆ x 3³⁄₁₆ in.
Castelli Feigen Corcoran

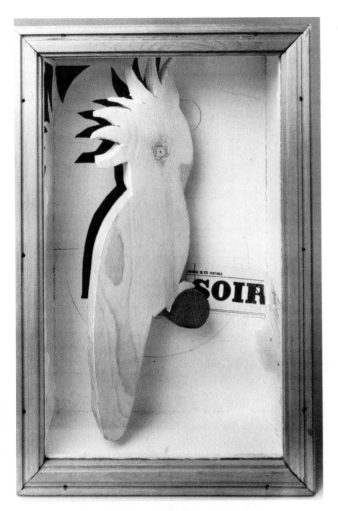

149. Untitled (Cutout Cockatoo). c. 1954–55
Construction, 16¾ x 11 x 4⁵⁄₁₆ in.
Private collection, New York

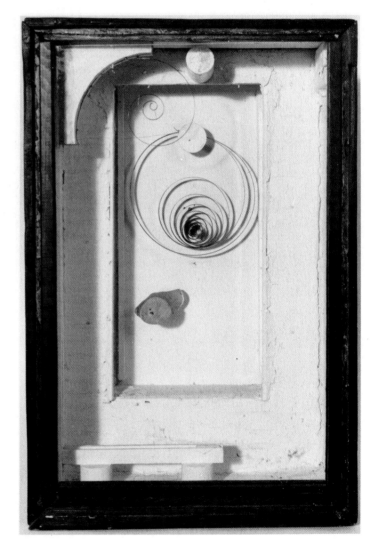

150. Untitled. c. 1950–54
Construction, 18⅞ x 12⁹⁄₁₆ x 6¼ in.
Estate of Joseph Cornell,
Courtesy Castelli Feigen Corcoran

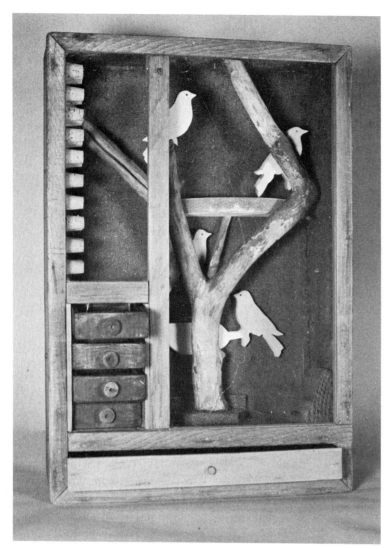

151. Untitled. c. 1948
Construction, 21⅛ x 15 x 6⁵⁄₁₆ in.
Collection Mr. and Mrs. E. A. Bergman, Chicago

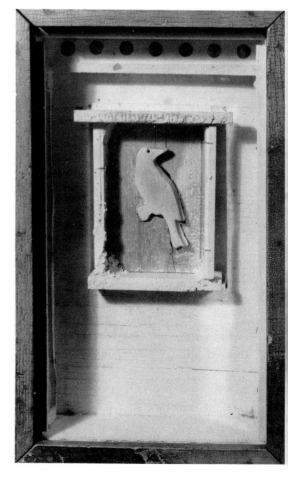

152. Untitled (Weather Prophet). c. 1954
Construction, 18 x 10½ x 4½ in.
Collection Arno Schefler, New York

153. Untitled (Hotel Bellagio). c. 1949–50
Construction, 6⅝ x 4½ x 2⅛ in.
Collection Daniel Varenne, Geneva

154. Untitled. c. 1948
Construction, 12³⁄₁₆ x 10¹⁄₁₆ x 5½ in.
Collection Mr. and Mrs. E. A. Bergman, Chicago

155. Untitled (Yellow Bird). 1950
Construction, 9 x 5¾ x 3½ in.
Private collection, U.S.A.

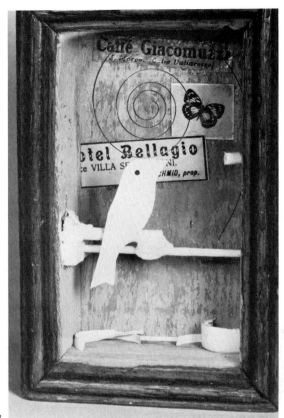

153

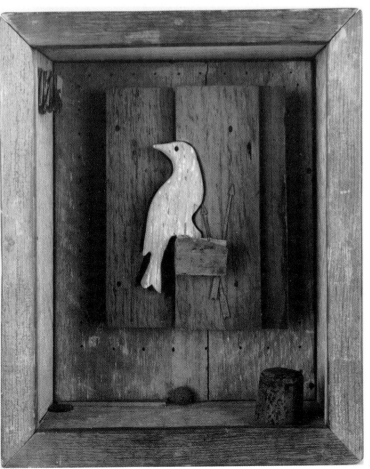

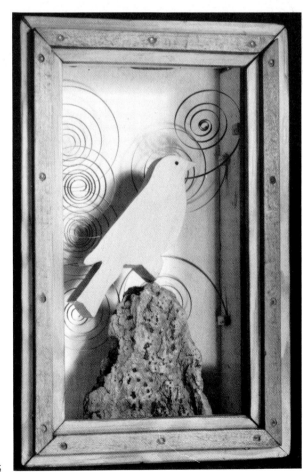

155

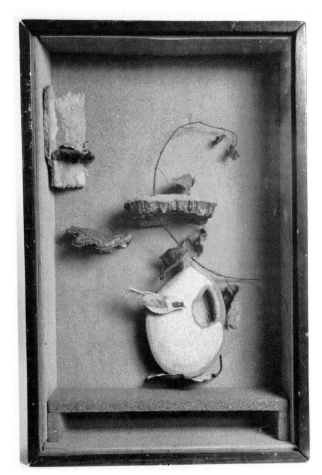

156. Untitled. 1948–49
Construction, 19 x 12⅜ x 3½ in.
Estate of Joseph Cornell,
Courtesy Castelli Feigen Corcoran

157. Untitled. 1949
Construction, 14¾ x 10⁵⁄₁₆ x 5³⁄₁₆ in.
Private collection, New York

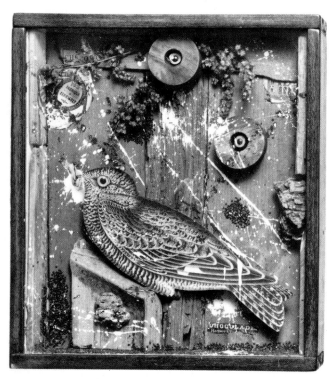

158. Untitled. 1943
Construction, 12⁹⁄₁₆ x 11½ x 2¾ in.
Kaiser Wilhelm Museum, Krefeld, Germany,
Sammlung Helga und Walter Lauffs

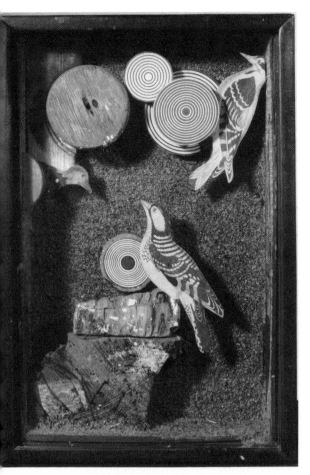

159. Untitled (Woodpecker Habitat). 1946
Construction, 13⅝ x 9⅛ x 3 in.
Collection Mr. and Mrs. E. A. Bergman, Chicago

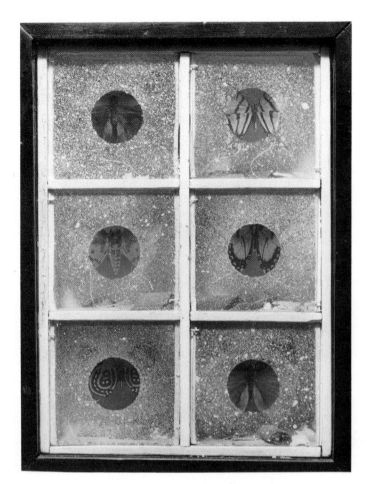

160. Untitled (Butterfly Habitat). c. 1940
Construction, 12 x 9³⁄₁₆ x 3³⁄₁₆ in.
Collection Mr. and Mrs. E. A. Bergman, Chicago

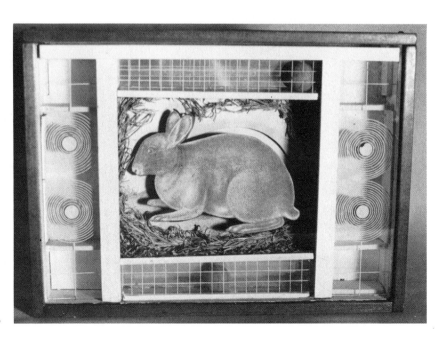

161. Untitled (American Rabbit). 1945–46
Construction, 11⅜ x 15⁹⁄₁₆ x 2⅞ in.
Collection Mr. and Mrs. E. A. Bergman, Chicago

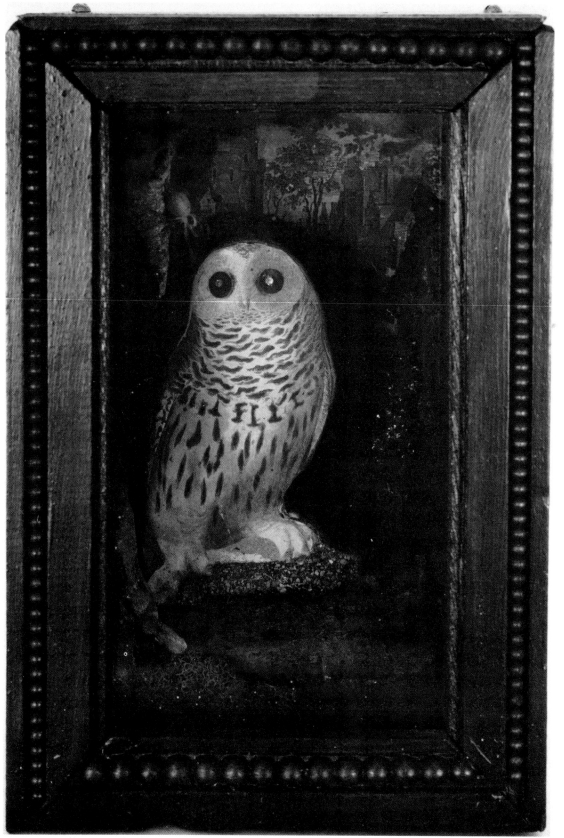

162. *An Owl for Ondine.* Summer 1954
Construction, 9⁷/₁₆ x 6⁵/₁₆ x 4½ in.
Estate of Joseph Cornell,
Courtesy Castelli Feigen Corcoran

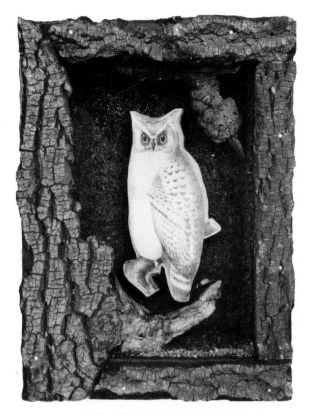

163. Untitled (Owl Box). c. 1948–50
Construction, 11¼ x 8¼ x 5 in.
Collection Mr. and Mrs. E. A. Bergman, Chicago

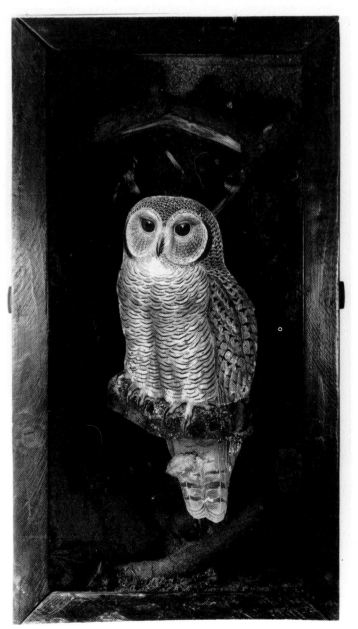

164. Untitled (Owl Box). 1945–46
Construction, 25 x 13½ x 6¼ in.
Musée National d'Art Moderne,
Centre National d'Art et de Culture Georges Pompidou, Paris

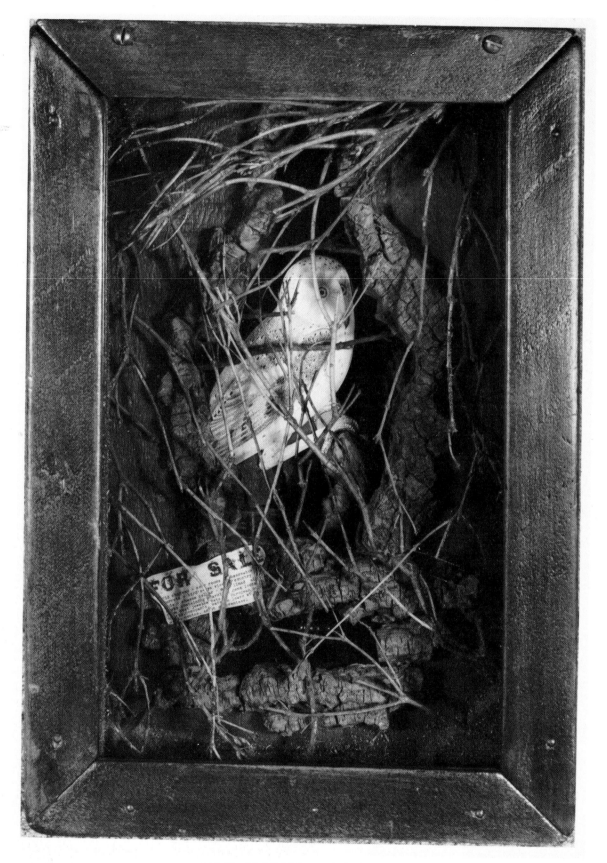

165. Untitled (Habitat with Owl). 1946
Construction, 12 x 8 x 4½ in.
Collection Arno Schefler, New York

166. Untitled (for Sheree North). 1953–59
Construction, 16¾ x 10¾ x 5⁵⁄₁₆ in.
Estate of Joseph Cornell,
Courtesy Castelli Feigen Corcoran

167. Untitled (Mélisande). c. 1948–50
Construction, 18 x 12 x 6 in.
Collection Arno Schefler, New York

168. Untitled. c. 1946–48
Construction, 12⅞ x 9¹⁵⁄₁₆ x 5 in.
Estate of Joseph Cornell,
Courtesy Castelli Feigen Corcoran

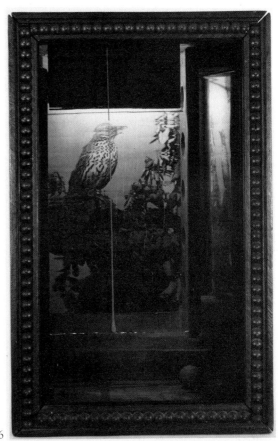

166

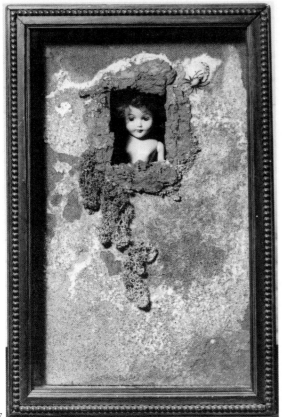

167

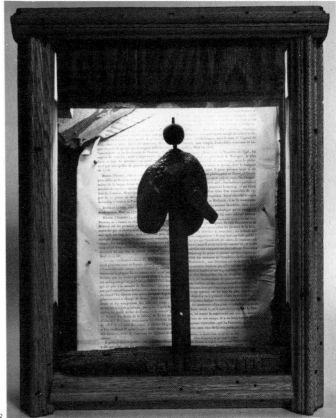

168

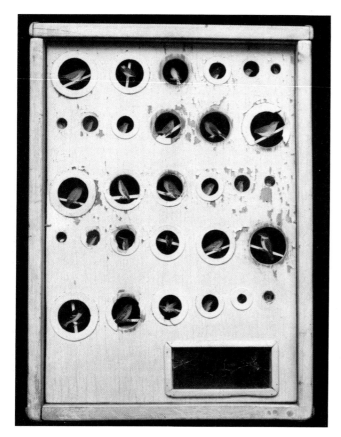

169. Untitled (Forgotten Game). c. 1949
Construction, 21⅛ x 15½ x 3¹³⁄₁₆ in.
Collection Mr. and Mrs. E. A. Bergman, Chicago

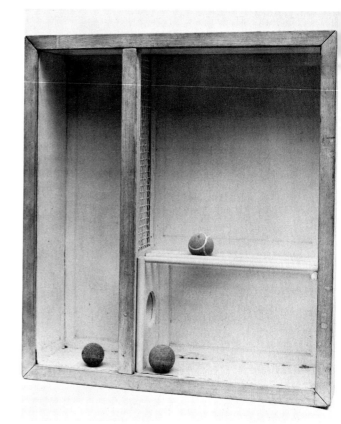

170. Untitled (The Cage). 1949
Construction, 17¾ x 16½ x 4½ in.
Addison Gallery of American Art,
Phillips Academy, Andover, Massachusetts

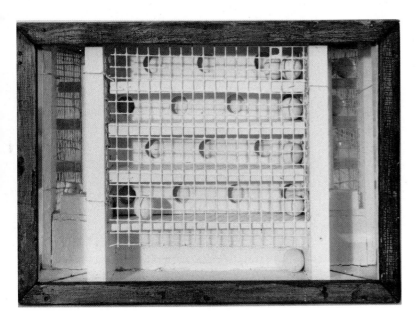

171. Untitled (Dovecote). c. 1953
Construction, 11¹¹⁄₁₆ x 16⅞ x 3⅞ in.
Estate of Joseph Cornell,
Courtesy Castelli Feigen Corcoran

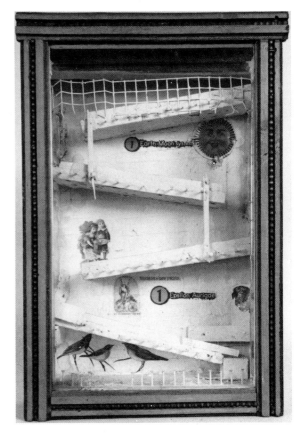

172. Untitled. c. 1954
Construction, 17¹⁄₁₆ x 11¼ x 5⅞ in.
Estate of Joseph Cornell,
Courtesy Castelli Feigen Corcoran

173. Untitled (Multiple Cubes). 1946–48
Construction, 14 x 10⅜ x 2⁵⁄₁₆ in.
Collection Mr. and Mrs. E. A. Bergman, Chicago

174. Untitled. c. 1954–56
Construction, 14¹³⁄₁₆ x 10⅝ x 2¹³⁄₁₆ in.
Estate of Joseph Cornell,
Courtesy Castelli Feigen Corcoran

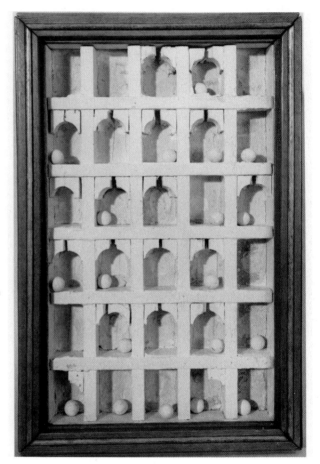

175. Untitled (Dovecote; Hinged Colombier). c. 1953
Construction, 14⅛ x 10⅛ x 1⅞ in.
The Regis Collection, Minneapolis

176. *"Dovecote" American Gothic.* c. 1954–56
Construction, 17¾ x 11½ x 2¹¹⁄₁₆ in.
Collection Mr. and Mrs. Carl D. Lobell, New York

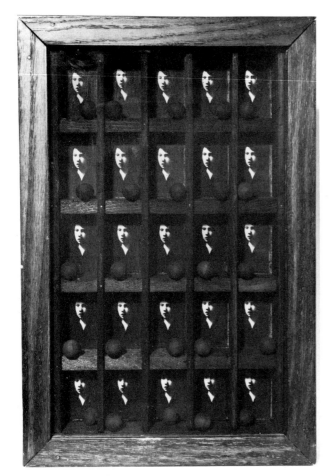

177. Untitled (Compartmented Box). 1954–56
Construction, 15⁵⁄₁₆ x 10¼ x 2⁷⁄₁₆ in.
Moderna Museet, Stockholm

178. Untitled (Dovecote). c. 1951–52
Construction, 14⅛ x 9¹⁵⁄₁₆ x 3 in.
Private collection, New York

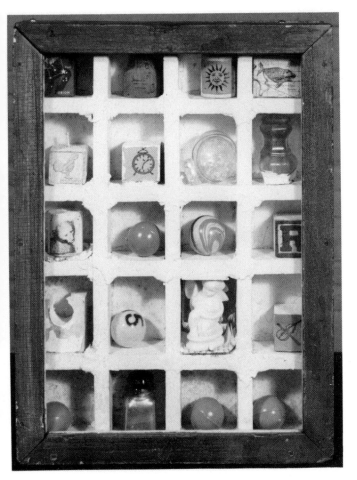

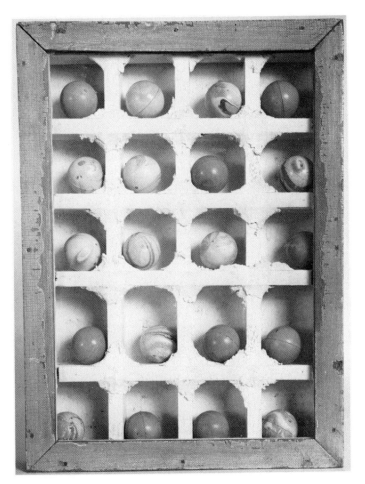

179. Untitled (Compartmented Box). c. 1954–56
Construction, 14¹³⁄₁₆ x 10⅞ x 2¼ in.
Collection Allan Stone, New York

180. Untitled (Discarded Descartes). c. 1954–56
Construction, 15 x 11 x 2⁵⁄₁₆ in.
Estate of Joseph Cornell,
Courtesy Castelli Feigen Corcoran

181. Untitled (Sand Box). c. 1948–50
Construction, 1⅜ x 6⁹⁄₁₆ x 9¹¹⁄₁₆ in.
Estate of Joseph Cornell,
Courtesy Castelli Feigen Corcoran

182. Untitled (Sand Box). c. 1948–50
Construction, 1⅜ x 6⁷⁄₁₆ x 9⅝ in.
Estate of Joseph Cornell,
Courtesy Castelli Feigen Corcoran

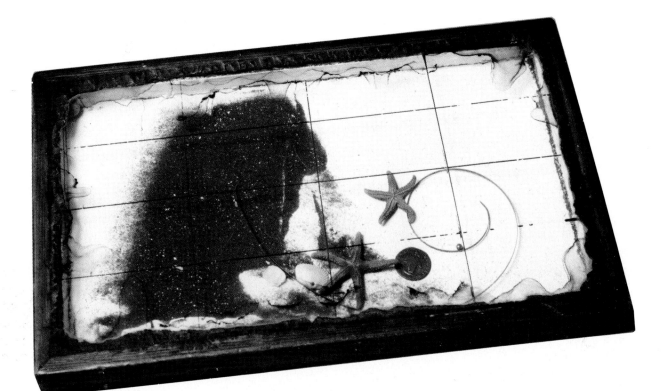

183. Untitled (Starfish). c. 1952
Construction, 1¼ x 9½ x 15½ in.
Collection Mr. and Mrs. Joseph R. Shapiro, Oak Park, Illinois

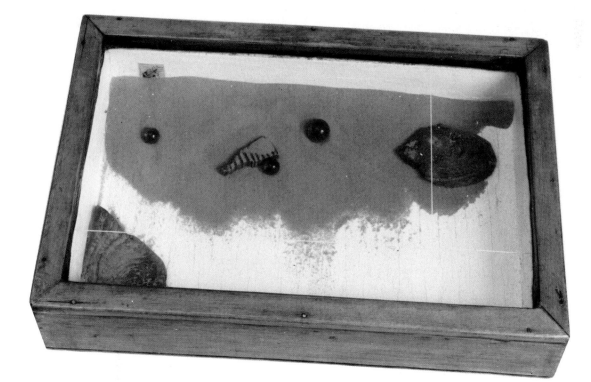

184. Untitled (Sand Box). c. 1953–55
Construction, 2⅞ x 14⅝ x 9⅛ in.
Collection Mr. and Mrs. E. A. Bergman, Chicago

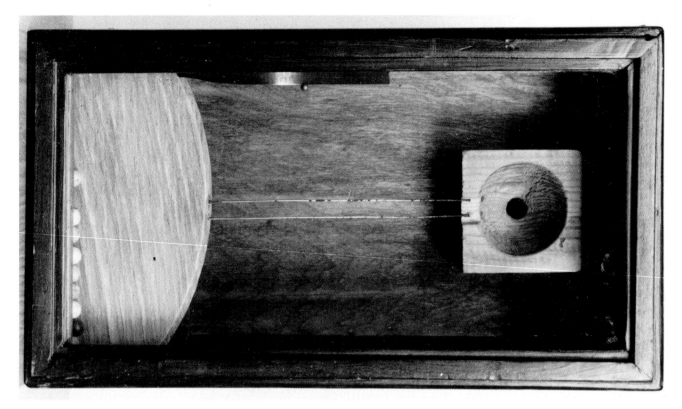

185. Untitled. c. 1940
Construction, 6¹⁄₁₆ x 13⅝ x 7¼ in.
Collection Mr. and Mrs. E. A. Bergman, Chicago

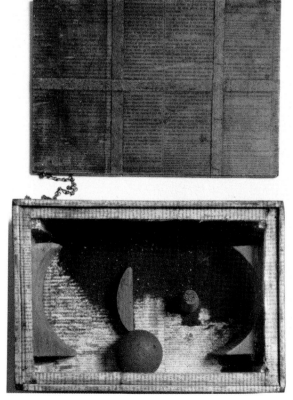

186. Untitled (Sand Box). c. 1946–48
Construction, 3⅝ x 11⁷⁄₁₆ x 7⁹⁄₁₆ in.
Estate of Joseph Cornell,
Courtesy Castelli Feigen Corcoran

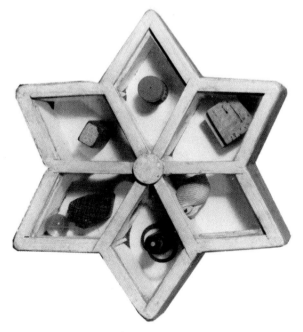

187. Untitled (Star Game). c. 1948
Construction, 2⅝ x 12¾ in. (point to point)
Private collection, New York

188. Untitled (Sand Box). c. 1946
Construction, 13⅞ x 5¾ x 4⅞ in.
Private collection, New York

189. Untitled (Sand Box). c. 1952
Construction, 1⅛ x 14⁷/₁₆ x 7¼ in.
Estate of Joseph Cornell,
Courtesy Castelli Feigen Corcoran

190. Untitled (Sand Box). c. 1950
Construction, 2⅜ x 12⅞ x 7½ in.
Estate of Joseph Cornell,
Courtesy Castelli Feigen Corcoran

191. Untitled (Sand Box). c. 1956–58
Construction, 1½ x 8⅞ x 15⅝ in.
Collection Julianne Kemper

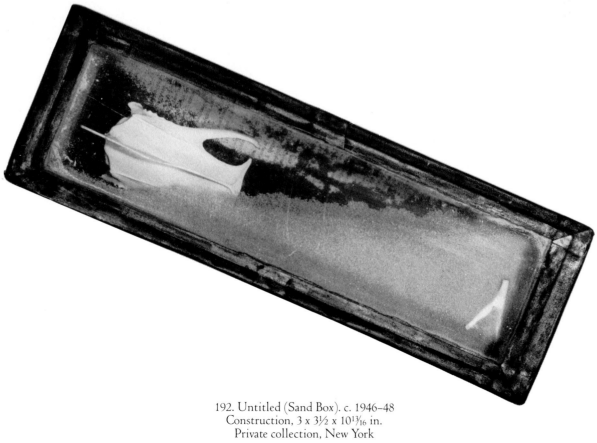

192. Untitled (Sand Box). c. 1946–48
Construction, 3 x 3½ x 10¹³⁄₁₆ in.
Private collection, New York

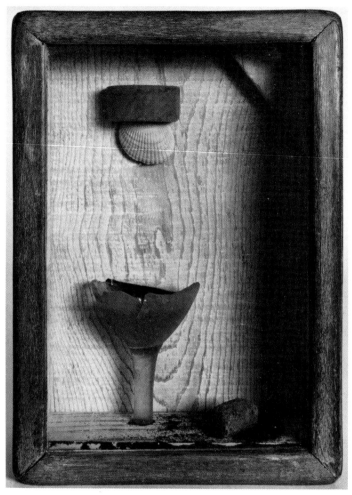

193. Untitled (Sand Fountain). c. 1956
Construction, 11¹⁄₁₆ x 7⅞ x 3¹⁵⁄₁₆ in.
Estate of Joseph Cornell,
Courtesy Castelli Feigen Corcoran

194. Untitled (Sand Fountain). 1954
Construction, 12¹⁄₁₆ x 7¹¹⁄₁₆ x 4 in.
Private collection, New York

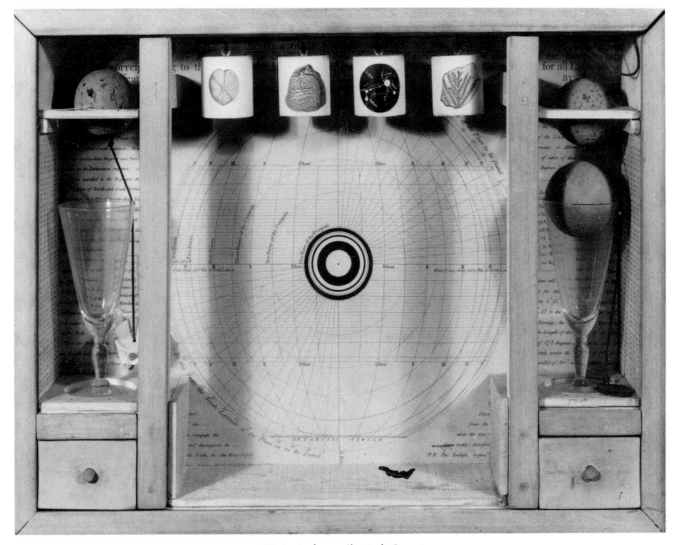

202. *An Analemma, Shewing by Inspection*
the Time of Sun Rising and Sun
Setting, the Length of Days and Nights. 1948–50
Construction, 15½ x 20¼ x 4 in.
Estate of Joseph Cornell,
Courtesy Castelli Feigen Corcoran

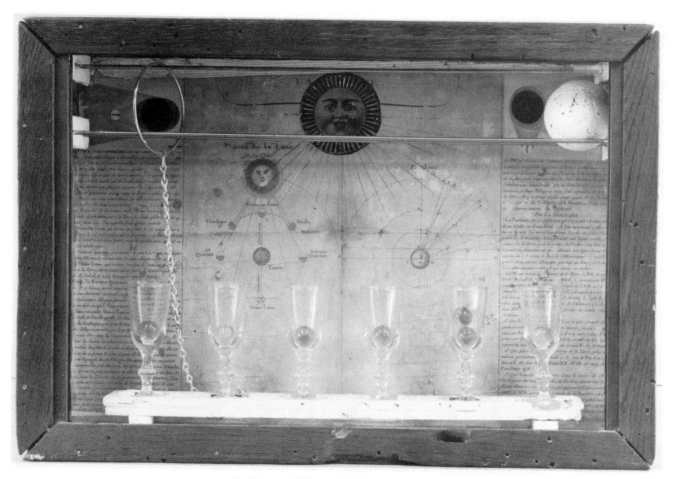

203. Untitled (Phases de la lune). c. 1957–59
Construction, 12¼ x 18 x 4¾ in.
Allen Memorial Art Museum, Oberlin College, Ohio,
R.T. Miller, Jr., Ruth C. Rousch, and
Special Acquisitions Funds

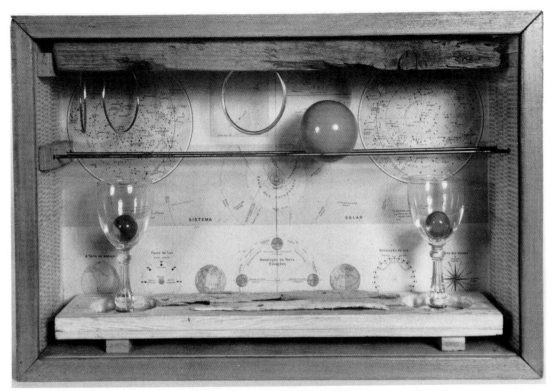

204. *Elementos de Cosmographia.* c. 1956–58
Construction, 12½ x 18¹⁵⁄₁₆ x 4⅝ in.
Estate of Joseph Cornell,
Courtesy Castelli Feigen Corcoran

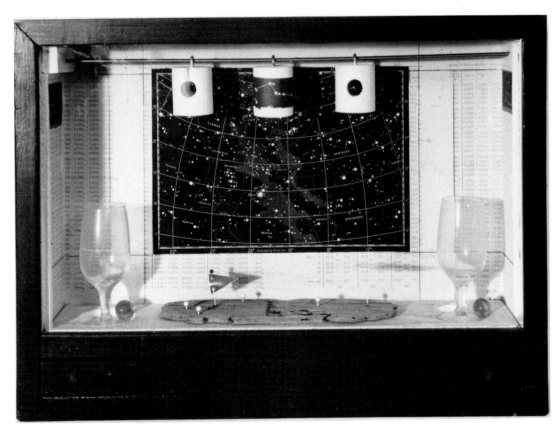

205. Untitled. c. 1956–58
Construction, 12⅛ x 17 x 3⅝ in.
Collection Françoise and Harvey Rambach, New York

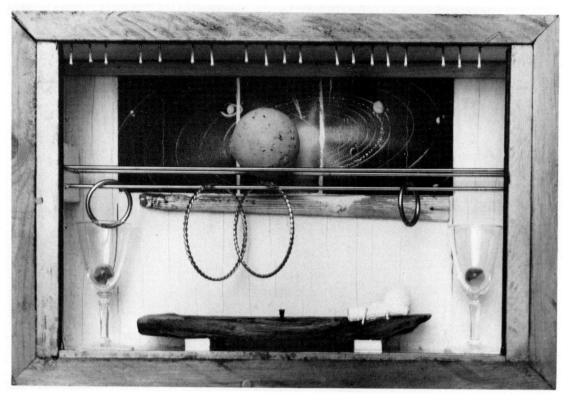

206. *Sun Box.* c. 1956
Construction, 10⅛ x 15¼ x 3⅓ in.
Collection Mr. and Mrs. Alvin S. Lane

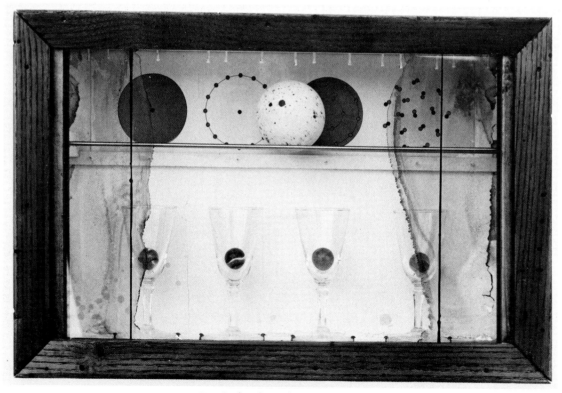

207. *Birth of the Nuclear Atom.* c. 1960
Construction, 9¾ x 15 x 3¾ in.
Private collection, Los Angeles

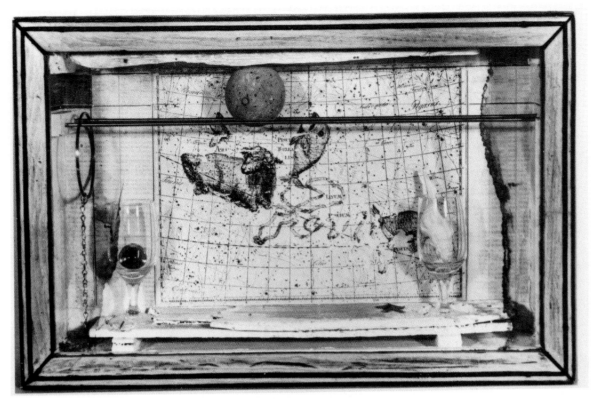

208. Untitled (Constellations zodiacales). c. 1958
Construction, 10¹⁵/₁₆ x 17⁷/₁₆ x 3¹³/₁₆ in.
Donald Morris Gallery, Birmingham, Michigan

209. Untitled (Space Object Box). c. 1958
Construction, 11 x 17½ x 5¼ in.
The Solomon R. Guggenheim Museum, New York

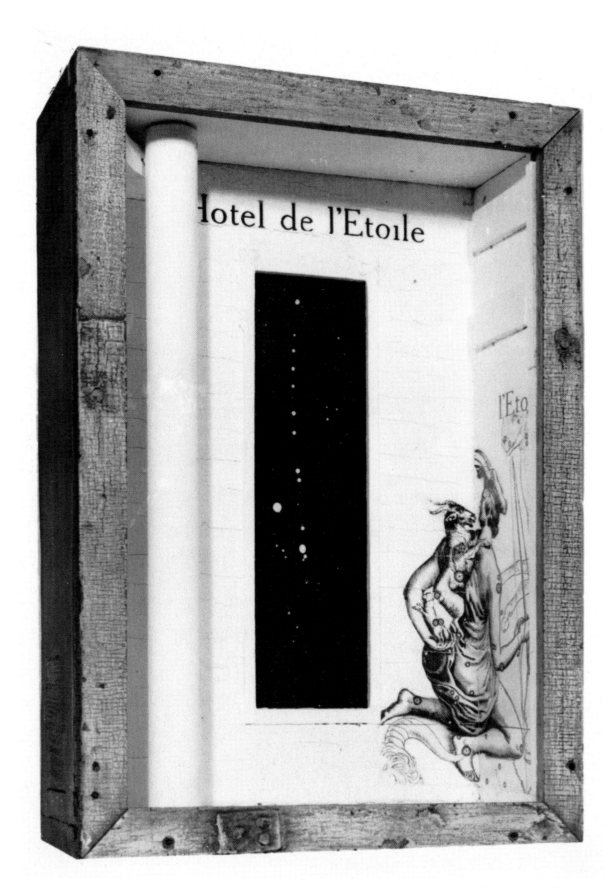

210. Untitled (Hotel de l'Etoile; Night Skies: Auriga). 1954
Construction, 19¼ x 13½ x 6¹⁵⁄₁₆ in.
Collection Mr. and Mrs. E. A. Bergman, Chicago

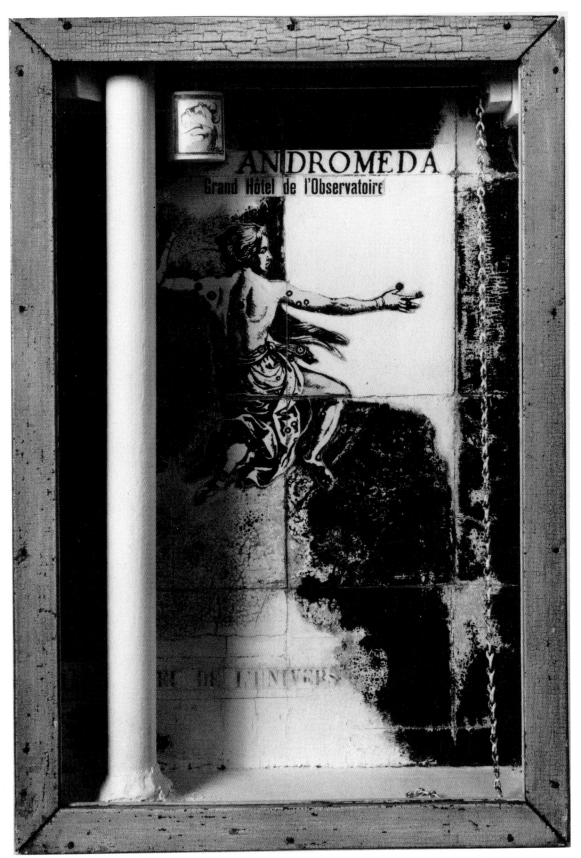

211. Untitled (Andromeda; Grand Hotel de l'Observatoire; Grand Hotel de l'Univers). 1954
Construction, 18⅝ x 12⅝ x 3⅞ in.
Estate of Joseph Cornell,
Courtesy Castelli Feigen Corcoran

212. *Central Park Carrousel — 1950 — in Memoriam.* 1950
Construction, 20¼ x 14½ x 6¾ in.
The Museum of Modern Art, New York,
Katharine Cornell Fund

213. *Pavilion.* 1953
Construction, 18¹⁵⁄₁₆ x 11¾ x 6⁹⁄₁₆ in.
Collection Mr. and Mrs. E. A. Bergman, Chicago

214. *Observatory Colomba Carrousel.* c. 1953
Construction, 18¹⁄₁₆ x 11⁹⁄₁₆ x 5¹³⁄₁₆ in.
Estate of Joseph Cornell,
Courtesy Castelli Feigen Corcoran

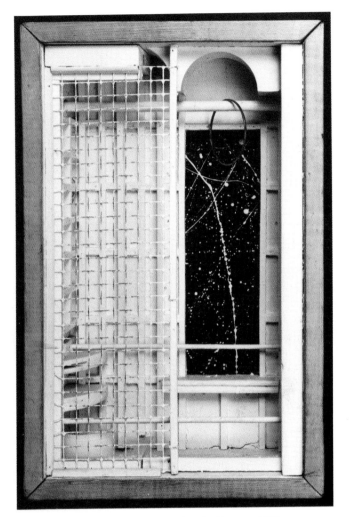

215. *Observatory Corona Borealis Casement.* 1950
Construction, 18⅛ x 11¹³⁄₁₆ x 5½ in.
Collection Mr. and Mrs. E. A. Bergman, Chicago

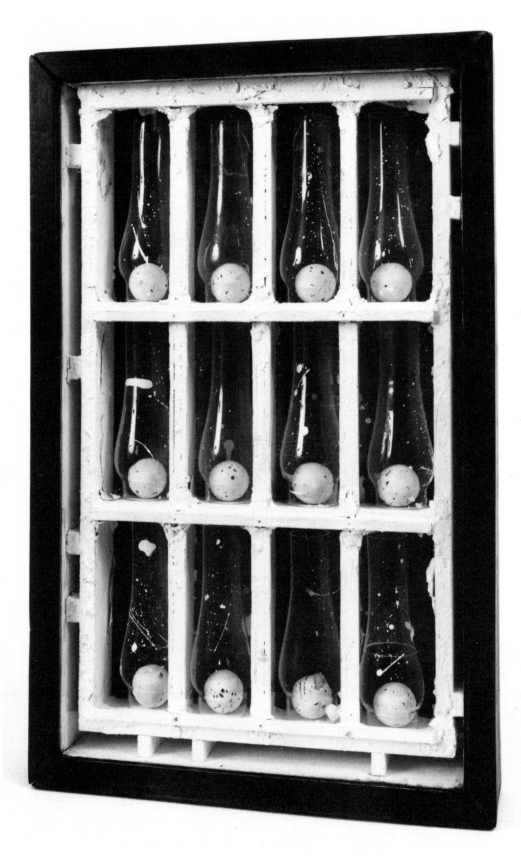

216. *Observatory American Gothic.* c. 1954
Construction, 17⁹⁄₁₆ x 11⁵⁄₁₆ x 2¹¹⁄₁₆ in.
Collection Mr. and Mrs. E. A. Bergman, Chicago

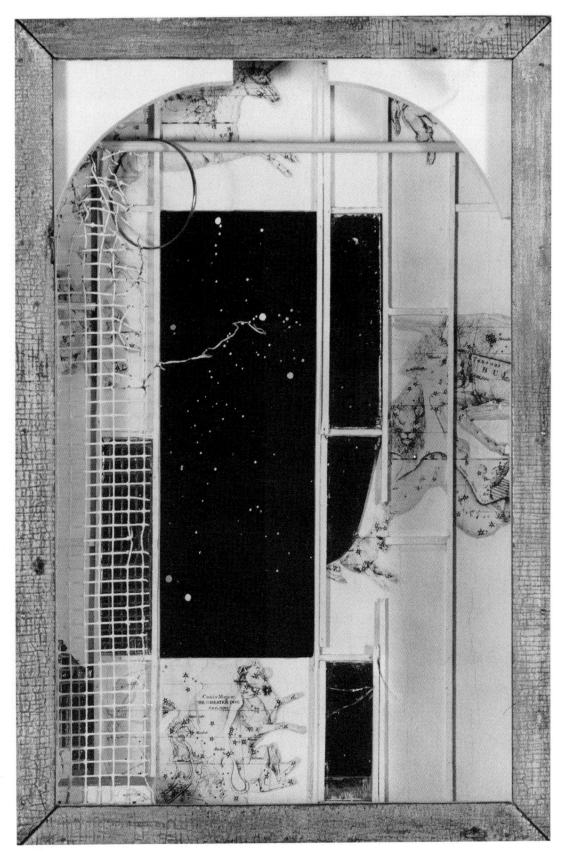

217. *Carrousel.* 1952
Construction, 19½ x 13 x 6 in.
Collection Mr. and Mrs. Morton G. Neumann, Chicago

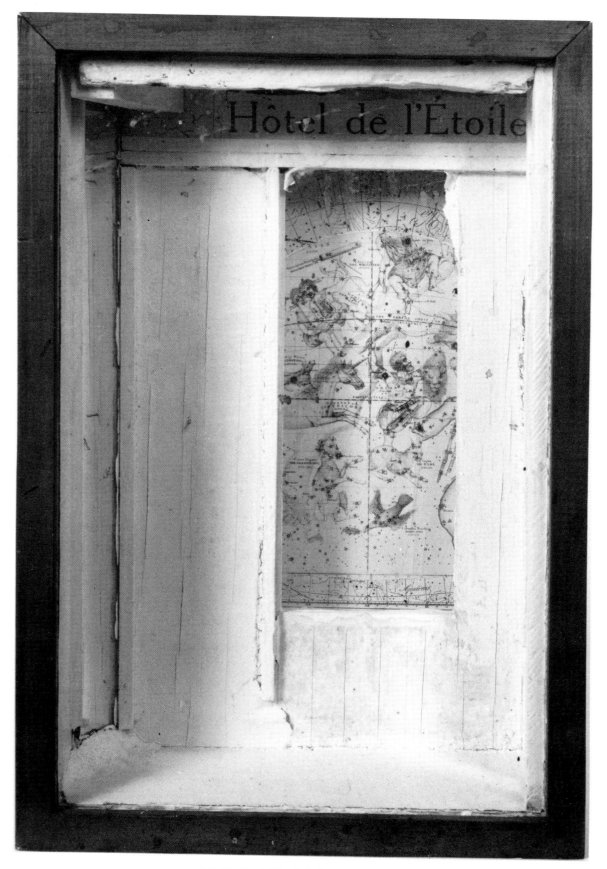

218. Untitled (Hotel de l'Etoile). c. 1953
Construction, 17⅛ x 11¾ x 6¹/₁₆ in.
Estate of Joseph Cornell,
Courtesy Castelli Feigen Corcoran

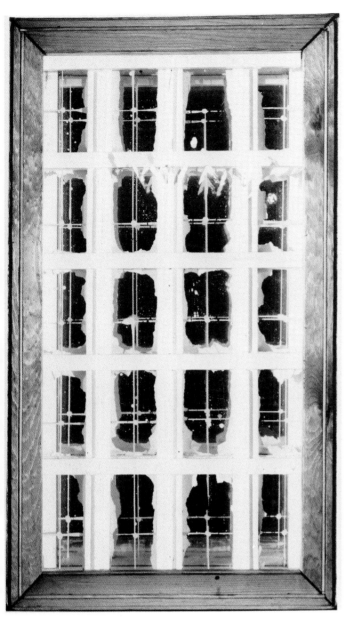

219. Untitled (Window Facade). c. 1953
Construction, 19⅛ x 11 x 4⅛ in.
Collection Mr. and Mrs. E. A. Bergman, Chicago

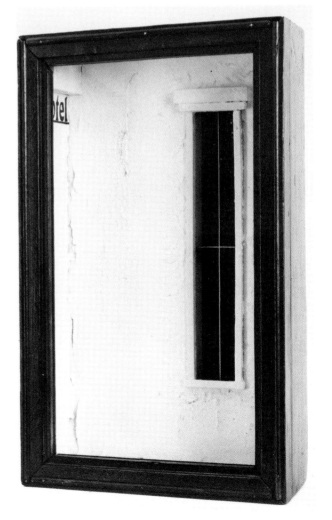

220. Untitled (Hotel Night Sky). c.1954
Construction, 16⅝ x 10⅛ x 6⅛ in.
Collection Irving Blum, New York

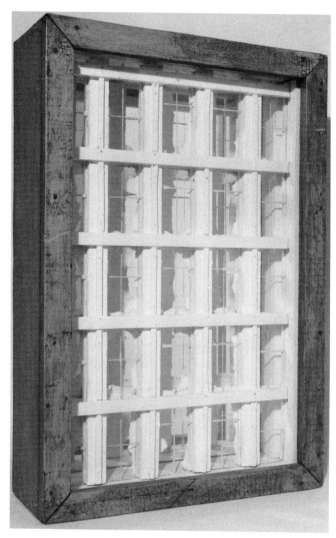

221. Untitled (Window Facade). c. 1953
Construction, 19⅛ x 13 x 4⁷⁄₁₆ in.
Collection Michael M. Rea, Washington, D.C.

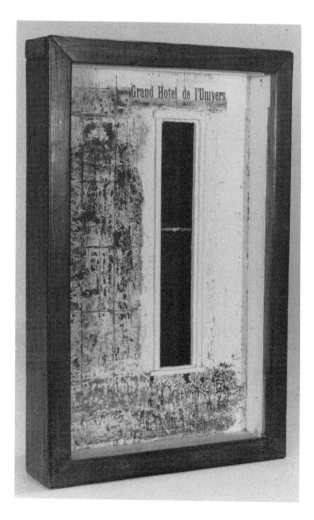

222. Untitled (Grand Hotel de l'Univers). c. 1953–55
Construction, 19 x 12⅝ x 4¾ in.
Collection June Schuster, Pasadena, California

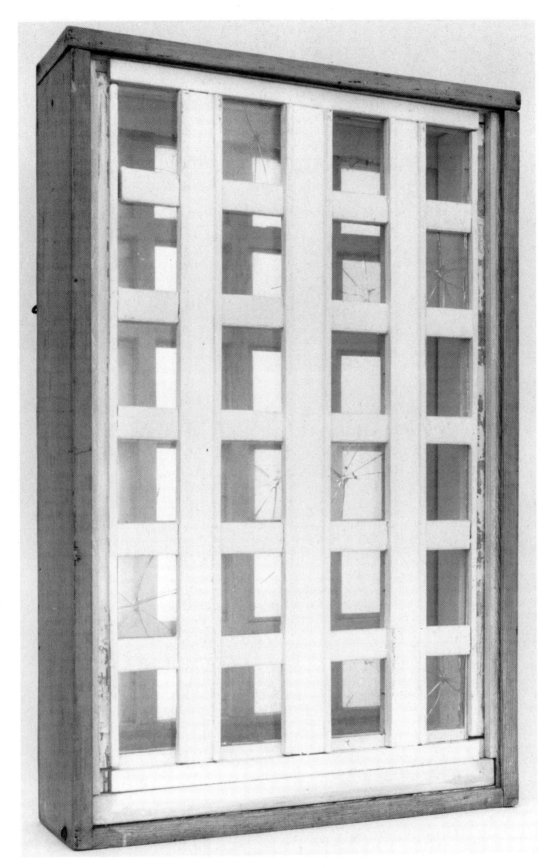

223. Untitled (Window Facade). c. 1953
Construction, 18⅝ x 12⅜ x 3⅝ in.
Private collection, New York

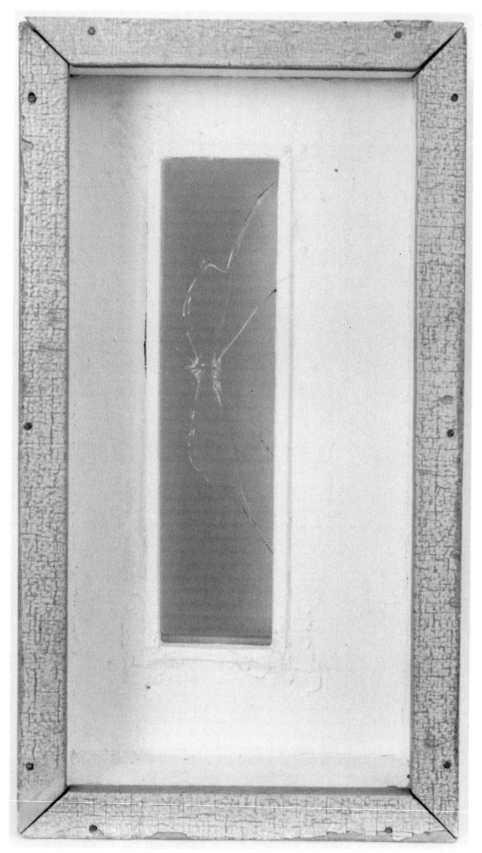

224. Untitled (Hotel Broken Window). c. 1955
Construction, 16⅝ x 9 x 5¼ in.
Castelli Feigen Corcoran

225. *After Giotto #2.* c. 1965–66
Collage, 11½ x 8½ in.
Estate of Joseph Cornell,
Courtesy Castelli Feigen Corcoran

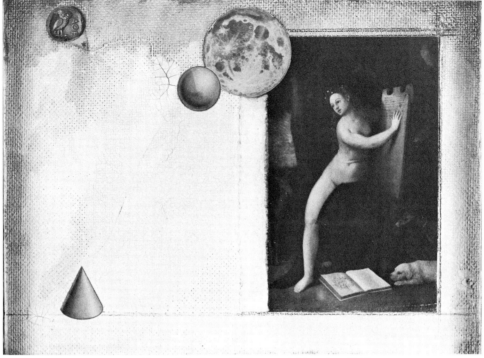

226. Circe and Her Lovers (Mathematics in Nature). c. 1964
Collage, 8½ x 11½ in.
Seattle Art Museum

227. Untitled (Jungle Scene). Summer 1959, 1966
Collage, 11⁷⁄₁₆ x 13⅝ in.
Estate of Joseph Cornell,
Courtesy Castelli Feigen Corcoran

228. *Flora.* c. 1966
Collage, 11½ x 8½ in.
Estate of Joseph Cornell,
Courtesy Castelli Feigen Corcoran

229. Untitled. Early 1960s
Collage, 14½ x 11 in.
Estate of Joseph Cornell,
Courtesy Castelli Feigen Corcoran

230. *Apparition of the Corticelli Kitten in "Croisée."*
Mid–1960s. Collage, 12³⁄₁₆ x 9⅛ in.
Estate of Joseph Cornell,
Courtesy Castelli Feigen Corcoran

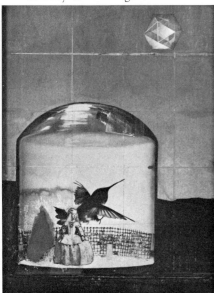

231. *Observations of Satellite I.* Mid–1960s
Collage, 11½ x 8½ in.
Estate of Joseph Cornell,
Courtesy Castelli Feigen Corcoran

232. *Where Does the Sun Go at Night?* c. 1963
Collage, 11¼ x 8¼ in.
Estate of Joseph Cornell,
Courtesy Castelli Feigen Corcoran

233. Untitled. Early 1960s
Collage, 4⅝ x 6½ in.
Castelli Feigen Corcoran

234. Untitled. Mid–1960s
Collage, 11⅜ x 15⁷⁄₁₆ in.
Estate of Joseph Cornell,
Courtesy Castelli Feigen Corcoran

235. Untitled (Ice). Mid–1960s
Collage, 11½ x 8⅝ in.
Collection Celeste and Armand Bartos, New York

236. *Mignon.* Early 1960s
Collage, 11½ x 8½ in.
Estate of Joseph Cornell,
Courtesy Castelli Feigen Corcoran

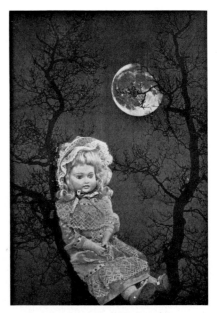

237. *The Puzzle of the Reward, 1670*
Mid–1960s. Collage, 11⅜ x 8⅜ in.
Donald Morris Gallery,
Birmingham, Michigan

238. *Isle of Children.* 1963
Collage, 11½ x 8½ in.
Estate of Joseph Cornell,
Courtesy Castelli Feigen Corcoran

239. Untitled. Early 1960s
Collage, 10½ x 7⅛ in.
Estate of Joseph Cornell,
Courtesy Castelli Feigen Corcoran

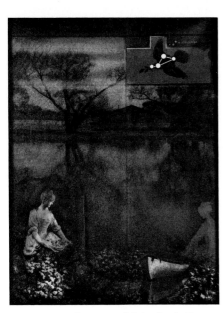

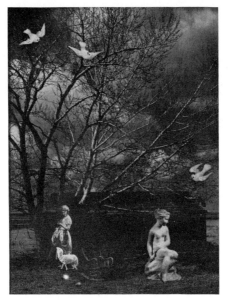

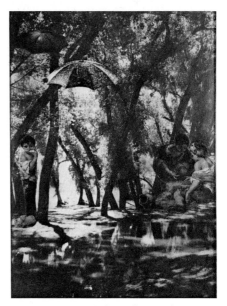

240. *Lepus, the Hare, and Columba, the Dove*
Mid–1960s. Collage, 11½ x 8½ in.
Estate of Joseph Cornell,
Courtesy Castelli Feigen Corcoran

241. Untitled (Home Poor Heart). c. 1962
Collage, 11⅛ x 8⅝ in.
The Museum of Modern Art, New York,
Gift of Mrs. Donald B. Straus

242. *The Sister Shade (Urchin Series).* 1956
Collage, 11⁵⁄₁₆ x 8⅜ in.
Estate of Joseph Cornell,
Courtesy Castelli Feigen Corcoran

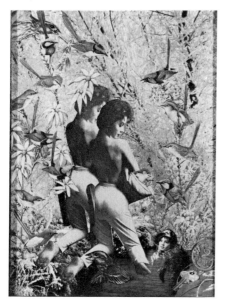

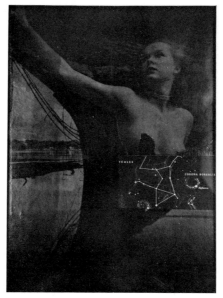

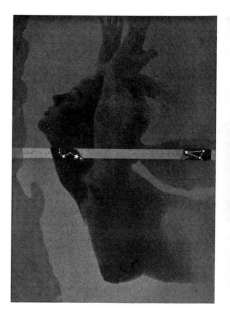

243. *Allegory of Innocence.* c. 1956
Collage, 12 x 9 in.
The Museum of Modern Art, New York,
Purchase

244. Untitled (Ship with Nude). Mid–1960s
Collage, 11½ x 8½ in.
Estate of Joseph Cornell,
Courtesy Castelli Feigen Corcoran

245. Untitled (Blue Nude). Mid–1960s
Collage, 11³⁄₁₆ x 8³⁄₁₆ in.
Estate of Joseph Cornell,
Courtesy Castelli Feigen Corcoran

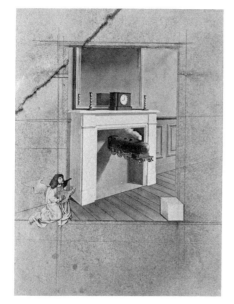

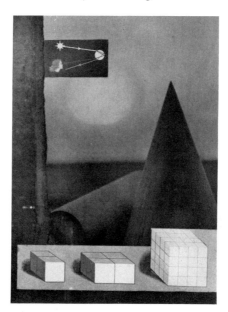

246. *Time Transfixed.* May 5, 1965
Collage, 9½ x 7½ in.
Collection Mr. and Mrs. Richard E. Lang,
Medina, Washington

247. *How to Make a Rainbow (for Jeanne Eagels)*
c. 1963–65. Collage, 11³⁄₈ x 8³⁄₈ in.
Estate of Joseph Cornell,
Courtesy Castelli Feigen Corcoran

248. *Robert Schumann/German Romanticism*
c. 1965–67. Collage, 11½ x 8⁵⁄₈ in.
Estate of Joseph Cornell,
Courtesy Castelli Feigen Corcoran

249. *Robinson Crusoe.* c. 1966
Collage, 9½ x 7½ in.
Estate of Joseph Cornell,
Courtesy Castelli Feigen Corcoran

250. *Aerodynamics.* c. 1960
Collage, 12⅛ x 9⅛ in.
Collection Miriam and Ronald Kottler

251. *Corner of Juan Gris.* Early 1960s
Collage, 12 x 9 in.
Marvin Ross Friedman and Co.,
Miami, Florida

252. *Allegra.* c. 1969
Collage, 11⅜ x 8⅜ in.
Private collection, New York

253. *For J. Derequelyne.* Early 1960s
Collage, 12⅛ x 8⅞ in.
Xavier Fourcade, Inc., New York

254. Untitled. Mid–1960s
Collage, 11⁹⁄₁₆ x 8½ in.
Estate of Joseph Cornell,
Courtesy Castelli Feigen Corcoran

255. *Apotheosis Penny Arcade.* 1965, 1968
Collage, 11⅜ x 8½ in.
Estate of Joseph Cornell,
Courtesy Castelli Feigen Corcoran

256. *Pascal's Triangle.* 1965, 1966
Collage, 11¼ x 7⅝ in.
Private collection

257. *Broken Valentine (Penny Arcade Series).* 1962
Collage, 11⅜ x 8⅝ in. (sight)
Collection Aaron B. Shraybman

258. *Constellations of Autumn.* Early 1960s
Collage, 9½ x 7½ in.
Castelli Feigen Corcoran

259. Untitled. Mid–1960s
Collage, 11⅜ x 8⁹⁄₁₆ in.
Estate of Joseph Cornell,
Courtesy Castelli Feigen Corcoran

260. *Vue par Tina (Mathematics in Nature).* 1962
Collage, 9⁷⁄₁₆ x 7½ in.
Estate of Joseph Cornell,
Courtesy Castelli Feigen Corcoran

261. *Sorrows of Young Werther.* 1966
Collage, 8¼ x 11¼ in.
The Hirshhorn Museum and Sculpture Garden,
Smithsonian Institution, Washington, D.C.

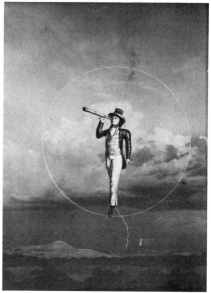

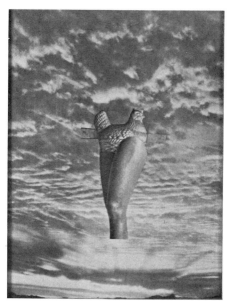

262. Untitled (Wine Glass). Mid–1960s
Collage, 11⁹⁄₁₆ x 8⁹⁄₁₆ in.
Estate of Joseph Cornell,
Courtesy Castelli Feigen Corcoran

263. Untitled (Ship Chandler Figure)
Mid–1960s. Collage, 11¹¹⁄₁₆ x 8⅝ in.
Estate of Joseph Cornell,
Courtesy Castelli Feigen Corcoran

264. Untitled. Mid–1960s
Collage, 11⅜ x 8½ in.
Estate of Joseph Cornell,
Courtesy Castelli Feigen Corcoran

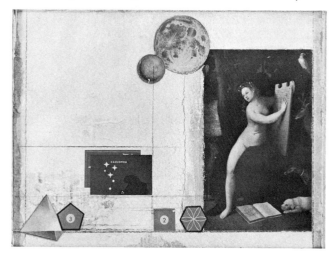

265. *Cassiopeia.* 1966
Collage, 9 x 11¾ in.
Collection Mr. and Mrs. E. A. Bergman, Chicago

266. *View at Ostend.* c. 1965
Collage, 9⅞ x 8³⁄₁₆ in.
Private collection

267. Verso of *View at Ostend*

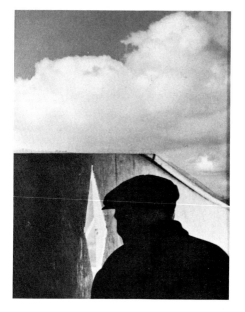

268. *The Uncertainty Principle.* 1966
Collage, 7½ x 9½ in.
The Hirshhorn Museum and Sculpture Garden,
Smithsonian Institution, Washington, D.C.

269. Untitled (Portrait of Lee Miller). c. 1948–49
Collage, 9¼ x 11 in.
Collection Vivian Horan, New York

270. *The Ellipsian.* c. 1966
Collage, 11⅛ x 8¼ in.
Estate of Joseph Cornell,
Courtesy Castelli Feigen Corcoran

271. *André Breton.* c. 1966
Collage, 11⅞ x 9¹⁵⁄₁₆ in.
Estate of Joseph Cornell,
Courtesy Castelli Feigen Corcoran

272. *La Petite Fumeuse du chocolat*. Mid–1960s
Collage, 11½ x 9 in.
Collection Mr. and Mrs. E. A.
Bergman, Chicago

273. Untitled (Souvenir de Bruxelles)
Early 1960s. Collage, 13 x 10 in.
Estate of Joseph Cornell,
Courtesy Castelli Feigen Corcoran

274. *Peter Ibbetson*. Early 1960s
Collage, 13½ x 9½ in.
Estate of Joseph Cornell,
Courtesy Castelli Feigen Corcoran

275. *English Miner*. Mid–1960s
Collage, 11⅜ x 8⅜ in.
Estate of Joseph Cornell,
Courtesy Castelli Feigen Corcoran

276. *For Sale*. Early 1960s
Collage, 11⅛ x 8³⁄₁₆ in.
Castelli Feigen Corcoran

277. *Collage entre chien et loup*. 1953
Collage, 4¹¹⁄₁₆ x 11⅝ in.
Allen Memorial Art Museum, Oberlin College, Ohio,
Gift of Donald Droll

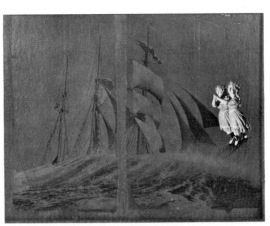

278. *Ce Soir la nostalgie de la mer, France Nüyen*
October 1958. Collage, 13⁷⁄₁₆ x 11¹⁄₁₆ in.
Estate of Joseph Cornell,
Courtesy Castelli Feigen Corcoran

279. *Lanner Waltzes.* Mid–1960s
Collage, 11½ x 15¹¹⁄₁₆ in.
Estate of Joseph Cornell,
Courtesy Castelli Feigen Corcoran

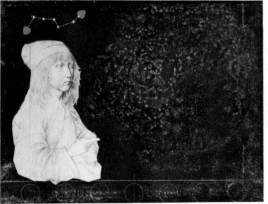

280. *Dürer.* 1965, 1966
Collage, 8½ x 11½ in.
Private collection, New York

281. Untitled. c. 1966
Collage, 8½ x 11⅜ in.
Estate of Joseph Cornell,
Courtesy Castelli Feigen Corcoran

282. Untitled (Prince Pince)
c. 1967. Collage, 11½ x 8½ in.
Estate of Joseph Cornell,
Courtesy Castelli Feigen Corcoran

283. Untitled. Mid–1960s
Collage, 13½ x 9½ in.
Estate of Joseph Cornell,
Courtesy Castelli Feigen Corcoran

284. Untitled. Mid–1960s
Collage, 8⅜ x 11½ in.
Estate of Joseph Cornell,
Courtesy Castelli Feigen Corcoran

285. Untitled. Mid–1960s
Collage, 11⅞ x 9 in.
Collection Mr. and Mrs. Julius E. Davis

286. *How Many Miles to Babylon?* c. 1969
Collage, 11⁵⁄₁₆ x 8⁵⁄₁₆ in.
Estate of Joseph Cornell,
Courtesy Castelli Feigen Corcoran

287. Verso of *How Many Miles to Babylon?*, pl. 28(

288. *Goya Capricho.* Mid–1960s
Collage, 11⁹⁄₁₆ x 8⅝ in.
ACA Galleries, New York

289. *The Last Prince of Urbino.* 1967
Collage, 12 x 9 in.
Collection Mr. and Mrs. Robert Baras, New York.

290. *Trista*. 1963–69
Collage, 11⁷⁄₁₆ x 8⁷⁄₁₆ in.
Estate of Joseph Cornell,
Courtesy Castelli Feigen Corcoran

291. *Le Bouquet naufragé*. 1966, 1971
Collage, 11⁷⁄₁₆ x 8⁷⁄₁₆ in.
Estate of Joseph Cornell,
Courtesy Castelli Feigen Corcoran

292. *Souvenir of a Penny Arcade*. 1965
Collage, 11½ x 8½ in.
Collection Celeste and Armand Bartos,
New York

293. Untitled (Derby Hat). 1972
Photogravure, 13¼ x 10⁵⁄₁₆ in.
The Museum of Modern Art, New York,
Gift of Brooke and Carolyn Alexander

294. Untitled. c. 1966
Collage, 11¼ x 8¼ in.
Estate of Joseph Cornell,
Courtesy Castelli Feigen Corcoran

BIBLIOGRAPHY

By Daniel A. Starr

1. Joseph Cornell Papers, Archives of American Art, Smithsonian Institution, gift of Elizabeth Cornell Benton. Available on microfilm for inspection at any of the Archive's offices or through inter-library loan.
2. Papers, documents, and working materials. Joseph Cornell Study Center, National Collection of Fine Arts, Smithsonian Institution, Washington, D.C., gift of Mr. and Mrs. John Benton.
3. Ashton, Dore. *A Joseph Cornell Album.* New York: Viking, 1974. Assorted ephemera, readings, decorations, and reproductions of works by Joseph Cornell; reviews: *43, 48, 103, 112, 168, 181.*
4. Waldman, Diane. *Joseph Cornell.* New York: Braziller, 1977. Reviews: *61A, 162.*

ARTICLES

5. Abadie, Daniel. "Deux alchimistes du quotidien: Joseph Cornell et Louise Nevelson," *XX⁰ siècle,* no. 40 (June 1973), pp. 104–09. Summary in English.
6. ———. "Surréalismes." In *401,* pp. 458–84.
7. Albright, Thomas. "Silk Purses in Boxes by a Master," *San Francisco Chronicle,* May 19, 1976, p. 48.
8. Alloway, Lawrence. "Art," *Nation,* Dec. 28, 1970, pp. 700–01.
9. ———. "The View from the 20th Century," *Artforum,* vol. 12, no. 5 (Jan. 1974), pp. 43–45.
10. "American Academy Gives Award to Box Sculptor," *New York Post,* Feb. 23, 1968.
11. Anderson, Alexandra C. "How to Make a Rainbow," *Art News,* vol. 69, no. 10 (Feb. 1979), pp. 50–52, 72–73.
12. Andreae, Christopher. "Cornell's Bird Cages and Slot Machines," *Christian Science Monitor,* May 10, 1967, p. 6.
13. "Art Academy Honor to Joseph Cornell," *New York Times,* Feb. 24, 1968, p. 22.
14. "Art Across the U.S.A.: Small Packages: The Metropolitan," *Apollo,* vol. 93 (May 1971), p. 432.
15. "As We Go to Press," *View,* vol. 1, no. 2 (Oct. 1940), p. 4.
16. Ashbery, John. "Cornell: The Cube Root of Dreams." *Art News,* vol. 66, no. 4 (Summer 1967), pp. 56–59, 63–64.
17. ———. "A Joyful Noise," *New York,* June 5, 1978, pp. 91–93.
18. Ashton, Dore. "The 'Anti-Compositional Attitude' in Sculpture: New York Commentary," *Studio International,* vol. 172, no. 879 (July 1966), pp. 44–47.
19. ———. "Art USA 1962," *Studio,* vol. 163, no. 826 (Feb. 1962), pp. 84–95.
20. ———. "The Arts of Joseph Cornell,"
One (London), no. 2 (Jan. 1974), pp. 10–15.
21. ———. "New York Letter," *Kunstwerk,* vol. 16, no. 10 (April 1963), p. 32.
22. Ballatore, Sandy. "Joseph Cornell's Collages," *Artweek,* vol. 7, no. 13 (March 27, 1976), pp. 1, 16.
23. Barrio-Garray, José Luis. "Crónica de Nueva York: ¿Un Caso Aparte?" *Goya,* no. 127 (July/Aug. 1975), pp. 42–43.
24. Barron, Mary Lou. "Looking into Private Spaces," *Artweek,* vol. 6, no. 40 (Nov. 22, 1975), p. 6.
25. Benedikt, Michael. "New York Letter," *Art International,* vol. 10, no. 8 (Oct. 20, 1966), p. 55.
26. ———. "Reviews and Previews: Joseph Cornell," *Art News,* vol. 65, no. 4 (Summer 1966), p. 11.
27. Bethany, Marilyn. "Joseph Cornell: December 24, 1903–December 29, 1972," *Saturday Review of the Arts,* Feb. 1973, p. 58.
28. Bochner, Mel. "In the Museums: Joseph Cornell," *Arts Magazine,* vol. 41, no. 8 (Summer 1967), pp. 53–54.
29. Borinsky, Alicia. "Equilibrismos: Poesia/Sentido," *Cuadernos Hispanoamericanos,* vol. 343 (1979), pp. 553–60. Discusses Octavio Paz and Cornell.
30. Bourdon, David. "Boxed Art of Joseph Cornell," *Life,* Dec. 15, 1967, pp. 52–61, 63, 66A.
31. Boyd, E. "Art," *Arts and Architecture,* Dec. 1948, p. 12.
32. Brown, Gordon. "A Visit with Joseph Cornell," *Arts Magazine,* vol. 41, no. 7 (May 1967), p. 51.
32a. Burrows, Carlyle. "Notes and Comment on Events in Art: Playful Objects," *New York Herald Tribune,* Dec. 10, 1939, section 6, p. 8.
33. Butler, Barbara. "New York Fall 1961," *Quadrum,* no. 12 (1961), pp. 133–40.
34. Butler, Joseph T. "The American Way with Art: The Art of Visual Metaphors: Joseph Cornell," *Connoisseur,* vol. 185 (April 1974), p. 305.
35. ———. "The Connoisseur in America: Joseph Cornell at the Guggenheim," *Connoisseur,* vol. 166 (Sept. 1967), pp. 64, 66.
36. Campbell, Lawrence. "Reviews and Previews: Joseph Cornell," *Art News,* vol. 55, no. 7 (Nov. 1956), pp. 6–7.
37. ———. "Reviews and Previews: Joseph Cornell and Robert Cornell," *Art News,* vol. 64, no. 10 (Feb. 1966), p. 14.
38. Case, William D. "In the Galleries: Joseph Cornell, Stone," *Arts Magazine,* vol. 46, no. 4 (Feb. 1972), p. 59.
39. Cavaliere, Barbara. "Arts Reviews: Enclosure and Concealment," *Arts Magazine,* vol. 54, no. 1 (Sept. 1979), pp. 25–26.
40. "The Compulsive Cabinetmaker," *Time,* July 8, 1966, pp. 56–57.
41. Conroy, William T. "Columbian Collage: American Art of Assembly," *Arts Magazine,* vol. 52, no. 4 (Dec. 1977), pp. 86–87.
42. Coplans, John. "Notes on the Nature of

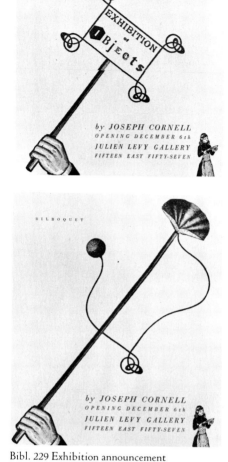

Bibl. 229 Exhibition announcement

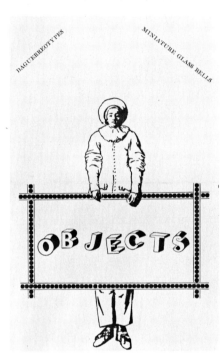

Bibl. 230 Exhibition announcement

Joseph Cornell," *Artforum*, vol. 1, no. 8 (Feb. 1963), pp. 27–29.

43. Copley, William. "*A Joseph Cornell Album by Dore Ashton*," *Print Collector's Newsletter*, vol. 6 (May/June 1975), p. 49.

44. Cortesi, Alexandra. "Joseph Cornell," *Artforum*, vol. 4, no. 8 (April 1966), pp. 27–31.

45. Coulonges, Henri. "Cornell et ses oeuvres fragiles connaissent subitement une faveur grandissante," *Connaissance des arts*, no. 262 (Dec. 1973), pp. 126–31.

46. Courthion, Pierre. "Situation de la nouvelle peinture américaine," *XXᵉ siècle*, no. 34 (June 1970), pp. 9–19.

47. D., H. "Here, There, Elsewhere," *New York Times*, Dec. 10, 1939, section 10, p. 12.

48. Dault, Gary Michael. "Books: Dore Ashton, *A Joseph Cornell Album*," *Artscanda*, vol. 75, no. 198–199 (June 1975), p. 75.

48a. Davenport, Guy. "Pergolesi's Dog," *New York Times*, Aug. 20, 1980, p. A19.

49. Davis, Douglas. "Living in Utopia," *Newsweek*, Feb. 5, 1973, p. 63.

50. ———, and Rourke, Mary. "Souvenirs," *Newsweek*, March 1, 1976, p. 81.

51. d'Harnoncourt, Anne. "The Cubist Cockatoo: A Preliminary Exploration of Joseph Cornell's Homages to Juan Gris," *Philadelphia Museum of Art Bulletin*, vol. 74, no. 321 (June 1978), cover, pp. 2–17.

52. Dorsey, Deborah. "Reviews and Previews: Joseph Cornell," *Art News*, vol. 70, no. 10 (Feb. 1972), p 13.

53. Dreiss, Joseph. "Arts Reviews: Group Show," *Arts Magazine*, vol. 49, no. 6 (Feb. 1975), pp. 17–18.

54. ———. "Arts Reviews: Group Show." *Arts Magazine*, vol. 49, no. 7 (March 1975), pp. 18–19.

55. Drexler, Sherman. "Reviews: Joseph Cornell, Leo Castelli Gallery Uptown," *Artforum*, vol. 14, no. 9 (May 1976), pp. 69–70.

56. Ellenzweig, Allen. "Arts Reviews: Group Show (Fourcade, Droll)," *Arts Magazine*, vol. 50, no. 2 (Oct. 1975), p. 13.

57. "Exhibitions: Cooper Union," *Art Journal*, vol. 31 (Summer 1972), p. 442.

58. Factor, Donald. "Boxes," *Artforum*, vol. 2, no. 10 (April 1964), pp. 20–23.

59. Flower, Edward. "The Sculptor and His Taxes," *National Sculpture Review*, vol. 25, no. 2 (Summer 1976), pp. 7, 28–31.

60. Frackman, Noel. "Arts Reviews: Joseph Cornell," *Arts Magazine*, vol. 50, no. 3 (Nov. 1975), pp. 14–15.

61. ———. "Joseph Cornell," *Arts Magazine*, vol. 50, no. 9 (May 1976), p. 5.

61a. Frankenstein, Alfred. "Moreau's Jewels, Cornell's Boxes, Stieglitz's Friends," *Art News*, vol. 76, no. 9 (Nov. 1977), p. 64.

62. Friedland, Hope. "In the Museums: Joseph Cornell," *Arts Magazine*, vol. 43, no. 1 (Sept./Oct. 1968), p. 58.

63. Geist, Sidney. "New York: Joseph Cornell," *Art Digest*, vol. 27, no. 12 (March 15, 1953), p. 18.

64. Geldzahler, Henry. "Collage by Joseph Cornell," *Metropolitan Museum of Art Bulletin*, vol. 29 (Dec. 1970), p. 192.

65. George, Laverne. "In the Galleries: Joseph Cornell," *Arts*, vol. 30, no. 4 (Jan. 1956), p. 50.

66. Glueck, Grace. "Notes: Dealers Score a Coup," *New York Times*, Jan. 4, 1976, section 2, p. 27.

67. ———. "Youths Laud Cooper Union 'Adult' Art," *New York Times*, Feb. 11, 1972, p. 22.

68. Goossen, E.C. "The Plastic Poetry of Joseph Cornell," *Art International*, vol. 3, no. 10 (1959/60), pp. 37–40.

69. Greenberg, Clement. "Joseph Cornell and Laurence Vail," *Nation*, Dec. 26, 1942, pp. 727–28. Reprinted in part in the catalog *Laurence Vail* (New York: Noah Goldowsky, 1974).

70. Griffin, Howard. "Auriga, Andromeda, Cameoleopardalis," *Art News*, vol. 56, no. 8 (Dec. 1957), pp. 24–27, 63–65.

71. Hagberg, Marilyn. "Schwitters and Collage," *Artweek*, vol. 4, no. 17 (April 28, 1973), pp. 1, 16.

72. Hammond, Paul. "Fragments of the Marvelous: Paul Hammond Looks at the Work of Joseph Cornell," *Art and Artists*, vol. 8, no. 4 (July 1973), pp. 28–33.

73. Henning, Edward B. "The Language of Art," *Bulletin of the Cleveland Museum of Art*, vol. 51 (Nov. 1964), pp. 210–31.

74. ———. "Sky Cathedral-Moon Garden Wall by Louise Nevelson," *Bulletin of the Cleveland Museum of Art*, vol. 64 (Sept. 1977), pp. 242–51.

75. Henry, Gerrit. "New York Letter," *Art International*, vol. 15, no. 3 (March 20, 1971), p. 53.

76. Hess, Thomas B. "Art: From 'Bisontennial' Beasts to Cornell Boxes," *New York*, March 22, 1976, pp. 59–61.

77. ———. "Eccentric Propositions," in *The Grand Eccentrics*, ed. Thomas B. Hess. New York: Art News Annual, 1966, pp. 9–27.

78. ———. "Reviews and Previews: Joseph Cornell," *Art News*, vol. 48, no. 9 (Jan. 1950), p. 45.

79. ———. "The Steel Mistletoe: Generalizations on the Relationship between Modern American Sculpture and Painting Based on the Whitney's Exhibition of 110 Sculptures," *Art News*, vol. 61, no. 10 (Feb. 1963), pp. 46–47, 55–57.

80. "Homage to Joseph Cornell," *Craft Horizons*, vol. 34, no. 5 (Oct. 1974), pp. 38–40.

81. Hopps, Walter. "Boxes," *Art International*, vol. 8, no. 2 (March 20, 1964), pp. 38–42.

82. Hughes, Robert. "The Last Symbolist Poet," *Time*, March 8, 1976, pp. 66–67.

83. Hussey, Howard. "Excerpts from Howard Hussey's Memoirs of Joseph Cornell (1966–1972)," *Parenthèse*, no. 3 (1976), pp. 153–58.

84. _____. "Joseph Cornell (Towards a Memoir)," *Prose*, no. 9 (Fall 1974), pp. 73–85.

85. _____. "Music in the World of Joseph Cornell," *Keynote*, vol. 3, no. 3 (May 1979), pp. 6–12.

86. Isenberg, Barbara. "Joseph Cornell's Magical Mystery Tour: Public Flocking to See—and to Buy," *Los Angeles Times*, March 12, 1976, pp. 1, 4.

87. Jacobs, Jay. "In the Galleries: Robert Cornell," *Arts Magazine*, vol. 40, no. 5 (March 1966), p. 64.

88. Johnson, Ellen H. "Arcadia Enclosed: The Boxes of Joseph Cornell," *Arts Magazine*, vol. 39, no. 10 (Sept./Oct. 1965), pp. 35–37.

89. _____. "A Loan Exhibition of Cornell Boxes," *Allen Memorial Art Museum Bulletin* (Oberlin College) vol. 23 (Spring 1966), pp. 127–31.

90. "Joseph Cornell, Sculptor, Dies; Noted for His Work With Boxes," *New York Times*, Dec. 31, 1972, p. 37.

91. "Joseph Cornell to Receive Award of Merit of American Academy of Arts and Letters," *News from the American Academy of Arts and Letters*, Feb. 1968.

92. Jouffroy, Alain. "Les Hôtels de Joseph Cornell," *Opus International*, no. 19/20 (Oct. 1970), pp. 52–56.

93. Kay, Jane Holtz. "A Dreamer and His Boxes," *Christian Science Monitor*, Oct. 29, 1975, p. 24.

94. Kerber, Bernhard. "Documenta and Szene Rhein-Ruhr," *Art International*, vol. 16, no. 8 (Oct. 1972), p. 68.

95. Kernan, Michael. "Visions from the Utopia Parkway," *Washington Post*, Jan. 2, 1974, pp. D1, D8.

96. Kingsley, April. "New York," *Art International*, vol. 17, no. 6 (Summer 1973), pp. 63–65.

97. Kirk, M. "Assemblages as Icons," *Art and Australia*, vol. 14 (Oct.–Dec. 1976), pp. 160–63.

98. Kozloff, Max. "Art," *Nation*, May 29, 1967, pp. 701–02.

99. Kramer, Hilton. "Collage Show Honors Joseph Cornell," *New York Times*, March 21, 1973, p. 52.

100. _____. "Collages of Joseph Cornell, the American Surrealist," *New York Times*, March 9, 1980, p. D27.

101. _____. "Cornell's Innocent World," *New York Times*, May 18, 1975, section 2, p. 35.

102. _____. "The Enigmatic Collages of Joseph Cornell," *New York Times*, Jan. 23, 1966, section 2, p. 15.

103. _____. "A Joseph Cornell Album," *New York Times Book Review*, Dec. 29, 1974, pp. 1–2.

104. _____. "Joseph Cornell's Baudelairean 'Voyage,'" *New York Times*, Dec. 20, 1970, section 2, p. 27.

105. _____. "New York Notes: the Secret History of Dada and Surrealism," *Art in*

"ENCHANTED WANDERER"

★ Excerpt from a Journey Album for Hedy Lamarr ★

By
JOSEPH CORNELL

Among the barren wastes of the talking films there occasionally occur passages to remind one again of the profound and suggestive power of the silent film to evoke an ideal world of beauty, to release unsuspected floods of music from the gaze of a human countenance in its prison of silver light. But aside from evanescent fragments unexpectedly encountered, how often is there created a superb and magnificent imagery such as brought to life the portraits of Falconetti in "Joan of Arc," Lillian Gish in "Broken Blossoms," Sibirskaya in "Menilmontant," and Carola Nehrer in "Dreigroschenoper?"

And so we are grateful to Hedy Lamarr, the enchanted wanderer, who again speaks the poetic and evocative language of the silent film, if only in whispers at times, beside the empty roar of the sound track. Amongst screw-ball comedy and the most superficial brand of clap-trap drama she yet manages to retain a depth and dignity that enables her to enter this world of expressive silence.

Who has not observed in her magnified visage qualities of a gracious humility and spirituality that with circumstance of costume, scene, or plot conspire to identify her with realms of wonder, more absorbing than the artificial ones, and where we have already been invited by the gaze that she knew as a child.

Her least successful roles will reveal something unique and intriguing—a disarming candor, a naivete, an innocence, a desire to please, touching in its sincerity. In implicit trust she would follow in whatsoever direction the least humble of her audience would desire.

"She will walk only when not bid to, arising from her bed of nothing, her hair of time falling to the shoulder of space. If she speak, and she will only speak if not spoken to, she will have learned her words yesterday and she will forget them to-morrow, if to-morrow come, for it may not."

(Or the contrasted and virile mood of "Comrade X" where she moves through the scenes like the wind with a storm-swept beauty fearful to behold).

* * * * * * *

At the end of "Come Live With Me" the picture suddenly becomes luminously beautiful and imaginative with its nocturnal atmosphere and incandescence of fireflies, flashlights, and an aura of tone as rich as the silver screen can yield. Her arms and shoulders always covered, our gaze is held to her features, where her eyes glow dark against the pale skin and her earrings gleam white against the black hair. Her tenderness finds a counterpart in the summer night. In a world of shadow and subdued light she moves, clothed in a white silk robe trimmed with dark fur, against dim white walls. Through the window fireflies are seen in the distance twinkling in woods and pasture. There is a long shot (as from the ceiling) of her enfolded in white covers, her eyes glisten in the semi-darkness like the fireflies. The reclining form of Snow White was not protected more

lovingly by her crystal case than the gentle fabric of light that surrounds her. A closer shot shows her against the whiteness of the pillows, while a still closer one shows an expression of ineffable tenderness as, for purposes of plot, she presses and intermittently lights a flashlight against her cheek, as though her features were revealed by slow-motion lightning.

In these scenes it is as though the camera had been presided over by so many apprentices of Caravaggio and Georges de la Tour to create for her this benevolent chiaroscuro . . . the studio props fade out and there remains a drama of light of the *tenebroso* painters . . . the thick night of Caravaggio dissolves into a tenderer, more star-lit night of the Nativity . . . she will become enveloped in the warmer shadows of Rembrandt . . . a youth of Giorgione will move through a drama evolved from the musical images of "Also Sprach Zarathustra" of Strauss, from the opening sunburst of sound through the subterranean passages into the lyrical soaring of the theme (apotheosis of compassion) and into the mystical night . . . the thunderous procession of the festival clouds of Debussy passes . . . the crusader of "Comrade X" becomes the "Man in Armor" of Carpaccio . . . in the half lights of a prison dungeon she lies broken in spirit upon her improvised bed of straw, a hand guarding her tear-stained features . . . the bitter heartbreak gives place to a radiance of expression that lights up her gloomy surroundings . . . she has carried a masculine name in one picture, worn masculine garb in another, and with her hair worn shoulder length and gentle features like those portraits of Renaissance youths she has slipped effortlessly into the rôle of a painter herself . . . le chasseur d'images . . . out of the fullness of the heart the eyes speak . . . are alert as the eye of the camera to ensnare the subtleties and legendary loveliness of her world. . . .

[*The title of this piece is borrowed from a biography of Carl Maria von Weber who wrote in the horn quartet of the overture to "Der Freischutz" a musical signature of the Enchanted Wanderer.*]

* Parker Tyler

★

Bibl. 190 Page from *View*

Bibl. 299 Exhibition announcement

America, vol. 56, no. 2 (March/April 1968), pp. 108–12.

106. _____. "The Poetic Shadow-Box World of Joseph Cornell," *New York Times,* May 6, 1967, p. 27.

107. _____. "Surrealism and Collages," *New York Times,* Dec. 12, 1970, p. 27.

108. Krasne, Belle. "Cornell Collages," *Art Digest,* vol. 25, no. 6 (Dec. 15, 1950), p. 17.

109. _____. "Listen to the Mock Birds," *Art Digest,* vol. 24, no. 6 (Dec. 15, 1949), p. 22.

110. _____. "10 Artists in the Margin: Joseph Cornell," *Design Quarterly,* no. 30 (1954), pp. 9, 12.

111. Kroll, Jack. "Paradise Regained," *Newsweek,* June 5, 1967, p. 86.

112. Kuh, Katharine. "Joseph Cornell: In Pursuit of Poetry," *Saturday Review,* Sept. 6, 1975, pp. 37–39.

113. Kultermann, Udo. "Vermeer and Contemporary American Painting," *American Art Review,* vol. 4, no. 6 (Nov. 1978), pp. 114–19, 139–40.

114. _____. "Vermeer, versions modernes," *Connaissance des arts,* no. 302 (April 1977), pp. 94–101.

115. Kurzen, Estelle. "Los Angeles: American Masters Show, Feigen/Palmer Gallery," *Artforum,* vol. 5, no. 2 (Oct. 1966), p. 54.

116. L., J. "New Exhibitions of the Week: Joseph Cornell's Concoctions from the Unconscious," *Art News,* vol. 38, no. 12 (Dec. 23, 1939), p. 8.

117. LaFarge, Henry. "Reviews and Previews: Joseph Cornell," *Art News,* vol. 55, no. 1 (March 1956), p. 51.

118. Lanes, Jerrold. "Current and Forthcoming Exhibitions: Rose Art Museum," *Burlington Magazine,* vol. 110 (July 1968), p. 425.

119. Lebel, Robert. "Les États-Unis à vol d'oiseau," in *Premier bilan de l'art actuel, 1937–1953,* ed. by Robert Lebel, Paris: Presses du livre française, 1953, pp. 197–99.

120. Leider, Philip. "Cornell: Extravagant Liberties within Circumscribed Aims," *New York Times,* Jan. 15, 1967, section 2, p. 29.

121. Levy, Julien. "J. C. of Utopia Parkway," *Juillard,* Winter 1968/69, pp. 29–33.

122. Lippard, Lucy R. "New York Letter," *Art International,* vol. 9, no. 3 (April 1965), pp. 63–64.

123. Loercher, Diana. "Art: Cornell's 'Allusive, Elusive' Boxes," *Christian Science Monitor,* April 28, 1972, p. 4.

124. Loring, John. "Phoenix House Portfolio," *Arts Magazine,* vol. 47, no. 3 (Dec. 1972), pp. 70–71.

125. McBride, Henry. "Reviews and Previews: Joseph Cornell Maquettes," *Art News,* vol. 49, no. 9 (Jan. 1951), p. 50.

126. MacKeeman, K. "Halifax: Folk Art of Nova Scotia," *Artmagazine,* vol. 8, no. 30 (Dec. 1976/Jan. 1977), pp. 6–10.

127. Marandel, J. Patrice. "Lettre de New York," *Art International,* vol. 15, no. 3 (March 20, 1971), pp. 54–55.

128. Marmer, Nancy. "Los Angeles: 20th Century Masters, Feigen/Palmer Gallery," *Artforum,* vol. 3, no. 8 (May 1965), p. 14.

129. Meilach, Dona Z. "The Intriguing Simplicity of Box Art," *New York Times,* April 27, 1975, section 2, pp. 36, 42.

130. Mekas, Jonas, and Windham, Donald. "Joseph Cornell: December 24, 1903–December 29, 1972," *Village Voice,* Jan. 11, 1973, p. 26.

131. Miller, Louis J. "Creativity in Boxes," *Design* (Syracuse, N.Y.), vol. 75, no. 2 (Winter 1973), pp. 20–21.

132. Morgan, Stuart. "About Art About Art," *Arts Magazine,* vol. 53, no. 1 (Sept. 1978), pp. 148–49.

133. "Mostre: Torino, Joseph Cornell," *Domus,* no. 504 (Nov. 1971), p. 51.

134. Myers, John Bernard. "Cornell: The Enchanted Wanderer," *Art in America,* vol. 61, no. 5 (Sept./Oct. 1973), pp. 76–81.

135. _____. "Joseph Cornell and the Outside World," *Art Journal,* vol. 35 (Winter 1975/76), pp. 115–17.

136. _____. "Joseph Cornell: 'It Was His Genius to Imply the Cosmos,'" *Art News,* vol. 74, no. 5 (May 1975), pp. 33–36.

137. Newbill, Al. "Month in Review: Cornell and Lewitin," *Arts Digest,* vol. 29, no. 19 (Aug. 1, 1955), p. 29.

138. Nordland, Gerald. "Los Angeles Letter," *Kunstwerk,* vol. 16, no. 5/6 (Nov./Dec. 1962), p. 67.

139. O'Doherty, Brian. "Cornell: Disappearing Act," *New York Post,* Aug. 17, 1974, p. 32. Also in *447.*

140. O'Hara, Frank. "Joseph Cornell," *Art and Literature,* no. 12 (Spring 1967), p. 71.

141. _____. "Reviews and Previews: Joseph Cornell and Landes Lewitin," *Art News,* vol. 54, no. 5 (Sept. 1955), p. 50.

142. "Old Prom Programs, Etc.?" *Art Digest,* vol. 14, no. 6 (Dec. 15, 1939) p. 13.

143. Phillips, McCandlish. "The Portrait of Queens Artist," *New York Times,* April 15, 1973, News of Brooklyn, Queens, and Long Island, pp. 71, 74.

144. Picard, Lil. "Joseph Cornell (Solomon Guggenheim Museum)," *Kunstwerk,* vol. 20, no. 9/10 (June/July 1967), p. 63.

145. Pomeroy, Ralph. "Torrents of Spring: New York," *Art and Artists,* vol. 2, no. 4 (July 1967), p. 42.

146. Porter, Fairfield. "Joseph Cornell," *Art and Literature,* no. 8 (Spring 1966), pp. 120–30.

147. _____. "Reviews and Previews: Joseph Cornell," *Art News,* vol. 52, no. 2 (April 1953), p. 40.

148. Rand, Harry. "Joseph Cornell." *Arts Magazine,* vol. 52, no. 4 (Dec. 1977), p. 3.

149. Ratcliff, Carter. "New York Letter," *Art International,* vol. 14, no. 7 (Sept. 20, 1970), p. 90.

150. _____. "New York Letter: Collage," *Art International,* vol. 15, no. 8 (Oct. 20, 1971), p. 58.

151. _____. "Notes on Small Sculpture," *Artforum,* vol. 14, no. 8 (April 1976), pp. 35–42.

152. Raynor, Vivien. "In the Galleries: Joseph Cornell, Willem de Kooning," *Arts Magazine,* vol. 39, no. 6 (March 1965), p. 53.

153. [Reproduction]. "Glass Bell, Joseph Cornell," *Minotaure,* no. 10 (1937), p. 34.

154. Restany, Pierre. "Dada à Paris: Apothéose et naufrage," *Domus,* no. 445 (Dec. 1966), pp. 53–56. Summary in English.

155. Rose, Barbara. "Looking at American Sculpture," *Artforum,* vol. 3, no. 5 (Feb. 1965), pp. 29–36.

156. Rosenberg, Harold. "Object Poems," *New Yorker,* June 3, 1967, pp. 112, 114–18. Also in *450.*

157. Rosenthal, Deborah. "…the Opera Glass," *Arts Magazine,* vol. 51, no. 8 (April 1977), p. 10.

158. Rotzler, Willy. "Glas im Spiegel der Kunst," *Du,* no. 438 (Aug. 1977), pp. 32–61.

159. Rubinfien, Leo. "Reviews: New York: Joseph Cornell, Leo Castelli Gallery," *Artforum,* vol. 17, no. 1 (Sept. 1978), pp. 79–80.

160. Russell, John. "Art: Joseph Cornell (A.C.A. Galleries)," *New York Times,* May 17, 1975, p. 14.

161. _____. "Art People," *New York Times,* Jan. 26, 1979, p. C16.

162. _____. "Joseph Cornell," *New York Times,* July 29, 1977, p. C18.

163. _____. "Worlds of Boxes, Packages and Columns," *New York Times,* March 14, 1976, section 2, pp. 29–30.

164. Samaras, Lucas. "Cornell Size," *Arts Magazine,* vol. 41, no. 7 (May 1967), pp. 45–47.

165. Schwartz, Barbara. "Exhibitions: New York/Sculpture and Craft," *Craft Horizons,* vol. 36, no. 3 (June 1976), p. 66.

166. Schwartz, Ellen. "New York Reviews: Joseph Cornell (ACA)," *Art News,* vol. 76, no. 10 (Dec. 1977), p. 133.

167. Schwartz, Sanford. "New York Letter," *Art International,* vol. 17, no. 4 (April 1973), p. 49.

168. _____. "Review of Books: New York School: *A Joseph Cornell Album,* by Dore Ashton," *Art in America,* vol. 63, no. 5 (Sept./Oct. 1975), pp. 25, 27.

169. Secunda, Arthur. "In the Galleries: Joseph Cornell, Stone," *Arts Magazine,* vol. 46, no. 5 (March 1972), p. 60.

170. Seldis, Henry J. "Joseph Cornell's Magical Mystery Tour: Artist's Collages at Corcoran Gallery," *Los Angeles Times,* March 12, 1976, pp. 1, 4–5.

171. Spector, Stephen. "Joseph Cornell at the Metropolitan Museum of Art," *Arts Magazine,* vol. 45, no. 3 (Dec.1970/Jan. 1971), p. 53.

172. Stiles, Knute, "'Untitled '68': The San Francisco Annual Becomes an Invitational," *Artforum,* vol. 7, no. 5 (Jan. 1969), pp. 50–52.

173. "The Surrealists," *Harper's Bazaar,* Nov.

1936, pp. 62–63, 126.

174. Tono, Y. "Cornell's Seven Boxes," *Mizue*, no. 877 (April 1978), pp. 52–59. In Japanese; summary in English.

175. Tyler, Parker. "Reviews and Previews: Joseph Cornell," *Art News*, vol. 56, no. 9 (Jan. 1958), pp. 18–19.

176. Vaizey, Marina, "Documenta 5 at Kassel," *Arts Review*, vol. 24 (Aug. 12, 1972), pp. 478–79.

177. "The 'Vasari' Diary: The Legacy of Joseph Cornell," *Art News*, vol. 74, no. 5 (May 1975), pp. 16–18.

178. Waldman, Diane, "Cornell: The Compass of Boxing," *Art News*, vol. 64, no. 1 (March 1965), pp. 42–45, 49–50.

179. _____. "Joseph Cornell, 1903–1972," *Art News*, vol. 72, no. 2 (Feb. 1973), pp. 56–57.

180. Weller, Allen S. "Chicago: Joseph Cornell," *Art Digest*, vol. 27, no. 14 (April 15, 1953), pp. 13–14.

181. Windham, Donald. "Letters to the Editor: Joseph Cornell," *New York Times Book Review*, Feb. 2, 1975, pp. 28–30.

182. Winter, Peter. "Henri Michaux und Joseph Cornell," *Kunstwerk*, vol. 26, no. 1 (Jan. 1973), p. 74.

183. Wortz, Melinda. "Los Angeles: High Hopes," *Art News*, vol. 73, no. 8 (Oct. 1974), pp. 86–87.

184. _____. "Los Angeles: Magic and Mysteries," *Art News*, vol. 75, no. 5 (May 1976), pp. 83–84.

185. Wright, Martha McWilliams. "A Glimpse at the Universe of Joseph Cornell," *Arts Magazine*, vol. 51, no. 2 (Oct. 1976), pp. 118–21.

186. Zucker, Barbara. "Joseph Cornell (Castelli, Uptown)," *Art News*, vol. 75, no. 5 (May 1976), pp. 130–31.

By Cornell

187. "Monsieur Phot (Scenario)" in *445*, pp. 77–88; also the cover design. Also reprinted *226*, pp. 151–59. An original typescript of "Monsieur Phot (Seen through the Stereoscope)" is in the Mary Reynolds Collection, Ryerson and Burnham Libraries, The Art Institute of Chicago. For description, see Hugh Edwards, comp., *Surrealism and Its Affinities: The Mary Reynolds Collection: A Bibliography*. Chicago: The Art Institute, 1956; rev. ed. 1973.

188. [Cover]. *290*, 1932.

189. [Cover]. Charles Henri Ford. *ABC's for the Children of No One, Who Grows Up to Look Like Everyone's Son*. Prairie City, Ill.: James A. Decker Press, 1940.

190. [Collage and essay]. "'Enchanted Wanderer': Excerpt from a Journey Album for Hedy Lamarr," *View*, series 1, no. 9/10 (Dec. 1941/Jan. 1942), p. 3.

191. [Cover]. "Hommage à Isadora," *Dance Index*, vol. 1, no. 1 (Jan. 1942).

192. [Cover]. "The Parker Sisters," *Dance Index*, vol. 1, no. 2 (Feb. 1942).

193. [Cover]. "Loïe Fuller," *Dance Index*, vol. 1, no. 3 (March 1942).

194. [Collages]. "Story without a Name — for Max Ernst," *View*, series 2, no. 1 (April 1942), p. 23.

195. [Cover: Denishawn Chart]. *Dance Index*, vol. 1, no. 6 (June 1942).

196. [Cover, essays, collage]. "Americana Fantastica," *View*, series 2, no. 4 (Jan. 1943), cover, pp. 10–16, 21, 36. Includes "The Crystal Cage (Portrait of Berenice)"; "...like a net of stars..."

197. [Cover]. "Portrait of Allen Dodworth (1847)," *Dance Index*, vol. 2, no. 4 (April 1943).

198. [Fashion layout incorporating four shadow boxes]. *Mademoiselle*, March 1944, pp. 130–31.

199. [Cover montage]. "European Dance Teachers in America," *Dance Index*, vol. 3, no. 4/5/6 (April/May/June 1944).

200. [Cover design and selections from collection]. "Le Quatuor dansè à Londres par Taglione, Charlotte Grisi, Cerrito et Fanny Elsler [sic]," *Dance Index*, vol. 3, no. 7/8 (July/Aug. 1944), cover, pp. 121–25, passim.

201. [Cover montage]. "Three or Four Graces," *Dance Index*, vol. 3, no. 9/10/11 (Sept./Oct./Nov. 1944).

202. [Collage]. "¾ Bird's-Eye View of 'A Watch-Case for Marcel Duchamp,'" *View*, series 5, no. 1 (March 1945), p. 22.

203. [Cover]. *Dance Index*, vol. 4, no. 5 (May 1945).

204. [Cover]. "Annetta Galletti, Louise Lamoureux, Ermesilda Diana, Kate Penoyer, Joseph De Rosa," *Dance Index*, vol. 4, no. 6/7/8 (June/ July/Aug. 1945).

205. [Cover design, scenario, selection of illustrations]. "Hans Christian Andersen," *Dance Index*, vol. 4, no. 9 (Sept. 1945), pp. 139, 155–59. Covers were selected from Andersen's work.

206. [Cover]. "Around a Scene from Sadler Wells' 1943 Revival of The Swan Lake," *Dance Index*, vol. 4, no. 10 (Oct. 1945).

207. "[Constellation] Adaptation by Joseph Cornell from a 19th Century Astronomical Engraving." Christmas card designed for The Museum of Modern Art, 1945.

208. [Cover]. "Clowns, Elephants and Ballerinas," *Dance Index*, vol. 5, no. 6 (June 1946).

209. [Cover design and compilation and arrangement of issue]. "Americana Romantic Ballet," *Dance Index*, vol. 6, no. 9 (Sept. 1947), cover, p. 203, passim.

210. "Make it from a Pattern for your Dream-Child," *Harper's Bazaar*, Dec. 1947, pp. 132-33.

210a. [Announcement]. *235*, 1948.

211. [Collage of Newport]. *Mademoiselle*, July 1950, pp. 70–71.

212. "Constellation," Christmas card designed for The Museum of Modern Art, 1954.

213. *Maria* (1954) and *The Bel Canto Pet* (1955). Booklets privately published by Cornell using texts by Elise Polko and Nathaniel Parker Willis. Collage inserts vary in individual copies of both booklets, which the artist signed and dated according to the year he sent them to friends.

214. "Bank of True Love," *Mademoiselle*, Feb. 1957, p. 103. A valentine from the collection of Cornell.

215. "Carrousel." Christmas card designed for The Museum of Modern Art, 1957.

216. [Collage, postcard, and a letter to Eleanor Ward dated April 12, 1966]. *Tracks: A Journal of Artists' Writings*, vol. 1, no. 2 (Spring 1975), pp. 32–35.

217. [Cover]. *Juillard*, Winter 1968/69.

On Cornell's Films

218. Camper, Fred. "On Film: Cornell," *Soho Weekly News*, March 11, 1976, p. 27.

219. Friedrich, Su. "Sitney on Cornell at the Collective for Living Cinema, October 5, 1979," *Downtown Review*, vol. 2, no. 1 (Fall/Winter 1979/80), pp. 30–31.

220. Hoberman, J. "The Strange Films of Joseph Cornell." *American Film*, vol. 5, no. 4 (Jan./Feb. 1980), pp. 18–19.

221. _____. "Where Is the Avant-Garde Going?" *American Film*, vol. 5, no. 2 (Nov. 1979), pp. 36–40.

222. Kitley, R. "Cannes Film Festival," *Film*, (London), vol. 64 (1978), p. 7.

223. Mekas, Jonas. *Movie Journal: The Rise of the New American Cinema, 1959-1971*. New York: Collier, 1972, p. 110.

224. _____. "Movie Journal," *Village Voice*, Dec. 31, 1970, p. 41. Also in *3*, pp. 162–67, and *223*, pp. 407–10, as "The Invisible Cathedrals of Joseph Cornell."

225. Michelson, Annette. "'Rose Hobart' and 'Monsieur Phot': Early Films from Utopia Parkway," *Artforum*, vol. 11, no. 10 (June 1973), pp. 47–57.

226. Sitney, P. Adams, ed. *The Avant-Garde Film: A Reader of Theory and Criticism*. New York: New York University Press, 1978, pp. 51–59.

227. _____. *Visionary Film*. New York: Oxford University Press, 1974.

One-Man Exhibitions

228. 1932. New York. Julien Levy Gallery. "Objects by Joseph Cornell" (Nov. 26–Dec. 30). Announcement.

229. 1939. New York. Julien Levy Gallery. "Exhibition of Objects (Bilboquet) by Joseph Cornell" (Dec. 6–31). Catalog: text by Parker Tyler. Reviews: *32A*, *47*, *116*, *142*.

230. 1940. New York. Julien Levy Gallery. "Joseph Cornell: Exhibition of Objects" (opening Dec. 10). Announcement.

231. 1942. New York. Wakefield Gallery. (May).

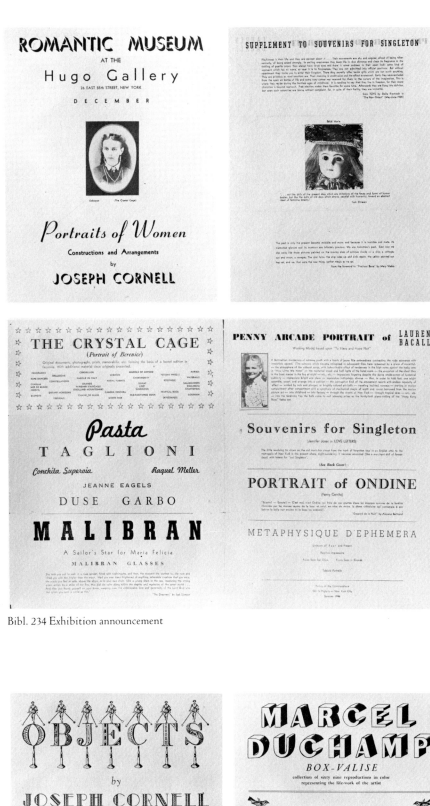

Bibl. 234 Exhibition announcement

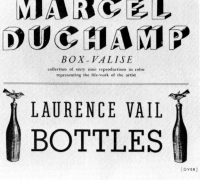

Bibl. 297 Exhibition announcement

232. 1942. Philadelphia. Ayer Galleries (N.W. Ayer & Son, Inc.).

232a. 1945–46. New York. The Museum of Modern Art. "Portrait of Ondine" (Nov. 28–Feb. 17). Press release.

233. 1946. New York. Park Lane Hotel. "'From the Dawn of Diamonds': an Art Exhibit which Traces the Origins of our Oldest Bridal Traditions, Created by Joseph Cornell" (March 15, 1946): Arthur A. Everts, Dallas (Dec.); arranged by N.W. Ayer & Son, Inc. Checklist.

234. 1946. New York. Romantic Museum at the Hugo Gallery. "Portraits of Women: Constructions and Arrangements by Joseph Cornell" (Dec.). Announcement.

235. 1948. Beverly Hills. Copley Galleries. "Objects by Joseph Cornell" (opening Sept. 28). Announcement designed by Cornell; reviews: 31.

236. 1949–50. New York. Egan Gallery. "Aviary by Joseph Cornell" (Dec.–Jan. 7). Checklist: text by Donald Windham; installation photograph in 446; reviews: 78, 109.

237. 1950. New York. New York Public Library, Central Children's Room. "The Fairy Tale World" (June 5–Nov. 4); organized by Maria Cimino. A description of the exhibition is in Annual Report of Exhibitions in the Central Children's Room, June 30, 1951.

238. 1950–51. New York. Egan Gallery. "Night Songs and Other New Work, 1950, by Joseph Cornell" (Dec. 1–Jan. 13). Announcement; reviews: 108, 125.

239. 1953. Chicago. Allan Frumkin Gallery. "Joseph Cornell: 10 Years of His Art" (April 10–May 7). Announcement; reviews: 180.

240. 1953. Minneapolis. Walker Art Center. "Joseph Cornell" (July 12–Aug. 30). Catalog was never published; for Robert Motherwell's preface, see 273.

241. 1953. New York. Egan Gallery. "Night Voyage by Joseph Cornell" (Feb. 10–March 10). Announcement; reviews: 63, 147.

242. 1955–56. New York. Stable Gallery. "Winter Night Skies by Joseph Cornell" (Dec. 12–Jan. 13). Announcement; reviews: 65, 117.

243. 1956. New York. One-Wall Gallery, Wittenborn. "Portrait of Ondine" (Nov. 1–15). Reviews: 36.

244. 1957. New York. Stable Gallery. "Joseph Cornell: Selected Works" (Dec. 2–31). Announcement; reviews: 70, 175.

245. 1959. Bennington, Vt. New Gallery, Bennington College. "Selected Works by Joseph Cornell: Bonitas Solstitialis and An Exploration of the Colombier" (Nov. 20–Dec. 15). Checklist.

246. 1962. Los Angeles. Ferus Gallery. "Joseph Cornell" (Dec. 10). Reviews: 138.

247. 1963. New York. New York University Art Collection, Loeb Student Center

(Dec. 3–18). Called a "Christmas present to the students of New York University" by Cornell.

248. 1965. Detroit. J. L. Hudson Gallery. "Joseph Cornell" (closed Oct. 30). Checklist.

249. 1965–66. Cleveland. Cleveland Museum of Art. "The Boxes of Joseph Cornell" (Nov. 30–Feb. 27). Checklist: text by Edward B. Henning.

250. 1966. New York. Allan Stone Gallery. "Joseph Cornell" (Feb.).

251. 1966. New York. Robert Schoelkopf Gallery. "Joseph Cornell" (April 26–May 14). Checklist; reviews: *18, 25, 26.*

251a. 1966. Oberlin, Ohio. Allen Memorial Art Museum. A loan exhibition of 29 boxes from Cornell (indefinite). Checklist: see *89.*

252. 1966–67. Pasadena. Pasadena Art Museum. "An Exhibition of Works by Joseph Cornell" (Dec. 27–Feb. 11). Catalog: preface by James Demetrion; introduction by Fairfield Porter; reviews: *120.*

253. 1967. New York. The Solomon R. Guggenheim Museum. "Joseph Cornell" (May 4–June 25). Catalog: text by Diane Waldman; reviews: *12, 16, 28, 35, 98, 106, 144, 145, 164.*

254. 1968. Flushing, N.Y. Queens College of the City University of New York. "Joseph Cornell" (Nov.–Dec.). Brochure: text from *146.*

255. 1968. Waltham, Mass. Rose Art Museum, Brandeis University. "Boxes and Collages by Joseph Cornell" (May 20–June 23). Checklist; reviews: *62, 118.*

256. 1970. New York. Cosmopolitan Club. "Joseph Cornell" (Feb. 16–March 23). Announcement.

257. 1970–71. New York. The Metropolitan Museum of Art. "Collage by Joseph Cornell" (Dec. 10–Jan. 24). Reviews: *8, 11, 14, 75, 104, 107, 127, 171.*

258. 1971. Turin. Galleria Galatea. "Joseph Cornell" (Oct. 15–Nov. 13). Catalog: text by Luigi Carluccio; reviews: *133.*

259. 1972. Buffalo. Albright-Knox Art Gallery. "Joseph Cornell: Collages and Boxes" (April 18–June 7). Announcement (April 15).

260. 1972. New York. Allan Stone Gallery. "Joseph Cornell" (Jan. 29–Feb. 24). Reviews: *38, 52, 169.*

261. 1972. New York. Cooper Union. A Joseph Cornell exhibition for children (Feb. 10–March 2); arranged by Dore Ashton for the Department of Art and Architecture. Reviews: *57, 67.*

262. 1972. Zurich. Gimpel und Hanover Galerie. "Joseph Cornell: Boxes und Collages" (Jan. 15–Feb. 19). Catalog: text from *330.*

263. 1972–73. Hanover. Kestner-Gesellschaft Studio. "Joseph Cornell" (Nov. 17–Jan. 7). Catalog: text by Wieland Schmied; reviews: *182.*

264. 1973. Flushing, N.Y. Queens County Art

Bibl. 235 Exhibition announcement

Bibl. 193 Cover of *Dance Index*

and Cultural Center. "Homage to Joseph Cornell, 1903–1972" (March 18–May 6). Catalog: text from 179; reviews: 96, 99, 143.

265. 1973. Hanover, N.H. Hopkins Center Art Galleries, Dartmouth College. "Joseph Cornell: Collages and Boxes" (Jan. 5–Feb. 28).

265a. 1973. New York. The Solomon R. Guggenheim Museum. "Joseph Cornell, 1903–1972" (Jan. 9–April). A memorial exhibition of 10 boxes; reviews: 96, 167.

266. 1973–74. Chicago. Museum of Contemporary Art. "Cornell in Chicago" (Nov. 17–Jan. 6). Catalog: text by Patricia Stewart.

267. 1973–74. Washington, D.C. National Collection of Fine Arts, Smithsonian Institution. "Joseph Cornell (1903–1972)" (Dec. 23–June 2). Reviews: 34, 95.

268. 1974. Hanover, N.H. Hopkins Center Art Galleries, Dartmouth College. "Collages by Joseph Cornell" (April 25–May 5).

269. 1975. New York. ACA Galleries. "Joseph Cornell" (May 3–31). Catalog text by John Bernard Myers; reviews: 23, 60, 101, 160.

270. 1975. Santa Barbara. College of Creative Studies, University of California. "Collages by Joseph Cornell" (Oct. 24–Nov. 11). Catalog: A.M. Wade and Suzanne Miller.

271. 1975. Washington, D.C. Pyramid Galleries. "Joseph Cornell" (April 15–May 19). Catalog.

272. 1976. Los Angeles. James Corcoran Gallery, in association with Leo Castelli Gallery and Richard L. Feigen & Company, New York. "Joseph Cornell: Collages" (March 4–31). Reviews: 22, 86, 170, 184.

273. 1976. New York. Leo Castelli Gallery. "Joseph Cornell" (Feb. 28–March 20). Catalog: edited by Sandra Leonard Starr, contributions by Donald Barthelme et al.; reviews: 55, 61, 76, 163, 165, 186.

274. 1976. San Francisco. John Berggruen Gallery. "Joseph Cornell: Constructions and Collages" (May 12–June 12). Checklist; reviews: 7.

275. 1977. Houston. Rice Museum, organized by the Institute for the Arts, Rice University. "Joseph Cornell" (Sept. 16–Dec. 31). Checklist.

276. 1977. Los Angeles. James Corcoran Gallery. "Joseph Cornell: Sandboxes" (April 16–May 14). Checklist.

277. 1977. New York. ACA Galleries. "Joseph Cornell: Boxes and Collages" (Oct. 22–Nov. 12). Catalog; reviews: 148, 166.

278. 1977. Nyack, N.Y. Edward Hopper House (closed July 30). Reviews: 162.

279. 1977. Rome. L'Attico. "Joseph Cornell: Boxes and Films" (Dec. 2–21). Catalog: filmography by Jonas Mekas.

280. 1978. Akron, Ohio. Akron Art Institute. "Joseph Cornell" (Sept. 16–Oct. 29). Catalog: introduction by John Coplans.

281. 1978. Los Angeles. James Corcoran Gallery. "Joseph Cornell: Box Constructions" (Feb. 11–March 25). Announcement.

282. 1978. New York. Leo Castelli. "Joseph Cornell Collages: 1931–1972" (May 6–June 3). Catalog: texts by Donald Windham and Howard Hussey; introduction by Richard L. Feigen; reviews: 17, 159.

283. 1978. Tokyo. Gatodo Gallery. "Seven Boxes by Joseph Cornell" (March 3–April 8). Catalog: text in Japanese; captions, bibliography, exhibitions list, and reprint of Robert Motherwell's preface also in English; reviews: 174.

284. 1979. Boston. Institute of Contemporary Art. "Joseph Cornell, Collages" (May 8–June 24).

285. 1979–80. Berkeley. University Art Museum. "Joseph Cornell" (Oct.–Dec.). Matrix/Berkeley 30. Checklist.

286. 1980. New York. Castelli, Feigen, Corcoran. "Joseph Cornell: The Early Collages" (Feb. 12–March 15). Checklist.

287. 1980. Paris. Baudoin Lebon. "Joseph Cornell (1903–1972): Boîtes" (May 29–July 5); also shown Musée de Toulon (July 4–Sept. 1). Catalog.

288. 1980. Reno, Nev. Sierra Nevada Museum of Art. "Joseph Cornell: A Survey" (Feb. 9–March 10).

289. 1980. Wichita, Kans. Ulrich Museum of Art, Wichita State University. "Joseph Cornell: 12 Box Constructions" (Feb. 6–March 2). Announcement.

GROUP EXHIBITIONS

290. 1932. New York. Julien Levy Gallery. "Surréalisme" (Jan. 9–29). Announcement: cover designed by Cornell.

291. 1933–34. New York. Julien Levy Gallery. "Objects by Joseph Cornell, Posters by Toulouse-Lautrec, Watercolors by Perkins Harnly, Montages by Harry Brown" (Dec. 12–Jan. 3). Announcement.

292. 1935. Hartford, Conn. Wadsworth Atheneum. "American Painting and Sculptures of the 18th, 19th & 20th Centuries" (Jan. 29–Feb. 19). Catalog.

293. 1936–37. New York. The Museum of Modern Art. "Fantastic Art, Dada, Surrealism" (Dec. 9–Jan. 17). Catalog: edited by Alfred H. Barr, Jr.; 2nd ed. (1937) and 3rd ed. (1947) with additional essays by Georges Hugnet.

294. 1938. Hartford, Conn. Wadsworth Atheneum. "The Painters of Still Life" (Jan. 25–Feb. 15). Catalog: foreword by A. Everett Austin and Henry R. Hitchcock; introduction by "J.R.S." states that Cornell objects were exhibited but not cataloged.

295. 1938. Paris. Galerie Beaux-Arts. "Exposition internationale du surréalisme" (Jan.–Feb. 1938); organized by André Breton and Paul Eluard. Checklist.

296. 1940. New York. Julien Levy Gallery. "Surrealist Group Show" (Feb. 1940).

297. 1942. New York. Art of this Century. "Objects by Joseph Cornell; Marcel Duchamp: Box-Valise; Laurence Vail: Bottles" (Dec. 1942). Announcement; reviews 69.

298. 1942–43. New York. The Museum of Modern Art. "20th Century Portraits" (Dec. 9–Jan. 24). Catalog: Monroe Wheeler.

298a. 1943. New York. Art of this Century. "Exhibition of Collage" (April 16–May 15). Announcement.

299. 1943. New York. Julien Levy Gallery. "Through the Big End of the Opera Glass: Marcel Duchamp, Yves Tanguy, Joseph Cornell" (Dec. 7–28). See also 400.

300. 1944. Cincinnati. Cincinnati Art Museum. "Abstract and Surrealist Art in the United States" (Feb. 8–March 12); Denver Art Museum (March 26–April 23); Seattle Art Museum (May 7–June 10); Santa Barbara Museum of Art (June–July); San Francisco Museum of Art (July); selected by Sidney Janis. Catalog: introduction by Sidney Janis; published by the San Francisco Museum of Art.

301. 1945. San Francisco. California Palace of the Legion of Honor. "Contemporary American Painting" (May 17–June 17). Catalog.

302. 1945–46. New York. Hugo Gallery. "Poetic Theater" (Dec. 19–Jan. 12). Announcement.

303. 1946. New York. 67 Gallery. "40 American Moderns." Checklist.

304. 1948. New York. The Museum of Modern Art. "Collage" (Sept. 21–Dec. 5). Checklist.

304a. 1949. New York. Hugo Gallery. "La Lanterne Magique du Ballet Romantique of Joseph Cornell" and "Décors for Ballets Choreographed by Roland Petit" (Opened Nov. 14). Announcement.

305. 1949. San Francisco. California Palace of the Legion of Honor. "Illusionism and Trompe L'Oeil" (May 3–June 12). Catalog: texts by Jermayne MacAgy, Alfred Frankenstein, and Douglas MacAgy.

306. 1950. New York. Egan Gallery. "New Work by Joseph Cornell" (June 1–24). Announcement includes other gallery artists.

307. 1952. San Francisco. California Palace of the Legion of Honor. "Time and Man: An Idea Illustrated by an Exhibition" (March 29–May 11). Catalog: texts by Jermayne MacAgy, Irene Lagorio, and Sidney Peterson.

308. 1953. New York. Whitney Museum of American Art. "1953 Annual Exhibition" (April 9–May 29). Catalog.

308a. 1954. Minneapolis. Walker Art Center. "Reality and Fantasy, 1900–1954" (May 23–July 2). Catalog.

309. 1954. New York. Stable Gallery. Third annual exhibition of painting and sculpture (Jan. 27–Feb. 20).

310. 1954. New York. Whitney Museum of American Art. "1954 Annual Exhibition..." (March 17–April 18). Catalog.

310a. 1955. New York. Stable Gallery. Joseph

Cornell and Landes Lewitin (through July 16). Reviews: *137, 141.*

311. 1955. New York. New York Public Library, Central Children's Room. An exhibition in honor of the 150th anniversary of the birth of Hans Christian Andersen (April 2–June); organized jointly by the Library and the Danish Information Office. A description of the exhibition is in *Annual Report of the Central Children's Room, June 1955.*

312. 1955. New York. Whitney Museum of American Art. "Annual Exhibition" (Jan. 12–Feb. 20). Catalog.

313. 1956. New York. Whitney Museum of American Art. "1956 Annual Exhibition" (April 18–June 10). Catalog.

314. 1956–57. New York. Whitney Museum of American Art. "Annual Exhibition" (Nov. 14–Jan. 6). Catalog.

315. 1957. Houston. Contemporary Arts Museum. "Recent Contemporary Acquisitions in Houston" (July 25–Aug. 25). Catalog: foreword by Jermayne MacAgy.

316. 1957. Chicago. The Art Institute of Chicago. "62nd American Exhibition" (Jan. 17–March 3). Catalog: foreword by Frederick A. Sweet.

316a. 1957. New York. Stable Gallery. Sixth annual exhibition of painting and sculpture (May 7–June 28).

317. 1957–58, New York. Whitney Museum of American Art. "1957 Annual Exhibition" (Nov. 20–Jan. 12). Catalog.

318. 1958. Houston. Contemporary Arts Museum. "The Disquieting Muse: Surrealism" (Jan. 9–Feb. 16). Catalog: texts by Jermayne MacAgy and Julien Levy.

319. 1958. Houston. Contemporary Arts Museum. "Collage International: From Picasso to the Present" (Feb. 27–April 6). Catalog: text by Jermayne MacAgy.

320. 1958–59. New York. Whitney Museum of American Art. "Annual Exhibition" (Nov. 19–Jan. 4). Catalog.

321. 1958–59. Pittsburgh. Department of Fine Arts, Carnegie Institute. "The 1958 Pittsburgh Bicentennial International…" (Dec. 5–Feb. 8). Catalog: introduction by Gordon Bailey Washburn.

322. 1959. Houston. Contemporary Arts Association of Houston. "Out of the Ordinary" (Nov. 26–Dec. 27). Catalog: text by Harold Rosenberg.

323. 1959–60. Chicago. The Art Institute of Chicago. "63rd American Exhibition" (Dec. 2–Jan. 31); selected by Katharine Kuh and Frederick A. Sweet.

324. 1959–60. Chicago. Richard Feigen Gallery. "Constructions, Joseph Cornell; Paintings and Drawings, Fred Berger; Sculpture, Kathryn Carloye" (Dec. 17–Jan. 8). Catalog.

325. 1959–60. New York. Time, Inc. "Art and the Found Object" (Jan. 12–Feb. 6); Williams College, Williamstown, Mass. (Feb. 22–March 15); Cranbrook Academy of Art, Bloomfield Hills, Mich. (April 8–28); Arts Club of Chicago (May 20–June 20); University of Notre Dame (July 1–21); Montreal Museum of Fine Arts (Sept. 27–Oct. 18); Vassar College, Poughkeepsie (Nov. 4–24); Brandeis University, Waltham, Mass. (Dec. 15–Jan. 15); organized by the American Federation of Arts; selected by Roy Moyer.

326. 1960–61. New York. D'Arcy Galleries. "Surrealist Intrusion in the Enchanters' Domain" (Nov. 28–Jan. 14); directed by André Breton and Marcel Duchamp; managed by Edouard Jaguer and José Pierre. Catalog: text translated from the French by Julien Levy and Claude Tarnaud.

327. 1960–61. New York. Whitney Museum of American Art. "Annual Exhibition 1960" (Dec. 7–Jan. 22). Catalog.

328. 1961. Dallas. Dallas Museum for Contemporary Arts. "The Art That Broke the Looking-Glass" (Nov. 15–Dec. 31). Catalog: text by Douglas MacAgy.

329. 1961. New York. Rose Fried Gallery. "Modern Masters" (Nov. 20–Dec. 16).

329a. 1961–62. "The Collection of Mr. and Mrs. Ben Heller" (circulated 1961–62); organized by the Department of Circulating Exhibitions, The Museum of Modern Art. Catalog: texts by Alfred H. Barr, Jr., Ben Heller, and William C. Seitz.

330. 1961–62. New York. The Museum of Modern Art. "The Art of Assemblage" (Oct. 2–Nov. 12); Dallas Museum for Contemporary Arts (Jan. 9–Feb. 11); San Francisco Museum of Art (March 5–April 15). Catalog: text by William C. Seitz; Cornell entry by Kynaston L. McShine; reviews: *33.*

331. 1962. Seattle. Seattle World's Fair. "Art since 1950: American and International" (April 21–Oct. 21). Catalog: introduction to the American section by Sam Hunter. American section later exhibited at the Rose Art Museum, Brandeis University, Waltham, Mass. and the Institute for Contemporary Art, Boston, under the title "American Art since 1950." Catalog: foreword and introduction by Sam Hunter.

332. 1962–63. New York. The Solomon R. Guggenheim Museum. "Modern Sculpture from the Joseph H. Hirshhorn Collection" (Oct. 3–Jan. 20). Catalog: text by H. H. Arnason.

333. 1962–63. New York. Whitney Museum of American Art. "Annual Exhibition 1962…" (Dec. 12–Feb. 3); including a separate section on Cornell. Catalog; reviews: *21, 79.*

334. 1963. New York. Royal Marks Gallery. "Much Has Happened 1910–1959: Key Transitions" (Nov. 25–Dec. 21). Catalog: text by Dore Ashton.

335. 1964. Chicago. The Art Institute of Chicago. "67th Annual American Exhibition" (Feb. 28–April 12). Catalog: note by John Maxon; foreword by A. James Speyer.

Bibl. 202 Collage from *View*

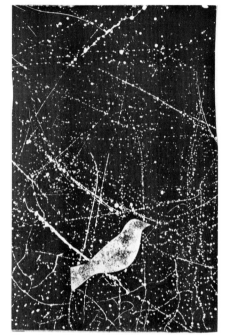

Constellation (Project for Christmas card, bibl. 212). 1953. Gouache and collage, 14 x 9⅛ in. The Museum of Modern Art, New York, Gift of Monroe Wheeler

Bibl. 242 Exhibition announcement

336. 1964. Houston. Fine Arts Gallery, University of St. Thomas. "Out of this World: An Exhibition of Fantastic Landscapes from the Renaissance to the Present" (March 20–April 30). Catalog: texts by Dominique de Menil, Etienne Souriau, and Jermayne MacAgy.

337. 1964. London. The Tate Gallery. "Painting & Sculpture of a Decade, 54–64" (April 22–June 28); organized by the Calouste Gulbenkian Foundation. Catalog.

338. 1964. Los Angeles. Dwan Gallery. "Boxes" (Feb. 2–29). Catalog: text by Walter Hopps; reviews: 58, 81.

339. 1964. Los Angeles. Feigen/Palmer Gallery. "20th Century Masters" (May 3–23).

340. 1964. New York. Allan Stone Gallery. "De Kooning/Cornell" (Feb. 13–March 13).

341. 1964. New York. Martha Jackson Gallery. "New Acquisitions" (Sept. 18–Oct. 15).

342. 1964. New York. Rose Fried Gallery. "Modern Masters" (Jan. 11–Feb. 15). Catalog.

343. 1964. Paris. Galerie Charpentier. "Le surréalisme: sources, histoire, affinités." Catalog: text by Patrick Waldberg.

344. 1964–65. New York. Whitney Museum of American Art. "Annual Exhibition 1964" (Dec. 9–Jan. 31). Catalog.

345. 1965. Chicago. Richard Feigen Gallery. "Poetry in Painting 1931-1949, from the Collection of the Julien Levy Gallery, New York" (Nov. 10–Dec. 18). Catalog: foreword by Julien Levy.

346. 1965. Irvine. University of California. "Twentieth Century Sculpture, 1900/1950, Selected from California Collections" (Oct. 2–24). Catalog: text by John Coplans.

347. 1965. Los Angeles. Feigen/Palmer Gallery. "20th Century Masters" (May). Reviews: 128.

348. 1965. New York. Allan Stone Gallery. "De Kooning/Cornell" (Feb. 20–March 18). Reviews: 122, 152, 178.

349. 1965. New York. Allan Stone Gallery. "Founding Fathers" (Oct. 26–Nov. 13).

349a. 1965. New York. Byron Gallery. "The Box Show." Reviews: 122.

350. 1965. New York. The Museum of Modern Art. "American Collages" (May 11–July 25; circulated, 1964–66, see also 358, 363, 364); directed by Kynaston McShine. Checklist.

351. 1965. Paris. Musée Rodin. "Etats-Unis: Sculpture du XXᵉ siècle"; organized by the International Council of The Museum of Modern Art. Catalog: texts by Cécile Goldscheider and René d'Harnoncourt. See also 351A.

351a. 1965–66. Berlin. Deutsche Gesellschaft für Bildende Kunst (Kunstverein Berlin). "Amerikanische Plastik—USA 20. Jahrhundert" (Nov. 20–Jan. 9); Staatliche Kunsthalle, Baden-Baden (March–April 1966); organized by the International Council of The Museum of Modern Art. Catalog: texts by René d'Harnon-

court and Dietrich Mahlow. See also 351.

352. 1966. Katonah, N.Y. Katonah Gallery. "Boxes: Work of Mary Bauermeister, Joseph Cornell, Louise Nevelson and Others" (March 6–April 5). Announcement.

353. 1966. Los Angeles. Feigen/Palmer Gallery. "American Masters." Reviews: 115.

354. 1966. New York. Pierre Matisse Gallery. "Seven Decades, 1895–1965: Crosscurrents in Modern Art" (April 26–May 21); organized by the Public Education Association and shown at 10 galleries in New York City; Cornell included in the 1935–1944 section at the Matisse Gallery. Catalog: text by Peter Selz.

355. 1966. New York. Robert Schoelkopf Gallery. "Robert Cornell: Memorial Exhibition, Drawings by Robert Cornell, Collages by Joseph Cornell, Related Varia" (Jan. 4–29). Reviews: 37, 87.

356. 1966–67. New York. The Museum of Modern Art. "Art in the Mirror" (Nov. 22–Feb. 5; circulated 1967–68). Checklist: text by G. R. Swenson.

357. 1966–67. New York. Whitney Museum of American Art. "Annual Exhibition 1966" (Dec. 16–Feb. 5). Catalog.

358. 1967. Copenhagen. Court Gallery. "American Collages" (Jan. 6–23); organized by the The Museum of Modern Art. Catalog.

359. 1967. Hanover, N.H. Dartmouth College. "Sculpture in Our Century: Selections from the Joseph H. Hirshhorn Collection" (May 25–July 9). Catalog: introduction by Abram Lerner.

360. 1967. Los Angeles. Irving Blum Gallery. "Paintings and Sculpture from the Gallery Collection" (opening Dec. 5). Catalog.

361. 1967. Los Angeles. Los Angeles County Museum of Art. "American Sculpture of the Sixties" (April 28–June 25); Philadelphia Museum of Art (Sept. 15–Oct. 29); selected by Maurice Tuchman. Catalog: essays by Lawrence Alloway et al.

362. 1967. New York. Sidney Janis Gallery. "Homage to Marilyn Monroe" (Dec. 6–30).

363. 1967. Oslo. Kunstnernes Hus. "American Collages" (Feb. 11–March 5); organized by The Museum of Modern Art. Catalog: text in Norwegian.

364. 1967. Stockholm. Liljevalchs Konsthall. "American Collages" (June 2–18); organized by The Museum of Modern Art. Catalog: text in Swedish.

365. 1968. Kassel. Galerie an der Schönen Aussicht. "Documenta 4" (June 27–Oct. 6). Catalog.

366. 1968. New Delhi. Lalit Kala Akademi. First Triennale—India. (Feb.–April).

367. 1968. New York. Finch College Museum of Art. "Betty Parsons' Private Collection" (March 13–April 24); Cranbrook Academy of Art, Bloomfield Hills, Mich. (Sept. 22–Oct. 20); Brooks Memorial Art Gallery, Memphis (Nov. 1–Dec. 1). Catalog: foreword by E. C. Goossen.

368. 1968. New York. The Museum of Modern Art. "Dada, Surrealism, and Their Heritage" (March 27–June 9); Los Angeles County Museum of Art (July 16–Sept. 8); The Art Institute of Chicago (Oct. 19–Dec. 8). Catalog: text by William S. Rubin.

369. 1968. New York. Whitney Museum of American Art. "The 1930's: Painting and Sculpture in America" (Oct. 15–Dec. 1). Catalog: William C. Agee.

370. 1968. San Francisco. San Francisco Museum of Art. "Untitled 1968" (Nov. 9–Dec. 29). Catalog: introduction by Wesley Chamberlain; reviews: 172.

371. 1968–69. Houston. University of St. Thomas. "Jermayne MacAgy: A Life Illustrated by an Exhibition" (Nov.–Jan.). Catalog: introduction by Dominique de Menil.

372. 1969. Andover, Mass. Addison Gallery of American Art, Phillips Academy. "7 Decades, Seven Alumni of Phillips Academy." Catalog.

372a. 1969. New York. Byron Gallery. "The Surrealists" (Nov. 11–Dec. 21). Catalog.

373. 1969. New York. The Solomon R. Guggenheim Museum. "Selected Sculpture and Works on Paper" (July 8–Sept. 14). Catalog.

374. 1969–70. New York. The Metropolitan Museum of Art. "New York Painting and Sculpture: 1940–1970" (Dec. 6–March 8). Catalog: text by Henry Geldzahler; essays by Harold Rosenberg et al. Reviews: 46.

375. 1970. New York. The Solomon R. Guggenheim Museum. "Selections from the Guggenheim Museum Collection, 1900–1970." Catalog: introduction by Louise Averill Svendsen.

376. 1970–71. Pittsburgh. Museum of Art, Carnegie Institute. "Pittsburgh International" (Oct. 30–Jan. 10). Catalog: introduction by Leon Anthony Arkus; biographical notes by Alice Davis.

376a. 1971. La Jolla, Calif. La Jolla Museum of Art. "Continuing Surrealism" (Jan.–March 21); organized by Lawrence Urrutia.

377. 1971. New York. Contemporary Wing, Finch College Museum of Art. "The Permanent Collection: A Selection" (May 12–June 11).

377a. 1971. New York. The Museum of Modern Art. "Ways of Looking" (July 28–Nov. 1). Review: 150.

378. 1971. Washington, D.C. Corcoran Gallery of Art. "Depth and Presence" (May 3–30). Catalog: introduction by Stephen S. Prokopoff.

379. 1971. Yonkers, N.Y. Hudson River Museum. "20th Century Painting and Sculpture from the New York University Collection" (Oct. 2–Nov. 14). Catalog: introduction by Irving H. Sandler.

380. 1972. Chicago. Museum of Contemporary Art. "Modern Masters from Chicago Collections" (Sept. 8–Oct. 22). Catalog:

introduction by Stephen S. Prokopoff.

381. 1972. Kassel. Neue Galerie. "Documenta 5: Befragung der Realität, Bildwelten Heute" (June 30–Oct. 8). Catalog: edited by Harald Szeeman et al. (Kassel: Bertelsman, 1972); reviews: *94, 176.*

382. 1972. New York. New York Cultural Center. "Prints for Phoenix House" (Nov. 16–Dec. 31). Review: *124.*

383. 1973. La Jolla, Calif. La Jolla Museum of Contemporary Art. "Kurt Schwitters and Related Developments" (April–May 6). Review: *71.*

384. 1973. Santa Barbara. Art Galleries, University of California. "19 Sculptors of the 40's" (April 3–May 6). Catalog: essay by David Gebhard.

385. 1973–74. Washington, D.C. National Gallery of Art. "American Art at Mid-Century, I" (Oct. 28–Jan. 6). Catalog: introduction by William C. Seitz; review: *9.*

386. 1974. New York. Rosa Esman Gallery. "Small Master Works" (Nov. 23–Dec. 28). Review: *53.*

387. 1974. University Park. Pennsylvania State University. "Surrealism—A Celebration: Exhibition of Surrealist Art" (Nov. 7–23). Catalog: texts by Robert Lima and Timothy Hewes.

388. 1974–75. Los Angeles. University of Southern California. "Reality and Deception" (Oct. 16–Nov. 24); Seattle Art Museum (Dec. 4–Jan. 12); Honolulu Academy of Art (Jan. 23–Feb. 23); Santa Barbara Museum of Art (March 13–April 20). Catalog: introduction by Alfred Frankenstein; review: *183.*

389. 1975. New York. Grey Art Gallery and Study Center, New York University. "Inaugural Exhibition: Selections from the New York University Art Collection" (Autumn). Catalog: introduction by Joy L. Gordon.

390. 1975. New York. Pace Gallery. "5 Americans at Pace" (Jan. 11–Feb. 22). Brochure; review: *54.*

391. 1975. Washington, D.C. National Collection of Fine Arts, Smithsonian Institution. "Sculpture: American Directions, 1945–1975" (Oct. 3–Nov. 30). Checklist.

392. 1976. New York. Austrian Institute. "The World of Tilly Losch: An Exhibit" (May 21–June 30); organized by Louise Kerz. Checklist.

393. 1976. New York. Hirschl and Adler. "2nd Williams College Alumni Loan Exhibition" (April 1–24); Museum of Art, Williams College, Williamstown, Mass. (May 9–June 13). Catalog: introduction by S. Lane Faison, Jr.

394. 1976. New York. The Solomon R. Guggenheim Museum. "Twentieth Century American Drawing: Three Avant-Garde Generations" (Jan. 23–March 21). Catalog: text by Diane Waldman.

Bibl. 196 Pages from *View*

The Crystal Cage

Bibl. 196 Page from *View*

395. 1976. New York. Whitney Museum of American Art. "200 Years of American Sculpture" (March 16–Sept. 26). Catalog: essays by Wayne Craven et al.

396. 1976–77. Cleveland. Cleveland Museum of Art. "Materials and Techniques of 20th Century Artists" (Nov. 17–Jan. 2). Catalog.

397. 1977. New Brunswick, N.J. Rutgers University Art Gallery. "Surrealism and American Art, 1931–1947" (March 5–April 24). Catalog: Jeffrey Wechsler; with collaboration and an introductory essay by Jack J. Spector.

398. 1977. New York. Andrew Crispo Gallery. "Twelve Americans: Masters of Collage" (Nov. 18–Dec. 30). Catalog: text by Gene Baro; review: *41*.

399. 1977. New York. Grey Art Gallery and Study Center, New York University. "Drawing and Collage: Selections from the New York University Art Collection" (June 1–July 1). Catalog.

400. 1977. New York. Washburn Gallery. "'Through the Big End of the Opera Glass,' II: Joseph Cornell, Marcel Duchamp, Yves Tanguy" (Feb. 12–March 12); a reconstruction of *299*. Catalog; review: *157*.

401. 1977. Paris. Centre National d'Art et de Culture Georges Pompidou. "Paris-New York" (June 1–Sept. 19, 1977). Catalog: preface by Pontus Hulten.

402. 1978. Lawrence. Helen Foresman Spencer Museum of Art, University of Kansas. "Artists Look at Art" (Jan. 15–March 12). Catalog: William J. Hennessey.

403. 1978. London. Hayward Gallery. "Dada and Surrealism Reviewed" (Jan. 11–March 27). Catalog: Dawn Ades; introduction by David Sylvester; supplementary essay by Elizabeth Cowling (London: Arts Council of Great Britain, 1978).

404. 1978–79. New York. Pace Gallery. "Grids: Format and Image in 20th Century Art" (Dec. 16–Jan. 20); Akron Art Institute, Akron, Ohio (March 24–May 6). Catalog: essay by Rosalind Krauss.

405. 1978–79. New York. Whitney Museum of American Art. "Art about Art" (July 19–Sept. 24); North Carolina Museum of Art, Raleigh (Oct. 15–Nov. 26); Frederick S. Wight Art Gallery, University of California, Los Angeles (Dec. 17–Feb. 11); Portland Art Museum, Portland, Ore. (March 6–April 15). Catalog by Jean Lipman and Richard Marshall; review: *132*.

406. 1978–79. Pittsburgh. Carnegie Institute. "Collection of Mr. and Mrs. Orin Raphael" (Dec. 7–Jan. 21).

407. 1979. Boston. Sunne Savage Gallery. "Thirty Years of Box Construction" (Nov. 2–30); Jeremy Stone, guest curator. Catalog.

408. 1979. New York. Whitney Downtown Museum. "Enclosure and Concealment" (April 18–May 23). Review: *39*.

409. 1979–80. New Brunswick, N.J. Art Gallery, Rutgers University. "Vanguard

American Sculpture, 1913–1939" (Sept. 16–Nov. 4); William Hayes Ackland Art Center, University of North Carolina, Chapel Hill (Dec. 4–Jan. 20); Joslyn Art Museum, Omaha (Feb. 16–March 30); Oakland Museum (April 15–May 25). Catalog: Joan M. Marter, Roberta K. Tarbell, and Jeffrey Wechsler.

410. 1979–80. Williamstown, Mass. Williams College Museum of Art. "Documents, Drawings and Collages: Fifty American Works on Paper from the Collection of Mr. and Mrs. Stephen D. Paine" (June 1–30). Toledo Museum of Art (Oct. 6–Nov. 18); John and Mable Ringling Museum of Art, Sarasota, Fla. (Dec. 7–Feb. 17); Fogg Art Museum, Harvard University, Cambridge, Mass. Catalog: text by Hiram Carruthers Butler et al.; entries on Cornell by Kim Verzyl.

411. 1980. New York. Maxwell Davidson Gallery. "Around Surrealism" (May 3–June 14).

412. 1980. New York. Whitney Museum of American Art. "American Sculpture: Gifts of Howard and Jean Lipman" (April 15–June 15). Checklist.

413. 1980. Philadelphia. Jeffrey Fuller Fine Art. "Sign and Symbol: Metaphor in Art" (Sept. 12–Oct. 15).

414. 1980. Ridgefield, Conn. Aldrich Museum of Contemporary Art. "Mysterious and Magical Realism" (April 27–Aug. 31). Catalog: introduction by Martin T. Sosnoff.

SELECTED
FILM SCREENINGS

Programs include both artist's own films and those from his collection.

415. 1936. New York. Julien Levy Gallery. "Goofy Newsreels" (Dec.).

416. 1947. New York. Norlyst Gallery. "Film Soirée:Selected Rarities from the Collection of Joseph Cornell" shown with special music (March 2 and 16).

417. 1949. New York. New Art School. "The Subjects of the Artist: Early Films from the Unique Collection of Joseph Cornell" (Jan. 21).

418. 1957. New York. New York Public Library. A'screening of some of Cornell's films for the staff of the Picture Collection (Dec.).

419. 1958. Houston. Contemporary Arts Museum. "Films 1948–1958" (Jan.–Feb.). Organized by Jermayne MacAgy.

420. 1963. New York. Film-makers Cinematheque, Gramercy Arts Theatre. "Cornell" (Nov. 25).

421. 1963. New York. 9 Great Jones Street. "Comedy Americana: A Series of Film Programs from the Collection of Joseph Cornell" (April 26–27).

422. 1964. Los Angeles. Feigen/Palmer Gallery. "Joseph Cornell Film Preview" (Jan. 28–29).

423. 1968. New York. Contemporary Study Wing, Finch College Museum of Art. "Collage Film," shown in the exhibition "Projected Art" (Dec. 8–Jan. 8).

424. 1970. New York. Anthology Film Archives. "Joseph Cornell" (Dec. 1, 17–18).

425. 1975. New York. The Solomon R. Guggenheim Museum. *Rose Hobart* (March 8–9).

426. 1976. New York. Anthology Film Archives. "Films of Joseph Cornell; Conferences on 'Working with Cornell'; Cornell's Sources and Materials" (March 5–26). Preview: *218*.

427. 1976. Rome. L'Attico (Dec. 2–31). See *279*.

428. 1978. New York. Leo Castelli [Gallery]. "Aviaries, Utopiaries 3708: Joseph Cornell's Explorations in Film and Collage," a commentary by Howard Hussey with slides and film selections (May 16).

429. 1978. New York. Leo Castelli [Gallery]. "Films by Joseph Cornell" (May 6–June 3). Checklist.

BOOKS

430. Alloway, Lawrence. *Topics in American Art since 1945.* New York: Norton, 1975, pp. 140–41.

431. Baur, John I. H. *Revolution and Tradition in Modern American Art.* Cambridge, Mass.: Harvard University Press, 1951, p. 31.

432. Blesh, Rudi. *Modern Art USA.* New York: Knopf, 1956, pp. 176, 215, 244.

433. Breton, André. *Surrealism and Painting.* Trans. Simon Watson Taylor. New York: Harper & Row, Icon Editions, 1972. Translation of: *434*.

434. ———. *Le Surréalisme et la peinture.* Paris: Gallimard, 1928; nouv. éd., 1965. New York: Brentano's, 1945. Originally appeared in *La Revolution Surréaliste,* nos. 4, 6, 7, 9/10 (1925–27).

435. Calas, Elena and Nicolas. *The Peggy Guggenheim Collection of Modern Art.* New York: Abrams, 1966, pp. 122–23.

436. Calas, Nicolas and Elena. *Icons and Images of the Sixties.* New York: Dutton, 1971, pp. 22–24, 258, 319.

437. Hunter, Sam. *American Art of the Twentieth Century: Painting, Sculpture, Architecture.* Rev. ed. New York: Abrams, 1974, pp. 295, 331, 421.

438. ———. *Modern American Painting and Sculpture.* New York: Dell, 1959, pp. 183–84.

439. Janis, Harriet, and Blesh, Rudi. *Collage: Personalities Concepts Techniques.* New York: Chilton, 1962, pp. 86–87, 253.

440. Janis, Sidney. *Abstract and Surrealist Art in America.* New York: Reynal & Hitchcock, 1944, pp. 86, 88, 106.

441. Jean, Marcel, and Mezei, Arpad. *Histoire de la peinture surréaliste.* Paris: Editions de Seuil, 1959.

442. ———. *The History of Surrealist Painting.* Trans. Simon Watson Taylor. New York: Grove Press, 1960.

443. Johnson, Ellen H. *Modern Art and the Object: A Century of Changing Attitudes.* London: Thames & Hudson, 1976.

444. Levy, Julien. *Memoir of an Art Gallery.* New York: Putnam, 1977. Review: *157*.

445. ———. *Surrealism.* New York: Black Sun Press, 1936.

446. *Modern Artists in America.* 1st Series. Ed. Robert Motherwell and Ad Reinhardt; photography by Aaron Siskind; documentation by Bernard Karpel. New York: Wittenborn, Schultz, 1951.

447. O'Doherty, Brian. *American Masters: The Voice and the Myth.* New York: Random House, 1974, pp. 254–83.

448. Rose, Barbara. *American Art since 1900.* Rev. ed. New York: Praeger, 1975, pp. 178, 265–66.

449. Rosenberg, Harold. *The Anxious Object: Art Today and Its Audience.* New York: Horizon, 1964, p. 64.

450. ———. *Artworks and Packages.* New York: Horizon Press, 1969.

451. Rubin, William S. *Dada and Surrealist Art.* New York: Abrams, 1969, pp. 266, 468.

452. Windham, Donald. *Tanaquil.* New York: Popular Library, 1972, Fiction. The character of William Dickinson is based upon Cornell.

A DOSSIER
FOR JOSEPH CORNELL

Hans Christian Andersen, Apollinaire, Aristotle, Ashbery, Austen, Ayer, Baedeker, Balzac, Barzun, Beckett, Walter Benjamin, Berdyaev, Bergson, Bernardin de Saint-Pierre, Aloysius Bertrand, Bible, Borges, Elizabeth Bowen, Breton, Brisset, Emily Brontë, Elizabeth Barrett Browning, Robert Browning, Byron, Camus, Lewis Carroll, Carson McCullers, André Chastel, René Clair, Cocteau, Coleridge, Colette, e.e. cummings, Dante, De Quincey, Walter de la Mare, Descartes, Desnos, Emily Dickinson, Isak Dinesen, Donne, Dostoyevsky, Mary Baker Eddy, Einstein, Eisley, T. S. Eliot, Eluard, Camille Flammarion, Charles Henri Ford, Foucault, Freud, Théophile Gautier, Gênet, Jean Giono, Giraudoux, Goethe, Gogol, Graves, Heidegger, Heine, Hemingway, Hesse, Hölderlin, Huneker, Ionesco, Max Jacob, Henry James, Jarry, Ben Jonson, Joyce, Jung, Keats, Kepler, Kierkegaard, Koestler, Lautréamont, Maeterlinck, Mallarmé, Herbert Marcuse, Mauriac, Mérimée, Marianne Moore, Robert Nathan, Gérard de Nerval, Anaïs Nin, Novalis, Frank O'Hara, Montagu O'Reilly, Paracelsus, Pascal, Octavio Paz, Max Planck, Elise Polko, Katherine Anne Porter, Beatrix Potter, Pound, Racine, Radiguet, Rilke, Rimbaud, Robbe-Grillet, Ronsard, Raymond Roussel, St. Exupéry, J. D. Salinger, Sartre, Schiller, Shakespeare, Shelley, Edith Sitwell, Susan Sontag, Spender, Jean Stafford, Gertrude Stein, Stendhal, Supervielle, Teilhard de Chardin, Valéry, Carl Van Vechten, Jules Verne, Eudora Welty, Glenway Wescott, Edith Wharton, E. B. White, Walt Whitman, Oscar Wilde, Tennessee Williams, William Carlos Williams, Nathaniel Parker Willis, Edmund Wilson, Donald Windham, Thomas Wolfe, Virginia Woolf, Wordsworth.

"Study to be quiet."
Izaak Walton, *The Compleat Angler*

1

2

3

4

5

6

7

8

9

10

11

12

13

Albers, Diane Arbus, Arp, Atget, Atkinson, Giovanni Bellini, Hans Bellmer, Eugene Berman, Ralph Blakelock, Peter Blume, Bonnard, Bontecou, Bosch, Botticelli, Brancusi, Bronzino, Alexander Brook, Canaletto, Caravaggio, Cartier-Bresson, Cézanne, Chagall, Petrus Christus, Corot, Carlo Crivelli, Currier & Ives, Dali, de Chirico, de Kooning, Delacroix, Demuth, Derain, Dorazio, Dosso Dossi, Duchamp, Dürer, Eakins, Ernst, Frankenthaler, the Futurists, Gainsborough, Gauguin, Giotto, Glackens, Gorky, Goya, Gozzoli, Juan Gris, Haberle, Hartley, Robert Henri, Hiroshige, Hopper, Friedrich Hundertwasser, Indiana, Ingres, Jasper Johns, Ray Johnson, Kandinsky, Kitaj, Klee, Lipchitz, Leonardo, Lotto, George Platt Lynes, Magritte, Maillol, Manet, Man Ray, Marisol, Master of the St. Lucy Legend, Matisse, Matta, Memling, Duane Michals, Lee Miller, Miró, Joan Mitchell, Modigliani, Mondrian, Morandi, Motherwell, Namuth, Barnett Newman, Noguchi, Parmigianino, Pascin, Picasso, Pinturicchio, Pollock, Fairfield Porter, Redon, Renoir, Rodin, Rosenquist, Dante Gabriel Rossetti, Rothko, Rousseau, Ruisdael, Rachel Ruysch, Carolee Schneeman, Schwitters, Seurat, Sylvia Sleigh, Moses Soyer, Raphael Soyer, Frank Stella, Stieglitz, the Sung Dynasty, Tchelitchew, Dorothea Tanning, Tiepolo, Tintoretto, Tobey, Twombly, Uccello, Laurence Vail, van Eyck, van Gogh, Velásquez, Vermeer, Vuillard, Watteau, Warhol, Frank Lloyd Wright.

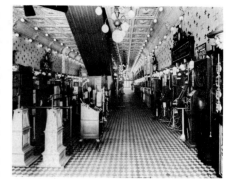

16

14

15

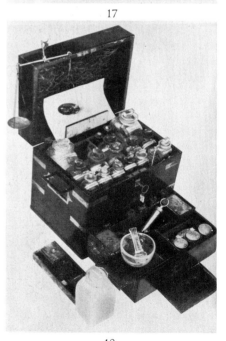

17

18

280

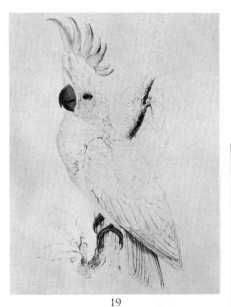

19

20

21

Albeniz, Bach, Bartok, Beethoven, Bellini, Berlioz, Brel, Bruckner, Chabrier, Charpentier, Chausson, Chopin, Copland, Couperin, Debussy, Dukas, Fauré, Haydn, Honegger, Lanner, Liszt, Mahler, Mendelssohn, Milhaud, Mozart, Offenbach, Pergolesi, Poulenc, Prokofieff, Rachmaninoff, Ravel, Rossini, Satie, Scarlatti, Schubert, Schumann, Scriabin, Stravinsky, Virgil Thomson, Vivaldi, Wagner, Webern.

22

23

JOSEPH CORNELL

Into a sweeping meticulously-detailed disaster the violet light pours. It's not a sky, it's a room. And in the open field a glass of absinthe is fluttering its song of India. Prairie Winds circle mosques.

You are always a little too young to understand. He is bored with his sense of the past, the artist. Out of the prescient rock in his heart he has spread a land without flowers of near distances.

—Frank O'Hara

24

25

26

27

281

LIST OF ILLUSTRATIONS

Compiled by Monique Beudert

In this listing, dates enclosed in parentheses do not appear on the works themselves and have been assigned based on dated works, previously published information, and Cornell's diary notes. Titles are given only where inscribed by the artist on the works themselves. Descriptions enclosed in parentheses indicate a commonly referred to title or type. The contents and structure of some sixty boxes are recorded in detail in order to give an idea of the materials and methods Cornell used. Unless otherwise described, all boxes in these descriptions are made of wood and have clear glass fronts. Dimensions are in inches and centimeters, height preceding width preceding depth. Sizes for the collages do not include frame dimensions, nor are frames included in the reproductions of the collages. A debt of gratitude is owed to Diane Waldman and to Lynda Roscoe Hartigan for sharing unpublished information, and to the Pasadena Art Museum (bibl. 252) and Sandra Leonard Starr (bibl. 273) for their previously published information.

I. Untitled (Soap Bubble Set). (1936). Brown box with recessed metal handle on each side and removable glass front. Interior lined with pale blue fabric held in place by blue thumbtacks, rear wall partially lined with French map headed *CARTE GEO-GRAPHIQUE DE LA LUNE.* Interior divided into 7 compartments by 6 sheets of glass painted white on outside edges and held in place by metal pins. Upper compartment: 4 hanging cylindrical wood blocks painted white with reproductions adhered to blocks on each end; left compartment: cordial glass holding egg painted blue with gold highlights; right compartment: small blue and gold child's head attached to wood block; center compartment: clay pipe, flanked by 2 white wood elements attached to rear wall, resting on glass shelf, below which are 3 glass discs, each in its own compartment. 15¾ x 14¼ x 5⁷⁄₁₆ in. (40 x 36.2 x 13.8 cm.). Wadsworth Atheneum, Hartford, Connecticut, The Henry and Walter Keney Fund.

II. *Tilly Losch.* (c. 1935). Construction, 10 x 9¼ x 2⅛ in. (25.4 x 23.5 x 5.4 cm.). Collection Mr. and Mrs. E. A. Bergman, Chicago. N.B.: Tilly Losch was a Viennese dancer and actress who was at one time married to Edward James, the well-known collector of Surrealist art.

III. *Object* (Abeilles). 1940. Box construction with cork-veneered outer sides, blue border around glass front; back of interior lined with steel engraving of a seaside town, studded with rhinestones. Contains steel engraving of figures in flight on a country road with center portion cut away; engraving mounted on a vertical sheet of blue glass set in front of back liner. Series of cutout printed words *les abeilles ont attaqué le bleu céleste pâle* mounted on vertical sheet of clear glass set in front of blue glass. Signed. 9⅛ x 14⅛ x 3⁷⁄₁₆ in. (23.2 x 35.9 x 8.7 cm.). Collection Mr. and Mrs. Frederick Weisman, Beverly Hills, California.

IV. *Défense d'Afficher Object.* 1939. Black box constuction, painted brown border around glass front, interior lined in black velvet. Contains 5 truncated pastel cardboard cones attached to back near floor; yellowed photograph with figure of posing dancer cut away (*Défense d'Afficher* painted on glass mount within silhouette left by cutout); cutout of posing dancer, suspended from back, which appears to be dancing on cones. Verso inscribed *Annie St. Stel, dancer/Ca. 1885.†* Signed. 8¹⁵⁄₁₆ x 13¹⁵⁄₁₆ x 2⅛ in. (22.7 x 35.4 x 5.4 cm.). Collection Denise and Andrew Saul.

V. *L'Egypte de Mlle Cléo de Mérode.* 1940. Hinged casket; lid lined with marbleized paper, cutouts of printed phrases *L'EGYPTE/de Mlle de Cléo de Mérode/COURS ELEMENTAIRE/D'HISTOIRE NATURELLE* and picture of seated Egyptian female; box divided by sheet of glass into 2 horizontal levels. Contents of sealed lower level: loose red sand, doll's forearm, wood ball, German coin, several glass and mirror fragments. Contents of upper level: 12 removable cork-stopped bottles (tops of corks covered with marbleized paper, most bottles labeled with cutout printed words), in 4 rows of 3 set in holes in sheet of wood covered with marbleized paper; strips of glass forming 2 rows of glass-covered compartments (3 each) at sides of bottles. Contents of each bottle (and labels): (1) cutout sphinx head, loose red sand; (2) numerous short yellow filaments with glitter adhered to one end (*Gameh, Kontah/Blé* [*Triticum sativum, Linn.*]); (3) 2 intertwined paper spirals (*Les reptiles des illes du Nile*); (4) cutout of woman's head (*CLEO DE MERODE/momie/sphinx*); (5) cutout of camels and men, loose yellow sand, ball (*sauterelles*); (6) pearl beads (*météorologique/chutes de grêles de Cléopâtre*); (7) glass tube with bulge in center, residue of dried green liquid (*Nileomètre*); (8) crumpled tulle, rhinestones, pearl beads, sequins, metal chain, metal, and glass fragments (*Les Mille et une Nuits*); (9) red paint, shell or bone fragments (*Temps fabuleux/fossiles végétaux*); (10) threaded needle pierced through red wood disc labeled *Cleopatra's Needle (colonnes tournoyantes)*; (11) bone and frosted-glass fragments (*Pétrifications animales/albâtre de Cléopâtre*); (12) blue celluloid liner, clear glass crystals (*cadeau d'émeraudes de Cléo de Mérode*). Contents of each glass-covered compartment (and labels): LEFT (1) 7 balls (*Préambule*), (2) rock specimen (*géologique pharonique*), (3) plastic disc; RIGHT (4) plastic rose petals (*Rosée à feuilles de rose*), (5) empty, (6) 3 miniature tin spoons. Cléo de Mérode was a famous courtesan and ballerina in the 1890 s. Signed. 4¹¹⁄₁₆ x 10¹¹⁄₁₆ x 7¼ in. (11.9 x 27.1 x 18.4 cm.). Collection Richard L. Feigen, New York.

VI. Untitled (Pharmacy). 1943. Construction, 15¼ x 12 x 3⅛ in. (37.7 x 30.5 x 7.9 cm.). Collection Mrs. Marcel Duchamp, Paris.

VII. Untitled (Pink Palace). (c. 1946–48). Construction, 10 x 16⁷⁄₁₆ x 3¾ in. (25.4 x 41.8 x 9.5 cm.). Private collection, New York.

VIII. Untitled (Bébé Marie). (Early 1940s). Construction, 23⅜ x 12⁵⁄₁₆ x 5¼ in. (59.4 x 31.3 x 13.3 cm.). The Museum of Modern Art, New York, Purchase.

IX. Untitled (Paul and Virginia). (c. 1946–48). Box construction with hinged door (mirror on exterior, see pl. 108) and latch closing, covered with collage fragments of book pages in English and illustrations on the theme of Paul and Virginia (cf. *Paul et Virginie,* a romance by Bernardin de Saint-Pierre, Paris, 1788). Central section glass sealed and masked; eggs and nesting material are visible through center opening.

Three framing compartments contain 16 small empty boxes. Top compartment sealed with deep-turquoise glass striated with wire fragments, behind which appear aquatic forms and shells. Signed. 12½ x 9¹⁵⁄₁₆ x 4⅜ in. (31.8 x 25.2 x 11.1 cm.). Collection Mr. and Mrs. E. A. Bergman, Chicago.

X. Untitled (Penny Arcade Portrait of Lauren Bacall). (1945–46) Brown box construction, latched at right, with blue-glass front. Interior contains Masonite panel partially stained blue, with circular openings and divided into compartments. Seven circular openings across top are covered with glass, their circumferences mirrored; below these is horizontal opening containing 5 postcard views of New York behind blue-glass panes; beneath that 5 circular openings behind which 2 parallel threads coil around 5 small gears. Compartment in center frames recessed black-and-white photograph of Lauren Bacall and 2 glass runways behind blue-glass pane bisected vertically by line of blue paint. Center compartment flanked by 2 vertical compartments, each containing 12 columns of 8 wood cubes painted blue or faced with reproductions of details of childhood photographs of Bacall. Below central compartment are 3 small compartments containing mirror in central compartment and reproductions of details of photographs of Bacall in left and right compartments, all behind blue-glass pane. Small red wood ball passes through interior by series of concealed glass runways, drops into mirrored compartment across bottom of box, and exits through hinged door at bottom right side. 20½ x 16 x 3½ in. (52 x 40.6 x 8.9 cm.). Collection Mr. and Mrs. E. A. Bergman, Chicago.

XI. Untitled (Medici Princess). (c. 1948). Blue box construction with lower compartment housing a drawer. Interior partly lined with maps and divided into 4 sections by 2 map-covered vertical projections and a horizontal glass shelf, painted blue on face, under which rest 8 wood blocks covered with illustrations. Central vertical compartment contains reproduction of detail of Agnolo Bronzino portrait of Bia di Cosimo de' Medici (Uffizi, Florence) par-

tially mounted on panel attached to rear wall and partially affixed to rear wall, to which have been added touches of blue paint. Central compartment sealed by clear glass painted with vertical blue line intersected by 4 horizontal blue lines and containing orange wood ball resting on map-covered shelf, mirrors, and wood block covered with map. Two side compartments faced with clear glass panes, each painted in blue at top to frame metal spiral, with 2 vertical lines and one thin horizontal line at bottom. Side compartments contain 25 loose wood blocks covered with details of portrait of Bia and of Bernardo Pinturicchio's A Boy (Gemäldegalerie, Dresden), stars, numerals, foil, and Baedeker maps; 3 metal jacks; cork ball; red marble; and small red wood dowel. Drawer, lined with Baedeker maps, contains purple feather; pink-and-silver foil ball; fan covered with map and foil, tied with blue thread; wood block covered with maps and seal of clock face; and packet of map details, tied with orange thread. 17⅜ x 11⅛ x 4⅜ in. (44.8 x 28.3 x 11.1 cm.). Private collection.

XII. Untitled (Medici Prince). (c. 1952). Construction, 15½ x 11½ x 5 in. (39.4 x 29.2 x 12.7 cm.). Collection Mr. and Mrs. Joseph R. Shapiro, Oak Park, Illinois.

XIII. Untitled (Medici Boy). 1942–52. Brown box construction with hinged door and latch closing. Interior compartments sealed with amber glass. Central section contains reproduction of Bernardo Pinturicchio's A Boy (Gemäldegalerie, Dresden), with image repeated in miniature in 2 side sections. Lower compartment mirrored on rear wall, divided into 3 by 2 glass panes; contains 2 blocks covered with collage and metal spiral. Inner sides and bottom of box covered with Baedeker map sections of Venice. Signed. 13¹⁵⁄₁₆ x 11³⁄₁₆ x 3⅞ in. (35.4 x 28.4 x 9.8 cm.). Estate of Joseph Cornell, Courtesy Castelli Feigen Corcoran.

XIV. Untitled (Hotel du Cygne). (c. 1952–55). Construction, 19³⁄₁₆ x 12¾ x 4½ in. (48.7 x 32.4 x 11.4 cm.). Castelli Feigen Corcoran.

XV. Untitled (Apollinaris). (c. 1954). Construction, 15¹⁵⁄₁₆ x 9¾ x 4⅜ in. (40.5 x 24.8 x 11.1 cm.). Collection Mr. and Mrs. E. A. Bergman, Chicago.

XVI. Untitled (Solar Set). (c. 1956–58). Yellow box construction. Glass-fronted upper compartment: back and sides covered with various charts, diagrams, and tables relating to solar system; top and floor covered with sections of maps. Contains 4 metal rings, 2 wood cylindrical blocks (one with diagram of planets adhered, other with diagram of sun) hanging from horizontal metal rod near top; row of 5 cordial glasses recessed in floor and each containing glass marble; cork ball resting on floor. Lower compartment lined with charts relating to the sun and housing drawer. Exterior of yellow drawer covered with pages from Latin book; white interior sealed with glass top. Contents of drawer: loose yellow sand, 5 metal balls, coin, wood fragment, shell. Verso, pages from French book headed DAVID. Signed. 11½ x 16¼ x 3⅝ in. (29.2 x 41.3 x 9.2 cm.). Collection Donald Karshan, New York.

XVII. Object (Roses des Vents). 1942–53. Brown hinged box construction with wood lid divided into 3 latched parts, interior of lid lined with German maps of the Coral Sea and the Great Australian Bight. Interior divided into upper and lower areas by removable wood panel, its bottom surfaced with plexiglass on which rest 21 compasses, fitted into holes (3 rows of 7) pierced through panel. Lower area divided by corrugated cardboard and wood strips into 17 compartments of unequal size, which contain maps, spirals, marbles, plaster chips, spring, seeds, shells, glass balls, beetle, sequins, torn paper, pins, paper fish, constellation diagrams, etc. Five compartments are covered in clear, green, yellow, or blue glass; some are painted or lined with paper. When panel is in place individual compasses can be removed, allowing view into compartment below hole in panel. Rose des vents is French term for compass dial. Signed. 2⅝ x 21¼ x 10⅜ in. (6.7 x 54 x 26.4 cm.). The Museum of Modern Art, New York, Mr. and Mrs. Gerald Murphy Fund.

XVIII, XIX. Cassiopeia #1. (c. 1960). Green box construction with blue beaded frame, white interior. Rear wall partially covered with cutout illustration of star, Tycho's Nova; cutout illustrations of Taurus and Orion

constellations from Golden Guide; and series of blue-and-white pencil lines. Contains white cork ball balanced on 2 metal rods; mirror on upper left side wall; Golden Guide cutout on upper-right side wall; white wood fragments; white pipe bowl resting on white wooden block; and blue sand. Verso, Latin text papers headed *T. LUCRETII* stained green; paper cutouts of red, blue, and white constellation diagrams; Golden Guide cutouts; fragment of numerical table; and reproduction of figurine. Signed. 9⅞ x 14⅞ x 3¾ in. (25.1 x 37.8 x 9.5 cm.). Estate of Joseph Cornell, Courtesy Castelli Feigen Corcoran.

XX. Untitled. 1942. Construction, 13⅛ x 10 x 3½ in. (33.3 x 25.4 x 8.9 cm.). Private collection, New York.

XXI. Untitled (Grand Owl Habitat). (c. 1946). Brown box construction. Central section contains cutout paper owl mounted on wood, perched on bark fragment with fungi, surrounded by 30 compartments, divided by wooden strips covered with sawdust and cobwebs, each containing dried leaf. 24 x 13⅛ x 4¹³⁄₁₆ in. (61 x 33.3 x 12.2 cm.). Collection Mr. and Mrs. Richard L. Kaplin, Toledo, Ohio.

XXII. Untitled (The Hotel Eden). c. 1945. Brown box construction. Interior partially lined with paper, painted white, divided into 3 areas by white wood strips. Contains yellow wood ball resting on white wood dowels; spiral-painted paperboard cutout and metal spiral behind wood-framed glass window painted with spiral; cutout of parrot, mounted on wood, resting on wood branch; cord passing from bottom of box through parrot's beak to cutout spiral; music box enclosed in wood on which sits inverted glass bottle with newspaper stopper containing 12 white cylindrical wood blocks; 3 loose cylindrical wood blocks; white dowel placed at angle below parrot; and 3 printed labels affixed to back of box, including advertisement for Hotel Eden, which is spattered with white paint. Signed. 15⅛ x 15¾ x 4¾ in. (38.4 x 40 x 12.1 cm.). National Gallery of Canada, Ottawa.

XXIII. *Habitat Group for a Shooting Gallery.* 1943. Hinged cabinet construction with a pane of shattered glass set between 2 intact panes behind glass front; splatters of red, yellow, and blue paint on white interior. Contains suspended individual colored cutouts of 2 macaws, a parrot, and a cockatoo (splatter of red paint on head of parrot directly behind center hole in shattered glass) with cutout printed numbers adhered to each; printed seals, papers, and cards affixed to walls; bits of paper and red, yellow, and blue feathers rest on floor; bouquet of dried weeds attached to right side; clump of torn newspapers attached to top. Signed. 15½ x 11⅛ x 4¼ in. (39.4 x 28.3 x 10.8 cm.). Des Moines Art Center, Coffin Fine Arts Trust Fund.

XXIV. *A Parrot for Juan Gris.* Winter 1953–54. Construction, 17¾ x 12³⁄₁₆ x 4⅝ in. (45 x 31 x 11.7 cm.). Collection Paul Simon.

XXV. *Grand Hotel Semiramis.* 1950. Construction, 18 x 11⅞ x 4 in. (45.7 x 30.2 x 10.2 cm.). Private collection, New York.

XXVI. Untitled (Cockatoo and Corks). (c. 1948). Hinged cabinet construction with door latched at right. Interior divided into 4 compartments. Upper compartment, painted white and sealed by clear glass pane, contains paper cutout of white cockatoo mounted on wood and attached to branch fragment; pink thread running through beak of cockatoo to bottom of small compartment holding corks and fronted by glass pane painted with 2 intersecting white lines; 2 loose corks; feeding dish, made up of wood fragments, which holds a red wood ball; and structure made up of flat wood piece and 2 cylindrical pieces, one covered with French text painted white and passing through to empty section of lower right compartment, which is defined by horizontal glass shelf with white paint on front edge. Below this is another section, defined by similar piece of glass, holding 3 corks. Both areas sealed by glass. Small green cardboard box edged in pink with French text on top rests in bottom section and holds a small piece of glass below which is blue wood block with star collaged on it. Three similar boxes are in 3 sections of lower right compartment defined by 2 horizontal glass shelves. Interior of top box is lined with sawdust and contains cork; middle box holds small piece of glass, below which is wooden block with star collaged on it; and bottom box holds small piece of glass below which is wood fragment. Center compartment houses working music box. 14⅜ x 13½ x 5⅝ in. (36.5 x 34.3 x 14.3 cm.). Private collection.

XXVII. *Toward the "Blue Peninsula."* 1951–52. Construction, 10⅝ x 14¹⁵⁄₁₆ x 3¹⁵⁄₁₆ in. (27 x 37.9 x 10 cm.). Collection Daniel Varenne, Geneva.

XXVIII. Untitled (Vierge Vivace). 1970. Collage, 14 x 12¹⁄₁₆ in. (35.6 x 30.6 cm.). Estate of Joseph Cornell, Courtesy Castelli Feigen Corcoran.

XXIX. *The Tiara.* (c. 1966–67). Collage, 8¼ x 11¹⁵⁄₁₆ in. (21 x 30.3 cm.). Collection Mr. and Mrs. E. A. Bergman, Chicago.

XXX. Untitled (Penny Arcade with Horse). (c. 1965). Collage, 11½ x 8⅜ in. (29.2 x 21.3 cm.). Estate of Joseph Cornell, Courtesy Castelli Feigen Corcoran.

XXXI. Untitled (Early 1960s). Collage, 8⅝ x 13¾ in. (21.9 x 34.9 cm.). Estate of Joseph Cornell, Courtesy Castelli Feigen Corcoran.

XXXII. *Portrait of the Artist's Daughter by Vigée Lebrun.* (c. 1960). Collage, 10½ x 13⅜ in. (26.7 x 34 cm.). Collection Mr. and Mrs. Donald B. Straus, New York.

door, latched at right, with blue-glass front. Interior divided into 3 vertical compartments over horizontal compartment. Central vertical section contains reproduction of detail from Bronzino's portrait of Bia di Cosimo de' Medici (Uffizi, Florence) behind 2 painted glass panes, one blue, one clear. Each flanking vertical compartment has mirror at top and 2 columns of attached wood cubes faced with assorted illustrations and reproductions, including details of Bia, numerals, and animals, recessed behind 2 panes of painted clear glass. Clearglass sheet defines horizontal chamber fronted by painted clear-glass pane and lined with mirror on rear wall and details from Baedeker maps on floor and sides. Chamber contains 2 wood cubes with details of Bia, flat wood block with Baedeker map detail, and metal spiral. 14 x 11 x 3⅞ in. (35.6 x 27.9 x 9.8 cm.). Collection Mr. and Mrs. E. A. Bergman, Chicago.

119. Untitled (Medici Prince). (c. 1952–54). Construction, 15¼ x 11 x 5 in. (38.7 x 28 x 12.7 cm.). Private collection.

120. Untitled (Medici Princess). (c. 1952–54). Construction, 18½ x 11⁷⁄₁₆ x 4⁷⁄₁₆ in. (47 x 29.1 x 11.3 cm.). Gatodo Gallery, Tokyo.

121. Untitled (Medici Boy). (c. 1953). Construction, 18¼ x 11½ x 5¾ in. (46.4 x 29.2 x 14.6 cm.). The Fort Worth Art Museum, Benjamin J. Tillar Memorial Trust Fund.

122. Untitled (La Bella). 1950. Brown box construction, interior painted and stained white and pink. Contains detail of reproduction of Parmigianino's Portrait of "Antea" (Pinacoteca del Museo Nazionale, Naples) and papers stained pink pasted onto rear wall. Verso, text papers stained deep maroon. 18¾ x 12⁷⁄₁₆ x 3¼ in. (47.6 x 31.6 x 8.3 cm.). Estate of Joseph Cornell, Courtesy Castelli Feigen Corcoran.

123. Untitled (Caravaggio Boy). October 1955. Construction, 14⅜ x 10⅜ x 5¼ in. (36.5 x 26.4 x 13.3 cm.). Private collection, New York.

124, 125. Untitled (Hotel Royal des Etrangers). (c. 1952). Construction, 17¼ x 12 x 6¼ in. (43.8 x 30.5 x 15.9 cm.). Collection Diane and Paul Waldman, New York.

126. Swiss Shoot the Chutes. (Hotel de l'Ange). 1941. Construction, 21³⁄₁₆ x 13⅞ x 4⅛ in. (53.8 x 35.2 x 10.5 cm.). The Peggy Guggenheim Collection, Venice, The Solomon R. Guggenheim Foundation.

127. Untitled (Hotel de l'Etoile). 1951–52. Construction, 19½ x 11½ x 4½ in. (49.5 x 29.2 x 11.4 cm.). ACA Galleries, New York. N.B.: Central figure is Lorenzo de' Medici, detail from Benozzo Gozzoli's fresco, Journey of the Magi (1459–63), Medici Chapel, Florence.

128. Untitled (Hotel Sun Box). (c. 1956). Construction, 17³⁄₁₆ x 11¼ x 4¾ in. (43.7 x 28.6 x 12.1 cm.). Castelli Feigen Corcoran.

129. Untitled (des Voyageurs). (c. 1956). Construction, 18¼ x 10⅝ x 3⅝ in. (46.4 x 27 x 9.2 cm.). Private collection, New York.

130. Untitled (Hotel de la Pomme d'Or). (c. 1954–55). Construction, 18 x 10¹¹⁄₁₆ x 3¾ in. (45.7 x 27.1 x 9.5 cm.). Estate of Joseph Cornell, Courtesy Castelli Feigen Corcoran.

131. Parrot Music Box. (c. 1945). Construction, 16 x 8¾ x 6¹¹⁄₁₆ in. (40.6 x 22.2 x 17 cm.). The Peggy Guggenheim Collection, Venice, The Solomon R. Guggenheim Foundation.

132. Untitled (Parrot and Butterfly Habitat). (c. 1948). Construction, 19⅝ x 13⅝ x 6½ in. (49.8 x 34.6 x 16.5 cm.). Private collection, Tokyo.

133. Object. 1941. Box construction with velvet-paneled exterior sides, brass-ring grip, and paint-spattered glass front. Contains 3 paper parrot silhouettes, mounted on wood backings, paper cutout of 2 parakeets, corks, miniature fork and spoon, pine cone and bark, and dried leaf fronds. Back and sides of interior covered with collage of German book fragments, baby photo, paper clock face, etc. Column at left covered with collage of German book fragments with penny candy embedded in it. Signed. 14½ x 10½ x 3½ in. (36.8 x 26.7 x 8.9 cm.). Collection Richard L. Feigen, New York.

134. Untitled (Palais de Cristal). (c. 1953). Box construction with crackled white paint on front frame. White interior, thin layer of paint on back wall revealing wood grain. Contains cutout parrot mounted on wood, 2 metal spirals, 2 pieces of wood, 8 short dowels of varying lengths, 3 irregular pieces of mirror, and 3 labels affixed to back wall; one reads PALAIS DE CRISTAL, one is advertisement for LISANDRO TORRINI, LAMPMAKER, and third, partially obscured by white paint, is advertisement image of angel with bicycle. Verso, German text stained blue. Signed. 12¹⁵⁄₁₆ x 9¼ x 4³⁄₁₆ in.

(32.9 x 23.5 x 10.6 cm.). Collection Mr. and Mrs. Edward R. Hudson, Jr., Fort Worth, Texas.

135. The Caliph of Bagdad. (c. 1954). Amber box construction, lined with newsprint painted white. Contains screening painted white, curved wood branch, pair of parrots mounted on wood, and miniature eight-ball. Rear wall collaged with advertisements for Grand Hotel Fontaine and Grand Hotel du Vesuve, Baedeker map fragment, stamp, and photostatic copy of label for Grand Hotel BON PORT. Glass sheet separates drawer at bottom, lined with details from Baedeker maps, holding 26 assorted paper packets, some bound with multicolored threads. Verso, French text stained amber. Signed. 20⁷⁄₁₆ x 13¾ x 4½ in. (51.9 x 34.9 x 11.4 cm.). Collection Mr. and Mrs. E. A. Bergman, Chicago.

136. Untitled (for Mylene Demongeot). (c. 1954). Construction, 17 x 11 x 4½ in. (43.2 x 27.9 x 11.4 cm.). Barbara Mathes Gallery, New York, and John C. Stoller and Company, Minneapolis.

137. Untitled (Green Parrot; Hotel Voyageurs). (c. 1953). Construction, 18 x 12 x 4⅝ in. (45.7 x 30.5 x 11.7 cm.). Collection Dr. and Mrs. Joseph Gosman.

138. Untitled (Parrot Habitat). (c. 1953). Construction, 17⅛ x 11⅛ x 5 in. (43.5 x 28.3 x 12.7 cm.). Collection Tony Berlant, Santa Monica, California.

139. Untitled (Chocolat Menier). (1952). Construction, 17 x 12 x 4¾ in. (43.2 x 30.5 x 12.1 cm.). Grey Art Gallery and Study Center, New York University.

140. Untitled (A Suivre). 1949. Construction, 17¼ x 12¼ x 4⅜ in. (43.8 x 31.1 x 11.1 cm.). Collection Robert Motherwell.

141. Untitled. (c. 1948–50). Blond box construction. Interior painted white, divided into 3 compartments. Contains paper cutout of cockatoo mounted on wood, 20 clock faces without hands, 3 wood forms, loose watch parts, and nonfunctioning music box in glass-paned chamber. Verso, French text stained blond. 16¼ x 17 x 4⁷⁄₁₆ in. (41.3 x 43.2 x 11.3 cm.). Collection Mr. and Mrs. E. A. Bergman, Chicago.

142. Isabelle/Dien Bien Phu. (1954). Yellow box construction with amber front and pane of shattered glass set between 2 intact panes. Interior covered with cracked and peeling layer of thin wood painted white over lower layer painted yellow; rear wall spattered with red paint. Contains paper cutout of white

cockatoo with orange crest mounted on wood attached to rear wall next to wood bowl partially painted white; mirror fragments on left side wall and upper-right corner; and white wood arch upper-left corner. Verso, German map of Asia and East Indian Ocean collaged with portion of newspaper article: *A hard core band of 2,000 Foreign Legionnaires chose to go/ down fighting for the glory of France in a suicidal attack on/ the Communist captors of Dien Bien Phu./ The French High Command at Hanoi said the Legionnaire[s]/ under the command of Col. André Lalande at outpost "Isabell[e"]/preferred a fight to the end than to surrender./ A Communist Radio Peking broadcast heard in Tokyo said/ the Communist Indochinese conquerors of Dien Bien Phu h[ad]/ "annihilated" the Legionnaires hours after the main fortress [had] fallen.* Signed. 18 x 12 x 6 in. (45.7 x 30.5 x 15.2 cm.). ACA Galleries, New York.

143. Untitled. (1950–52). Construction, 20 x 12 x 4 in. (50.8 x 30.5 x 10.2 cm.). Collection Allan Stone, New York.

144. Untitled (Juan Gris). c. 1953–54. Box construction with crackled white paint on front frame. White interior, partially collaged with pages from French encyclopedia of French history and advertisements for Hotel des Etrangères, Rapallo, Pension Pendini, Florence, and Palace Hotel, Perugia, among others. Cutout of white cockatoo mounted on wood and attached to center of rear wall above curved wooden perch. Behind it is collage of wood-grained paper, black construction paper, magazine reproduction of blue sky with clouds, and reproduction of newspaper title, *BULLETIN DES TRIBUNAUX*. Blue pencil shading and yellow and orange pencil lines are drawn on rear wall. Contains yellow plastic bracelet on metal rod across top of box and white perforated plastic ball. Verso, French text *(Cours de Littérature)*. Signed. 18½ x 12½ x 4¾ in. (47 x 31.8 x 12.1 cm.). Philadelphia Museum of Art, John D. McIlhenny Fund.

145. *Le Déjeuner de Kakatoes pour Juan Gris (Juan Gris Cockatoo Series)*. (c. 1953–55). Light-blue box construction, interior lined with French text pages with bottom painted blue. Pages on rear wall partly stained yellow and marked with several blue pencil lines; strip of paper painted white borders bottom, and photostat of label reading *de l'Etoile* borders top. Collaged on rear wall are partial silhouette of cockatoo in black

paper; irregular paper strips stained blue intersecting at right angles, and details of Juan Gris's *Breakfast* (1914; The Museum of Modern Art, New York). Contains wood strips painted blue, translucent pink plastic bracelet on metal rod across top of box, 2 wood blocks, orange rubber ball, cracked mirror and mirror fragments. Verso, covered with paper stained blue, on which is pasted reproduction of white cockatoo stained blue and mounted on circular paper cutout, stained and outlined in blue. Signed. 19⅝ x 12 1/16 x 4⅜ in. (49.8 x 30.6 x 11.1 cm.). Collection Mr. and Mrs. E. A. Bergman, Chicago.

146. Untitled (Hotel Beau-Séjour). (c. 1954). Blond box with sides and rear wall collaged with stamps, labels and reproductions of labels, hotel advertisements and reproductions of hotel advertisements, illustrations, and floral-patterned paper embellished with pink, yellow, and blue pastel. Sides are partly mirrored. Contains metal rod with metal ring, paper cutout of cockatoo mounted on wood, wood branch, piece of wood, and cork ball. Drawer at bottom, separated by sheet of glass and lined with floral-patterned paper on bottom and back and with maps on sides, contains 3 sheets of floral-patterned paper. When drawer is pulled out, map of Pacific Ocean is visible on bottom of box. Verso, text pages stained yellow and blue. Signed. 17¾ x 12¼ x 4½ in. (45.1 x 31.1 x 11.4 cm.). The Museum of Modern Art, New York, Promised Gift of an Anonymous Donor.

147. Untitled (Hotel Neptun). (c. 1953–55). Construction, 19½ x 12¼ x 4 in. (49.5 x 31.1 x 10.2 cm.). Estate of Joseph Cornell, Courtesy Castelli Feigen Corcoran.

148. Untitled (Parrot Collage; Grand Hotel de la Pomme d'Or). (c. 1954–55). Construction, 18 15/16 x 10 11/16 x 3 3/16 in. (48.1 x 27.1 x 8.1 cm.). Castelli Feigen Corcoran.

149. Untitled (Cutout Cockatoo). (c. 1954–55). Construction, 16¾ x 11 x 4 5/16 in. (42.5 x 27.9 x 11 cm.). Private collection, New York.

150. Untitled. (c. 1950–54). Construction, 18⅞ x 12 9/16 x 6¼ in. (47.9 x 31.9 x 15.9 cm.). Estate of Joseph Cornell, Courtesy Castelli Feigen Corcoran.

151. Untitled. (c. 1948). Construction, 21⅛ x 15 x 6 5/16 in. (53.7 x 38.1 x 16 cm.). Collection Mr. and Mrs. E. A. Bergman, Chicago.

152. Untitled (Weather Prophet). (c. 1954). Construction, 18 x 10½ x 4½ in. (45.7 x 26.7 x 11.4 cm.). Collection Arno Schefler, New York.

153. Untitled (Hotel Bellagio). (c. 1949–50). Construction, 6⅝ x 4½ x 2⅛ in. (16.8 x 11.4 x 5.4 cm.). Collection Daniel Varenne, Geneva.

154. Untitled. (c. 1948). Construction, 12 3/16 x 10 1/16 x 5½ in. (31 x 25.6 x 14 cm.). Collection Mr. and Mrs. E. A. Bergman, Chicago.

155. Untitled (Yellow Bird). 1950. Construction, 9 x 5¾ x 3½ in. (22.9 x 14.6 x 8.9 cm.). Private collection, U.S.A.

156. Untitled. 1948–49. Brown box construction, interior lined with fiberboard covered with sawdust, with ledge of same material across bottom. Contains pieces of wood, fungus, bark, twig, 5 dried leaves, and paper cutout of bird mounted on wood. Signed. 19 x 12⅜ x 3½ in. (48.3 x 31.4 x 8.9 cm.). Estate of Joseph Cornell, Courtesy Castelli Feigen Corcoran.

157. Untitled. 1949. Construction, 14¾ x 10 5/16 x 5 3/16 in. (37.5 x 26.2 x 13.2 cm.). Private collection, New York.

158. Untitled. 1943. Construction, 12 9/16 x 11½ x 2¾ in. (31.9 x 29.2 x 7 cm.). Kaiser Wilhelm Museum, Krefeld, Germany, Sammlung Helga und Walter Lauffs.

159. Untitled (Woodpecker Habitat). 1946. Black box construction with brown frame. Top, bottom, and rear wall of interior lined with sawdust; side walls partially stained blue. Contains 3 paper cutouts of woodpeckers (two adult, one immature) mounted on wood; pieces of wood, some spattered with white and blue paint; 4 paper targets mounted on wood; and French mustard label. Right side wall has 4 stamps of woman with laurel, partially stained blue. Verso, paper stained black. Signed. 13⅝ x 9⅛ x 3 in. (34.6 x 23.2 x 7.6 cm.). Collection Mr. and Mrs. E. A. Bergman, Chicago.

160. Untitled (Butterfly Habitat). c. 1940. Dark-brown box construction containing 6 compartments, each covered with frosted glass, divided by wood strips. Through circular unfrosted apertures in each compartment appear cutout paper butterflies hanging from strings and with strings hanging below. Also contains plaster chips, small wood fragments. Signed. 12 x 9 3/16 x 3 3/16 in. (30.5 x 23.3 x 8.1 cm.). Collection Mr. and Mrs. E. A. Bergman, Chicago.

161. Untitled (American Rabbit). 1945–46. Russet-brown box construction

Private collection, New York.

189. Untitled (Sand Box). (c. 1952). Flat amber box construction with glass pane painted with 2 blue lines intersecting in center, stained blue and amber along edges, and sealed with amber-stained plastic wood. Cracked white interior. Contains yellow sand, small starfish, 2 metal ball bearings, metal spiral, and 2 metal arcs. Signed. 1⅛ x 14⁷⁄₁₆ x 7¼ in. (2.9 x 36.7 x 18.4 cm.). Estate of Joseph Cornell, Courtesy Castelli Feigen Corcoran.

190. Untitled (Sand Box). (c. 1950). Construction, 2⅜ x 12⅞ x 7½ in. (6 x 32.7 x 19.1 cm.). Estate of Joseph Cornell, Courtesy Castelli Feigen Corcoran.

191. Untitled (Sand Box). (c. 1956–58). Construction, 1½ x 8⅞ x 15⅝ in. (3.8 x 22.5 x 39.7 cm.). Collection Julianne Kemper.

192. Untitled (Sand Box). (c. 1946–48). Construction, 3 x 3½ x 10¹³⁄₁₆ in. (7.6 x 8.9 x 27.5 cm.). Private collection, New York.

193. Untitled (Sand Fountain). (c. 1956). Light-green box construction; white interior, thin layer of paint revealing wood grain. Contains dark green sand; piece of cork; wooden disk attached to rear wall with shell attached below; broken wine glass embedded in floor. Fountain is fed when construction is turned, causing sand to flow through opening at upper right into hidden compartment, through spout behind shell into glass, over glass onto floor. Verso, French text pages stained green. Signed. 11¹⁄₁₆ x 7⅞ x 3¹⁵⁄₁₆ in. (28.1 x 20 x 10 cm.). Estate of Joseph Cornell, Courtesy Castelli Feigen Corcoran.

194. Untitled (Sand Fountain). 1954. Construction, 12¹⁄₁₆ x 7¹⁄₁₆ x 4 in. (30.6 x 19.5 x 10.2 cm.) Private collection, New York.

195. Untitled (Sand Fountain). 1957. Construction, 14¼ x 7¼ x 4¾ in. (36.2 x 18.4 x 12.1 cm.). Collection Rhett and Robert Delford Brown, New York.

196. Untitled (Sand Fountain). (c. 1959). Construction, 14¼ x 7¹⁵⁄₁₆ x 4¹⁄₁₆ in. (36.2 x 20.2 x 10.3 cm.). Estate of Joseph Cornell, Courtesy Castelli Feigen Corcoran.

197. *Trade Winds #2.* (c. 1956–58). Blue box construction, lower compartment housing drawer. Glass-fronted upper compartment: back and sides painted white, top and floor, blue; map of world diagraming wind currents adhered to back; sections of maps of Pacific Ocean adhered to sides. Contains 2 metal rings hanging from horizontal metal rod near top; 2 cordial glasses, each containing glass marble, fitted at left and right into piece of blue wood attached to floor; 8 straight pins stuck into blue wood fragment attached to floor, center; 2 cork balls resting on floor. Blue drawer with white interior sealed with glass top; bottom collaged with 6 postage stamps from Italy, Belgian Congo, Nicaragua, Libya, Ecuador, and Spain. Contents of drawer: loose blue sand, metal watch parts, metal balls, and shells. Signed. 11 x 16¹³⁄₁₆ x 4¹⁄₁₆ in. (27.9 x 42.7 x 10.3 cm.). Collection Edwin Janss.

198. *Object (Roses des Vents)*, pl. XVII, with compass tray in place.

199, 200. Untitled (for Trista). (c. 1969). Construction, 13⅜ x 18 x 4½ in. (34 x 45.7 x 11.4 cm.). Collection Mr. and Mrs. E. A. Bergman, Chicago. N.B.: This box was made for Trista Stern, daughter of ballerina Allegra Kent.

201. Untitled (Suite de la longitude). (c. 1957). Construction, 13⅛ x 19¾ x 4⅜ in. (33.3 x 50.2 x 11.1 cm.). The Hirshhorn Museum and Sculpture Garden, Smithsonian Institution, Washington, D.C.

202. *An Analemma, Shewing by Inspection the Time of Sun Rising and Sun Setting, the Length of Days and Nights.* 1948–50. Blond box construction containing solar diagram with target center on rear wall and solar tables on inside walls. Four white wood cylindrical blocks collaged with illustrations of (from left to right) pink sand dollar, yellow biomorphic form, Sirius constellation, and yellow fern fossil hang from top. Two side compartments each contain large cork ball at top suspended on weighted length of blue cord (cork at left and coin at right); empty wooden drawer, sides collaged with solar tables; and cordial glass, one at right containing yellow rubber ball. Bottom painted white. Signed. 15½ x 20¼ x 4 in. (39.4 x 51.4 x 10.2 cm.). Estate of Joseph Cornell, Courtesy Castelli Feigen Corcoran.

203. Untitled (Phases de la lune). (c. 1957–59). Construction, 12¼ x 18 x 4¾ in. (31.1 x 45.7 x 12.1 cm.). Allen Memorial Art Museum, Oberlin College, Ohio, R. T. Miller Jr., Ruth C. Rousch, and Special Acquisitions Funds.

204. *Elementos de Cosmographia.* (c. 1956–58). Construction, 12½ x 8¹⁵⁄₁₆ x 4⅜ in. (31.8 x 48.1 x 11.7 cm.). Estate of Joseph Cornell, Courtesy Castelli Feigen Corcoran.

205. Untitled. (c. 1956–58). Construction, 12⅛ x 17 x 3⅝ in. (30.8 x 43.2 x 9.2 cm.). Collection Françoise and Harvey Rambach, New York.

206. *Sun Box.* (c. 1956). Construction, 10⅛ x 15¼ x 3⅓ in. (25.7 x 38.7 x 8.5 cm.). Collection Mr. and Mrs. Alvin S. Lane.

207. *Birth of the Nuclear Atom.* (c. 1960). Blue box construction with vertical line painted and blue glaze washed along left and right sides of glass front; white interior cracked and peeling; row of 4 cutout diagrams of atomic structures adhered across back near top. Contains white cork ball on 2 horizontal metal rods (below row of diagrams); row of 4 cordial glasses, each containing glass marble, attached to floor; row of nails driven into top and floor directly behind glass. Verso, pages from Latin book headed *T. LUCRETII.* Signed. 9¾ x 15 x 3¾ in. (24.8 x 38.1 x 9.5 cm.). Private collection, Los Angeles.

208. Untitled (Constellations zodiacales). (c. 1958). Construction, 10¹⁵⁄₁₆ x 17⁷⁄₁₆ x 3¹³⁄₁₆ in. (27.8 x 44.3 x 8.1 cm.). Donald Morris Gallery, Birmingham, Michigan.

209. Untitled (Space Object Box). (c. 1958). Construction, 11 x 17½ x 5¼ in. (27.9 x 44.5 x 13.3 cm.). The Solomon R. Guggenheim Museum, New York.

210. Untitled (Hotel de l'Etoile; Night Skies: Auriga). (1954). Construction, 19¼ x 13½ x 6¹⁵⁄₁₆ in. (48.9 x 34.3 x 17.6 cm.). Collection Mr. and Mrs. E. A. Bergman, Chicago.

211. Untitled (Andromeda; Grand Hotel de l'Observatoire; Grand Hotel de l'Univers). 1954. Construction, 18⁵⁄₁₆ x 12⁵⁄₁₆ x 3⅞ in. (46.5 x 31.3 x 9.8 cm.). Estate of Joseph Cornell, Courtesy Castelli Feigen Corcoran.

212. *Central Park Carrousel—1950—in Memoriam.* (1950). Construction, 20¼ x 14½ x 6¾ in. (51.4 x 36.8 x 17.1 cm.). The Museum of Modern Art, New York, Katharine Cornell Fund.

213. *Pavilion.* 1953. Light brown box construction, interior lined with newsprint painted bluish white; vertical rectangle, with strips of mirror above and to right, cut through back wall of construction at upper right, opening into rear compartment which contains reproduction of map of constellations Cepheus, Ursa Minor, Cauda Draconis, and Draco. Contains 3 curved mirror fragments and reproduction of dove constellation on back wall, mirror fragment on right side wall, mirror frag-

ment and reproduction of dog and horse constellations on left wall, white wood dowel at left, and white wood plank at right. Verso, including rear compartment, text papers stained blue; lid of compartment trimmed with illustration of constellation. Signed. 18¹⁵⁄₁₆ x 11¾ x 6⁹⁄₁₆ in. (48.1 x 29.8 x 16.7 cm.). Collection Mr. and Mrs. E. A. Bergman, Chicago.

214. *Observatory Colomba Carrousel.* (c. 1953). Construction, 18¹⁄₁₆ x 11⁹⁄₁₆ x 5¹³⁄₁₆ in. (45.9 x 29.4 x 14.8 cm.). Estate of Joseph Cornell, Courtesy Castelli Feigen Corcoran.

215. *Observatory Corona Borealis Casement.* 1950. Construction, 18⅛ x 11¹³⁄₁₆ x 5½ in. (46 x 30 x 14 cm.). Collection Mr. and Mrs. E. A. Bergman, Chicago.

216. *Observatory American Gothic.* (c. 1954). Construction, 17⁹⁄₁₆ x 11⁵⁄₁₆ x 2¹¹⁄₁₆ in. (44.6 x 28.7 x 6.8 cm.). Collection Mr. and Mrs. E. A. Bergman, Chicago.

217. *Carrousel.* 1952. Construction, 19½ x 13 x 6 in. (49.5 x 33 x 15.2 cm.). Collection Mr. and Mrs. Morton G. Neumann, Chicago.

218. Untitled (Hotel de l'Etoile). (c. 1953). Construction, 17⅛ x 11¾ x 6¹⁄₁₆ in. (43.5 x 29.8 x 15.4 cm.). Estate of Joseph Cornell, Courtesy Castelli Feigen Corcoran.

219. Untitled (Window Facade). (c. 1953). Construction, 19⅛ x 11 x 4⅛ in. (48.6 x 27.9 x 10.5 cm.). Collection Mr. and Mrs. E. A. Bergman, Chicago.

220. Untitled (Hotel Night Sky). (c. 1954). Construction, 16⅝ x 10⅛ x 6⅛ in. (42.2 x 25.7 x 15.6 cm.). Collection Irving Blum, New York.

221. Untitled (Window Facade). (c. 1953). Construction, 19⅛ x 13 x 4⁷⁄₁₆ in. (48.6 x 33 x 11.3 cm.). Collection Michael M. Rea, Washington, D.C.

222. Untitled (Grand Hotel de l'Univers). (c. 1953–55). Blue box construction; white interior covered with heavy impasto, crackled, rubbed, and incised with grid of lines; vertical rectangle (with strip frame and sill) cut through back wall of construction at center right, opening into rear compartment; paper strip imprinted *Grand Hotel de l'Univers* adhered to back above opening. Contains reversible wood panel, one side painted blue, other white, horizontally cracked into 2 pieces, inserted vertically into back compartment. Verso, including rear compartment, covered with texts. Signed. 19 x 12⅝ x 4¾ in. (48.3 x 32.1 x 12.1 cm.). Collection June Schuster, Pasadena, California.

223. Untitled (Window Facade). (c. 1953). Construction, 18⅝ x 12⅜ x 3⅝ in. (47.3 x 31.4 x 9.2 cm.). Private collection, New York.

224. Untitled (Hotel Broken Window). (c. 1955). Construction, 16⅝ x 9 x 5¼ in. (42.2 x 22.9 x 13.3 cm.). Castelli Feigen Corcoran.

225. *After Giotto #2.* (c. 1965–66). Collage, 11½ x 8½ in. (29.2 x 21.6 cm.). Estate of Joseph Cornell, Courtesy Castelli Feigen Corcoran.

226. *Circe and Her Lovers (Mathematics in Nature).* (c. 1964). Collage, 8½ x 11½ in. (21.6 x 29.2 cm.). Seattle Art Museum.

227. Untitled (Jungle Scene). Summer 1959, 1966. Collage, 11⁷⁄₁₆ x 13⅝ in. (29.1 x 34.6 cm.). Estate of Joseph Cornell, Courtesy Castelli Feigen Corcoran.

228. *Flora.* (c. 1966). Collage, 11½ x 8½ in. (29.2 x 21.6 cm.). Estate of Joseph Cornell, Courtesy Castelli Feigen Corcoran.

229. Untitled. (Early 1960s). Collage, 14½ x 11 in. (36.8 x 27.9 cm.). Estate of Joseph Cornell, Courtesy Castelli Feigen Corcoran.

230. *Apparition of the Corticelli Kitten in "Croisée."* (Mid-1960s). Collage, 12³⁄₁₆ x 9⅛ in. (31 x 23.2 cm.). Estate of Joseph Cornell, Courtesy Castelli Feigen Corcoran.

231. *Observations of Satellite I.* (Mid-1960s). Collage, 11½ x 8½ in. (29.2 x 21.6 cm.). Estate of Joseph Cornell, Courtesy Castelli Feigen Corcoran.

232. *Where Does the Sun Go at Night?* (c. 1963). Collage, 11¼ x 8¼ in. (28.6 x 21 cm.). Estate of Joseph Cornell, Courtesy Castelli Feigen Corcoran.

233. Untitled. (Early 1960s). Collage, 4⅝ x 6½ in. (11.7 x 16.5 cm.). Castelli Feigen Corcoran.

234. Untitled. (Mid-1960s). Collage, 11⅜ x 15⁷⁄₁₆ in. (28.9 x 39.2 cm.). Estate of Joseph Cornell, Courtesy Castelli Feigen Corcoran.

235. Untitled (Ice). (Mid-1960s). Collage 11½ x 8⅝ in. (29.2 x 21.9 cm.). Collection Celeste and Armand Bartos, New York.

236. *Mignon.* (Early 1960s). Collage, 11½ x 8½ in. (29.2 x 21.6 cm.). Estate of Joseph Cornell, Courtesy Castelli Feigen Corcoran.

237. *The Puzzle of the Reward, 1670.* (Mid-1960s). Collage, 11⅜ x 8⅜ in. (28.9 x 21.3 cm.). Donald Morris Gallery, Birmingham, Michigan.

238. *Isle of Children.* 1963. Collage, 11½ x 8½ in. (29.2 x 21.6 cm.). Estate of Joseph Cornell, Courtesy Castelli Feigen

Corcoran. N.B.: The title refers to Robert L. Joseph's play, in which Patty Duke appeared as Deirdre Striden.

239. Untitled. (Early 1960s). Collage, 10½ x 7⅛ in. (26.7 x 18.1 cm.). Estate of Joseph Cornell, Courtesy Castelli Feigen Corcoran.

240. *Lepus, the Hare, and Columba, the Dove.* (Mid-1960s). Collage, 11½ x 8½ in. (29.2 x 21.6 cm.). Estate of Joseph Cornell, Courtesy Castelli Feigen Corcoran.

241. Untitled (Home Poor Heart). (c. 1962). Collage, 11⅝ x 8⅝ in. (29.5 x 21.9 cm.). The Museum of Modern Art, New York. Gift of Mrs. Donald B. Straus.

242. *The Sister Shade (Urchin Series).* 1956. Collage, 11⁵⁄₁₆ x 8⅜ in. (28.7 x 21.3 cm.). Estate of Joseph Cornell, Courtesy Castelli Feigen Corcoran.

243. *Allegory of Innocence.* (c. 1956). Collage, 12 x 9 in. (30.5 x 22.9 cm.). The Museum of Modern Art, New York, Purchase.

244. Untitled (Ship with Nude). (Mid-1960s). Collage, 11½ x 8½ in. (29.2 x 21.6 cm.). Estate of Joseph Cornell, Courtesy Castelli Feigen Corcoran.

245. Untitled (Blue Nude). (Mid-1960s). Collage, 11³⁄₁₆ x 8³⁄₁₆ in. (28.4 x 20.8 cm.). Estate of Joseph Cornell, Courtesy Castelli Feigen Corcoran.

246. *Time Transfixed.* May 5, 1965. Collage, 9½ x 7½ in. (24.1 x 19.1 cm.). Collection Mr. and Mrs. Richard E. Lang, Medina, Washington.

247. *How to Make a Rainbow (for Jeanne Eagels).* (c. 1963–65). Collage, 11⅜ x 8⅜ in. (28.9 x 21.3 cm.). Estate of Joseph Cornell, Courtesy Castelli Feigen Corcoran.

248. *Robert Schumann/German Romanticism.* (c. 1965–67). Collage, 11½ x 8⅝ in. (29.2 x 21.9 cm.). Estate of Joseph Cornell, Courtesy Castelli Feigen Corcoran.

249. *Robinson Crusoe.* (c. 1966). Collage, 9½ x 7½ in. (24.1 x 19.1 cm.). Estate of Joseph Cornell, Courtesy Castelli Feigen Corcoran.

250. *Aerodynamics.* (c. 1960). Collage, 12⅛ x 9⅛ in. (30.8 x 23.2 cm.). Collection Miriam and Ronald Kottler.

251. *Corner of Juan Gris.* (Early 1960s). Collage, 12 x 9 in. (30.5 x 22.9 cm.). Marvin Ross Friedman and Co., Miami, Florida.

252. *Allegra.* (c. 1969). Collage, 11⅜ x 8⅜ in. (28.9 x 21.3 cm.). Private collection, New York.

253. *For J. Derequelyne.* (Early 1960s). Collage, 12⅛ x 8⅞ in. (30.8 x 22.5 cm.).

PHOTOGRAPH CREDITS

Photographs reproduced have been provided in the majority of cases by the owners or custodians of the works indicated in the captions. The following list applies to photographs in the Plate section for which a separate acknowledgment is due:

Franco Aschieri, Turin: 75, 126, 131. Oliver Baker Associates, Inc., New York:

86. E. Irving Blomstrann, New Britain, Connecticut: I. Bevan Davies, New York: VIII, XVIII, XIX, XX, XXVIII, XXX, XXXI, 2–13, 15, 22, 25–33, 35–37, 63, 66, 83, 84, 88, 91, 93, 96, 98, 100–104, 109, 112–15, 122, 128, 130, 132, 134, 146, 147, 150, 156, 157, 162, 166, 168, 171, 172, 174–78, 180–82, 186, 189, 190, 193, 194, 196, 204, 205, 211, 214, 218, 221, 223–28, 230–42, 244–46, 248, 254, 252, 255–60, 262–64, 270, 271, 273–76, 278–87, 290–92, 294. Jonas Dovydenas, Chicago: 106, 118, 169, 173. eeva-inkeri, New York: 124. Tom Van Eynde, Berkeley, Illinois: XII, 81, 135, 183. Thomas Feist, Riverdale, New York. 143. Brian Forrest, West Los Angeles, California: 197. Tom Gower, Minneapolis: 94. Hickey and Robertson, Houston, Texas: 73, 107. Kate Keller, Staff Photographer, The Museum of Modern Art: XI, XVII, XXVI, XXXII, 62, 82, 85, 129, 140, 198, 220. Walter Kidd, Bridgewater, Connecticut: 14, 34. Robert Mates and Paul Katz, New York: VI, 160. Robert Mates and Gail Stern, New York: 117. James Mathews, New York: 54. Katherine McHale, Chicago: 24. Courtesy Museum of Contemporary Art, Chicago: 78. O. E. Nelson, New York: 139. Mali Olatunji, Staff Photographer, The Museum of Modern Art: 293. Rolf Petersen, New York: 20. Eric Pollitzer, New York: I, III, IV, V, VII, IX, XXI, 19, 58, 60, 61, 64, 71, 72, 74, 79, 86, 89, 90, 92, 105, 110, 123, 133, 138, 148, 152, 159, 164, 165, 167, 179, 187, 188, 191, 202, 208. Seymour Rosen, Los Angeles: 207. Soichi Sunami, New York: 87, 212. Frank Thomas, Los Angeles: 59, 76, 192. Malcolm Varon, New York: XIII, XIV, XXIV, XXV, 149, 229, 247, 254.

© Estate of Joseph Cornell, for each work appearing with the credit Estate of Joseph Cornell, Courtesy Castelli Feigen Corcoran; and Castelli Feigen Corcoran.

The following list, keyed to page numbers, applies to other photographs for which separate acknowledgement is due:

The Art Institute of Chicago: 70, 71. Ernst Beadle: 279 top left. E. Irving Blomstrann, New Britain, Connecticut: 281 left center. Percy C. Byron: 280 right top. Colten: 28 top. Joseph Cornell Study Center, National Collection of Fine Arts, Smithsonian Institution, Washington, D.C.: 10 top, 103. Bevan Davies, New York: 42 top, 66 top. Dorka, Paris: 280 left (third). Giraudon, Paris: 279 right (third). Bill Holland, courtesy Harry N. Abrams, New York: 82 bottom, 281 center bottom. Howard Hussey Archive, New York: 266–68, 271, 272, 274, 276, 277. Kate Keller: 32, 64. Julius Kirschner: 280 center bottom. James Mathews: 23 right. Eric Pollitzer: 37. Soichi Sunami: 14, 20, 23 left, 29. The New York Public Library, Prints and Photographs Division: 58 top; Print Collection: 53 top, 60, 61 bottom.

LENDERS TO THE EXHIBITION

Addison Gallery of American Art, Phillips
Academy, Andover, Massachusetts
Australian National Gallery, Canberra
Des Moines Art Center, Des Moines, Iowa
The Fort Worth Art Museum, Fort Worth,
Texas
Wadsworth Atheneum, Hartford,
Connecticut
William Rockhill Nelson Gallery of Art,
Atkins Museum of Fine Arts, Kansas
City, Missouri
Kaiser Wilhelm Museum, Krefeld,
Germany
Grey Art Gallery and Study Center, New
York University, New York
The Solomon R. Guggenheim Museum,
New York
Whitney Museum of American Art,
New York
Allen Memorial Art Museum, Oberlin
College, Oberlin, Ohio
National Gallery of Canada, Ottawa
Musée National d'Art Moderne, Centre
National d'Art et de Culture Georges
Pompidou, Paris
Philadelphia Museum of Art
Seattle Art Museum
Moderna Museet, Stockholm
The Hirshhorn Museum and Sculpture
Garden, Smithsonian Institution,
Washington, D.C.
National Collection of Fine Arts,
Smithsonian Institution,
Washington, D.C.

ACA Galleries, New York
Mr. and Mrs. Robert Baras, New York

Celeste and Armand Bartos, New York
Mr. and Mrs. E. A. Bergman, Chicago
Tony Berlant, Santa Monica, California
Irving Blum, New York
Rhett and Robert Delford Brown,
New York
Castelli Feigen Corcoran, New York
Estate of Joseph Cornell, Courtesy
Castelli Feigen Corcoran
Mr. and Mrs. Julius E. Davis
Mrs. Marcel Duchamp, Paris
Stefan Edlis
Richard L. Feigen, New York
Xavier Fourcade, Inc., New York
Marvin Ross Friedman and Co.,
Miami, Florida
Gatodo Gallery, Tokyo
Mr. and Mrs. Philip Gersh, Beverly Hills,
California
Dr. and Mrs. Joseph Gosman
Vivian Horan, New York
Jeffrey Horvitz
Mr. and Mrs. Edward R. Hudson, Jr.,
Fort Worth, Texas
Edwin Janss
Mr. and Mrs. Richard L. Kaplin, Toledo,
Ohio
Donald Karshan, New York
Julianne Kemper
William Kistler III, New York
Miriam and Ronald Kottler
Felix Landau, Los Angeles
Mr. and Mrs. Alvin S. Lane
Mr. and Mrs. Richard E. Lang, Medina,
Washington
Mr. and Mrs. Julien Levy, Bridgewater,
Connecticut

Mr. and Mrs. Carl D. Lobell, New York
Barbara Mathes Gallery, New York
Christophe de Menil
Menil Foundation Collection Inc.,
Houston, Texas
Donald Morris Gallery, Birmingham,
Michigan
Robert Motherwell
Mr. and Mrs. Morton G. Neumann,
Chicago
Muriel Kallis Newman, Chicago
Betty Parsons, New York
Lewis and Lynn Pollock
Françoise and Harvey Rambach, New York
Mr. and Mrs. Orin Raphael
Michael M. Rea, Washington, D.C.
The Regis Collection, Minneapolis
Denise and Andrew Saul
Michael Scharf, Jacksonville, Florida
Arno Schefler, New York
June Schuster, Pasadena, California
Mr. and Mrs. Joseph R. Shapiro, Oak Park,
Illinois
Aaron B. Shraybman
Paul Simon
John C. Stoller and Co., Minneapolis
Allan Stone, New York
Mr. and Mrs. Donald B. Straus,
New York
Daniel Varenne, Geneva
Diane and Paul Waldman, New
Mr. and Mrs. Frederick Weisma
Beverly Hills, California
Mr. and Mrs. Billy Wilder,
Los Angeles

Several anonymous lenders